Digital Photography Exposure

FOR

DUMMIES®

by Jim Doty, Jr.

WILEY

Wiley Publishing, Inc.

Digital Photography Exposure For Dummies®

Published by
Wiley Publishing, Inc.
111 River St.
Hoboken, NJ 07030-5774
www.wiley.com

WILEY

About the Author

Jim Doty, Jr., is a landscape, event, and commercial photographer. His landscape and event images have been published in newspapers, magazines, books, tourism brochures, and corporate reports; and his commercial work appears on Web sites for several corporations. Jim's workshop and teaching experience includes seven years on the faculty at the Kalamazoo Institute of Arts, where he taught general and nature photography. One of his favorite things is to be up on some mountainside, or in the deserts of the Southwest, camera in hand.

Dedication

To my family, who endured numerous unplanned roadside stops, usually in the middle of nowhere, while I chased wildlife, wildflower, and landscape photos.

Author's Acknowledgments

My heartfelt thanks goes to Jennifer Connolly, Tim Gallan, Jennifer Tebbe, and the rest of the editorial staff at John Wiley and Sons. Their editorial skills made this a much better book. My thanks also goes to the rest of the team at John Wiley and Sons for the myriad things they do to take words and photos and turn them into eye-catching books.

My gratitude also goes to Barbara Doyen, my literary agent extraordinaire, who contacted me about writing a book and started me on this remarkable journey. A very special thanks to Mike Baroli, a photographer who went way beyond his sales job after selling me a camera. He critiqued my slides, recommended excellent books, converted me from Ektachrome 200 to Kodachrome 64, challenged me, and sent me well down the road to being a much better photographer. Our visits across the camera counter were a source of inspiration, and his critiques led to my first published landscape photos.

My thanks also to the fun crew at the *Yukon Review,* who showed me the ropes for sports photography and published my articles and photos about music concerts, the school debate team, and other eclectic stories. Special thanks to Jim Riegel, who asked me to teach at the Kalamazoo Institute of Arts, where I worked on my ability to communicate photographic ideas and concepts, had a great time taking photographers on field trips, and began writing about photography on a regular basis. Speaking of teaching, thanks to all the photographers who have participated in my classes, workshops, and field trips. Thanks also to those who encouraged me to start a Web site to share my photos and photography articles.

A very special thanks goes to family, friends, and total strangers who graciously granted permission to put the photos I've taken of them into this book.

Finally, and most importantly, my love and thanks goes to my family for their love, encouragement, and support.

Publisher's Acknowledgments

We're proud of this book; please send us your comments through our Dummies online registration form located at http://dummies.custhelp.com. For other comments, please contact our Customer Care Department within the U.S. at 877-762-2974, outside the U.S. at 317-572-3993, or fax 317-572-4002.

Some of the people who helped bring this book to market include the following:

Acquisitions, Editorial, and Media Development

Senior Project Editor: Tim Gallan

Acquisitions Editor: Stacy Kennedy

Senior Copy Editor: Jennifer Tebbe

Assistant Editor: Erin Calligan Mooney

Senior Editorial Assistant: David Lutton

Technical Editors: Ross Bothwell, Kate Snell Brown

Editorial Manager: Michelle Hacker

Editorial Assistants: Jennette ElNaggar, Rachelle S. Amick

Art Coordinator: Alicia B. South

Cover Photo: Jim Doty

Cartoons: Rich Tennant (www.the5thwave.com)

Composition Services

Project Coordinator: Patrick Redmond

Layout and Graphics: Claudia Bell, Timothy C. Detrick, Samantha K. Cherolis, Cheryl Grubbs, Mark Pinto

Proofreaders: Laura Albert, Betty Kish

Indexer: WordCo Indexing Services

Special help: Caitlin Copple

Publishing and Editorial for Consumer Dummies

 Diane Graves Steele, Vice President and Publisher, Consumer Dummies

 Kristin Ferguson-Wagstaffe, Product Development Director, Consumer Dummies

 Ensley Eikenburg, Associate Publisher, Travel

 Kelly Regan, Editorial Director, Travel

Publishing for Technology Dummies

 Andy Cummings, Vice President and Publisher, Dummies Technology/General User

Composition Services

 Debbie Stailey, Director of Composition Services

Contents at a Glance

Table of Contents

Part III: Taking Exposure a Step Further: Creating Great Images ... 221

Chapter 11: Candids, Portraits, and More: People Photography223

Chapter 12: Taking a Walk on the Wild Side: Photographing Wildlife239

Introduction

I'm going to let you in on a little secret: Sometimes my camera is set to P for program mode (some pros sarcastically say the P stands for perfect). That's right, in program mode, I turn all the exposure decisions over to the camera. A few of my favorite photographs were taken in program mode, but most of them were created when I was in control of the exposure. Why? Because P doesn't always stand for perfect.

Despite being technological wonders, even the best camera metering systems can totally miss the right exposure when faced with an unusual lighting situation. Because these types of situations often give you the most wonderful images, you need to know how to take control of your exposures. *Digital Photography Exposure For Dummies* lets you know when and how to take control of exposure. And as you discover in this book, controlling exposure is one of the first and best steps to achieving better, more dramatic images.

Developing your exposure skills is a lifelong process (even some of the world's best photographers take multiple, varied exposures trying to capture the perfect one in some difficult lighting situations), but reading this book and applying what you read will give you the skills you need for the vast majority of exposure situations. The rest comes with experience and exploration.

About This Book

Digital Photography Exposure For Dummies explores the technical and artistic sides of exposure and applies both to real-world situations. It lays out the technical side of exposure so you have a solid foundation as you delve into the artistic side of exposure, with all the wonderful, creative options this side offers. It also features numerous photo exercises that you can try out at your own pace and comfort level. I include these exercises because reading about techniques is all well and good, but actually *doing* them locks them into your memory (including the important muscle memory that comes from doing things with your hands).

This book is designed to be your go-to resource for information related to digital photography exposure. Whether you need the foundational information — such as terminology and how certain facets of your camera affect your exposures — or inspiration for capturing your very own memorable images of subjects ranging from people and wildlife to landscapes and events, *Digital Photography Exposure For Dummies* has what you're looking for.

By the way, about 90 percent of the advice in this book applies to film photography. But there are different exposure approaches and techniques you should be aware of if you shoot with film. That coverage is beyond the scope of this book, but you can find plenty of advice on my Web site: JimDoty.com.

Conventions Used in This Book

Perhaps the most important convention used in this book involves the exposure information that accompanies almost every photo. This information appears in small print immediately after each photo and looks like this:

24mm, 30 sec., f/4, 400

The first bit of information refers to the focal length of the lens I used to take the photo. (In a few cases, the photos were taken with a cropped-frame digital camera, so the *effective focal length* is longer than the actual focal length of the lens.) The second number is the shutter speed, the third number is the aperture, and the fourth number is the ISO.

Following are a few extra conventions that should make reading and understanding the concepts I present even easier:

- ✔ **Boldface** tells you you're looking at the action steps of a task or the main points in a list of information.

- ✔ *Italics* introduce new terminology that I define for you. They also occasionally indicate a word I'm emphasizing.

- ✔ Monofont alerts you to the presence of a Web site address. Rest assured that even if a Web site's address breaks from one line to the next, I haven't added any hyphens or other symbols — just type the address into your browser exactly as it appears in the book.

What You're Not to Read

Although I'd love for you to read this entire book, not all of the information I share is vital to your understanding of digital photography exposure. The sidebars (gray-shaded boxes that pop up periodically) and paragraphs marked with a Technical Stuff icon contain tidbits that I find interesting enough to mention. However, you're welcome to skip over them if you aren't interested in them or if you just don't have the time to read them.

Foolish Assumptions

Here's what I assumed about you as I wrote this book:

- ✔ You already know the basics about using a digital camera, but you aren't necessarily familiar with the foundational concepts of digital photography exposure.
- ✔ You know a little bit about exposure, but you want to dig a lot deeper to discover all the ways you can create better images.
- ✔ You have a digital single-lens-reflex (SLR) camera or a high-end point-and-shoot camera that allows you to take control of the basic exposure settings (aperture, shutter speed, and ISO).
- ✔ You picked up this book because you want to be a better photographer and you're ready to take the necessary steps to do that.

How This Book Is Organized

Digital Photography Exposure For Dummies covers all the basics of exposure, plus a whole lot more, in five parts. Each of these parts has a specific focus. The following sections break down what you can find in each part.

Part 1: The Science of Exposure

This part explains the technical side of exposure — the science behind the art that allows you to get the exposure you want. It's the foundation for all the other chapters in this book. Chapters 1 and 2 introduce you to the language of light and exposure. In them you explore how apertures, shutter speeds, and ISO settings work together. Chapter 3 shows you how to meter with your camera and how to match metering patterns to a scene. It also introduces you to the concept of exposure compensation (which is a tool for making your subjects as light or as dark as you want them to be). Chapter 4 explains how to use incident light meters, gray cards, and other exposure tools to help simplify your exposure life, and Chapter 5 exposes you to all kinds of lighting situations and equips you to make the most of light.

Part 11: The Art of Exposure

The ways you combine apertures, shutter speeds, and ISO settings can dramatically change the look of your images. Mastery of these exposure choices is therefore the key to the artistic side of exposure. Chapters 6 and 7 explore

the creative use of apertures. In them you discover how to create images where your subject stands out sharply against a soft, blurred background and how to do the opposite to achieve amazing near-to-far sharpness in your photos. Chapter 8 shows you the creative ways to use shutter speeds, such as freezing a moment in time to reveal things the human eye can't see. Chapter 9 looks at several artistic uses of ISO settings so you can have a much broader range of aperture and shutter speed options, and Chapter 10 takes you through the basics of flash so you can create some extra light when you need to.

Part III: Taking Exposure a Step Further: Creating Great Images

Also known as the "go out and do it" part, this is where you apply your exposure knowledge to real-life situations and create great images. Chapter 11 gives you creative ideas for photographing people outdoors and indoors in casual moments and classic portraits. Chapter 12 helps you solve the exposure challenges you can expect to face when photographing wildlife. Chapter 13 reveals how to combine good exposure skills with great light to create dramatic landscapes, and Chapter 14 presents several ideas for creating flower photos that stand out from the crowd. Last but not least, Chapter 15 shows you how to use the best locations and the peak of the action to create better sports photos.

Part IV: Exposure in Special Situations

Special situations provide special challenges for both your exposure skills and your techniques. This part guides you through several of these situations. Chapter 16 leads you into the strange and delightful world of close-up photography, and Chapter 17 opens your eyes to the possibilities available when shooting in low light and at night (believe me, there are more great photo opportunities than you may think).

Part V: The Part of Tens

For Dummies books are famous for their top ten lists, and this book is no exception. In this part, Chapter 18 introduces you to ten accessories that can make your life easier and improve your photography, and Chapter 19 keeps you in photo heaven by helping you avoid ten common mistakes photographers make.

Icons Used in This Book

Throughout this book, I flag different points that I want you to notice with special icons. Here's what each icon means.

When I want to let you know something that you absolutely shouldn't forget, I use this icon.

This information is interesting but nonessential to your understanding of digital photography exposure. Skip it if you prefer.

Keep your eyes peeled for this bull's-eye if you're interested in tips that can save you time, make your photographic life easier, and give you better exposures.

Every once in a while, you may encounter some subjects or situations that can really damage your camera, your exposures, or even you personally. Be sure to read the warnings flagged by this icon.

Where to Go from Here

Feel free to jump in at several different places and pick up a feel for the whole book. However, you should know that Parts III and IV have lots of references to exposure concepts that are covered in detail only in Parts I and II.

Exposure is partly a technical subject, and certain basics about it are essential to know, so it's probably best if you read Parts I and II before the rest of the book. Yes, the technical side of the book may be just a tad less fun than the artsy side, but it gives you the foundation you need to do the wonderful and creative things that make photography such a joy. And besides, if you happen to sneak a peek at Part III while you're going through Chapter 2, no one will know. I promise the chapter police won't show up at your door. However you choose to read this book, you're guaranteed to become a better photographer as you experiment with the concepts, tools, and techniques you discover here.

I love photography, and I love watching the light go on as other photographers discover new ways to do things to improve their photography. I hope you have a great time reading this book and an even better time going out with your camera and trying what you've read. Most of all, I hope sometime in the future you look back and say, "Wow! Look how far I've come!"

Part I
The Science of Exposure

The 5th Wave — By Rich Tennant

"Hold on, Barbara — I don't have the right ISO setting! Let me open the aperture...get the right depth of field. There, now I feel better about the ISO. Now the shutter. What would you call this, an action shot or a portrait?"

In this part . . .

If you want to capture stunning photographs, and I'm guessing you do since you're reading this, you need to be able to speak the language of exposure so your camera can understand what you want. When the technical aspects of exposure — apertures, shutter speeds, and ISO settings — become second nature to you, then creating "perfect" exposures is less intimidating.

That's what Part I is all about. If the language seems a little strange at first, that's okay. Keep at it, and you'll soon be speaking fluently. Better yet, your camera will understand you, and you'll get the exposures you want.

1

Discovering the Art of Exposure

*I*f you're new to the world of controlling exposure (part of which has to do with how light or dark your photos are), then you have an exciting new realm of photography to explore. Several combinations of aperture, shutter speed, and ISO can provide the same exposure, but knowing *which* combination to choose can make the difference between an ordinary snapshot and a great image. Why? Because every exposure decision is also an artistic one.

This chapter introduces you to the technology and the artistic sensibilities required for achieving great exposures. You need the right tools, but you also need to have an understanding of the artistic control you can exercise over your photography. Sure, cameras have automatic settings that can make all the exposure decisions for you, but that means turning over all the artistic decisions to computer circuitry. When the camera's in charge, you end up with a lot of serviceable but ordinary photos. With a little knowledge, you can start tinkering with the exposure settings and get amazing photographs as a result.

Picking the Right Camera: Your Top Priority

Before you can attempt to understand photographic exposure or improve your exposure skills, you need to have a camera that aids your efforts and doesn't hinder them. Two popular types of digital cameras exist (Figure 1-1 helps you see the differences between them):

- ✔ **Point and shoot:** This is the most common type of digital camera due to its extreme portability, low price, and relative ease of use. The average point-and-shoot camera has a nonremovable lens (although some recent versions are offering interchangeable lenses). Some of these cameras have an optical viewfinder, but the scene you see doesn't come from the lens, so it's only an approximation of what the camera lens is seeing. If the camera has an electronic viewfinder (EVF), the scene comes from the lens, so the EVF shows you exactly what the lens is seeing (which is also true for the rear LCD screen). Many point-and-shoot cameras have a full range of exposure controls, but they're often placed in the menu structure, which means they aren't always quick and simple to use. However, some of the best and most recent models are making exposure controls easier to access.

- ✔ **Single lens reflex (SLR):** This is a bigger and heavier digital camera that's usually more expensive than the majority of point-and-shoot cameras. A digital SLR camera uses interchangeable lenses and has a move-able reflex mirror that takes the scene provided by the lens and reflects the image up through a *pentaprism* (or mirror box) and out to the eye-piece. Basically, what you see is what the lens is seeing. When you take a picture, the reflex mirror flips up and out of the way so the image hits the digital sensor when the shutter opens. One big advantage of most digital SLRs is how easy and fast they make it to access most exposure controls (such as the ones I list later in this section). On the majority of digital SLRs, these controls are immediately available to the photographer in the form of dials and buttons, as opposed to being tucked away in the camera's menu structure (like on many digital point-and-shoot cameras). Digital SLRs also have a much larger sensor, which translates into several image-quality advantages.

In addition to these two types of digital cameras, some interesting hybrids are becoming available. Most of them have some combination of features found on digital point-and-shoot and digital SLR cameras. These hybrid cameras are worth watching as the technology matures over time.

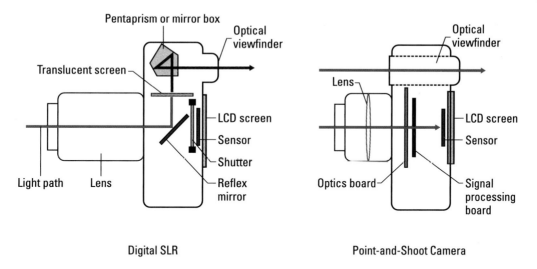

Figure 1-1: A digital SLR camera (left) and a digital point-and-shoot camera (right).

To use exposure as a creative, artistic tool, you need a digital camera that not only allows you to control aperture, shutter speed, and ISO but also gives you the ability to lock in an exposure reading. Following are the camera features to look for:

- ✔ **Aperture-priority mode (Av):** In aperture-priority mode, you choose the size of the lens aperture, and the camera picks the shutter speed. The *aperture* is the variable opening in the lens that the light flows through. The size of the lens aperture controls how much light can flow through the lens at any one moment in time and determines the *depth of field* (the amount of near-to-far sharpness) in a photograph.

- ✔ **Shutter-priority mode (Tv):** In this mode, you choose the shutter speed, and the camera picks the size of the lens aperture. *Shutter speed* determines how long light is allowed to flow through the lens. Changing the shutter speed allows you to determine the sharpness or blurriness of moving subjects. The combination of aperture (how much) and shutter speed (how long) determines the total amount of light that reaches the digital sensor.

- ✔ **Manual ISO settings:** *ISO* refers to the camera's sensitivity to light. At a higher ISO speed, the camera can provide the same exposure with less light than at a lower ISO speed. In other words, the camera can do more with less light at a higher ISO setting, giving you more exposure options and allowing you to use faster shutter speeds in low-light conditions.

- ✔ **Manual exposure mode (M):** When your camera is in manual exposure mode, you choose both the aperture and the shutter speed.

✔ **Exposure compensation (EV):** This setting allows you to vary the exposure by telling the camera to add or subtract light from what the camera thinks is a good "average exposure." In other words, exposure compensation is how you tell the camera to make a subject lighter or darker.

✔ **Exposure lock:** This feature gives you the ability to meter one subject, lock in that exposure, and re-aim the camera at a different subject without losing the original exposure setting — ultimately giving you more control over your exposures. The exposure lock feature is very useful when you want to photograph a scene with a lot of different subjects but base your meter reading on only one subject in that scene.

If your camera makes it easy to control exposure, you'll be a happy photographer, but if your camera makes it difficult to select desired exposures, you'll be continually frustrated. I recommend evaluating your current digital camera to make sure it has all the features and settings I describe in this section. If it doesn't, or if you feel like it's holding back your artistic growth as a photographer, start researching newer digital camera models and be sure to try some out in person so you end up with a camera that's perfect for you and your ongoing exposure adventure.

The Web site `dpreview.com` is an excellent resource for dependable reviews of digital cameras and the latest technology. Use it as a starting point for research if you need to purchase a new camera.

Personally, I believe digital SLRs make exposure much easier than the majority of point-and-shoot cameras. If you're on the fence about which type of digital camera to purchase, let me gently suggest hopping over to the digital SLR side.

Looking at the Scientific Side of Exposure

The scientific side of digital photography is expressed in your camera's technology. To make your camera reveal all of its tricks and secrets, you need to speak your camera's language, from f-stops to equivalent exposures. Enter Chapter 2. It'll have you speaking fluent "camera talk" in no time.

But that's not all you need. You also have to be able to work with light, which is where the meter in your camera comes in handy. It's a remarkable technological tool that can do wonders for your photography. But left on its own, it does a great job of creating average-looking photos (ones that aren't too light or too dark). That may not sound so bad, but consider that when faced with a high-contrast situation, like the Alaskan scene in Figure 1-2, your meter can get confused and do almost anything — and the result may not be pretty.

If you want to be sure you're going to wind up with the exposure you want, you have to give your meter more specific instructions. When you tell your meter what to do, you kick open the door to all kinds of new possibilities. You can make any subject as light or as dark as you want — even if your subject ends up lighter or darker than it is in real life. Great photographers do this all the time!

When armed with the right metering know-how, the next time you're faced with a beautiful sunset, you can decide whether it should be light and airy (like the Tahitian sunset in Figure 1-3, top) or dark and dramatic (like the sunset over Mo'orea in Figure 1-3, bottom). Say the word and your meter will, as they say on the starship *Enterprise,* "make it so."

Chapters 3 and 4 are your comprehensive guides to all the ins and outs of metering. They also help you explore exposure accessories that can simplify your life and turn you into a metering whiz. As an added bonus, Chapter 5 leads you through the process of working with all kinds of light.

About 50mm, around 1/400 sec., about f/11, 100

Figure 1-2: Knowing what to tell the meter helped me capture the right exposure for this high-contrast scene.

28–135mm lens at 28mm, 1/45 sec., f/8, 100

100–300mm lens at 300mm, 1/250 sec., f/8, 100

Figure 1-3: Light and dark sunset photos, courtesy of different light metering choices.

Taking Control of the Artistic Side of Exposure

Your camera has the technical wizardry to provide a decent exposure much of the time, but it doesn't know how you want your images to look. Unless you tell your camera, it doesn't know whether you want to create a little depth of field or a lot, and it has no clue whether you want to freeze your subject or add some creative, artistic blur. Photography is a fascinating mix of art and science, but your camera is focused on the science. It has this part of the mix down pat, most of the time anyway, but the artistic part is entirely up to you. The chapters in Part II help you discover and embrace the artistic aspects of exposure. They focus on the following:

✔ **Aperture:** The size of the lens aperture is one of your primary tools for controlling depth of field, which is one of your most powerful creative tools. By minimizing depth of field, you can make a subject in the foreground stand out against a soft, out-of-focus background (like the chicory in Figure 1-4). Or you can maximize depth of field to make everything in an image look sharp and crystal clear. Notice how the black, sandy beach and the distant clouds all look sharp in Figure 1-5's early morning beach photo. Chapters 6 and 7 give you all kinds of ways to use and control depth of field.

28–135mm lens at around 135mm, about 1/60 sec., around f/5.6, 100

Figure 1-4: A shallow depth of field puts the emphasis on the flower.

17–40mm lens at 17mm, 1/6 sec., f/13, 100

Figure 1-5: There's a lot of depth of field in this Tahitian beach photo.

✓ **Shutter speed:** Working with shutter speeds can help you stop a moving subject in its tracks (such as the wave in Figure 1-6) or record seconds of time (see Figure 1-7), several minutes of time, or even hours of time with the right subject and the right conditions. For the full scoop on all the artistic things you can do by changing shutter speeds, flip to Chapter 8.

100–300mm lens at 150mm, 1/750, f/11, 400

Figure 1-6: A fast shutter speed allows you to freeze the motion of a wave.

70–200mm lens at 135mm, 10 sec., f/22, 100

Figure 1-7: A long shutter speed recorded traffic patterns on the Las Vegas Strip.

✔ **ISO:** Higher ISO speeds allow you to use small apertures *and* fast shutter speeds, a combination that isn't possible at slower ISO speeds. Refer to Figure 1-6 for an example of the results this combination gives you. The ISO 400 setting allowed me to use a small aperture to keep much of the scene in focus *and* a fast enough shutter speed to freeze the wave. Without the higher ISO setting, the waves would be blurred or most of the scene would be out of focus. I delve into how to make the most of ISO speeds in Chapter 9.

✔ **Flash:** When you don't have enough light, a little bit of portable sunlight in the form of an electronic flash unit helps. Indoors, when the light levels are low, a bit of flash can help you capture a happy moment like the one in Figure 1-8. Outdoors, in bright sunlight, flash can throw some much-needed light into overly dark shadows. In the studio, one or more flash units with some umbrellas to soften the light can help you take wonderful portraits. Turn to Chapter 10 for all things flash related.

28–135mm lens at 30mm, 1/60 sec., f/8, 400

Figure 1-8: This happy photo was made possible with a small dose of flash.

Applying Exposure to Real-World Photography

All the technical and artistic digital photography knowledge in the world isn't going to do much for you unless you get out there and snap some pictures. Photographers shoot all kinds of things, but the most common subjects are people, wildlife, landscapes, flowers, sporting events, and other special events. I fill you in on these subjects in the sections that follow.

Your images won't be perfect if you're just getting started, but I guarantee that with time and practice, you *will* become a better photographer. The more you keep at it, the better you'll get.

People

Metering people is easy if you remember one simple piece of advice: Get close enough to fill the frame with your subject's face as you meter and then back up to take the picture.

Of course, there's more to great people photography than that. Whether you're taking photographs of people indoors or out, at work or at play, with complicated studio lighting or with just a single household light bulb (see Figure 1-9), Chapter 11 will send you well down the road to people photos you can be proud of.

24–105mm lens at 65mm, 1/20 sec., f/4.5, 800

Figure 1-9: A simple portrait taken using a single household light bulb.

Wildlife

I don't recommend walking up close to a bull moose to meter its face, but thanks to some basic metering skills, you can easily bring home eye-catching wildlife photos. With the information I provide in Chapter 12, you'll be ready to go when you, say, spot a bobcat in a tree on a bitter-cold winter morning (see Figure 1-10). By itself, your camera's meter won't know what to do with the mostly dark, high-contrast scene, but you'll know how to pick out the right tone to meter to get the exposure just right for the whole scene.

300mm, around 1/125 sec., about f/8, 100

Figure 1-10: Give your camera's meter a little guidance in high-contrast scenes like this one.

Landscapes

Landscapes are tricky to meter, but with the additional tips and tricks I share in Chapter 13, the next time you're faced with a landscape that contains a wide range of tones, like the one in Figure 1-11, you'll know just what to meter and how to adjust your camera so the scene looks exactly how you want it to.

Flowers

Flowers are simple to meter — provided you tell your camera's meter how to make light flowers light and dark flowers dark. Whether you want to capture a close-up of one flower (see Figure 1-12) or a cluster of flowers, Chapter 14 reveals how to meter flowers and create gorgeous flower photos.

17–40mm lens at 17mm, 1/20 sec., f/16, 100

Figure 1-11: Cooks Bay, Mo'orea, metered to the sunny parts of the scene.

100mm, about 1/2 sec., around f/8, 100

Figure 1-12: A yellow orchid, metered to maintain its light, bright tones.

Sports

Photographing sports is guaranteed to challenge all of your metering skills and make you a much better photographer. Chapter 15 gets you feeling comfortable with the pace and practices required for sports photography. (Don't be surprised if some of your favorite photos come from shooting from odd angles; see Figure 1-13).

10–22mm lens at 10mm, 1/320 sec., f/8, 100

Figure 1-13: Being in the right spot can help you get great shots.

Keeping Your Cool in Special Exposure Situations

By breaking out of the box and putting yourself in situations that other photographers tend to avoid, you can wind up with some really great images. From the small subjects that are the focus of close-up photography to the magic that occurs in low-light situations, there's a lot of fun to be had in the world of special exposure situations. The following sections are guaranteed to expand your photographic horizons (and they may even instill a passion for a newfound subject).

Close-up photography

Sometimes the littlest things in life are the most fascinating to photograph, which means you need to have a handle on close-up photography if you want to be able to freeze that subject for a moment in time (like I did with the red dragonfly in Figure 1-14). Chapter 16 presents the tools, techniques, and unique metering skills necessary for close-up photography.

100mm, around 1/125 sec., about f/8, 100

Figure 1-14: The right close-up gear helped make this photo possible.

Low-light photography

You don't have to put your camera away when darkness starts to creep up on you. Sure, taking pictures in low light requires some planning, practice, and maybe some additional equipment, but it's possible, and the results can be quite stunning. See for yourself in Figure 1-15. The white cloud reminds me of a dove, floating over the planet Venus. Chapter 17 leads you through several low-light photography scenarios.

24mm, around 20 sec., about f/4, 100

Figure 1-15: You can create memorable photos even when the light is low.

2

Exposure 101: The Basics

Knowing how to effectively use apertures, shutter speeds, and ISO settings allows you to not only take control of the exposure of your images but also take a step toward capturing creative, dynamic photographs. Every exposure decision combines the art and science of photography. At its best, exposure is an artistic adventure; at its worst, exposure is a puzzling technical challenge.

If you're new to controlling apertures, shutter speeds, and ISO settings, mastering the language can seem challenging at first, but hang in there. Before long you'll be able to rattle off that f/16 is 2 stops less light than f/8, that 1/60 second is 2 stops more light than 1/250 second, and that ISO 800 is 3 stops faster than ISO 100. You won't even have to think about it!

Of course, you also need to have a solid grip on the technical aspects of aperture, shutter speeds, and ISO. After all, better technical skills lead to greater artistic potential. Poor technical exposure skills hinder your progress as a photographer, but good exposure skills empower your art. This chapter is your first big step toward mastering exposure. Prepare to dive into the language of exposure and catch a few sneak peeks at the artistic possibilities you can create when you play with apertures, shutter speeds, and ISO settings.

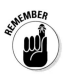

This book doesn't pretend to present the "one true way" to arrive at a good exposure. You can get a good exposure by using reflected light meters, incident light meters, gray cards, exposure calibration targets, histograms, exposure guides, and basic daylight exposure (BDE). I'm merely helping you explore a bunch of ways to arrive at exposure. Over time, you can evolve a way of arriving at exposures that works best for you.

Exploring Exposure Challenges: The Variety of Light and Tonality

Each and every photographer faces the same challenges to creating a great exposure: the variety of light and the vast range of tonalities in the world.

The incredible variety of light is the glory of photography, and it makes for endless exposure challenges as well as opportunities. This variety is matched only by the vast range of subject tonalities, from sparkling white snow to black velvet. (*Tonality* refers to how light or dark in tone the colors are — light green, dark red, medium gray, and so on.) Naturally, the many possible tonalities just add to the exposure challenges every photographer faces. For instance, in the same light, a very-light-toned subject requires a different exposure than a very-dark-toned subject.

In addition, the human eye can see a much broader range of light than any digital camera sensor. Your amazing eyes can see sunlit snow on the mountains and purple flowers in the dense shade, all at the same time. Your camera, however, can see only one of these at a time because digital sensors have a limited range of tonalities that they can capture with one exposure.

Tonality applies to both black-and-white and color photography. In the black-and-white universe, the tonalities range from pure white through various shades of gray to textureless black. In the world of color, you can have every imaginable color tone, from very light to very dark for every color of the rainbow. As a photographer, you decide how light or dark to make the color tonalities in your images.

Of course, you don't usually want all the subjects in your photos to have the same tonality. When they do, your photos can lack zip. Photos generally need contrast to be interesting. The right exposure, combined with some extra added contrast courtesy of good photo-editing software, can increase the range of tonalities to bring life back to a photograph. Of course, even if your photo doesn't have enough tonality contrast, it can still be a great photo if it has a lot of color contrast. Just think of a bunch of flowers with different colors but the same tonality.

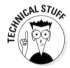

With all of these variables in play, it's not surprising that some of the best photographers bracket exposures in some difficult lighting situations (such as when there's a mixture of sun and shade or a broad range of subject tones ranging from very light to very dark). To *bracket* exposures is to use several different exposures to ensure that one of them is the exposure you want, as I explain in more detail in Chapter 4.

To really understand what I mean about the variety of light and range of tonalities, check out Figure 2-1. This photograph has a huge tonality range from granite peaks in sunlight to dark green evergreens in the shade. A camera can't capture all of these colors and tones, which is why an experienced photographer chooses to capture the most important tonalities in the scene. In this case, I chose to focus on the sunlit granite. With the right exposure decisions, you can create great images in contrasty situations.

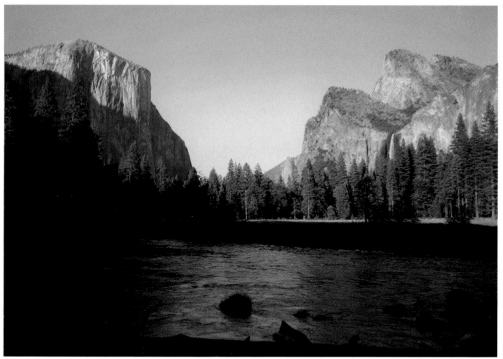

24–105mm lens at 28mm, 1/160 sec., f/8, 100

Figure 2-1: I focused my exposure on the sunlit granite in this photo.

Capturing the Exposure You Want

The challenge of exposure is to take the range of light and subject tonality and translate that into the language of apertures, shutter speeds, and ISO settings. If you make the right f-stop, shutter speed, and ISO decisions, you'll have a good exposure. If you don't, you'll have a bad exposure. Figure 2-2 is an example of an exposure that worked. I wanted the icicle to be reasonably bright without burning out too many highlights, so I chose my camera settings accordingly.

Because one photo is hardly enough to help you distinguish a good exposure from a not-so-good one, I present the characteristics of both in the following sections. I also help you understand that you have the ability to create any type of exposure you want.

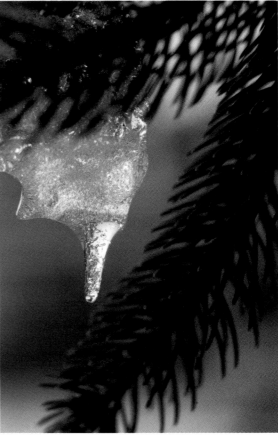

100mm, 1/80 sec., f/8, 100

Figure 2-2: An icicle amid evergreen needles, exposed to keep some of the highlights.

Recognizing what makes an exposure good or bad

You have a good exposure when the resulting image turns out the way you wanted it to; you have a bad exposure when the photograph is different from what you wanted it to be. So, for example, if the range of subject tonalities in a photograph matches what you were going for, or if you captured the light the way you wanted to, or if you just plain like how the photo looks, then the exposure is a good one. On the other hand, if the image looks too light or too dark compared to how you wanted it to look, the exposure is a bad one.

A well-exposed image doesn't have to look like the original scene. Nor does it have to be technically correct. You can shift the whole range of tonalities in a scene, making them lighter or darker. For instance, you can darken storm clouds to make them more ominous or lighten the tonalities of a flower to make it look more delicate. A single scene can provide a range of interpretations. Sunsets are a classic example. By simply changing the exposure, you can make the same sunset light and airy or dark and dramatic. What all of this means, of course, is that it's perfectly okay to try several different exposures for the same scene. Sometimes you're pleasantly surprised by an alternate exposure that really grabs your attention.

Figures 2-3 and 2-4 were photographed the same evening from the same location.

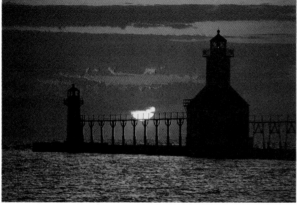

Probably 80–200mm lens at 200mm, 1/60 sec., f/8, 50

Figure 2-3: A dark-looking sunset in Michigan.

Around 50mm, around 1/8 sec., about f/8, 50

Figure 2-4: A lighter evening sky, shot on the same day.

I tried several exposures for the sunset, and later on, for the evening light. When I looked at the images later, I preferred darker tonalities for the sunset and lighter tonalities for the late evening light. It was actually much darker than you'd think from looking at Figure 2-4, but that's one of the artistic wonders of exposure — you can make your subjects lighter or darker to create the kinds of images you want.

You have a technically correct exposure if the photo you create is an accurate representation of what you saw with your own eyes. Here are some other characteristics of technically correct exposures:

✓ There aren't any *overexposed* (that is, washed out and featureless) highlights.

✓ Light tones are light, and dark tones are dark.

✓ Nothing important is lost in inky-black shadows.

With a limited tonality range in the original scene, you can create a technically correct exposure with one carefully metered exposure. With a high-contrast scene, you can still come close to a technically correct exposure — provided nothing in the scene is moving — by taking several different exposures of your scene with a tripod-mounted camera and combining the photographs on your computer with the help of photo-editing software.

Of course, you'll be a better photographer if you can accept that some scenes look better if you vary from the technically correct exposure for an artistic one. After all, having an image that speaks to you is more important than having one that's technically correct.

To save you from going crazy in the mad pursuit of the ideal exposure for every photographic scene, keep these guidelines in mind:

✓ A seriously over- or underexposed photo (one that's several stops off) is a throwaway.

✓ A modestly underexposed photo (2 or 3 stops off) can be saved in the digital darkroom, although the quality may suffer if you've pushed the limits of your camera's sensor.

✓ A slightly over- or underexposed photo (½ stop off as long as you're shooting Raw files) usually isn't a problem — getting pretty close means you're home free. (To find out more about Raw versus JPEG files, see Chapter 3.)

Having it your way

Ultimately, exposure is a matter of personal taste. Three photographers can photograph the same model, and one will give her realistic skin tones, the

second will make her skin light and glowing, and the third will give her darker, richly saturated skin tones. All three photographers made "good" exposures decisions for the vision they had in mind.

24–105mm lens at 65mm, 1/8 sec., f/8, 400

Figure 2-5: A model, metered to make her skin light in tone.

In the next two photos, both persons have skin that's pretty close to the same tonality, but I wanted lighter, more neutral skin tones for the photo of the woman (Figure 2-5) and warmer, more saturated (richly colored) skin tones for the photo of the boy (Figure 2-6). I exposed accordingly and simply adjusted the white balance in the photo of the boy (*white balance* is a camera setting for adjusting the overall color balance of an image so it's cool, neutral, or warm; see Chapter 5 for more).

Personal taste applies not only to the exposures you choose but also to the way you go about arriving at those exposures. Most really good photographers have a certain way of arriving at the exposures they use. With time and experience, they've each found a particular approach that works best for them. But what works best for Photographer A may not be suited to how Photographer B likes to

24–105mm lens at 90mm, 1/13 sec., f/8, 400

Figure 2-6: The warmer skin tones here are courtesy of the exposure and white balance.

work. So feel free to learn from other photographer's approaches to exposure, but don't be afraid to develop your own exposure style.

Controlling the Light with Stops

Because exposure depends on the amount of light that hits your camera's digital sensor, the way to change the exposure from one image to another is to control the amount of light that hits the sensor. All the exposure controls on your camera — the shutter speed dial, the aperture ring, and the ISO setting dial — work in stops and fractions of stops, which means you need to start thinking in terms of *stops* — a doubling or halving of the amount of light. A 1-stop increase in exposure means the amount of light has been doubled, whereas a 1-stop decrease in exposure means the light has been cut in half.

You may occasionally come across some books and articles that use the word *steps* in addition to the word *stops*. A stop or a step both mean the light has been doubled or cut in half.

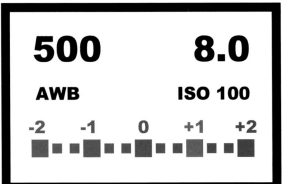

The next sections explore shutter speeds, apertures, and ISO settings in greater depth. I encourage you to grab your camera and its manual as you read them.

If you don't have your camera handy, check out Figure 2-7, which is typical of some of the information you can expect to find on the LCD screen of most digital cameras.

Figure 2-7: An LCD screen with the typical exposure info found on a digital camera.

Using shutter speeds

Shutter speeds change the amount of light that hits a camera's digital sensor by changing how long the camera's shutter is open. Following is a typical shutter speed series in increasing 1-stop increments (note that the *s* stands for seconds):

1/1000, 1/500, 1/250, 1/125, 1/60, 1/30, 1/15, 1/8, 1/4, 1/2, 1s, 2s, 4s

As you move from left to right, each shutter speed is twice as long as the one before it and lets in twice as much light — a 1-stop increase. When you move from right to left, you reduce the amount of light by half. Each move to the left is a 1-stop decrease in light. Some cameras also include faster shutter speeds (1/2000, 1/4000, 1/8000), and some feature longer shutter speeds (8s, 15s, and 30s). Older cameras provide shutter speeds in one-stop increments,

whereas more recent cameras have shutter speeds in half- or third-stop increments.

Because shutter speeds follow a predictable mathematical progression, you can easily figure out stops in your head. If I were to ask you which shutter speed provides 2 stops more light than 1/125 second, all you'd have to do is picture the shutter speed series to tell me that the answer is 1/30 second. Being able to figure out shutter speeds in full-stop increments in your head is very hand when you do exposure compensation (see Chapter 3) and when you're out creating great images in unusual lighting situations. (I share several creative uses of shutter speeds in Chapter 8.)

Shutter speeds usually aren't written as fractions because the fraction is understood, so the shutter speed series on a camera actually looks like this:

1000, 500, 250, 125, 60, 30, 15, 8, 4, 2, 1s, 2s, 4s, 8s, 15s, 30s

The sections that follow help you figure out how many stops apart your camera's shutter speeds are and how it indicates the longer shutter speeds.

Determining your camera's shutter speed increments

If you ever want to vary from your camera meter's exposure recommendations, you need to know how many clicks of the shutter speed dial equal 1 stop of light. Here's how to figure out your camera's shutter speed increments:

1. **Put your camera in shutter-priority mode (Tv).**

2. **Adjust the shutter speeds and watch the changing series of numbers.**

3. **Figure out how many shutter speeds exist between 1/125 second and 1/60 second.**

 If there's one speed between them, your camera has shutter speeds in half-stop increments. If you see two speeds between them, your camera has shutter speeds in third-stop increments. Remember this information when you start doing exposure compensation (see Chapter 3).

 If your camera has third-stop increments and you want to vary from its recommendation by 2 full stops, that's six clicks of the shutter dial.

Note: Some cameras let you choose between half- and third-stop increments in the camera's menu settings.

Understanding how your camera indicates longer shutter speeds

When you're working in low-light conditions, you need to have a handle on how your camera indicates shutter speeds that are longer than 1 second. After all, there's a big difference between 1/4 second and 4 seconds, both of which are indicated by the number 4 on your camera's shutter speed dial, along with some kind of extra notation for 4 seconds.

Turn your shutter speed dial past the 4, 2, and 1s marks and make note of how your camera indicates shutter speeds that are longer than 1 second. *Note:* If you find yourself using a separate hand-held meter and it recommends a shutter speed of 8 seconds (or 1/8 second), you need to know which 8 is 8 seconds and which 8 is 1/8 second.

The longer shutter speed series, beginning at 1 second, looks like this (*s* stands for seconds, *m* stands for minutes, and *h* stands for hours):

1s, 2s, 4s, 8s, 15s, 30s, 1m, 2m, 4m, 8m, 15m, 30m, 1h, 2h, 4h

Keep turning the dial until you get to the longest shutter speed. If you run out of shutter speeds on your dial, don't worry. You can still obtain really long shutter speeds. Just put the camera shutter on B (for bulb) and manually hold the shutter button for as long as you want. Better yet, use a locking electronic cable release so you don't jar the camera while you're holding the shutter button for so long.

Some manufacturers make an electronic cable release that lets you set shutter speeds as long as 99 hours, 59 minutes, 59 seconds, which is just what you always wanted for those long winter nights in Antarctica! If you end up taking a lot of exposures with long, long shutter speeds, an electronic cable release with a built-in timer is very handy.

One night in Rocky Mountain National Park, I was taking long exposures by the light of the moon when a car drove down the road in the valley below me. A 93-second shutter speed captured the movement of the car and the movement of the stars (see Figure 2-8). I forgot my locking electronic cable release (shame on me), so I just held down the shutter button and counted one-thousand-one, one-thousand-two, and so on until I got to 90. Then I released the shutter. To my surprise, when I opened the digital file in my computer, the camera had recorded the shutter time as 93 seconds. I was off by 3 seconds, but when your shutter speed is 90 seconds, being off by 3, 5, or 10 seconds doesn't matter much.

Choosing aperture settings

Most lenses have *aperture blades* that control the amount of light that enters the camera by changing the size of the lens opening (which is technically referred to as an *iris diaphragm*). Aperture settings in a lens are measured in f-stops. The f-stop series follows in decreasing one-stop increments:

f/1.4, f/2, f/2.8, f/4, f/5.6, f/8, f/11, f/16, f/22

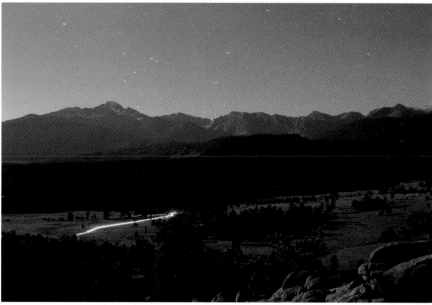

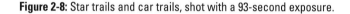
24mm, 93 sec., f/4, 400

Figure 2-8: Star trails and car trails, shot with a 93-second exposure.

As you move from left to right, each f-stop lets in half as much light as the one before. Moving from right to left, each aperture lets in twice as much light as the one before. So f/4 is 2 stops more light than f/8, and f/16 is 3 stops less light than f/5.6. Most lenses also have half-stop or third-stop settings in between the full stops.

 If the aperture series seems counterintuitive, try thinking of each aperture as a fraction because that's what apertures really are. F-stops are actually the ratio of the aperture diameter to the focal length of the lens (which is why there's a slash between the f and the number). An aperture of f/2 means there's a focal ratio of 1:2 (or ½), and an aperture of f/16 means there's a focal ratio of 1:16 (or ⅟₁₆); ½ of a pie is a lot more than ⅟₁₆ of a pie, and an aperture of f/2 lets in a lot more light than an aperture of f/16.

 When you go from larger apertures to smaller apertures (in other words, when you move from left to right along the f-stop series), that's called *stopping down*. When you go from smaller apertures to larger apertures, that's called *opening up*. Finally, when a lens is set to its maximum (widest) aperture setting, it's said to be *wide open*.

The following figures show you f-stops in action. In Figure 2-9, the aperture blades are opened up to f/2 to let in a lot of light. In Figure 2-10, the lens is stopped down to f/11, letting in much less light.

Figure 2-9: Aperture set to f/2.

Figure 2-10: Aperture set to f/11.

Different lenses have a different range of aperture settings. The range for a majority of zoom lenses is f/4 to f/22. Some "faster" zoom lenses begin at f/2.8, and some "fast" single-focal-length lenses begin with f/1.4 or f/2. The wider the maximum aperture, the "faster" the lens is said to be.

Get up close and personal with your camera's f-stops by following these steps:

1. **Set your camera to aperture-priority mode (Av).**

2. **Turn the dial and check out your f-stop settings.**

3. **Find the widest and smallest f-stops.**

4. **Determine the number of f-stops between f/5.6 and f/8.**

 If there's just one f-stop between f/5.6 and f/8, your camera's apertures are in half-stop increments. If there are two f-stops between f/5.6 and f/8, the f-stops are in third-stop increments. Just like with shutter speeds, this information is good to know when you do exposure compensation (see Chapter 3).

TIP

Memorizing the f-stop series is helpful (besides, it gives you something fun to do during boring TV commercials). To help you remember the series, start with the number 1.4 (the square root of 2) and keep doubling it (with some rounding off). Doing so gives you every other f-stop setting: 1.4, 2.8, 5.6, 11, 22. If you start with the number 2 and keep doubling it, you have the rest of the f-stop series (the in-between f-stops): 2, 4, 8, 16, 32. Merge the two lists

together, and you have the whole series in full-stop increments. Just remember that when you go from f/2 to f/4, that's a 2-stop change in the light, not a 1-stop change. Also, f/8 is 2 stops smaller than f/4.

Note: Apertures settings have a creative purpose in addition to an exposure purpose. I cover the creative uses of apertures in detail in Chapters 6 and 7, but Figure 2-11 features an example of what I mean. Using a small aperture setting gave me a lot of near-to-far depth of field in this photograph of the Cut River Bridge in Michigan's Upper Peninsula.

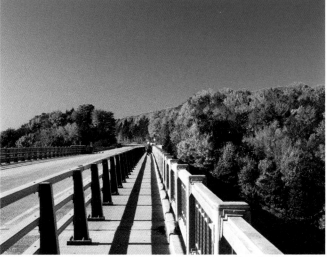

24mm, about 1/15 sec., f/16, 40

Figure 2-11: A small aperture creates a lot of near-to-far depth of field.

Working with ISO settings

The *ISO setting* of a digital camera's sensor determines how quickly the sensor responds to light. Following is the ISO setting series in 1-stop increments, from least sensitive to most sensitive:

100, 200, 400, 800, 1600, 3200, 6400, 12800

As you move to the right, each ISO setting responds twice as quickly to the light as the one to the left. In other words, as you move to the right, each ISO setting is 1 stop "faster," and as you move to the left, each ISO setting is 1 stop "slower." ISO 800 is therefore 3 stops faster than ISO 100, and ISO 200 is 1 stop slower than ISO 400. Why is this distinction important? If you have a good exposure at one ISO but your shutter speed is too slow, you can increase the ISO by 1 or more stops and use either faster shutter speeds by the same number of stops or smaller lens apertures.

To be just a little more technically correct, when you increase the ISO speed, the camera is *increasing the gain,* or boosting the electronic signal from the sensor (like turning up the volume for a weak radio station). You aren't really changing the sensor's sensitivity to the light. The camera is simply doing a bit of electronic magic so the photo *looks* like the sensor is more sensitive to the light. Increasing the ISO by 1 stop has exactly the same effect on the exposure as increasing the shutter speed by 1 stop: The resulting photo is 1 stop lighter. However, when you're out taking pictures, it's simpler to think that higher ISOs equal an increased sensitivity to light.

Digital camera sensors usually begin around ISO 100 and go up to as high as ISO 3200, 6400, and higher. Most digital cameras have ISO settings at half-stop or third-stop increments in between the standard full-stop settings.

Here's how to figure out the stop increments between ISO settings on your camera:

1. **Turn your camera on and set the ISO to 200.**

2. **Change the ISO to 400 and count the number of settings between 200 and 400.**

 If there's one setting between 200 and 400, your camera changes ISO settings in half-stop increments. If there are two settings between 200 and 400, your camera changes ISO settings in third-stop increments. (Refer to your camera's manual for instructions if you don't know how to change the ISO settings).

This information is handy to have when you change ISO settings to control exposure. For instance, if you want to increase the exposure by 2 stops and your camera does ISOs in third-stop increments, you know that six clicks of the ISO dial will give you a 2-stop change.

To remember the series of ISO settings, just think of this sentence: Double the ISO, double the sensitivity.

The flexibility of being able to switch to a higher ISO setting whenever you want is a big plus. If I hadn't been able to use a higher ISO setting, I wouldn't have been able to capture the picture of a marmot in Figure 2-12. When I took this photo, the sun had set, and the light was fading fast. By switching from ISO 100 to ISO 400, I was able to change my shutter speed from 1/10 second to 1/40 second — just barely fast enough to catch the not-too-active marmot with a lens set at 400mm in focal length. For the how-to on the creative uses of ISO settings, turn to Chapter 9.

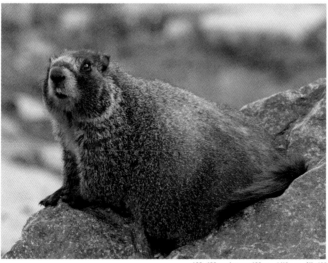

100–400mm lens at 400mm, 1/40 sec., f/8, 400

Figure 2-12: Being able to switch to a higher ISO made this photo of a marmot possible.

Putting it all together

You can create some magical images when you start using two or more of your digital camera's exposure settings (shutter speed, aperture, and ISO). The combination of shutter speed and aperture determines how much light hits the digital sensor, and the ISO setting determines how quickly the sensor responds to the light.

A simple way to illustrate how the three exposure settings work together is to think of filling a water bucket. Here are the components of this analogy:

- A full bucket = a good exposure
- The size of the bucket = the ISO
- The size of the garden hose filling the bucket = the lens aperture
- The amount of time it takes to fill the bucket = the shutter speed

Say you're in your yard with a bucket and garden hoses of different sizes. The bigger the garden hose, the faster you can fill the bucket. You can fill the bucket by using any size garden hose you want, but the time it takes to fill the bucket is determined by the size of the hose. If you want the bucket to fill up faster without using a bigger garden hose, you can use a smaller bucket.

To put the water-bucket analogy in photography terms, think of your camera's digital sensor as a light bucket. Large apertures "fill" your sensor with light faster than small apertures. If you set your sensor to a faster ISO (in other words, if you make the bucket a smaller size), it'll fill up with light faster than it would at a slower ISO setting. Large apertures (as well as high ISOs) call for faster shutter speeds. Small apertures (or low ISOs) require longer shutter speeds.

Pretend it's after sunset and you're getting ready to photograph some deer browsing in a meadow. Your camera is still set to ISO 100 from photographing landscapes earlier in the day. With your zoom lens at f/4, its widest aperture, you meter the deer with your camera meter and get a shutter speed of 1/8 second. At 1/8 second, the slow-moving deer will be blurred. You don't want that look, but your lens is already at its widest aperture, meaning it can't let in any more light. Your best bet is to change the ISO to 800, which is 3 stops faster than ISO 100. Now you can use a shutter speed that's 3 stops faster (1/60 second rather than 1/8 second), which is plenty fast enough to keep the slow-moving deer from blurring in your photo.

Making the Most of Equivalent Exposures

When several different combinations of apertures, shutter speeds, and ISO settings give you the exact same exposure, they're called *equivalent exposures*. Although the resulting exposure is exactly the same with each combination, the *look* of the photo for each combination is different, sometimes by a little and sometimes by a lot.

Apertures and shutter speeds have a reciprocal relationship. If you cut the light in half with the lens aperture, you leave the shutter open twice as long to obtain the same exposure. If you use wider apertures (which let in more light), you compensate with shorter shutter speeds (which let in less light) to obtain the same exposure.

To get a better idea of what I mean by equivalent exposures and the role of apertures and shutter speeds, consider that a shutter speed of 1/125 second and an aperture of f/16 at an ISO of 100 is a typical exposure for a frontlit subject on a bright, sunny day. The following eight aperture/shutter speed combinations all provide the same exposure at ISO 100 (provided, of course, that the light doesn't change in between exposures):

- ✔ f/22 at 1/60 second
- ✔ f/16 at 1/125 second
- ✔ f/11 at 1/250 second
- ✔ f/8 at 1/500 second

- f/5.6 at 1/1000 second
- f/4 at 1/2000 second
- f/2.8 at 1/4000 second
- f/2 at 1/8000 second

With all of these combinations providing the same exposure, how do you know which one to choose? That depends on the look you want in your image. If your subject is moving, you can choose shutter speeds that either freeze or blur your subject. Or you can choose aperture settings that either increase or decrease depth of field. Chapters 6 through 9 explore all the artistic possibilities available to you courtesy of equivalent exposures.

So what happens when you change the ISO? Using faster ISO settings allows you to use faster shutters speeds and/or smaller apertures and still have the same exposure. Slower ISOs mean longer shutter speeds and/or wider apertures with the same exposure. Thanks to digital photography, the number of equivalent exposures in many situations has increased to dozens of combinations.

How do ISO settings make this possible? To borrow from the water bucket/ digital sensor analogy (see the preceding "Putting it all together" section), an ISO 200 "light bucket" (sensor) fills up twice as fast as an ISO 100 light bucket, cutting your shutter speed in half for the same exposure. Or you can go to an ISO that's 1 stop faster and use an aperture that's 1 stop smaller. So if f/16 and 1/125 second at ISO 100 gives you the exposure you want, you can change the ISO to 200 (a 1-stop faster response to the light) and change the shutter speed to 1/250 second (1 stop less light) and get the same exposure. Or you can change the ISO to 200, change the aperture to f/22, and leave the shutter speed unchanged. The following exposures, which use ISO changes to increase the shutter possibilities with the same lens aperture, are all equivalent to each other and to the list I present earlier in this section.

ISO	Aperture	Shutter Speed
100	f/16	1/125 second
200	f/16	1/250 second
400	f/16	1/500 second
800	f/16	1/1000 second
1600	f/16	1/2000 second

Basically, you can change all three exposure settings and still get an equivalent exposure. As long as the final exposure is the same, it doesn't matter whether you changed two settings or all three of 'em.

To simplify matters when it comes to equivalent exposures, go with the lowest ISO that gives you the aperture and shutter speed you want to use.

The lower the light level, the more valuable it is to throw ISO speeds into the equivalent exposure mix. Case in point: The standard base exposure for outside Christmas lights at night is an aperture of f/4 and a shutter speed of 1 second at ISO 100. That's fine if you have a tripod, a beanbag, or other camera support to hold the camera steady for an entire second, but what if you need to handhold the camera? In that case, set your digital camera to a higher ISO setting. Following is the range of equivalent exposures you can choose from.

ISO	*Aperture*	*Shutter Speed*
100	f/4	1 second
200	f/4	1/2 second
400	f/4	1/4 second
800	f/4	1/8 second
1600	f/4	1/15 second
3200	f/4	1/30 second

To check out the relationship between ISO and shutter speed for yourself, try these simple steps:

1. **Indoors at night, pick a subject in front of an even-toned wall in even light (but don't pull out the tripod).**

2. **Set your camera to aperture-priority mode (Av) and set the aperture to f/4.**

3. **Set the ISO to 100, meter the wall, and take a picture.**

4. **Set the ISO to 400, meter the wall, and take a picture.**

5. **Set the ISO to 800, meter the wall, and take a picture.**

6. **Set the ISO to 3200, meter the wall, and take a picture.**

Every time you bump up the ISO to a setting that's 2 stops faster, your camera meter should give you a shutter speed that's 2 stops faster. At ISO 100, your photo should be blurry (unless you're incredibly steady). As you move to higher ISOs and the resulting faster shutter speeds, your photos should get sharper. That's the power of ISO settings in equivalent exposures: better hand-held photos in low light!

Metering Essentials: Reflected Light Metering

In This Chapter

▶ Picking the right metering tools

▶ Making the most of reflected light meters

▶ Pairing up your camera's metering pattern to the scene at hand

▶ Knowing when to use which exposure mode

▶ Taking advantage of digital technology

*M*etering is all about taking the wide-ranging tonalities in the real world and turning them into the more limited range of tones found in a photograph. It's the key to good exposures and is both a skill and an art. The skill part comes into play as you decide how to meter a subject; the art is in deciding how light or dark you want all the tones in your scene to be and in choosing aperture and shutter speed combinations that can dramatically change the look of your images.

Because some situations involve more than one approach to metering, you need a basic under-standing of all the possible approaches. That's why I begin this chapter with a big-picture look at sev-eral metering tools and techniques. Then I help you explore in detail several ways to meter with reflected light (check out Chapter 4 for even more metering info, specifically the scoop on incident light metering). As you gain experience with metering, you can better decide which of the various metering options work best for you and how you shoot. Until then, try as many of them as possible using the exercises I include for you in this chapter. They'll hone your metering skills and give you insights into how your particular camera responds to the light (different models and brands respond differently). **Remember:** The more you practice metering, the more intuitive it becomes.

TIP

If you haven't already done so, buy an 18 percent gray card. Gray cards are inexpensive (about $12 for a pair), and they're very helpful for the exercises I present in this chapter.

Choosing the Best Metering Tools and Techniques

The best metering tools for you are the ones you're most comfortable using and that work best for the kind of subjects you like to photograph. If your big thing is landscape photography, your tools and approach to metering will probably be different from those of the person who spends most of his time doing studio photography with off-camera strobes. The sections that follow introduce you to the most important metering tools and techniques and give you a better understanding of the ones you may need to use.

REMEMBER

A metering example

When you meter a scene, you look at all the tones in the scene and make decisions about the following:

✔ Which tones are the most important

✔ Which tone(s) to meter

✔ How to set the appropriate exposure controls to make the tones as light or dark as you want them to be

I wound up with the exposure shown in Figure 3-1 because I decided that the light tones of the sky and the sunlight on the mountain were more important than the very dark tones of the evergreens in the shade. I zoomed in on the blue sky and the rocky face of the peak with my lens, set the meter to manual mode, and based my exposure on that area of the scene. After the exposure setting was locked in, I zoomed out to recompose and include the reflection of the peak in the lake before taking the picture. I knew before I clicked the shutter that I would lose the darker areas in the scene, but I wanted the bold contrast.

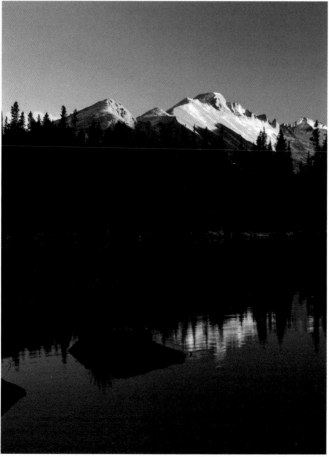

28–135mm lens at 28mm, 1/5 sec., f/16, 100

Figure 3-1: Long's Peak at sunset, metered for the sky and the sunlit rock face.

While I took the picture, the camera meter was screaming at me that the scene was too dark. It wanted me to change the exposure because it was looking at the huge dark area in the middle of the frame. After taking the photo in Figure 3-1, I let the camera meter have its way for Figure 3-2. The result? Properly exposed evergreens and washed-out sky and mountains. You can see why I chose to meter the sky and peak in manual mode (refer to Figure 3-1) to avoid that washed-out look.

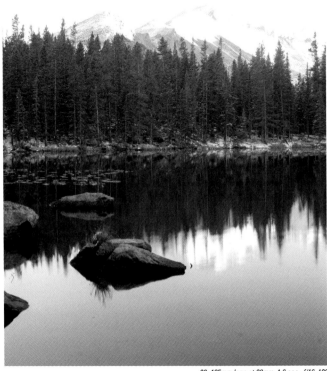

28–135mm lens at 28mm, 1.6 sec., f/16, 100

Figure 3-2: The same scene when the camera meter makes the decisions.

Reflected and incident light meters

Two primary kinds of light meters exist: reflected and incident.

- ✔ *Reflected light meters* meter the light that's reflected off of the subject. When you use a reflected light meter, you point the meter at the subject. The light meter built into your camera is a reflected light meter.

- ✔ *Incident light meters* measure the light that's falling on (or incident to) the subject. When you use an incident light meter, you point the meter at the light source. Incident light meters, like the one in Figure 3-3, are separate gadgets that you use in conjunction with your camera.

Both kinds of light meters do one thing, and they do it exceptionally well, albeit differently: They meter the intensity of light. The incident light meter measures the intensity of the light coming from the light source, whereas the reflected light meter measures the intensity of the light that's reflected off of the subject.

Note: Your camera's reflected light meter can't "see." It doesn't know whether your subject is a moose, a rock, a tree, or a scarecrow. As far as most camera meters are concerned, your subject could be red, green, blue, or purple with pink polka dots. Reflected light meters just measure reflected light.

Both reflected light and incident light meters assume that all the tones in your scene average out to a middle gray, which is about halfway between white and black. When either meter says "f/16 at 125 second," what it's really saying is that an aperture of f/16 and a shutter speed of 1/125 second is a good exposure if your subject is middle gray in tone (or if all the subjects in your scene average out to middle gray in tone).

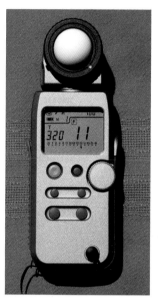

Figure 3-3: An incident light meter.

In bright sunlight, you don't need a light meter at all. You can use the *sunny f/16 rule,* which is also called *Basic Daylight Exposure* (BDE). If your frontlit subject is in bright sunlight sometime between two hours after sunrise and two hours before sunset, the exposure is f/16, and the shutter speed is 1/ISO (or whatever shutter speed is closest to the ISO). With digital cameras and third-stop increments, BDE for ISO 100 is f/16 at 1/100 second

The following sections provide you with a little Reflected Light and Incident Light 101 and share some inexpensive alternatives for incident light meters.

Reflected light basics

Whenever you point a reflected light meter at a subject, the meter does its best to make the subject middle gray in tone. So if you point one at a black locomotive, it'll try to make the locomotive middle gray; if you point it at white snow, it'll try to make the snow middle gray. To see this characteristic of reflected light meters in action, try this short experiment:

1. **Grab your camera and go outside.**

2. **Put your camera in aperture-priority mode (Av) and set the aperture to f/8.**

3. **If you have a spot or partial-area metering mode, use it.**

4. **In the same light, meter several subjects with as wide a range of tonalities (from light to dark) as possible.**

 Be careful not to move from sun to shade and back.

5. **Fill the frame with each subject so your meter doesn't read adjacent tones.**

6. **Watch the shutter speeds change with the lightness or darkness of your subjects' tones.**

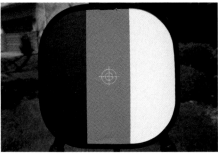

Figure 3-4: Calibration target, metered for the gray panel.

Did you notice that even though all of your subjects were in the same light, the shutter speeds were longer with dark-toned subjects and shorter with light-toned subjects? You just witnessed your meter trying to make everything middle gray, or in color terms, *medium toned.*

If you don't have time to perform the exercise, you can still get a visual of what I mean by looking at Figures 3-4, 3-5, and 3-6 (I included some background so you can better see the shift in tones in the background along with the shift in tones in the subject). Each of these figures is a photograph of a *calibration target,* a collapsible metering tool with black, gray, and white panels.

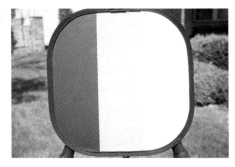

Figure 3-5: Calibration target, metered for the black panel.

In Figure 3-4, I metered the gray panel. The result? The calibration target looks just like it does in real life. In Figure 3-5, I metered the black panel, and it became a middle gray panel in the photograph, making the other panels lighter. In Figure 3-6, I metered the white panel and it became a middle gray panel, making the other panels darker. The differences may not be so obvious here, but if you punch a hole in a 3-x-5 card and then look at the metered panel in each photo, you'll see that they all ended up becoming middle gray, even if they were actually black or white.

Figure 3-6: Calibration target, metered for the white panel.

Here's the short story on reflected light meters:

- ✔ Whatever you point the meter at will end up being medium in tone, unless you depart from what the meter tells you.

- ✔ If you want your subject to be light, add light to what the meter tells you by using a wider aperture or a longer shutter speed.

- ✔ If you want your subject to be dark, take away light from what the meter tells you by using smaller apertures or faster shutter speeds.

- ✔ When metering multi-toned scenes, if you base your meter reading on something dark in the scene, the whole scene gets lighter (as in Figure 3-5). Meter something light in the scene, and the whole scene gets darker (as in Figure 3-6). Meter something medium in tone and what you see is what you get, more or less (as in Figure 3-4).

Incident light basics

Incident light meters aren't influenced by the tonality of the subject. To use one, you just set the ISO on the incident meter to match the ISO on your camera, point the white hemisphere on the incident light meter at the light source, and push the button to get your meter reading. Plug that reading back into your camera and take pictures. Light-toned subjects will be light, dark-toned subjects will be dark, and medium-toned subjects will be medium toned. (For the more detailed aspects of incident light metering, see Chapter 4.)

As long as the light doesn't change, all it takes is one simple meter reading for the whole world to look like it's supposed to. The exceptions are when you have very-light-toned or very-dark-toned subjects. I show you how to compensate for these in Chapter 4.

An incident light meter also has to be in the same light as the subject you're photographing. It won't work if your subject is in the sun and you're using the incident light meter in the shade, even if it's cooler in the shade.

Incident metering without an incident meter

If you want most of the convenience of an incident light meter without the high cost, you can purchase accessories that allow you to use your camera's reflected light meter to come up with light readings that are equivalent to those you'd get if you used an incident light meter. Here are two popular options:

✔ **An 18 percent gray card:** Photographers have used 18 percent gray cards for years as an inexpensive substitute for an incident light meter. An *18 percent gray card* (or *gray card* for short) is halfway between black and white and reflects 18 percent of the light that falls on it. Instead of metering the subject or scene in front of you, you meter the gray card in the same light that's falling on your subject. Just lock in that meter reading and take the picture.

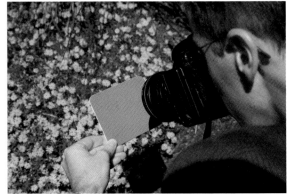

Figure 3-7: Using a gray card in the same light as the subject.

✔ **An ExpoDisc:** This device goes over your camera lens and allows you to use your camera like an incident light meter. Simply put an ExpoDisc onto your lens like a filter, point the lens at the light source, and take a meter reading. This is about as close as you can get to a true incident light reading without actually using an incident light meter.

Figure 3-8: Pointing a lens and ExpoDisc at the light source for an incident light meter reading.

The photographer in Figure 3-7 is metering a gray card in the same light as the subject. In Figure 3-8, the photographer is pointing her lens and ExpoDisc at the light source to get an incident light meter reading.

Using Reflected Light Meters: There's One Right in Your Camera

The most wonderful feature of the reflected light meter in your camera is that it meters right through the camera's lens. The advantage of *through the lens* (TTL) metering is that you don't have to recalculate exposures for any light lost due to accessories you're using in front of or behind your lens. The light passes through the lens and any accessories before it arrives at the metering system.

Using the reflected light meter in your camera requires you to choose and control subject tonalities. For some scenes, the simplest, fastest approach to metering is to choose and meter one tone and use that exposure for the whole scene. In other situations, the best approach is to meter one tone in the scene and use a different exposure than the camera meter suggests. If you choose to vary from what the suggested meter reading is, then you're using *exposure compensation.* I cover all of these approaches to metering with a reflected light meter (as well as how to handle some challenging metering situations) in the next sections.

Choosing one tone out of many to get the scene you want

When you have a scene with a lot of different tones, you need to choose a tone to meter that will give the overall scene the look that you want. The best way to explore this is to grab your camera (as well as a pen and paper for taking notes) and follow these steps:

1. **Pick a bright, sunny day, preferably without lots of clouds that could temporarily block sunlight and change the intensity of the light.**

2. **Find a scene with a broad range of tonalities.**

 Your own house or a friend's house is good as long as the scene has a wide range of tones.

3. **Set your camera to ISO 100.**

4. **Put your camera in aperture-priority mode (Av) and set the aperture to f/11.**

5. **Wander around the scene, meter and photograph several subjects, and write down each subject and the shutter speed you used to shoot it.**

 Get close enough to each subject that the meter isn't influenced by other subjects.

6. **Back up so your camera can take in the entire scene.**

7. Put your camera in manual mode and take pictures using the shutter speeds from your notes.

8. Compare the resulting photos to your notes for the individual subjects.

As you can see in Figures 3-9 through 3-14, the lighter the subject you meter, the darker the photo of the overall scene. Similarly, the darker the subject you metered, the lighter the photo of the overall scene.

A meter reading based on a medium-toned subject gives you a photo that's closest to how the scene looks to your eyes. If you don't have a medium-toned subject in the scene to meter, it's time to meter your handy gray card and use that as the exposure for the overall scene. The light green shrubbery, the exposure basis for Figure 3-11, was the closest subject to a medium tone in this scene, and provided the best overall exposure.

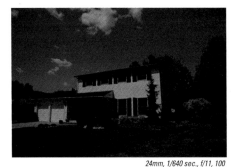

24mm, 1/640 sec., f/11, 100

Figure 3-9: White house, metered for the white garage door in the sun.

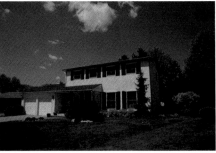

24mm, 1/400 sec., f/11, 100

Figure 3-10: White house, metered for the center of the white cloud.

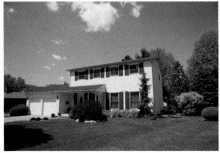

24mm, 1/160 sec., f/11, 100

Figure 3-11: White house, metered for the light green bushes below the window.

24mm, 1/100 sec., f/11, 100

Figure 3-12: White house, metered for the blue sky.

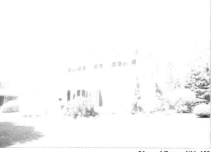

24mm, 1/50 sec., f/11, 100

24mm, 1/5 sec., f/11, 100

Figure 3-13: White house, metered for the grass in the sun.

Figure 3-14: White house, metered for the grass in the shade.

Experimenting with exposure compensation to get desired tonalities

After you meter a subject, you can use exposure compensation to make the subject as dark or as light as you want it to be. Follow these steps to discover your preferences when it comes to color tonalities for several different subjects:

1. **Pick a bright, sunny day with few or no clouds so that the light stays constant.**

2. **Find something red and something yellow to take outside along with your camera; bring your gray card too.**

3. **Begin by taking a picture of the gray card at the exposure setting the camera recommends.**

4. **Add 1 stop of light and take another picture; then add another stop of light and take a third picture.**

5. **Set the camera at 1 stop less than the recommended exposure and take another picture; subtract another stop of light and take a fifth picture.**

6. **You now have five photos of the gray card with the following exposure compensation series: 0 (no compensation), +1, +2, –1,–2.**

7. **Point your camera at a section of clear blue sky and repeat the process, taking five photos of the sky in 1-stop increments from –2 to +2.**

8. **Meter your red subject and repeat the whole process, taking five photos.**

9. **Repeat the process with the yellow subject, taking five more pictures.**

10. **Repeat the whole process a final time, using green grass as your subject and capturing five images.**

 You now have a set of five photos of each subject, all ranging from −2 to +2 stops of exposure compensation in 1-stop increments.

I'm betting your results look like the tones in Figure 3-15. Am I right?

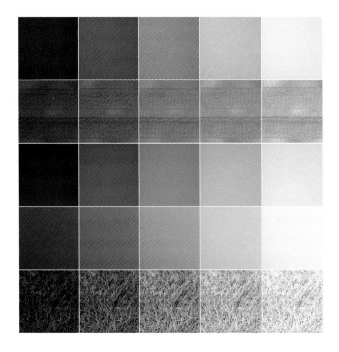

Figure 3-15: An exposure compensation chart in 1-stop increments from −2 to +2.

One of the benefits of performing this little exercise is that you discover which color tones you like best for each subject. If you like light yellow roses, add ½ to 1 stop of light to what the meter tells you. If you see a different kind of yellow flower and want it to be darker in tone, you can do that too. If you like medium to slightly darker versions of red tones for firetrucks, subtract a ½ stop of light from what the meter tells you the next time you meter a red firetruck. What I'm getting at here is that the more you work with colors and tones, the better you'll understand your preferences and know how much to vary from the meter reading in order to achieve them.

Another benefit of this exercise is the chance to experience firsthand the limits of subject tonality. Adding 2 stops of light to what the camera meter says is pretty much the upper limit for the primary subject in a photograph. The limit on the dark side is 2 stops less light than what the camera meter says. I rarely meter a dark subject and subtract more than 1 stop of light, but your tastes may be different. Of course, there are tones in some scenes that are much darker than that, or even black, but they aren't the main subjects in the scene.

You can do exposure compensation in your head by using the aperture and shutter speed lists I present in Chapter 2, but most cameras have a metering scale to help you with the process. Following are the numbers of the scale and the tones with which they correspond:

−2 (very dark), −1 (dark), 0 (medium), +1 (light), +2 (very light)

When you meter a single subject and the metering scale says 0, your subject will be medium toned in the photo. If your camera is in manual mode and you change the aperture or shutter speed so the metering scale says +2, your subject will be very light in tone. If your camera is in automatic mode and you change the exposure compensation so the metering scale reads −1, your subject will be dark in the photo.

In automatic exposure modes, exposure compensation is limited to the amount of compensation on the metering scale. In manual mode you aren't limited to the amount of compensation on the metering scale. You can therefore add or subtract as many stops of light as you want, even if you go well past the ends of the scale.

Using exposure compensation with the meter in manual mode

In order to use exposure compensation when the camera's meter is in manual mode, zoom in on the subject you're going to meter and check the meter reading. Then manually add or subtract light to get the tonality you want. *Recompose* (zoom in on just one subject in a scene in order to meter it and then zoom back out to include more of the scene in the final photo) and take the picture.

To practice exposure compensation in manual mode, grab your camera; head outside on a nice, bright day; and follow these steps:

1. **Choose a medium-toned subject in a larger scene.**

2. **Put your camera in manual mode and set your aperture to f/8.**

3. Meter your medium-toned subject and turn the shutter dial until the metering scale reads 0 for no compensation.

4. Recompose to include your whole scene and take a picture.

5. Meter your medium-toned subject again but turn the shutter speed dial until the metering scale reads +1.

6. Recompose to include the whole scene and take a second picture.

7. Set the shutter speed to 1/250 second.

8. Meter your medium-toned subject and turn the aperture dial until the metering scale on your camera reads 0 for no exposure compensation.

9. Recompose to include the whole scene and take a third picture.

10. Meter your subject again, but turn the aperture dial until the metering scale reads −1.

11. Recompose to include the whole scene and take a final picture.

You should have two normally exposed scenes plus one light version of the scene and one dark version. As you can see from this exercise, you can use different aperture and shutter speed combinations to make any subject as light or dark as you want, adding light (+ compensation) to make your primary subject lighter in tone and subtracting light (− compensation) to make your primary subject darker in tone.

I used exposure compensation to capture the photo in Figure 3-16. The most important tone in this wintertime photo is the white, sunlit snow. The usual approach to a sunlit, middle-of-the-day scene like this one is to make the snow light and bright and let all the other tones in the scene fall where they may. You do this by metering only the snow and adding 1½ to 2 stops of light to what the camera meter recommends. I zoomed in to meter just the snow, set the aperture to f/11, and turned the shutter dial until the metering scale in the camera read +2. With the "snow meter reading" locked in, I zoomed out to include the rest of the scene and clicked the shutter. I also bracketed exposures (I fill you in on bracketing in Chapter 4) to be sure I had bright snow without burning out the highlights; after highlights have been totally burned out, you can't recover them later with photo-editing software.

Using exposure compensation in automatic modes

Exposure compensation isn't just for when you're operating your camera manually. It can also come in handy when it's in one of the automatic modes (I describe these in the later "Selecting the Best Exposure Mode" section).

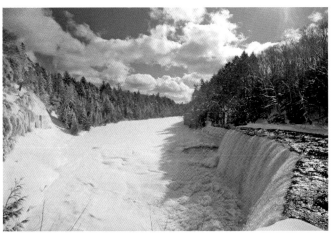

17–40mm lens at 17mm, 1/400 sec., f/11, 100

Figure 3-16: I metered the snow and added 2 stops of light.

When you meter and photograph just one subject, using exposure compensation in automatic modes is simple. You put your camera in one of the modes and use your camera's exposure compensation feature to make your subject lighter or darker. With some cameras, you start by pushing the exposure compensation button (labeled "+/–"), which is sometimes called the *EV button* (for Exposure Value), and then turn a dial to add or subtract light. The metering scale tells you how much light you've added (+) or subtracted (–). Other cameras use a menu setting to do exposure compensation. Your camera's manual should tell you how to use the exposure compensation feature in an automatic mode.

If you zoom in to meter one subject and then recompose to include more sub-jects in your frame, the meter sees the other tones in the scene and revises your original meter reading along with any exposure compensation you applied. In other words, you don't get the exposure you wanted. To keep this from happening, you need to *lock in* your exposures so you can recompose to include the larger scene without losing your initial meter reading. One of the most common ways to lock in exposures is to use the exposure lock button (although not all cameras have one). With an exposure lock button, you zoom in, meter your subject, set the exposure compensation you want, push or hold down the exposure lock button, recompose, and take the picture.

With some cameras, you have to hold the exposure lock button down until you click the shutter; if you don't, the camera meters the scene again. With other cameras, you push the exposure lock button once, and the camera remembers your exposure setting for several seconds, giving you time to recompose and take the picture.

Note: Some cameras allow you to use the shutter button to lock in the exposure in some metering modes or with some specific menu settings. Check your camera's manual.

Some photographers prefer to use exposure lock with an automatic metering mode; others prefer to do exposure compensation in manual mode. Then there are those who use both, depending on the situation (like auto mode and exposure lock for fast-shooting situations and manual mode for more methodical work). Landscape photographers in particular enjoy manual metering because it's like having exposure lock turned on all the time. After you've metered your subject and set the aperture and shutter speed, you can point your camera anywhere you want, and the exposure won't change until you readjust the aperture and shutter speed.

Tackling metering challenges

When using the reflected light meter in your camera, a few situations can present some interesting challenges. I explain how to handle them here.

Black and white tones in a scene

When you have both black and white tones in a particular scene, your goal should generally be to keep the white tones from burning out, making the rest of the scene look good and sacrificing the texture in the black tones. You can see an example of what I mean in Figure 3-17, which features a man and woman in white and black attire, respectively. This scene was easy to meter because the gray building

50mm, around 1/60 sec., about f/8, 100

Figure 3-17: Two people dressed in black and white, shot with ½ stop of light subtracted after metering the building.

in the background served as a giant gray card. I pointed the camera so it saw only the gray building, metered it, subtracted about a half-stop of light from the meter reading to keep the whites from burning out, locked in the meter reading, recomposed, and took the picture. As you can see, I lost all texture in the black dress thanks to my exposure choice, but the skin tones are good, and the white uniform isn't burned out.

Medium-dark and dark tones in a scene

When all the tones in a scene are darker than a medium tone, a photo can end up looking much too dark. The best approach is to lighten the tones in the scenes. The rabbit in Figure 3-18 was darker than a medium tone, and the grass was much darker. With no light tones in the scene to worry about, metering was easy. I metered the scene, including the rabbit and the grass, and subtracted ½ stop of light to keep them slightly darker than a medium tone, but not as dark as they were in real life.

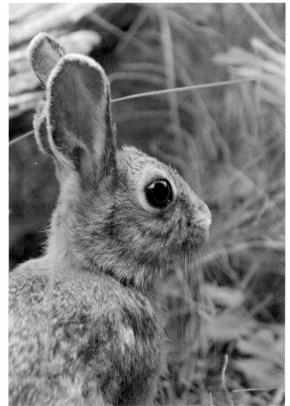

100–400mm zoom lens at 400mm, 1/80 sec., f/7.1, 400

Figure 3-18: A rabbit, shot with ½ stop of light subtracted after metering the scene.

Darker subjects when there are lighter tones in the scene

When you have a dark subject in light surroundings, meter the dark subject and make it light enough to have some texture and tone while keeping an eye on the histogram to make sure you don't have burned-out highlights. As an example, to get the shot in Figure 3-19, I zoomed in to meter the side of the elk to make it a medium tone (letting the head and neck go dark). Then I zoomed back out to create the picture. If I hadn't been able to meter the side of the elk, I'd have just metered the snow and added 1½ to 2 stops of light to keep the snow light and bright.

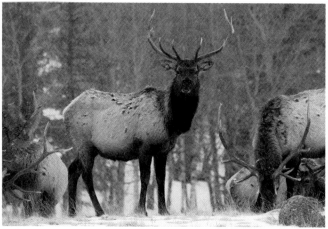

100–400mm lens at 285mm, 1/50 sec., f/8, 400

Figure 3-19: Elk in the snow, metered for the side of the elk (a medium tone).

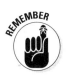

With dark subjects against light backgrounds, always check the histogram on the back of the camera to make sure you don't have any burned-out highlights (refer to the later "Reviewing a histogram" section for the scoop on histograms). If the highlights are burned out, you must subtract light from the exposure you're using.

When shooting dark subjects in lighter surroundings, you'll have a higher percentage of "keepers" on cloudy days when the light is soft, which reduces contrast.

Matching the Camera's Metering Pattern to the Scene

Most modern cameras give you a choice of several metering patterns, which may include center-weighted metering, spot metering, partial-area metering, and multisegment metering (Figure 3-20 has examples of a few of these). With all of these metering options, you want to choose the one that matches the size of the metering area in the camera to the size of the area in the scene that you want to meter. I help you figure out how to make this decision in the following sections.

The spot and partial-area metering patterns are usually the best choices when you're metering a single tone, especially when you're making your own exposure decisions. The center-weighted and multisegment metering patterns are generally the best options for metering several tones at once, especially when the camera is making the exposure decisions.

Center-weighted metering

Most newer digital cameras have a *center-weighted metering* option. When this option is turned on, the camera's meter measures the light intensity of the whole frame but assumes that what's in the center of the frame is most important. For all practical purposes, when you use center-weighted metering, you should assume that the camera is ignoring the outer edges of the frame.

Center-weighted metering is a good choice when you want the meter to average everything in the central area of the frame. It's a fairly safe metering choice simply because it meters a much wider area than spot metering (see the next section). If the scene you're shooting includes a wide variety of tones, the center-weighted metering feature will average them out to come up with a pretty good exposure recommendation, so long as the whole scene isn't really light (like snow in the winter) or really dark (like gorillas in the jungle).

Figure 3-21 is a good example of a scene that's just about ideal for center-weighted metering because that metering pattern wasn't unduly influenced by the dark tones in the tunnel and put the emphasis on metering the center of the frame. Most of the central area of the scene averaged out to a medium tone. The meter saw all the different tones in the middle, averaged them out, and came up with a good exposure.

Center-weighted metering

Partial-area metering

Spot metering

Figure 3-20: Camera metering patterns.

24–105mm lens at 82mm, 1/125 sec., f/11, 100

Figure 3-21: A bridge shot from a tunnel using center-weighted metering.

Spot metering

When *spot metering* is turned on, the camera meters only 1 to 4 percent of the very center of the frame. Spot metering is therefore the most precise form of metering, giving you a great deal of control over what you're metering. It's ideal when you want to meter a very small portion of a scene, like a performer in a spotlight, surrounded by inky darkness.

Spot metering is also the most dangerous form of metering for an inexperienced photographer (not you, of course). If your camera is set to spot metering and you hand it to an inexperienced photographer who lets the camera make all the decisions, exposure disasters can occur. The meter could end up metering a very dark or very light tone in an otherwise average scene, throwing off the exposure for the whole scene.

Figure 3-22 is a good example of a scene where spot metering is the simplest way to meter. The trees are almost black, the sky is darker than a medium tone, and the granite cliff is about 1 stop lighter than a medium tone. Center-weighted metering would see the dark trees in the center, make them medium toned, and wind up making the cliff and sky much too light. The best approach is to spot meter the granite cliff, add 1 stop of light to make the cliff lighter than medium toned, and take the picture.

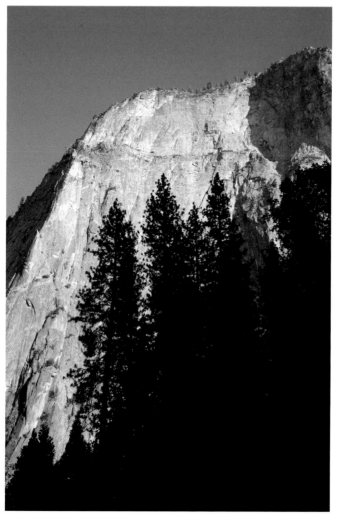

24–105mm lens at 55mm, 1/8 sec., f/11, 100

Figure 3-22: A granite cliff, shot using spot metering.

Partial-area metering

With the *partial-area metering* feature, the camera meters a circular area that covers about 8 to 12 percent of the center of the frame. You can think of partial-area metering as a sort of wider-area spot metering (see the preceding section) or a trimmed down version of center-weighted metering.

When do you use it? Drum roll please — when the subject you want to meter fills about 8 to 12 percent of the frame! To be more specific, if center-weighted metering takes in too much of the frame for the subject you want to meter, switch to partial-area metering. It's more precise than center-weighted metering without being as risky as spot metering. It's therefore just about perfect when you want something "in between."

Multisegment metering

Multisegment metering goes by a variety of names, including *evaluative, matrix, honeycomb,* and *multizone metering.* Regardless of what it's called multisegment metering still does the same thing: It divides the frame into segments ranging from as few as 5 or 6 to more than 1,000, depending on the camera model. When this feature is turned on, the camera's meter measures the light intensity of each individual segment and compares those segments to thousands of "photos" in its computer memory and tries to make an educated guess as to what the scene is and what the exposure should be.

In my camera, a tiny elf is in charge of each metering segment. After the elves have measured the light intensity of each segment, all 320 of them get together and discuss possibilities. Several elves report that it's somewhat dark across the top of the frame; others report that it's very dark all across the bottom of the frame. Consequently, the elves decide my subject could be grass or water because grass and water can be dark. The elves in the middle of the frame report that it's pretty light, but a few elves toward the left center and right center say that their segments are dark. The elves compile everyone's observations, make their best guess as to what the scene might be, and recommend an exposure. Amazingly, they do all of this in the tiniest fraction of a second. Much of the time, they get things pretty close to right. Sometimes they're totally off, but that's what you get with elves.

To see what the elves were looking at, check out Figure 3-23. To see what the lens was pointed at, look through the photos in Chapter 5.

Figure 3-23: What a multisegment meter "sees."

Every camera is a little different. You may have a whiz-bang computer in yours instead of a bunch of tiny elves. Either way, sometimes multisegment metering gets it right, and sometimes it doesn't. I've done some comparison tests with my camera, and I've discovered that my camera's multisegment metering does really well with bright subjects against a dark background. However, if I have a darker subject against a lighter background, for some reason my camera's multisegment metering usually burns out the background, giving me unusable photos.

Discovering how your camera handles metering

The best way to find out how your camera handles metering is to experiment. Locate a white subject, a dark blanket, a dark subject, and a white sheet, and then follow these steps (white on dark and dark on white are the most challenging situations for a meter to handle when you let it do its own thing):

1. **Put your camera in program mode (P).**

2. **Set the metering pattern to center-weighted metering.**

3. **Place the white subject in the middle of the dark blanket.**

 Don't have a dark blanket? Use dark green grass or another dark background.

4. **Make sure your camera sees only the white subject and the dark background and take a picture.**

5. **Switch the camera to multisegment metering and photograph the same scene again.**

6. **Put the dark subject on the white sheet.**

7. **Set the metering pattern back to center-weighted metering.**

8. **Verify that your camera sees only the dark subject and the white background and take a picture.**

9. **Switch the metering pattern to multisegment metering and take another picture of the same scene.**

I'd tell you what to expect from this little exercise, but I don't know. It all depends on your specific camera. If one metering pattern clearly works better in a given situation, that's the pattern you should use in similar situations.

Keep experimenting with metering patterns and conduct a little test every once in a while. After you've photographed a scene with center-weighted metering, switch to multisegment metering (or vice versa) to see whether you get better results. Why? Because you need to know which metering pattern does the best job of metering several tones at the same time. (No need to worry about testing the spot and partial-area metering patterns. They're primarily designed to make it easy for you to meter a single tone.)

Selecting the Best Exposure Mode

Knowing what mode to use to get the best possible exposure requires you to understand not only what each mode does but also the type of exposure you want to achieve. Most cameras offer these shooting modes: manual, program, aperture priority, and shutter priority. The last three, along with the scene modes, are all *automatic modes,* meaning the camera automatically picks the aperture, shutter speed, or both, depending on the mode.

You should use an automatic mode when

- ✓ **You don't have time to meter.** For instance, if you're shooting a soccer match and the field is half in the sun and half in the shade, you don't have time to manually change the aperture and shutter speed every time the action moves from sun to shade and back again.

- ✓ **The scene doesn't provide any major exposure challenges.** In this case, like when you're photographing a sea of even-toned flowers in soft, even light, you trust that the camera will make good decisions without guidance from you.

- ✓ **You just don't want to think about metering.** For example, you're climbing the face of El Capitan and you stop just long enough to free up one hand to grab a photo of your climbing partner.

Figure 3-24 is an example of a scene in which any automatic mode can provide a good exposure. Lighting complications are absent, and the aspen and blue sky don't create any tonality obstacles. In this case, aperture-priority mode is the best artistic choice because you can select a small aperture to provide lots of *depth of field* (near-to-far sharpness; see Chapters 6 and 7). You can add in a little + exposure compensation to keep the aspen light in tone without making the blue sky too light.

In the sections that follow, I provide details on the most common exposure modes. I also give you an idea of scenarios in which one mode is preferable over another one, as well as when you may want to use a manual mode rather than an automatic one.

17–40mm lens at 17mm, 1/40 sec., f/11, 100

Figure 3-24: An aspen grove that's ideal for aperture-priority mode.

Manual mode (M)

Manual mode (abbreviated *M*) is the ultimate do-it-yourself metering mode. It gives you maximum exposure control over your images.

Use your camera's manual mode when

- ✔ You want very precise control of subject tonality.
- ✔ The lighting is tricky.

✔ The subject tonalities are likely to cause problems for the automatic metering system.

✔ You're metering a specific subject in a scene, locking in the exposure setting, and recomposing to take in the whole scene before taking the picture.

✔ You want more stops of exposure compensation than the automatic modes allow.

Program mode (P)

Program mode (usually abbreviated as *P*) is the one to use when you want the camera to do all the thinking. In this mode, the camera chooses the aperture and shutter speed. It works very well when you have either a medium-toned subject or scenes that average out to a medium tone.

Some cameras have a variation on the program mode called "Auto." The difference between the two is that program mode allows you to use exposure compensation and Auto mode doesn't. Auto is okay for very inexperienced photographers, but I'm betting you want the extra control provided by exposure compensation.

Some scenes make it very easy for the meter to do its thing without any help from you. Figure 3-25's scene from Yosemite National Park is filled with subjects that average out to a medium tone. The mountainside is a virtual gray card. To shoot it, you just put your camera in program mode and let it do its thing.

Aperture-priority mode (Av)

In *aperture-priority mode* (the *Av* abbreviation used on most cameras stands for *aperture value*), you pick the aperture, and the camera selects the shutter speed. This mode is ideal when you want to choose the aperture to determine the depth of field in your scene. Small apertures give you more depth of field, and large apertures give you less (I cover depth of field in Chapters 6 and 7).

Following is a little exercise to help you get a feel for what the aperture-priority mode can do:

1. **Go outside with your camera and a wide-angle lens.**

2. **Manually focus on something that's about 4 feet from the camera.**

3. **Put your camera in aperture-priority mode (Av).**

4. **Choose the widest aperture and take a picture.**

5. **Choose the smallest aperture and take a picture.**

24–105mm lens at 24mm, 1/25 sec., f/8, 100

Figure 3-25: The Royal Arches in Yosemite, a perfect scene for program mode.

The depth of field should look dramatically different between the two photos, but the exposure should be the same. (In other words, the two exposures should be equivalent; turn to Chapter 2 for details on equivalent exposures.)

Shutter-priority mode (Tv)

With *shutter-priority* mode (abbreviated *Tv* for *time value*) turned on, you select the shutter speed, and the camera chooses the aperture. Opt for fast shutter speeds to freeze motion and slow shutter speeds to blur motion. (You get a chance to experiment with shutter speeds in Chapter 8.)

Bulb (B)

Many digital cameras have a long exposure mode, known as *bulb mode* (abbreviated *B*). If your camera's longest shutter speed isn't long enough for what you want to photograph, switch to bulb mode. When you set your camera to bulb, you set the aperture manually and hold down the shutter button for as long as you want, whether that's 47 seconds, 7 minutes, or 2 hours (you get the idea).

If you plan on doing a lot of long-exposure photography, invest in a locking electronic cable release that's specifically designed to work with your brand and model of camera.

Scene modes

Many digital cameras have several *scene modes:* a sports mode, a landscape mode, a night mode, and a portrait mode. These modes are usually found on the exposure mode dial, right along with P, Av, Tv, M, and B. If you don't see them there, look in the camera's menu choices.

The scene modes are usually variations on the aperture-priority and shutter-priority modes. The sports mode uses fast shutter speeds to freeze action, and the landscape mode picks small apertures to increase depth of field. The night mode uses flash to light a foreground subject and a long shutter speed to capture the nighttime background (which means you may need a tripod), and the portrait mode assumes you want to blur the background behind your subject so it picks wide apertures to minimize depth of field. Your camera's instruction manual is the resource to turn to for figuring out what the camera's various scene modes do.

Note: As you develop your exposure skills and understand how to use apertures and shutter speeds, you'll be able to make better choices than your camera's scene modes can provide. Scene modes are really just for photography newbies.

Making the Most of Your Digital Camera's Technology

Blown-out highlights are gone and can't be recovered. Or can they? When photographers worked with film, this statement was true. However, with digital cameras, you may have a little more headroom before the highlights are gone forever from your photos.

With digital photography, you can do more than just expose for the highlights and pray for the shadows. You can take more than one exposure of the same scene and use the extra exposures to recover shadow areas that would otherwise be lost.

Digital cameras vary in terms of their *exposure latitude* — the number of stops you can be off from the ideal exposure and still get a good image. The only way to figure out how much exposure latitude your camera has is to do a test. In the next sections, I explain how to perform this test, describe several digital metering tools, and reveal how to use a calibration target.

Determining your camera's digital exposure latitude

Digital cameras have a surprising amount of exposure latitude. You have a several-stop range, mostly on the underexposure side, in which you can get a good picture after you've worked on the digital file in photo-editing software (such as Adobe's Photoshop Elements or Photoshop) to correct for the over- or underexposure.

REMEMBER

If you haven't tested the exposure latitude of your digital camera, now's the time to do so. The exposure latitude among digital cameras can vary a lot, so you need to test your camera so you know how much you can over- or underexpose and still achieve a good-quality image.

TIP

If you happen to have a GretagMacbeth ColorChecker, you can use it to perform your test. If not, you can make your own color chart using white paper; gray paper; black, nonreflective paper (like construction paper); and a variety of colors. Head for the paint section at your nearest home-improvement store and grab a variety of color samples. (I suggest picking up red, orange, yellow, green, blue, and purple, plus some pastel colors.) Cut your color samples, white paper, gray paper, and black paper into 2-inch squares and paste them onto something flat and sturdy. You should end up with something that looks more or less like the GretagMacbeth ColorChecker shown in Figure 3-26.

Follow these steps to discover how your camera treats white, gray, black, and a variety of colors when an image is over- or underexposed:

100mm, 1/250 sec., f/11, 100

Figure 3-26: Proper exposure.

1. **Set up your color chart in bright sunlight, making sure there isn't any glare on the color samples.**

2. **Set the ISO on your camera to 100 and the aperture to f/11.**

3. **Set the capture mode to RAW+JPEG.**

 If you can't shoot in Raw, choose the highest-quality JPEG setting.

4. **Meter a gray card in the same light as the color chart.**

 You should get a shutter speed somewhere around 1/200 to 1/250 second; use this as your starting exposure.

5. **Change shutter speeds to take more exposures in 1-stop increments on the overexposure side: +1, +2, +3, +4, +5.**

6. **Change shutter speeds to take more exposures in 1-stop increments on the underexposure side: –1, –2, –3, –4, –5.**

When you open up these images on your computer, the JPEG files will, of course, range from very light to very dark. The question is this: How will the files look if you try to turn them back into normal-looking photos? If you're shooting Raw files, use your favorite Raw-conversion software (Adobe Camera Raw is a good choice). If you're shooting JPEGs, use whatever software you have to make the files look like the properly exposed image. The recent versions of Photoshop that open JPEG files in Adobe Camera Raw (ACR) are very good options. You can also use levels and curves in your favorite software. Whatever you choose to use, you should end up with photos that look kind of like Figures 3-27 through 3-30, all of which were created from Raw files with ACR.

Here's what I discovered about my camera's exposure latitude:

✔ At +1 exposure, the image looks great, very much like the proper exposure. Therefore, +1 is the overexposure limit for my camera when shooting Raw files.

100mm, 1/60 sec., f/11, 100

Figure 3-27: +2 exposure.

✔ At +2 exposure (see Figure 3-27), I'm losing colors. Compare the top-right color patch and the last two patches in the second row to the same patches in the "proper exposure." Clearly this image is unusable.

✔ At +3 exposure (see Figure 3-28), lots of colors are gone or fading fast.

✔ At –1 exposure, the image looks great, just like the proper exposure.

✔ At –2, the image looks very much like the proper exposure. Therefore, –2 is the underexposure limit for my camera if I want maximum image quality.

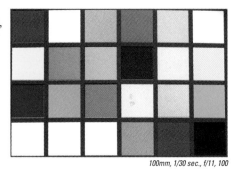

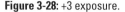
100mm, 1/30 sec., f/11, 100

Figure 3-28: +3 exposure.

✔ At –3 exposure (see Figure 3-29), most of the colors look great, but a couple are starting to shift. This setting would work in a pinch. The big

downside, which would be obvious in an 8-x-10 print, is that this image is getting noisy.

✔ At –4 exposure, several colors are beginning to shift. The image quality is unacceptable due to the color shifts and the digital noise.

✔ At –5 exposure (see Figure 3-30), several colors are gone, other colors have shifted dramatically, and there's a lot of noise. This exposure is unusable.

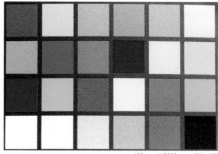

100mm, 1/2000 sec., f/11, 100

Figure 3-29: –3 exposure.

What does all of this data tell me? That my camera's exposure latitude for Raw files ranges from +1 to –2 if I want maximum image quality and that a setting of –3 works in a pinch. As for JPEGs? The exposure latitude is narrower. Even 1 stop of overexposure doesn't work with a JPEG file from my camera.

100mm, 1/8000 sec., f/11, 100

Figure 3-30: –5 exposure.

Although every model of camera has slightly different exposure latitude limits, *every* camera has less latitude when shooting JPEG files as compared to Raw files.

The acceptable limits are a matter of personal preference. Photographers tend to set more rigorous standards as they gain experience. Subject matter comes into play too. If your daughter hits the game-winning home run in the last game of the season, you'll cherish the photo even if the stadium lighting was lousy, the image is noisy, and the colors are starting to shift.

What's really important is how *your* camera responds to over- and underexposure. You get the best-quality images if you stay within the exposure latitude of your particular camera.

Shooting Raw versus JPEG

Increased exposure latitude is just one of the reasons to shoot Raw files rather than JPEGs. My camera is almost always set to RAW+JPEG, which means that it saves both a Raw file and a JPEG file for every image I capture. I use this setting because I like the immediacy of having a JPEG file, but I want all the benefits of a Raw file when I need them.

A Raw file lets you keep and use all the information your camera originally captured. With a Raw file, you can do a lot more with your images without digital gremlins sneaking in, such as *posterization* (when colors don't blend smoothly together, resulting in streaks or blotchiness in the image; also called *banding*). When your camera creates a JPEG file, it does a remarkable job of turning all the data in the original Raw image into a nice JPEG image, but in the process, it throws away a lot of information. When that information is gone, it's gone forever — one day you just might miss it. This trashed information is what helps you take an underexposed image and make it look normal again. It also allows you to make corrections to an image without the interference of digital gremlins.

The extra information involved in a Raw file is well worth the space it takes up, especially when you consider that digital storage is getting cheaper by the day and that memory cards aren't terribly expensive. Even if you don't want to mess with processing Raw files now, shoot RAW+JPEG anyway and use the JPEGs. When the day comes that a JPEG lets you down, you can go back to the original Raw file and thank me later. (For more information about Raw versus JPEG files, check out my Web site, `JimDoty.com`.)

If you download Adobe's free Raw file converter, you can turn your Raw files into DNG Raw files, a more universal file format. Head here for the download: `www.adobe.com/products/dng`.

Reviewing a histogram

A *histogram* is a map of the pixels in your image, with white-toned pixels on the far right; black-toned pixels on the far left; and dark-, medium-, and light-toned pixels spread out in between. High mountains mean there are lots of pixels; low valleys mean there aren't many pixels at all. A histogram is a wonderful tool to help you capture the most image information (even if it isn't always right). Just like a sound meter helps you record the maximum amount of sound without getting distortion, a histogram helps you capture the maximum amount of image information without blowing out the highlights.

If you want a mostly dark image, the pixels should be farther to the left. On the opposite end, a snowy winter scene should have a lot of pixels farther to the right. If the histogram doesn't match up with how you want your image to look, just change your exposure.

If a bunch of pixels are piled up on the far-right side of the histogram, you have a lot of burned-out highlights in your image. If you don't want burned-out highlights, you need to reduce your exposure.

Figure 3-31 is a photo of one of my favorite all-purpose test scenes: a white house surrounded by green trees. I use it whenever I'm testing a new camera. This figure also includes the rear-panel LCD screen for the same photo, complete with an RGB histogram and a luminance/brightness histogram. Your camera could have either or both. (There's also a small version of the photo along with the exposure data.)

Compare the mountains and valleys in the histogram to the tones in the photo. The tall spike at the left is for all the dark and black tones in the image. You can see the hills and valleys for the dark, medium, and light tones. The pixels to the right are getting very close to the right side of the histogram. What this information means is that using a longer shutter speed or a wider aperture will cause some of the highlights in the image to burn out. The histogram matches the photo I was after. The exposure is good, but I don't dare add another stop of light.

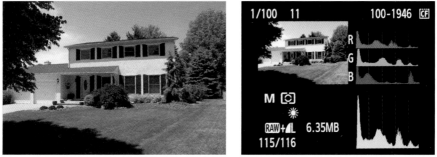

17–40mm lens at 17mm, 1/100 sec., f/11, 100

Figure 3-31: A properly exposed white house with histogram.

Figure 3-32 shows the histogram for a photo of green leaves. I exposed for the center leaf in the hopes of making the leaf medium in tone. The mountain in the middle of the histogram is for the medium-toned leaves; the spike at the left is for the shadows. The histogram matches the photo I wanted, and the leaves look good, so this is a good exposure (although there's enough room in the histogram for me to use a lighter exposure if I want to).

Exposing to the right for better image quality

Although there's more exposure latitude on the underexposure side of a digital image, you'll have better images if you expose as close as you can to the overexposure side. You just have to be careful not to burn out important highlights.

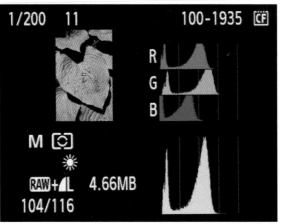

Original photo: 35mm, 1,200 sec., f/11, 100

Figure 3-32: The histogram for a shot of medium-toned green leaves.

Expose to the right is a reference to the histogram of your images. It's a simple way of saying you should shift the tones in your image toward the right side of your histogram (the lighter side) to get a better photo. Just be careful not to get a spike at the far right edge of the histogram. This practice makes sense because digital sensors don't capture information the same way that film does. Most of the information is captured at the lighter end of the exposure, which is why there's so much digital noise at the dark end of the exposure spectrum.

A digital camera is capable of capturing a wide range of tones. It uses half of those tones on the brightest stop of light, half as many tones on the next brightest stop of light, half of that on the next stop of light, and so on. To put this in simple terms, imagine that your camera has a box of 4,096 crayons in a wide range of colors and tones. Your camera uses 2,048 crayons on the brightest stop of light, 1,024 on the next brightest stop, 512 crayons on the next stop, 256 crayons on the next stop, 128 crayons on the next stop, 64 crayons on the next stop, and so on. It does a wonderful job using 2,048 crayons to recreate the brightest tones in your image, however, the darkest tones in your image get 64 (or fewer) crayons and turn out rather disappointing in quality. The dark areas of an image get so noisy because there aren't enough crayons to do a good job.

On the left side of Figure 3-33 is an enlargement of the middle gray patch from Figure 3-30 (bottom row, fourth patch). This gray patch was 5 stops underexposed, so it was very, very dark in the original image. You can see that it's getting very noisy and ugly (as gray patches go). Compare it to the nice, clean look of the right side of Figure 3-33, which is from the properly exposed middle gray patch in Figure 3-26. Which gray patch do you want *your* camera

to go out with? ***Note:*** This is an extreme example. In real life, a 1- or 2-stop change in exposure doesn't make as dramatic a difference in the quality of an image.

100mm, 1/8000 sec., f/11, 100 *100mm, 1/250 sec., f/11, 100*

Figure 3-33: The −5 exposure of a middle gray patch (left) and the proper exposure (right).

You get the most information in your digital exposures if you shift as many tones to the right (light) side of your histogram without blowing out the brightest tones. Even if your image is made up of medium to dark tones, exposing to the right allows you to capture more information. Although the photo will look too light on your camera's LCD display, you can darken the tones with a little help from your favorite photo-editing software.

Zeroing in on the best exposure with a calibration target

A calibration target (flip to the earlier "Reflected light basics" section to see photos of one) is a metering tool that goes a step beyond a gray card. It gives you all the advantages of using a gray card (which I explain earlier in this chapter) but still gives you a clue as to how very light and very dark tones will come out in an image.

To use a calibration target, you simply meter the center gray panel in the same light as your subject (just like a gray card) and then shoot the whole target. Then you check the histogram on the back of your camera. Figure 3-34 shows you what the typical histogram looks like for a calibration target (notice the nice spikes for black, gray, and white tones).

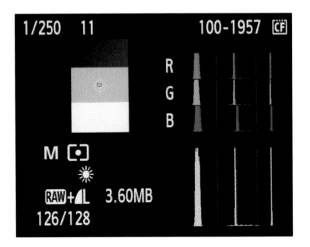

Figure 3-34: The histogram for a calibration target.

What's especially nice about using a calibration target is the ease with which you can expose to the right without blowing out the highlights in a photo. After metering the gray panel and checking the histogram, you simply increase the exposure until the white spike is as close to the right edge of the histogram as you want it. This distance depends on your particular camera, so you have to do some testing to figure out how close you can get without blowing out the highlights; I describe a test you can do in the earlier "Determining your camera's digital exposure latitude" section. After you take a picture of the target, you can use that photo to set the white balance on your camera according to your camera manual's instructions. (*Note:* There are different shades of white, and the white panel of a calibration target isn't as light as white snow in the sunlight, so you need to use a bit of caution when shooting snow scenes.) With the metering and the white balance all set, you can photograph your subject.

The histogram of a calibration target (or any other subject with white tones) isn't infallible. Your digital camera creates a histogram based on the same tone curve that it applies when it creates a JPEG image from the Raw data. In other words, the histogram is for a JPEG image, a fact that has implications for how you use the calibration target.

If you shoot Raw images while using a calibration target, you can have image information to the right (highlights that aren't blown out), but the histogram will show pixels bunched up at the right edge, a warning that you've blown out highlights. If you have the clipping warning turned on in your camera (which is a good idea), the part of the image that the camera thinks is *clipped* (blown out) will blink on and off at you. However, the highlights may not be burned out after all simply because you're shooting in the Raw format. So take the blinkies and the histogram as a guide — just not a perfect one.

If you shoot JPEG files, the opposite situation can occur: You can blow out the highlights without any warning from the camera. This scenario tends to happen when only one color channel is blown out (usually the red channel) and the other channels are just fine. If you have an RGB histogram, you can see the blown-out red channel. However, if you have a luminance histogram that averages all three channels, the camera thinks everything is okay on average, so you don't get a warning from the histogram (and no blinkies either). Everything seems just fine until you open the photo on your computer. So use the histogram as a guide, but don't count on it to be correct 100 percent of the time.

Getting the Shot When the Light Source Is the Subject

When you photograph, say, a golden western sky at sunset, you're mostly photographing a huge light source. That may make you a little nervous about the exposure right. When a big light source is your primary subject, you can trust the reflected light meter reading that your camera gives you.

One rainy evening in Yukon, Oklahoma, the clouds parted just enough for the sun to peak through, turning the city's wet streets into liquid gold. I immediately grabbed my tripod and set it up in a location that placed the sun partly behind a grain elevator. Metering was important because I wanted to capture the liquid gold in the streets. If the streets ended up being too light or too dark, they wouldn't look like I wanted them to.

In this situation, my trusty incident light meter just wouldn't do because there was no good place to point the dome. (Chapter 4 covers incident light meters, by the way.) If I pointed the dome at the sunset, I'd have a great meter reading for whatever was behind me, in the opposite direction of the sunset. If I pointed the dome away from the sunset (toward the camera), I'd have a great exposure for the shaded side of the grain elevator, and the sunset would be terribly overexposed.

I didn't have a spot meter so I couldn't meter the gold color in the streets, which I estimated to be medium in tone. So I picked an area in the sky to the right of the grain elevator that was also medium in tone and used that as my base exposure. I decided on an aperture around f/11 to give me a reasonable amount of depth of field for most of the scene with the lens I was using. (I knew how much depth of field I'd get with this aperture because I checked my camera's depth of field preview button.) I could have gone with a smaller aperture for more depth of field, but I wanted a fast enough shutter speed so the traffic wouldn't blur too much. The result, Figure 3-35, is one of my favorite photos of Yukon.

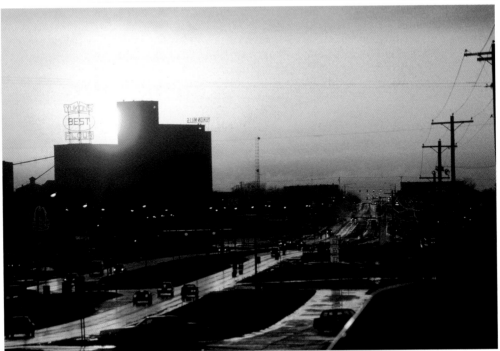

80–200mm lens around 100mm, around 1/125 sec., around f/11

Figure 3-35: Magic light in Yukon, shot by metering off the sky to the right of the grain elevator.

Complex Metering Simplified: Incident Light Metering, Bracketing, and More

In This Chapter

▷ Turning complex exposures into simple ones with an incident light meter

▷ Examining incident light meter alternatives

▷ Metering when you don't have a meter

▷ Ensuring you have a usable exposure with bracketing

*I*n this chapter, you discover ways to use a variety of tools designed to simplify your exposure life, including one of my favorites — the incident light meter, which is a great tool for dealing with difficult exposure situations.

If you don't have an incident light meter, you can purchase other accessories (some of them are very inexpensive) to use with your camera's meter to obtain a reliable meter reading with pretty much the same simplicity as using an incident light meter.

This chapter also covers metering without a light meter, exposure bracketing, and metering when you face the tricky situation of having a light source as the subject of your photo.

Using Incident Light Meters to Simplify Difficult Tonality Situations

An *incident light meter* (pictured in Chapter 3) measures the intensity of the light falling on a subject. It doesn't know whether the subject is orange or chartreuse, light or dark. This blindness to subject tonality is what makes an incident light meter so ridiculously easy to use. As long as the light doesn't change, you can put an incident light meter in front of any subject you want, and the meter reading will stay the same. Other than a few exceptions, no exposure compensation is necessary.

To use an incident light meter, set the ISO speed on the meter to match the ISO speed you're using on the camera, hold the incident light meter in front of the subject (or in the same light as the subject), point the white dome at the light source or camera, and push the button. When you do this, the meter gives you a reading that you can transfer to the camera and use to obtain a great exposure. For most subjects, that's all there is to it.

If you spin the dial on the meter, it'll give you every aperture and shutter speed combination that will provide the same exposure.

Wondering just how an incident light meter can simplify difficult exposure situations? Say you're photographing Red Rock Lake in Colorado. You set your camera to ISO 50 and survey the scene through a wide-angle lens. There's a wide range of tones: bright, white clouds and snow; rocky peaks that look middle gray or a bit lighter; dark blue water; dark green evergreens that are almost black on the shady side; and lilies on the water with leaves that look a little darker than a medium tone. You could spot meter lily leaves, but you don't have a true spot meter. You could also meter the gray granite peaks, but you aren't sure how much of the white snow or the dark blue sky your meter will see.

Take off the wide-angle lens, put on your longest telephoto lens, and meter the gray granite without including any snow. Then meter the snow and the cloud to make sure they aren't more than 2 stops lighter than the granite so that they don't burn out. Assuming the granite is middle gray, or pretty close, lock in the meter reading of the gray granite, take off the telephoto lens, put the wide-angle lens back on the camera, and take the picture.

Or you may choose to try a simpler approach: Pull out your incident light meter, set the ISO to 50 to match the camera, point the white dome of the meter at the light source (the sun), and push the button. The meter says f/16 at 1/60 second, so you set your camera accordingly and capture the image in Figure 4-1.

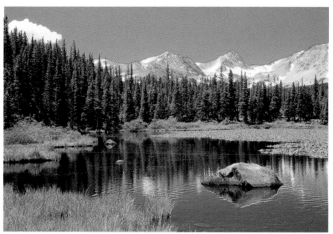

24mm, around 1/60 sec., about f/16, 50

Figure 4-1: A pretty lake scene, metered with an incident light meter.

You must always use an incident light meter in the same light as the subject. (Whether or not the meter is physically close to the subject doesn't matter when you're outside.) If your subject is bathed in sunlight but the dome of your incident light meter is in the shade, you'll get a great meter reading for a subject in the shade but not for a subject in the sunlight.

If you're in the sunlight on one mountain and you're photographing the sunlight on another mountain, an incident light meter will work just fine because the light on your subject and the light hitting your incident light meter is the same. If you're down in a valley in the shade and shooting up at a mountain in the sunlight, an incident light meter reading is totally worthless. That's when you make your highly paid assistant climb up the mountain into the sunlight and call you on your satellite phone with the correct meter reading!

My camera and I were in the shade when I photographed red boulders through "The Window" at Valley of Fire State Park in Nevada (see Figure 4-2). In order to get an accurate incident light meter reading, I had to get the meter in the same sunlight that was painting the red boulders. I climbed down from my location, ran around the shaded boulders into the sunlight, took a meter reading, and climbed back up to my shooting location. (It probably looked quite humorous to anyone watching.) I decided to use ½ stop less light than what the meter indicated because I wanted to saturate the color of the red boulders and ensure a deep blue sky.

50mm, around 1/15 sec., about f/16, 100

Figure 4-2: Red boulders, with the incident meter in the same light as the sunlit rocks.

As simple as incident light meters are to use, you still need to make some important decisions when using one (you knew there had to be a catch somewhere). I alert you to these considerations in the following sections.

Pointing the white dome in the right direction

Knowing where to point an incident light meter can be a little tricky depending on the location of your light source in relation to your subject. If your subject is frontlit, just point the white dome at the light source. Sidelit and backlit subjects require you to make a choice, as you discover in the next sections.

When you have sidelit subjects

If your subject is sidelit, you have a few different options. You can point the dome

- **At the light source:** The side of your subject that's toward the light source will be normally exposed, and the side of the subject that's toward you will be somewhat underexposed.

- **At the camera:** The side of the subject that's toward the camera will be normally exposed, and the side of the subject that's toward the light source will be overexposed.

- **Halfway between the subject and the camera:** This approach splits the difference.

In Figure 4-3, I wanted the emphasis to be on the sunlit side of the boulders so I let the shady side go dark. I chose to point the white dome toward the sun and subtracted about ½ stop of light from the meter reading to richly saturate the color of the red boulders.

50mm, around 1/15 sec., about f/16, 100

Figure 4-3: Boulders, metered by pointing the white dome at the sun.

When I took the photo in Figure 4-4, the light was coming from a window to the left of the subject. Light diminishes rapidly as you get farther away from a window, so I held the meter right in front of the subject's face with the dome pointed at the window.

REMEMBER

An incident meter needs to be close to a subject when you're taking photos indoors because light falls off with the square of the distance. That means if you double the distance to the light source, you lose 2 stops of light. For instance, if the meter is 2 feet from the window and the subject is 4 feet from the window, your subject will be 2 stops underexposed due to the loss of light. Outside in the sunlight, you and your subject are essentially the same distance from the sun, so

75mm, 1/50 sec., f/4, 800

Figure 4-4: A profile portrait, metered by pointing the white dome toward the window.

it doesn't matter how close the meter and the subject are to each other as long as both are in the sunlight. On the other hand, if you leave planet earth and head away from the sun by another 93 million miles or so, you'll lose 2 stops of light. Don't roll your eyes — NASA thinks about such things!

When you have backlit subjects

If your subject is backlit, hold the incident meter at the subject location and pick one of the following options:

✔ **Point the dome at the camera and subtract light.** The side of the subject that's toward the camera will be properly exposed, and the backlit side of the subject will be seriously overexposed. However, a backlit subject usually looks more normal if you subtract anywhere from ½ to 2 stops of light from what the meter tells you.

✔ **Point the dome at the light source and add light.** The side of the subject that's facing the camera will be underexposed, and the backlit side will be properly exposed, so you need to add 1 or 2 stops of light to what the meter tells you.

Backlit subjects usually look better if they're somewhat underexposed. How much to underexpose the subject is a matter of personal taste, though.

If your subject is backlit under just the right kind of conditions, especially if there's something dark behind it, you have the possibility of *rim light* (which is when the edges of your subject are outlined by light). Good rim light with well-defined edges isn't common outdoors, so make the most of it when you see it. Point the white dome at the light source and add 1 or 2 stops of light to the incident meter reading. You'll end up with a photo that looks something like Figure 4-5.

50mm, around 1/60 sec., about f/11, 100

Figure 4-5: A backlit cactus, metered by pointing the white dome at the light source and adding light.

Compensating for very light and very dark subjects

When you use an incident light meter, the majority of subjects look great without any exposure compensation (I cover this topic in Chapter 3). The exceptions are very light and very dark subjects. With a standard incident light meter reading, white or very light subjects can end up looking washed out, and very dark subjects can look too dark and lose detail.

If you're shooting white snow, subtract about ½ to 1 stop of light from what the meter tells you. If the subject is very light but *not* white, subtract about ½ stop. Experiment to find what you prefer.

If you refer to Figure 4-1, you'll notice that the snow is close to being washed out but that the snow patches in the scene are just small highlights in the photo. That's why I went with the incident light meter reading. If there had been a lot of sunlit snow in the scene, I would've reduced the exposure ½ to 1 stop from what my meter said to do.

For dark to very dark subjects, add ½ to 1 stop of light to what the meter tells you.

Bison are an example of a very dark subject. When I photographed the bison shown in Figure 4-6, I took advantage of the dark leaves behind them and the medium-toned grass by adding 1 stop of light to my incident light meter reading. This made the bison light enough to show more detail and texture in the photo. It also made the grass and leaves 1 stop lighter in the photo than they were in real life but not so light that they're a distraction.

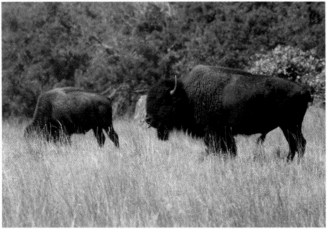

Around 200mm, around 1/250 sec., about f/8, 100

Figure 4-6: Bison, shot with an extra stop of light.

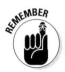

Exposure compensation with an incident light meter is in the opposite direction of exposure compensation with a reflected light meter. With a white or very light subject, you add light to a reflected meter reading and subtract light from an incident meter reading. With a dark-toned subject, you subtract light when using a reflected light meter and add light when using an incident light meter. (For more on reflected light meters, see Chapter 3.)

Compensating for accessories

Unlike the reflected light meter in your camera, which meters the light coming through the lens and any accessories you're using, an incident light meter doesn't know whether you're using filters, extension tubes, teleconverters, or any other light-robbing accessory. Consequently, when you use an incident light meter, you need to know how much light each accessory is costing you so you can add that amount of light to the reading the incident meter is giving you. For example, if a polarizing filter costs you 2 stops of light, you need to add 2 stops of light to the incident meter reading.

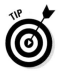

Filters have a filter factor that tells you how much light you're losing. Some filters come with this information included. For those that don't, you need to visit the manufacturer's Web site to find it. The same goes for other accessories.

Substituting for an Incident Light Meter

If you don't want to buy an incident light meter (a good basic model costs anywhere from $150 to $350), you can purchase any number of accessories that you can use in conjunction with the reflected light meter in your camera to obtain readings that are pretty much the same as the ones you'd get with an incident light meter. The following sections explain what these accessories are and how to use them.

18 percent gray cards

Called a *gray card* for short, an *18 percent gray card* looks like an ordinary 8-x-10-inch piece of cardboard that's painted gray. However, gray cards are specially manufactured so that the gray is a true "neutral gray" in tone (without any color cast). They're also designed to reflect exactly 18 percent of the light. Many 18 percent gray cards are white on the back to help you meter in very low light (I cover low-light photography in Chapter 17).

A gray card is a simple, inexpensive substitute for an incident light meter. Almost everything I tell you earlier in this chapter about metering with an incident light meter also applies to using a gray card. The only real difference is that instead of pointing a white dome at the light source (or the camera) you stand with your back to the light source, hold up the gray card so it faces the light source, and meter the card. Then you use the meter reading to take your picture. The sections that follow fill you in on some basic information about gray cards and how to use them.

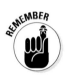

Surveying the basics

A gray card has three advantages over an incident light meter:

- ✔ It's cheap (about $12 for a pair of 8-x-10-inch cards) and easily replaceable.
- ✔ Metering is done through the lens so you don't have to worry about light-robbing accessories (such as filters, extension tubes, teleconverters, and macro lenses).
- ✔ You can photograph a gray card to set the white balance of a digital camera because it's a true "neutral gray" in tone. (Incident light meters, on the other hand can't provide a neutral reference tone because they are color blind and can't provide a neutral-toned image.)

Note: Most cameras are calibrated for subjects with a reflectance of about 12 to 14 percent. Because a gray card reflects 18 percent of the light, Kodak recommends you add ½ stop of light to the meter readings you get when you use a gray card. This is good advice, especially if your subjects are medium-dark to dark in tone (which applies to much of the outdoor world).

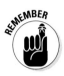

Following are some important characteristics of gray cards:

- ✔ You have to use them in the same light as the subject.
- ✔ They wear out with use. Replace a gray card when the surface develops a reflective shine or sheen that leads to inaccurate readings.
- ✔ If you cast a shadow on the card when you take a meter reading, your reading will be incorrect.
- ✔ You have to subtract light for very light subjects and add light for very dark subjects, just like you would with an incident light meter reading.

Putting a gray card to work

When your camera meters a gray card, it does so through all the accessories you're using, meaning you don't have to bother calculating how many stops of light those accessories are costing you. In Figure 4-7's photo of a pink lady's slipper, a lot of medium to dark tones are present, which can fool the light meter in a camera. After setting everything up to take the picture and manually focusing on the flower, I put a gray card between the flower and the lens, close enough to fill the frame. (In this type of situation, you never want to focus on the gray card. If you do, that changes the close-up magnification and consequently the amount of light that's lost.)

When using a gray card, the direction you point the card is more critical than with an incident light meter. See for yourself with this exercise:

1. **Go outside on a sunny day with your camera and a gray card.**

2. **Put your camera in aperture-priority mode and set the aperture to f/8.**

3. **With your back to the sun and the gray card facing the sun, meter the gray card and note the shutter speed.**

4. **Turn yourself and your gray card at a 45-degree angle to the sun and meter again.**

100mm, around 1/2 sec., about f/11, 50

Figure 4-7: A pink lady's slipper, focused manually and metered with a gray card.

5. **Turn yourself and your gray card another 45 degrees so the sun is to your side and meter once more.**

6. **Turn yourself and your gray card 45 degrees for a third time and meter again.**

7. **Turn yourself and your gray card 45 degrees one last time (so you're facing the sun and the gray card is facing away from the sun) and meter a final time.**

Notice how your meter reading changes as you change directions. When you meter with a gray card, think about where the sun (or other light source) hits your subject and the angle of the gray card. The more you experiment with gray card angles, the better you can decide the angle that's appropriate for any given situation.

In Figure 4-8, the light source for the leaves on the path was the overhead sky, so I pointed the face of my gray card straight up at the sky to get a meter reading. Because I like my reds darker than a medium tone, I subtracted ½ stop of light from the gray card reading before I took the picture. The lighting was really much darker than you'd guess from looking at the photo, hence the long shutter speed.

For another example, check out Figure 4-9. The seagull is sidelit from the left by diffused sunlight. I wanted the sunlit side to be normally exposed, so I turned my back to the sun, pointed the gray card toward the sun, metered the gray card, and used that exposure setting.

10–22mm lens at 10mm, 1.6 sec., f/22, 100

Figure 4-8: An autumn path, metered off a gray card facing straight up at the sky.

ExpoDiscs

An *ExpoDisc* looks like a translucent photographic filter with a honeycomb pattern (see Chapter 3 for the visual). You just pop it on your lens, point it at the light source, and meter like you would with an incident light meter (I explain how to use one of these earlier in this chapter). After you manually enter the exposure settings, you don't need to meter again until the light changes. ExpoDiscs come in different sizes (ranging in price from $70 to $100 for the most common filter sizes), but you only need one. Pick a size that fits a lens you always have with you.

An ExpoDisc is less directionally sensitive than a gray card but more directionally sensitive than an incident light meter, so always be aware of where you're pointing it.

Around 300mm, around 1/60 sec., about f/8, 100

Figure 4-9: A seagull, metered with a gray card facing the sun.

If you point an ExpoDisc Neutral at the light source and take a picture, you can use that picture to set a neutral white balance on your digital camera. If you want a warmer white balance, use an ExpoDisc Portrait.

Your 36, 18, or 9 percent "hand card"

Believe it or not, your body has a built-in gray card. Well, technically it's more of a hand card, and it may not reflect 18 percent of the light. Oh yeah. And it certainly isn't gray. It's actually the palm of your hand! But you can still use it to meter when you don't have a gray card with you. You just need to know how much lighter or darker your hand is than a gray card.

To figure that out, meter your hand and meter a gray card in the same light. The difference between your hand and the gray card is the difference you need to add or subtract from your hand card readings. So if your hand is 1 stop lighter than a gray card (it reflects 36 percent of the light), you need to add 1 stop of light to your hand reading. If your hand is 1 stop darker than a gray card (it reflects 9 percent of the light), subtract 1 stop of light from your hand reading.

The back of your hand is probably darker than the palm of your hand, so use whichever side is closest to a gray card reading for your hand card. Also, don't forget that a suntan can change the tonality of the back of your hand.

The palm of my hand reflects about 1 stop more light than a gray card, so I think of my hand as a 36 percent hand card. If I'm traveling light (without an incident light meter, gray card, or ExpoDisc) and I want to take an incident meter reading, I just meter the palm of my hand in the same light as the subject. Because my hand is 1 stop lighter than a gray card, I have to add 1 stop of light to my hand reading. For example, if my hand reading is f/11 at 1/250 second, then I shoot at f/8 at 1/250 second or f/11 at 1/125 second.

The photo in Figure 4-10 was based on a hand card reading. There were enough dark leaves in the background to mess up a meter reading of the scene, so I metered my 36 percent hand card and added 1 stop of light.

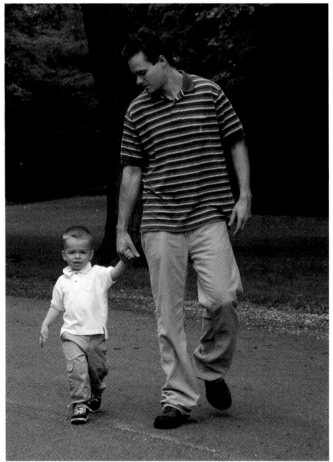

28–135mm lens at 85mm, 1/400 sec., f/10, 400

Figure 4-10: Friends, metered using my hand.

Metering without a Meter

The sun doesn't wake up on Saturday morning and say, "I think I'll be half as bright as yesterday. And because tomorrow is named after me, I'll be twice as bright as usual." That's because the sun's light output is consistent. As long as the sun isn't too low in the sky, you can use the sunny f/16 rule on bright, sunny days without ever touching a light meter. And when you're shooting outdoors on days that aren't bright and sunny, you can use exposure guides to help you determine the proper exposure for a photo. I cover both the sunny f/16 rule and exposure guides in the following sections.

The sunny f/16 rule

The *sunny f/16 rule,* which is also called the *fig rule* because f/16 looks a bit like the word *fig* when written out, tells you that the proper exposure for a frontlit subject is f/16 with a shutter speed of 1/ISO (that's 1 over the ISO in use). This rule also goes by the name *Basic Daylight Exposure,* or BDE for short. (*Note:* I use BDE throughout this book as a short way of referring to the sunny f/16 rule.)

According to the sunny f/16 rule, at ISO 100, BDE would be f/16 at 1/100 second, and at ISO 200, BDE would be f/16 at 1/200 second. Simple, huh?

On the next bright, sunny day, set the ISO of your camera to 100, the aperture to f/16, and the shutter speed to 1/100 second. Then go out and take pictures of some frontlit subjects. As long as your subject isn't white or black, the exposures should be great. No metering necessary.

You can use *equivalent exposures* (different combinations of apertures, shutter speeds, and ISO settings that provide exactly the same exposure) for the sunny f/16 rule. Table 4-1 shows equivalent exposures starting with the digital BDE for ISO 100. (I cover equivalent exposures in more detail in Chapter 2.)

Table 4-1	Equivalent Exposures for the Sunny f/16 Rule at ISO 100
Aperture	*Shutter Speed*
f/22	1/50 second
f/16	1/100 second
f/11	1/200 second
f/8	1/400 second
f/5.6	1/800 second
f/4	1/1600 second
f/2.8	1/3200 second

The sun was high and bright when I photographed the ocotillo plant shown in Figure 4-11. My ISO was 40, so the BDE was f/16 at 1/40 second. I used an equivalent exposure around f/9.5 and 1/125 second.

80–200mm lens at about 150mm, 1/125 sec., around f/9.5, 40

Figure 4-11: A desert plant, shot using the sunny f/16 rule (also known as BDE).

Following are some tidbits to keep in mind when you're thinking about applying the sunny f/16 rule:

✔ The sun needs to be high enough in the sky that its light intensity isn't reduced by the atmosphere. If your shadow is really long, the sun is too low in the sky for BDE to be reliable.

✔ BDE applies to regular-sized subjects, not close-ups. There's almost always some light loss involved in doing close-up photography.

✔ Some exposure compensation is involved for really light and really dark subjects, just like with an incident light meter reading. Subtract 1 stop of light for white subjects and ½ stop of light for very light subjects. Add ½ to 1 stop of light for dark and very dark subjects.

✔ Add 1 stop of light for sidelit subjects and 2 stops of light for backlit subjects.

Sticking with the earlier ISO 100 example, if you're shooting a frontlit subject at f/8 and 1/400 second and you see a sidelit subject, you need to add a stop of light by changing the aperture to f/5.6 or changing the shutter speed to 1/200 second. If the sidelit subject is white, you need to add 1 stop of light because the subject is sidelit, but you also need to subtract 1 stop of light because the subject is white; in other words, the two compensations cancel each other out so you can use BDE.

Table 4-2 features a handy cheat sheet for BDE exposure compensation.

Table 4-2	BDE Exposure Compensation
Type of Subject	**The Necessary Compensation**
Sidelit subject	BDE +1
Backlit subject	BDE +2
White subject	BDE −1
Very light subject	BDE −½
Dark subject	BDE +½
Very dark subject	BDE +1

I used BDE to shoot the photo in Figure 4-12. The subject was sidelit, which called for adding a stop of light, but it was also white, which meant subtracting a stop of light. The two cancelled each other out.

28–135mm lens at 38mm, 1/250 sec., f/11, 100

Figure 4-12: Part of the Denver airport building, shot at BDE.

Exposure guides

If your meter dies and it's not a bright, sunny day (BDE only works on sunny days), or if you're in one of those unusual situations where all the usual metering techniques don't work, or if it's too dark for your meter to respond to the light, use an exposure guide to help you determine the proper exposure for the scenario. You can still wind up with great results. Case in point: Figure 4-13. Because I didn't have a reliable way to meter the Brooklyn Bridge, I hauled out an exposure guide, looked up the type of scene I faced, and set my exposure based on what the guide recommended. I then bracketed on either side of the recommend exposure (see the later "Bracketing as Exposure Insurance" section for the scoop on bracketing).

I've been using the Black Cat Extended Range Exposure Guide for years. It's very handy and good at getting you close to the right exposure. The inside of this guide has a long list of scenes, like a moonlit landscape or brightly lit city streets at night, and each scene has a letter code. On the front of the dial, you put the scene's letter code opposite the ISO. Then you turn a dial to select apertures and shutter speeds for that particular scene.

So, for example, if you want to shoot a moonlit landscape, open up the guide to the scene list inside to find that the scene letter for a moonlit landscape is *S.* Set the camera ISO opposite the scene letter. (In Figure 4-14, the ISO speed of 100 is set opposite the scene letter *S.*) Next, turn the shutter triangle until you have a shutter speed and aperture combination that you like. In this case, the shutter speed is 3 minutes, and the aperture is f/4.

50mm, 16 sec., around f/8, 64

Figure 4-13: The Brooklyn Bridge, shot after using an exposure guide for street lamps.

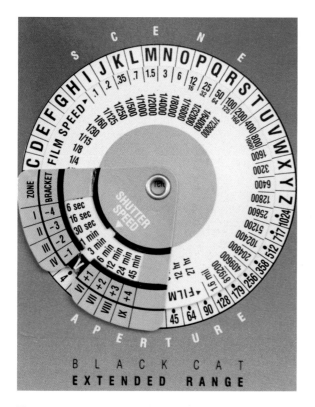

Figure 4-14: The front of a Black Cat Extended Range Exposure Guide.

Other exposure guides are on the market (including some for smartphones). Just do an online search for "exposure guides" to find them.Whatever guide you choose to use, be sure to bracket on either side of the recommended exposure. After all, these are just guides to get you close, not guarantees of the perfect exposure.

Bracketing as Exposure Insurance

No matter how carefully you meter, some situations make it pretty tough to obtain a truly accurate, reliable meter reading. When that happens, bracket your exposures.

Bracketing means to take several exposures on either side of your best exposure estimate. If the best exposure estimate you can come up with is f/8 at 1/125 second but you aren't really sure about it, you can bracket the exposure by trying exposures at 1/100, 1/80, 1/60, 1/160, 1/200, and 1/250 seconds. How widely you bracket depends on how close you think you are with your best exposure estimate. If you think you're within a stop, bracket on either side by up to 1½ stops. If you're pretty unsure of the exposure and you think you could be off by as much as 2 stops, bracket on either side by 3 stops.

Many cameras have an autobracketing feature. You pick your primary exposure and the camera adds two more exposures, one on the plus (+) side and one on the minus (–) side (check your camera's manual to see how to do this). Generally, you can choose the plus and minus amount of the additional exposures in half- or third-stop increments up to a maximum of +/– 2 or 3 stops. If you think your best estimate is really close, you can set autobracketing to +/– 1 stop (just to choose an example) and let the camera do its thing. If, however, you're less certain of your exposure and you want to take more than three exposures, it's simpler to put your camera in manual mode and vary your exposure by manually changing the shutter speeds or apertures.

Some of the best photographers bracket their exposures in critical and challenging situations. Bracketing isn't guessing. Nor is it a substitute for thoughtful metering. *Note:* If you're photographing a moving subject, like an animal, and you're bracketing wildly all over the place, you may have the worst exposure for the best-composed photo in the series. Do your best to meter the scene accurately and then bracket if necessary.

5

More Than Just Metering: Working with Light

*T*he incredibly varied and fascinating world of light is the language of photography. Photographers write with light. It is the ever-changing world of light that keeps photography interesting and provides an endless source of artistic opportunities and technical challenges.

All kinds of photographers work with light to capture the perfect image. For example, a landscape photographer waits minutes (or hours) for just the right light; a documentary photographer looks for hard, gritty light to illustrate a photo essay on urban decay; and a portrait photographer works to find the ideal ambient light or to create the right light.

In this chapter, you find out how to read the language of light, discover which light works best for which subjects, and realize how to work with and modify light to achieve the look you want. You also see how to apply different metering skills for different kinds of light and how to work with the color temperature of light. Plus, you get to do some hands-on training, working with light by performing the simple exercises found throughout this chapter.

Lighting characteristics occur in all kinds of combinations. Light can be warm or cool, bright or dim, hard or soft, low in contrast or high in contrast. You have a lot of possibilities to explore, so give them a go. If you're addicted to flowers in soft light (which is a good thing), try shooting something different in hard light. If you're a warm light junkie, try cool light. You get the idea. Ultimately, you become a better photographer by experimenting with all the different lighting possibilities.

Using the Light Mother Nature Provides

The best lighting advice I can give you is this: When you're working outside, shoot the kind of subject that works best with the kind of light Mother Nature is providing. In other words, work with the light, not against it. When you cooperate with the light you have, you can wind up with photos like the one in Figure 5-1, which was taken in Rocky Mountain National Park in low-intensity, cool light with a high-contrast, backlit subject.

To practice working with the light Mother Nature gives you, get up in the morning and instead of saying, "I think I'll shoot flowers today," say, "I wonder what kind of light Mother Nature is providing today." Then walk outside, take a look at the light of the day, and say, "Wonderful! Soft light! I'm shooting delicate flowers and intimate landscapes today." Or say, "Outstanding! A storm front is moving in. I'm shooting angry clouds today." Or say, "Excellent! The light is terrible. It's a great day to read a book like *Digital Photography Exposure For Dummies.*"

Sometimes, of course, you have no choice. If you're shooting a backyard birthday party and the light is terrible (which is any kind of light that's poorly suited to your subject), you must make the best of it and compensate for the bad light to the best of your ability. But when you have a choice, you get the best images by working *with* the light you have.

If you need further convincing, check out the clumps of grass shown in Figure 5-2. They never looked worthy of a photo until I saw them one evening in the warm, wonderful, contrasty sidelight of the setting sun (see the later related section for the scoop on sidelight). I quickly set up my tripod and camera and captured grass that was just popping out against the background (see Figure 5-3). I passed by that field many more times afterward, but the light on the grass was never as good as it was that one magical evening.

One of the keys to great photography is to remember that the light is often more important than the subject. Great light on an ordinary subject is almost always better than a great subject in bad light.

In the following sections, I introduce you to the three main characteristics of light: intensity, quality, and direction.

Intensity

Intensity is the level of brightness of the light, ranging from the brightness of a sunny day to the dimness of a starry night. Because the variation in light intensity is so vast, you need to take advantage of the huge range of shutter speeds available in order to achieve the proper exposure. For example:

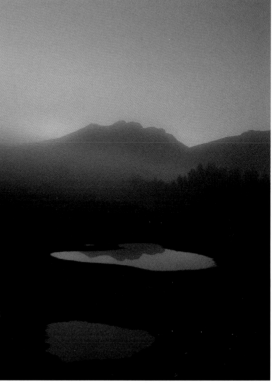

28–135mm lens at 28mm, 1/15 sec., f/8, 100

Figure 5-1: An example of what you can get when you work with the light.

✔ Shutter speeds in bright sunlight are usually measured in tiny fractions of a second.

✔ Shutter speeds at dawn and dusk are measured in seconds.

✔ Shutter speeds in deepening light and moonlight are measured in minutes.

✔ Shutter speeds for star trails in a very dark sky can be measured in hours.

50mm, around 1/250 sec., about f/11, 100

Figure 5-2: Nothing catches the eye in this photo because the light is flat and ordinary.

80–200mm lens at around 200mm, around 1/60 sec., about f/8, 100

Figure 5-3: The warm, directional quality of the light draws you into this photo.

Figures 5-4 and 5-5 provide you with some examples of how high- and low-intensity light can affect your shots. The Taiga trees and mountains in Denali National Park (see Figure 5-4) were shot in high-intensity midday light. The colors are vivid, but the photo is on the harsh side. In contrast, Figure 5-5's photo of the fog-encased trees and mountains in Denali National Park was taken in somewhat less intense light due to the cloud cover. Consequently, the photo doesn't look as harsh.

Probably 24mm, about 1/30 sec., around f/16, 100

Figure 5-4: The high-intensity light shining on this scene creates a harsh effect.

Around 24mm, around 1/60 sec., about f/16, 100

Figure 5-5: Lower-intensity light softens the overall photo here.

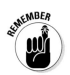

Some subjects look good in high-intensity light; others look better in low-intensity light. Experience and your own personal preferences, along with the information in Table 5-1, can help you sort out which is which.

Table 5-1	Using the Right Light Intensity
What You Want to Capture	*The Kind of Light You're Looking For*
Bold/subtle colors	Bright light is good for achieving bold solid colors. Low light is good for achieving subtle colors with gradual gradations in tone.
Sharp contrast	Bright light can make a light-toned subject look very dramatic against a dark background (think of bright sunlight in the foreground and dark clouds in the background).
Softness/harshness	High-intensity light can make some objects look harsh, like flowers with delicate colors. Harsh, high-intensity light is perfect for showing every crease, wrinkle, pore, and bit of hair stubble in a face with lots of character. Soft, low-intensity light can create some very interesting and creative color shifts, like the blue tones found in snow on a late winter evening. Soft, low-intensity light works well with soft, pastel colors.
A frozen moving object	Bright light is good for freezing fast-moving subjects, such as race cars.
A blurred moving object	Medium-intensity light is good for partially blurring subjects, like wildlife on the move. Low-intensity light is good for blurring subjects over seconds or minutes, like clouds or stars moving across the night sky.

When you're photographing a fast-moving subject (like, say, a flying bird) and you want a little depth-of-field insurance, you can get it by photographing the subject in bright light, which makes it possible to combine smaller apertures with fast shutter speeds for sharp results. (Turn to Chapters 6 and 7 for full details on depth of field.)

Quality

In photography, *quality of light* refers to whether the light is hard, soft, or somewhere in between. It's determined by the strength of the shadows.

Hard light comes from point light sources, such as the sun, a single light bulb, or a flash. It tends to

✔ Create dramatic shadows

✔ Be good for creating sharp edges and "gritty" city photos

✔ Work well with bold, even colors

✔ Enhance texture

✔ Be great for showing every line, crease, or whisker in a craggy face

✔ Require precise metering techniques (more about that later in this chapter)

The hard light on the sunflowers in Figure 5-6 works well. The high-intensity light enhances the contrast between the bold yellow colors and the deep blue Colorado sky. The shadows from the steep angle of the sun really bring out the details and texture in the "faces" of the sunflowers. In bright sunlight, basic daylight exposure (BDE) works just fine. No metering necessary.

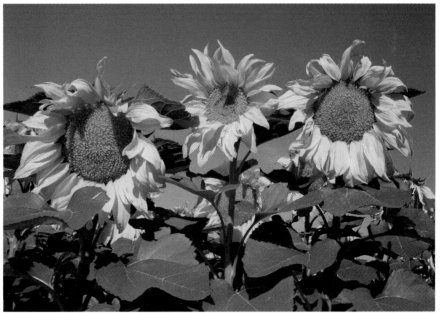

20mm, 1/125 sec., f/16, 100

Figure 5-6: The high-intensity hard light really makes these sunflowers pop.

Soft light comes from broad light sources, usually a point light source that has been diffused in some way. The bigger the light source, the softer the light. Clouds provide natural soft light, but when you need artificial soft light (like when you're shooting portraits), you can use large umbrellas to soften the light from a flash. Soft light generally

✔ Has no shadows or very soft shadows

✔ Is good for most delicate flowers

✔ Creates flattering portraits

✔ Minimizes texture

✔ Works well for intimate landscapes

✔ Is usually preferable for subjects with delicate tone transitions

✔ Is usually easier to meter

Figure 5-7 is a good example of what you get when you photograph subjects in soft light. When I captured this image, the light was soft and slightly cool in temperature (I tell you all about color temperature later in this chapter) due to some light drizzle. The cool light made the most of the delicate colors. Metering was simple: I just metered the flowers and took the picture.

Between hard and soft light lie lots of variations in light quality. Many subjects, including a lot of faces, look quite nice with semisoft, slightly directional light, which creates soft shadows.

28–135mm lens at 70mm, 1/90 sec., f/8, 400

Figure 5-7: The flowers in this photo were shot with soft light.

Direction

The *direction* of light describes where the light source is in relationship to you and your subject. It can change the look of your subject dramatically and therefore requires you to adjust your metering techniques somewhat. In the sections that follow, I describe the attributes of light based on the direction it's coming from and make some suggestions for using it.

How you choose to use the direction of light depends on which of the attributes of that particular light may or may not suit your purpose for a given image.

Frontlight

You have *frontlight* when the light source is on the same side of your subject as you are, like when the sun is behind you or when the flash on your camera goes off. Following are the characteristics of frontlight:

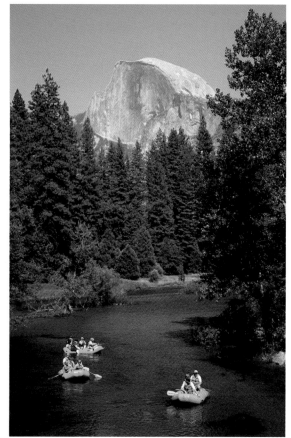

- ✔ It's very even.
- ✔ It doesn't add contrast to the subject.
- ✔ It shows colors and shapes well (unless the shapes are three-dimensional).
- ✔ It's good for variations in subject tonality.
- ✔ It usually minimizes texture.
- ✔ It can make subjects look flat and two-dimensional.
- ✔ It can be boring unless you have a subject with strong variations in color or tonality.

You can see frontlight at its best in Figure 5-8. In this photo of the Merced River and Half Dome, the frontlight makes the most of the rafts' bold colors.

24–105mm lens at 58mm, 1/250 sec., f/8, 100

Figure 5-8: The high-intensity front light helps the raft colors stand out.

Frontlight isn't great in all situations, but when it's soft, it's the best light for minimizing imperfections in human skin. (Now you know why they put that huge light in front of you when you got your school pictures back in the day.)

Avoid taking photos of people when they're facing the sun. It may be frontlight, but it's too harsh.

Even though the majority of people take lots of frontlit photos, you'll be a better photographer, hone your exposure skills more quickly, and have more dramatic images if you take a higher percentage of backlit and sidelit photos.

If you're feeling ready to experiment with frontlight, grab your camera and walk through the following exercise.

1. **Pick a bright, sunny day and head out about two to three hours before sunset.**

2. **Choose a subject with several bold colors.**

3. **Set the white balance on your camera to daylight.**

4. **With the sun behind you, take a picture of your subject every 15 to 20 minutes, using BDE when the sun is bright and metering a gray card as the sun gets lower and the light grows less intense.**

 If the light is changing quickly, snap your photos more frequently. Regardless, don't stop taking photos until after sunset when the light is cool and soft.

5. **Compare the photos.**

 Notice what happens to the bold colors in your subject as the light gets warmer, softer, and then cooler, all in frontlight.

Sidelight

If the sun or light source is to the side of your subject, you have *sidelight* — half the subject is lit and half is in shadow. The mix of light and shadow increases the contrast in the subject. The characteristics of sidelight are as follows:

✔ It's dramatic.

✔ It can cast long shadows when the sun is low in the sky.

✔ It makes subjects more three-dimensional.

✔ It's great at revealing texture.

✔ It can reduce the amount of color information.

✔ It's harder to meter than frontlight.

Landscape photographers love sidelight, especially warm sidelight when the sun is low across the sky, because it creates long shadows across the frame. Check out Figure 5-9, which shows sunrise light on Denali in Alaska, to see what I mean. Pay special attention to the dramatic shadows.

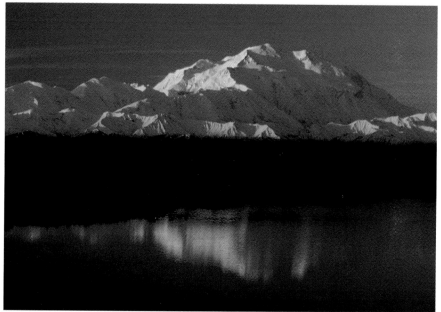

70–200mm lens at 70mm, about 1/8 sec., around f/11, 100

Figure 5-9: Sidelight creates the shadows that make this photo pop.

Some subjects tend to lack color interest, but they really pop with the contrast between light and shadow that sidelight creates.

Get comfortable shooting in sidelight with this exercise:

1. **Pick a sunny day when the sun is low in the sky.**

2. **Find a tree that has bark with deep grooves in it.**

3. **Stand on the sunny side of the tree with your shadow as close to the tree as possible, without it being on the tree itself.**

4. **Meter the tree (or a gray card) and take a photo of it.**

5. **Move to the side of the tree so that the sun is at your left or right.**

 The side you're facing should be half in sun and half in shadow.

6. **Using the same exposure as you used for the sunlit side of the tree, take another picture.**

7. **Add a half-stop of light to your original exposure and take a second picture.**

8. **Add another half-stop of light and take a third picture.**

9. **Add yet another half-stop of light and take a fourth picture.**

10. **Compare all four exposures to see the dramatic difference between the front and sidelit photos, as well as the difference the exposure can make.**

Backlight

You have *backlight* when the sun or other light source is behind your subject. It's bold and dramatic, but it's also a challenge to work with. Never fear, though. The photos you get when you use backlight are totally worth it. Following are the characteristics of backlight:

- It creates dramatic contrasts.

- It can significantly reduce the color information in your subject.

- It emphasizes shapes (so it's better for when you want shapes to take priority over color).

- It can create dramatic *rim lighting* (a bright halo of light around your subject) when the sun is directly behind the subject.

- It creates a fresh look because most people rarely try backlighting.

- It can be used to create silhouettes.

✔ It darkens unlit areas of the subject.

✔ It's the most challenging type of light to meter.

To see natural backlight in action, take a look at Figure 5-10. The frost on these trees is *subliming* (going directly from a solid to a gas without melting into a liquid) into the morning air. The combination of backlight and the dark background really makes the frost stand out.

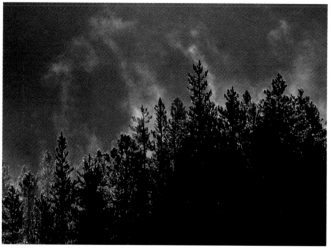

28–135mm lens at 135mm, 1/180 sec., f/8, 100

Figure 5-10: Sun-created backlight.

Of course, you can use light sources other than the sun to create backlighting. In Figure 5-11, the trees and distant mountain are backlit by the moon, creating silhouettes.

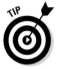
You can use backlighting to dramatic effect when sunlight hits the primary subject in your photo and the unlit background goes very dark. For example, if you shoot a bristly cactus when the sun is just above a mountain in the background but still lighting the cactus in the foreground, your backlit cactus, spines glowing in the sunlight, really pops against the dark backdrop of the mountain (as you can see in Figure 4-5 in Chapter 4).

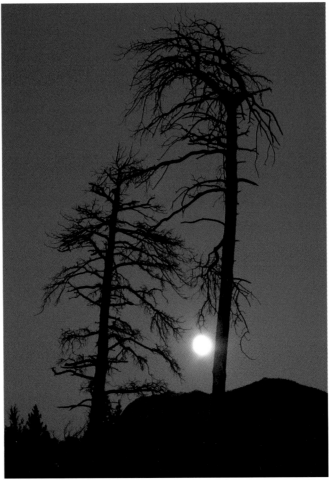

28–135mm lens at 65mm, 4 sec., f/11, 400

Figure 5-11: The moon provides the backlighting in this photo.

Here's a way to start getting comfortable working with backlighting:

1. **Find a subject that you think would look good when backlit and make sure that subject is in front of a building.**

2. **With your subject between you and your building backdrop, set up to take the picture just before the sun drops behind the building.**

3. **Choose a working distance and focal length so your camera sees only your subject and the building behind it, not the sun and sky.**

4. **Take three pictures with the following exposure settings: BDE, BDE +1, and BDE +2.**

 I fill you in on BDE in Chapter 4.

5. **Change how you compose your subjects in the frame so you can see your primary subject and also include the sun and sky in your photo.**

 To do this, you need to either back up or use a wider focal length.

6. **Take three more pictures using the exposure settings in Step 4.**

7. **Point the camera at the sky near the sun but without the sun in the frame.**

8. **Meter the sky and lock in that exposure manually so it doesn't change when you re-aim the camera.**

9. **Take another photo that includes your subject, the building, the sun, and the sky.**

10. **Compare the photos with and without the sun and sky and decide which composition and exposure setting you like best.**

Toplight

If the light is above your subject, like the sun in the middle of a summer day, you have *toplight*. Toplight can also happen inside when you have one overhead light source (as opposed to banks of overhead lights, which make the light less directional). The characteristics of toplight are as follows:

✔ Bright highlights on top of your subject

✔ Strong shadows below your subject

✔ Darker vertical surfaces, depending on the angle of the light source

✔ Dark shadows on faces

✔ Difficult metering contrasts

Toplight usually doesn't work because you don't get enough light on your subject. If you meter for the bright light on top of your subject, the rest of the subject winds up underexposed. If you meter the more shaded vertical sides of your subject, the top highlights get overexposed.

To see how bad toplight can look, check out Figure 5-12. The light in this toplit photo of a cardinal is harsh and contrasty, the eye is invisible, and there are distracting *hot spots* (white areas) in the background. Figure 5-13's sidelit photo of a robin is much more pleasing. Plus, the sun is reflected in the bird's eye, something that's always a plus when you're photographing wildlife.

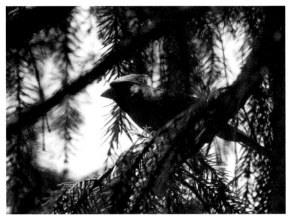

100–400mm lens at 300mm, 1/400 sec., f/7.1, 400

Figure 5-12: A cardinal in bad toplight.

I don't usually like toplight because it's rarely useful and can create horrible, ghastly shadows in the eye sockets of your subjects. Generally, toplight is suitable only for photographing people you don't like (just kidding . . . maybe).

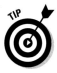 If you're photographing subjects in toplight, I strongly encourage you to use fill flash to fill in the shadows (see the later section "Filling in shadows with flash and reflectors" for details on fill flash).

100–400mm lens at 350mm, 1/320 sec., f/8, 100

Figure 5-13: A robin in sidelight.

Deciding How to Expose Your Subjects in Natural Light

One of the challenges of working in natural light is figuring out which subject to meter out of all the subjects in the scene. Most scenes have several subjects with a variety of tonalities (*tonality* refers to how light or dark in tone colors are). Getting a pleasing exposure is all about giving the right *visual weight*

(a fancy way of saying *importance* in photography terms) to the subjects in your scene. By that, I mean you have to weigh the visual importance of each subject and expose accordingly. The subject you choose to meter determines the tonality of all the other subjects in the scene. The next sections examine how to expose for different types of tonalities.

When deciding what to meter, be thoughtful about the whole scene and consider how metering for one tonality in the scene will affect the other tonalities in the scene.

Very-dark-toned subjects

Very-dark-toned subjects are the biggest, most complex exposure challenge. Follow these guidelines when working with them:

✔ **To shoot a tight portrait of a subject:** Meter just the subject and subtract light, or use an incident light meter reading or a gray card reading and add light according to the suggestions in Chapter 4. Just remember that the exposure compensation is in opposite directions between metering a dark-toned subject with a camera and metering a gray card with a camera. As long as you're doing a tight portrait of your subject, the tonality of the background doesn't matter.

✔ **To photograph very dark subjects in a larger scene:** The best exposure approach is to maintain as much tonality as possible in the subjects without *burning out* (turning to pure white) or overexposing the lighter-toned subjects in the same scene. When experienced photographers are faced with dark subjects in a lighter scene, like buffalo in a field of light-toned grass, they usually make sure the grass isn't seriously overexposed, even if the buffalo look too dark.

In the real world, jungle vegetation is medium dark in tone, and gorillas are very dark. If you're shooting gorillas in the mist (talk about a good movie title!) and using a gray card or incident light meter reading, the vegetation will look dark, which is okay, but the gorillas will be so dark that you'll lose their texture and details. The exposure solution is to lighten the overall exposure, shifting the vegetation from medium dark to medium toned and the gorillas from very dark to medium dark in tonality (I explain how to shift tonality in Chapter 3).

You can perform most of the exercises in this book from the comfort of your home or neighborhood, but this one may require some travel.

1. **Find the nearest zoo that's home to gorillas in a natural-looking enclosure.**

 No gorillas anywhere near you? Ask a friend whether you can photograph his black dog or cat.

2. **Pick a cloudy day or try to photograph the gorilla in the shade.**

3. **Meter just the gorilla by using your camera's meter, if you can get close enough to do that, and subtract ½, 1, and 1½ stops of light from the exposure recommendations the camera meter provides.**

4. **Take several pictures.**

5. **Meter a gray card or take an incident light meter reading in the same light that the gorilla's in.**

 If the gorilla is in the shade, you need to be in the same kind of shade as the gorilla, but not in the enclosure with the gorilla . . . that's just asking for it. If the gorilla is in the sun, you need to meter in the sunlight.

6. **Add ½, 1, and 1½ stops of light to the recommended meter reading.**

7. **Take several pictures.**

8. **Pick the exposure you like the best and write it down in your collection of preferred exposures for very dark subjects.**

The gorilla shown in Figure 5-14 was close enough that I could meter his face, subtract a stop of light to keep him dark toned, and take his picture. The shutter speed was 1/10 second for a hand-held camera and a long lens (I delve into the importance of appropriate shutter speeds in Chapter 8). What was I thinking? The image stabilization feature of the lens allowed me to take a steady shot.

100–400mm lens at 330mm, 1/10 sec., f/8, 100

Figure 5-14: A gorilla at the zoo, metered for his face.

If you're trying to photograph a black subject (like a black squirrel) against a completely white background (like snow), you're in the exposure danger zone. Why? Because to get the shot you must sacrifice one subject or the other. If you maintain texture in the squirrel, the snow will wash out, which is usually a bad thing. If you meter for the snow, the squirrel will look dark and lose a lot of detail and texture. Make your decision based on how close you are to the black subject, which in this case is the squirrel. If you can come close to filling the frame, meter for the squirrel and let the snow wash out. If the squirrel is small in the frame, make it more of an intimate (small-scale) landscape, expose for the snow (add 1 to 2 stops of light to your meter reading of the snow), and let the squirrel become a dark-but-interesting feature in the frame.

Medium-dark-toned subjects

As with very-dark-toned subjects (see the preceding section), the challenge with medium-dark-toned subjects is maintaining some texture and detail in the subject without burning out very-light-toned subjects. The exposure choices you make depend on the tonality of the other subjects in your scene and how prominent your medium-dark-toned subject is in the frame.

Subjects with multiple tonalities, such as elk, are an interesting exposure challenge. An elk's head and neck are very dark, but the rest of its body ranges from medium dark to medium toned. This subject becomes even more complicated to expose properly when bull elk roll in their own urine during the mating season because it makes them even darker.

To help you in your quest to master exposure, consider the following variations on a theme:

> ✔ **Variation 1:** Several elk are pretty far away in a meadow. The scene includes blue sky and sunlight on snow-capped mountain peaks. With a scene like this, the first goal is to not burn out the snow. Burned-out highlights (pure white with no texture) are a no-no most of the time. The priority in this scene is the bright snow, the mountains, and the blue sky. You can almost hear the tourism bureau discussing postcards. The elk play a minor supporting role, and they're far away, so it's okay if they look pretty dark. Consequently, your goal is to expose for the snow so it looks bright and shiny without getting burned out and let the elk go dark. You have several exposure options to choose from:
>
>> • You can spot meter the snow and add 1½ to 2 stops of light to what the meter tells you to keep the snow very light in tone.
>>
>> • You can go with BDE –1 stop to keep the snow from burning out.

- If you're in the same bright sunlight as the snow (not in the shadow of a passing cloud), you can meter a gray card in the sunlight at the same angle the sunlight is hitting the mountains and subtract 1 stop of light from what the meter tells you.

- If you have an incident light meter, you can point the hemisphere at the sun, meter, and subtract 1 stop from that meter reading.

✔ **Variation 2:** A frame-filling bull elk is in soft light with evergreen trees behind him. In this scene, the elk is the main subject, so you want to meter for the elk. Here are a couple options:

- Meter the medium-toned side of the elk (not the dark-toned neck and head) and take the picture. *Note:* Evergreens are significantly darker than medium toned, so don't let them skew your meter reading. If the meter sees the evergreens, it'll try to make them medium toned and overexpose the whole scene.

- Go with an incident light meter reading.

- Meter a gray card and go with that reading.

The elk in Figure 5-15 stepped out of the woods and walked down a mountain road right next to my car. I barely had time to switch to a shorter lens. I couldn't meter his side until he was next to my car window so I metered my hand (as a substitute gray card; more on that in Chapter 4) and added 1 stop of light because my hand is 1 stop lighter than a gray card.

24–105mm lens at 60mm, 1/50 sec., f/9, 400

Figure 5-15: A close-up of an elk, metered "by hand."

✔ **Variation 3:** Elk are on a ridge, backlit by the glow of an early morning sky. In this scene, the elk are the main attraction. But the sides of the elk and the ridge are several stops darker than the glowing early morning sky. Check out your options:

- If you meter for the elk and ridge, the sky will be washed out — a big no-no.

- If you meter for the sky (as in Figure 5-16), the elk will be silhou-etted against the sky, which is just fine. The only decision you need to make at this point is how light you want the sky to be. Meter the sky (without including the elk or ridge) in manual mode and lock in your exposure. Then recompose to include the elk. Bracket around your meter reading for the sky to give yourself several sky tonality options (flip to Chapter 4 for the how-to on bracketing).

100–400mm lens at 400mm, 1/500 sec., f/8, 400

Figure 5-16: Elk at sunrise, metered for the sky.

In all three variations, the tonality of the elk depends on the total scene. The elk are incidental to the first scene, and even though the elk are the main attraction in the next two scenes, the exposure required is different to suit the total scene.

Medium-toned subjects

Medium-toned subjects are the easiest to meter. Just meter the subject and shoot, or use a gray card reading or the reading from an incident light meter. Go out and look for some medium-toned subjects (such as medium-toned flowers or light green vegetation), put your camera in program mode, and let the camera do its thing.

If you also have a large, very-light-toned area in the picture, like snow-capped peaks, subtract anywhere from a half-stop to a full stop of light. Doing so shifts your subject to medium dark in tone, but everything else in the frame still looks good.

Figure 5-17 features a photo of a caribou in soft light. In this photo, the meter reading was based on the medium-toned vegetation.

100–400mm lens, around 1/60 sec., about f/8,100 at EI 160

Figure 5-17: Caribou, metered off the medium-toned background.

Very-light-toned subjects

The simple challenge when exposing for very light or white subjects is to keep them light in tonality while maintaining a balance with the darker-toned subjects in the scene. The exposure decisions you make for very-light-toned subjects depend on the visual weight they have in relationship to the other tonalities in the scene. Consider these two variations on a theme — white flowers in a meadow — to see what I mean:

✔ **Variation 1:** If you're doing a close-up of a few white flowers, the flowers should be the main thing, which means your meter reading should be based on the white flowers, even if everything else goes darker. Spot meter the white flowers and add 1 to 1½ stops of light. Or use an incident light meter or gray card and subtract anywhere from a half-stop to a full stop of light to keep the flowers from burning out (see Chapters 3 and 4 for tips on exposure compensation for white subjects).

✔ **Variation 2:** If you're photographing an entire meadow that consists of medium- to dark-colored flowers and vegetation with only a few white flowers scattered here and there, the medium and dark tones deserve more visual weight. Meter for a good exposure for the whole scene and let the white flowers burn out. *Remember:* You can get away with a few small burned-out flowers, but you can't get away with lots of burned-out snow, sky, or pretty much anything else that takes up a lot of space in the frame.

In Figure 5-18, I metered this scene as if the white flowers weren't even there.

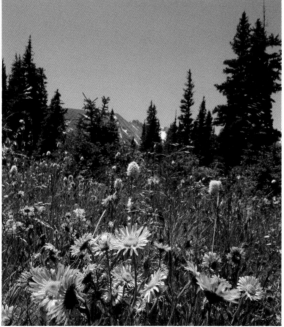

17–40mm lens at 17mm, 1/100 sec., f/16, 100

Figure 5-18: A toplit shot of flowers, metered so the whole scene has a good exposure.

Exploring the Color Temperature of Light

Color temperature refers to the color of a light source, and it falls somewhere on a scale from warm to neutral to cool (see Figure 5-19 for the range). Cool temperatures are bluish, whereas warm temperatures are yellow-amber. Both warm and cool light create a color cast on your subject, which is great sometimes but unwanted other times. In the following sections, I walk you through the basics of color temperature, color shifts, and how to manage it all to get the colors you want.

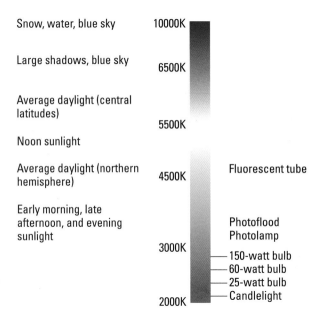

Snow, water, blue sky | 10000K

Large shadows, blue sky | 6500K

Average daylight (central latitudes) | 5500K

Noon sunlight

Average daylight (northern hemisphere) | 4500K | Fluorescent tube

Early morning, late afternoon, and evening sunlight | | Photoflood / Photolamp

3000K | 150-watt bulb / 60-watt bulb / 25-watt bulb / Candlelight

2000K

Figure 5-19: The color temperature table.

Observing color temperature shifts in natural light

On sunny days, the color temperature of natural light follows a predicable cycle. As night gives way to morning twilight, the color temperature is cool. As sunrise approaches, the color temperature begins to warm. It's warm at sunrise and for a while afterward (how warm it gets depends on how much dust and moisture is in the air). As the sun rises, the color temperature becomes more neutral and remains fairly neutral until late in the afternoon.

As the sun drops lower in the sky, the color temperature begins to warm up again. This warm light continues after sunset and can actually last quite a while if the atmospheric conditions are right. As evening falls, the light turns cool, the winds often die down (meaning the dust gradually settles), and the cycle repeats.

The shifting of color temperature that occurs throughout the day is most obvious on a sunny day in winter. The snow starts out very blue in the morning and warms up to yellow or gold at dawn before gradually turning white. It turns yellow or gold again at sunset before finally going back to blue.

I'm a warm light junkie, and I love the so-called golden hours around sunrise and sunset. However, I also like to explore the cool light of late evening and night. The cool light in the Rocky Mountains was perfect for capturing the nighttime shot shown in Figure 5-20.

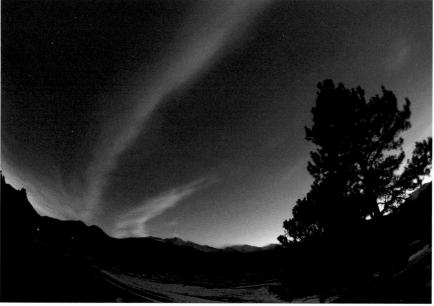

15mm, 30 sec., f/4.5, 400

Figure 5-20: A nighttime glimpse of the Rocky Mountains, shot in cool light.

Here are some tidbits about color temperature and natural light that I've discovered over the years:

> ✔ Sunsets are often warmer than sunrises on windy days because the wind sends dust into the atmosphere, which can affect the warmth of the light.

✔ The shade on a sunny day is very cool because the light in the shade comes from the blue sky rather than the sun.

✔ The color temperature of the light from a full moon is neutral, surprising as that may seem. If you take a picture by the light of a full moon without including the moon in the frame and leave the shutter open long enough, it'll look like a daytime photo.

✔ Depending on the amount of cloud cover, the color temperature on a cloudy day can vary from fairly neutral to slightly cool to very cool.

To get an idea of how color temperature affects images, try this exercise:

1. **Pick a sunny day when you know you'll be around all day.**

 A sunny day with snow on the ground is ideal, but any sunny day works.

2. **Set your camera's white balance to daylight.**

3. **Position your camera on a tripod or other support where it can face out a window.**

4. **Point your camera at the snow or a white house if there's one within eyesight of your window and add 1½ stops of light to the exposure reading the camera recommends.**

 If you don't have snow or a white house to look at, meter something medium toned and go with the meter reading the camera suggests.

5. **Take a picture one hour before sunrise, another one 30 minutes before sunrise, one at sunrise, and one 30 minutes after sunrise.**

6. **Continue taking a picture once an hour for the rest of the day until 30 minutes before sunset.**

7. **Take a picture 30 minutes before sunset, another one at sunset, one 30 minutes after sunset, and a final one an hour after sunset.**

8. **Compare the photos to see how the color temperature of natural light changes throughout the day and how those changes alter your photos.**

Seeing how color temperature changes in different types of artificial light

The color temperature of artificial light is anything but neutral. Household light bulbs, for example, range from warm to very warm. Case in point: The light for the photo in Figure 5-21 came from a household light bulb and an artificial candle, both of which gave off light that provided nice, warm skin tones.

Fluorescent lights are another common source of artificial light. Their color temperature is all over the place, including a ghastly green. (Green fluorescent light on human faces is artistically immoral.) Fortunately, you can buy some fluorescent lights that are more neutral in terms of color balance, including those environmentally friendly compact fluorescent light bulbs (CFLs).

58mm lens, 1/15 sec., f/1.4, 100

Figure 5-21: Candlelight and a light bulb make this photo very warm and inviting.

When you have artificial lights that are creating an unattractive color cast in your images, the most effective and time-consuming solution is to shoot Raw files and correct the color after the fact in your photo-editing software (I recommend Adobe Camera Raw, or ACR). A faster, in-camera solution is to use a preset or custom white balance for your JPEG files. (You can do both by shooting Raw and JPEG files.)

Making color temperature adjustments

The shift in color caused by color temperatures that aren't neutral can be quite charming, especially when you're photographing landscapes. After all, snow should look cold and blue in the evening, and the golden light around sunset and sunrise should be warm. In the middle of the day, color should be normal. To go with the colors Mother Nature provides, choose daylight from your camera's preset white balance options (I cover white balance in the next section).

Inside, candlelight should look warm. Other kinds of warm indoor light can look quite nice as well. If you like the color of the light indoors, stick with your camera's daylight white balance.

On the other hand, doing portraits in open shade can turn people unnaturally blue, and days with heavy overcast clouds can be so blue as to dramatically shift the color of flowers. Some kinds of indoor light can be rather unflattering too. If you don't like the color temperature of the light you have, it's time to take control.

With digital cameras, color correction is accomplished inside the camera or with the aid of software. Many digital cameras now have several preset white

balance modes that are represented by little symbols (like a sun to represent daylight), a choice of color temperature settings in degrees kelvin (K), or a custom white balance setting. (Some cameras actually have all three.)

Putting White Balance to Work

The purpose of the *white balance* setting on your digital camera is to match the color settings of the camera to the color temperature of the light source so a white subject looks white. If a white subject looks right, all other colors should look right too, meaning the colors you get will be true to the way the colors look in bright sunlight in the middle of the day. But if you so choose, you can purposely mismatch white balance settings to make your subjects look warm or cool in tone to match your creative vision for a particular subject. The sections that follow explain how to use and choose white balance. They also show you how to customize white balance for your particular needs.

Choosing a white balance mode

The fastest approach to choosing white balance, but not always the best, is to use the little symbols on your camera to match the white balance to the color temperatures of the scene. The names and symbols can vary from camera to camera, so double-check your manual for the specifics on your model. Table 5-2 shows you what the symbols generally tend to mean:

Table 5-2	The Standard White Balance Modes	
Name of White Balance Mode	**The Symbol That Represents It**	**When to Use It**
Automatic white balance mode	AWB	When you want the camera to set the white balance for you
Cloudy	Clouds	On cloudy days
Daylight	Sun	On sunny days
Flash mode	Lightning bolt	When you use a flash
Fluorescent	Fluorescent light tube	When you're shooting under white fluorescent lights
Open shade	Shaded building	When you're shooting in the shade on sunny days
Tungsten	Household light bulb	When you're shooting with tungsten lights

I trust the daylight setting and use it outdoors all the time in neutral, warm, and cool light. With this setting, warm light looks warm, and cool light looks cool. The open shade and cloudy settings are good for counteracting the blue in a scene when you're photographing people or flowers in the shade. The flash mode is good for adding a slight amount of warmth, and the tungsten mode acts like a cooling filter to counteract the warm light of household light bulbs. Auto white balance is helpful when there are several kinds of light.

The preset white balance modes can vary in accuracy and consistency from camera to camera. For instance, a couple of the white balance modes on my camera don't work very well, so I rarely use them. If you discover that one or more of the preset white balance modes on your camera doesn't do a consistently accurate job, use the custom white balance setting (if your camera has one).

Setting an accurate custom white balance

For the ultimate white balance accuracy, use a custom white balance setting. Your camera's manual should explain how to do this (so be sure to check it for instructions specific to your camera model), but generally you start by taking a picture of something white or neutral gray with absolutely no color cast and in the same light as your subject. (The white or gray side of a gray card works well.) Don't worry about focusing; just be sure to fill the frame with your subject so the camera doesn't see anything else besides white or gray. If you don't have a gray card with you, look for a white napkin or table-cloth, or anything else that's white.

Next, go into your camera menu and select custom white balance. From there, just pick your photo of the white or gray subject and set the dial your camera tells you to set to custom white balance. After you do that, you're good to go — provided you photograph your subject in the same light as your initial white or gray photo.

When taking the portraits in Figures 5-22 and 5-23, I set up a deliberate white balance mismatch between the light source and the camera setting so I could correct it and create a custom white balance.

In the first photo in Figure 5-22, the light source was a 100-watt light bulb, but the camera's white balance mode was set to daylight. As a result, the subject and the calibration target in her hands looked very yellow. I took a close-up photo of the calibration target and used that photo to set a custom white balance. The result is shown in the third photo in Figure 5-22. As you can see, the camera dialed in enough blue compensation to make everything look normal again.

With the camera still white balanced for the tungsten light source, I then took a photo with a studio flash, which is close in color temperature to normal

daylight (see the first photo in Figure 5-23). The camera was still using blue compensation because it thought I was still using tungsten lights (silly camera), which made everything blue. Using the studio flash, I took another close-up photo of the calibration target and used that photo to set a new custom white balance. The result, a normal-looking person, appears in the third photo in Figure 5-23.

Figure 5-22: Three shots lit by tungsten light. The first has a mismatched white balance setting; the other two use a custom white balance matched to the tungsten light.

If you're using a custom white balance, you need to change the white balance setting every time you change the color of the light source. (Or just switch back to one of your camera's preset white balance modes.)

Figure 5-23: Three shots lit by flash. The first has a mismatched white balance setting; the other two use a custom white balance matched to the flash.

Messing around with white balance

Occasionally, you may not want a truly neutral white balance. Some photographers, especially portrait and landscape photographers, prefer a warmer color balance so all the colors in the scene are shifted to warmer tones. To achieve this, they buy custom-made, blue-tinted cards (one source for these is warmcards.com/WC_PHOTO.html). The camera sees the blue cards and makes everything warmer. These specially made cards come in different shades of blue so you can achieve varying amounts of warmth in your images.

Fortunately, you don't need to buy a set of custom-made cards to experiment. All you really need to do is go to your local paint store and pick up the largest paint samples (on cards) you can find in several very light blue and pale yellow-amber shades. Setting a custom white balance with a cool blue paint sample warms up photos, whereas pale yellow-amber paint samples cool down photos. See for yourself in this exercise:

1. **Go to your local paint store and get large paint samples of two or three shades of pale blue and two or three shades of pale yellow-amber.**

2. **Set your camera to a daylight white balance.**

3. **Photograph something familiar in bright sunlight, like your house.**

4. **Shoot one of the pale blue cards and use that photo to set a custom white balance according to your camera's manual.**

5. **Take another photo of your familiar subject.**

6. **Photograph one of the pale yellow-amber cards and, following the instructions in your camera's manual, use that photo to set a custom white balance.**

7. **Photograph your familiar subject again.**

8. **Set a custom white balance with the other shades of blue and yellow-amber.**

Adjusting white balance for Raw files

The white balance settings of your camera are applied to your JPEG files but not your Raw files. When you create a Raw file, the camera saves all the original data your camera captured at the moment you clicked the shutter, without shifting the color balance. When you create a JPEG file, the camera throws away most of the original data and creates an interpretation of your image, which includes shifting the color balance based on your white balance settings.

As a matter of convenience, when you shoot a Raw file, the camera stores the white balance setting in the metadata for the file, but it doesn't change the original data for the photo itself. When you open a Raw file in your Raw-conversion software, you have the option of applying the white balance settings when the photo is processed, or you can change the setting of the white balance however you prefer.

If you shoot a bunch of photos in the same light, and if you include a white card or gray card in the scene, you can use your Raw-conversion software, select the white or gray card, and set the white balance for all the photos in one batch. Check your software manual for the instructions.

Dealing with High-Contrast Light

If you meter everything in a scene and the exposure difference is well beyond what your camera can capture in a single frame, you have *high-contrast lighting*. This scenario usually occurs when you have a mixture of sunlight and shade.

One very obvious way of dealing with high-contrast light is to just go with the flow. Expose for the brightly lit areas of the scene and let the rest of the areas go dark. More than one photographer has eliminated unsightly areas of a scene by waiting until those areas fell into the shadows and disappeared. I describe other approaches to dealing with high-contrast light in the next sections.

Filling in shadows with flash and reflectors

If you're photographing a small scene, such as portraits and close-ups of flowers, you can fill in the shadows in a high-contrast lighting situation with electronic flash or reflectors. If you're using *fill flash* (just enough light to fill in the shadows a bit), set the flash exposure compensation to somewhere from –½ to –2 stops. Do a little testing to see what amount of minus flash compensation you prefer (read more about this in Chapter 10). Ordinarily, you don't want the flash exposure to be as bright as the main light source because that looks unnatural. Your goal is to lighten the shadows, not eliminate them. In the photo in Figure 5-24, I used about –1 stop of flash compensation to fill in the shadows.

As for commercial reflectors, numerous kinds are available in all sorts of sizes. White reflectors provide the softest light, silver reflectors are more intense, and gold reflectors warm up the light. They collapse down to one-third of their open size. Of course, you can also make your own reflector by crumpling up some aluminum foil, opening it back out, and taping it to a piece of cardboard.

Follow these steps to get some experience working with reflectors:

28–135mm lens at 41mm, 1/250 sec., f/9, 100

Figure 5-24: A child on a playground, shot with –1 fill flash.

1. **Fashion a reflector out of aluminum foil.**

 Don't forget to crumple it up and open it before you use it.

2. **Make sure the sun's shining and go find a flower that looks interesting to photograph.**

3. **Meter the sunny side of the flower.**

4. **Shoot it from the side (without the reflector) so half of it's in the sun and half of it's in the shade.**

5. **Using the reflector this time to bounce some sunlight back onto the shady side of the flower, take the picture again with the same exposure.**

 Vary the distance from the reflector to the flower to change the intensity of the reflected light.

6. **Ask yourself which photo you prefer — the contrasty one or the one with some fill light.**

 Sometimes your preference depends on the look of the flower. When you're out in the wilderness, you should always photograph a flower from the side that provides the best background. If that means shooting a sidelit flower, you may want to use a reflector.

80–200mm lens at 200mm, around 1/4 sec., about f/16, 100

Figure 5-25: Mushrooms in low-contrast light.

If you have a scene in which the light is too soft, you can use a reflector to throw a little light back onto the subject to boost the contrast.

For example, check out the difference between Figures 5-25 and 5-26. Figure 5-25 is a photo of mushrooms in the shade on a light-dappled forest floor.

80–200mm lens at 200mm, around 1/4 sec., about f/16, 100

Figure 5-26: Mushrooms shot with a gold reflector to increase the contrast.

It's low in contrast — too low for my tastes. I made two changes before snapping the second photo: I dropped the tripod head down to the ground to get a lower angle, and I took a gold reflector and bounced some nearby sunlight back at the mushrooms to up the contrast of the light. The result is Figure 5-26.

Softening light with diffusers

Diffusers give you the ability to soften all the light hitting a subject. If you've watched any of the modeling shows on television, you've probably seen assistants holding huge diffusers to soften the sunlight on the models. A much smaller diffuser is suitable for flowers.

You can buy diffusers commercially in all kinds of sizes. I have a white umbrella that I use to diffuse light, but sometimes I bring along a diffused plastic sheet that I can use as a light tent if I need a big diffuser.

Figure 5-27 gives you an idea of how using a diffuser can alter an image. I found these flowers in bright sunlight. The scene was too contrasty, so I used my white umbrella and plastic sheet to create a light tent over the flowers.

100mm, around 1/60 sec., about f/11, 100

Figure 5-27: I used diffusers to soften the bright sunlight on these flowers.

Using graduated neutral density filters

Graduated neutral density filters, also called *split neutral density filters* or *gray grads,* have become quite popular with landscape photographers. These filters are half clear and half neutral density. They come in different strengths and are used to tame light contrast in large landscape scenes. Water reflections are a classic example. The reflection of a mountain can be 1 to 3 stops darker than the mountain, which is fine for the human eye but not for the limited contrast range of a camera. To fix the contrast, you simply position the clear part of a graduated neutral density filter in front of the lens so it lets all the darker light from the reflection through the clear part of the filter while the light from the brighter, upper part of the scene comes through the darker part of the filter, taming the contrast.

The best graduated neutral density filters fit in a holder. Within the holder, the filter can rotate and slide up and down so you can position the *gradation line* (the divider between the clear and dark portion) wherever you want it to be in the scene.

Here are a couple tricks to using graduated neutral density filters:

✔ Slide the dark part of the filter down over the center of the lens and meter the brighter part of the scene through the darker part of the filter. After you meter, position the filter so the gradation line matches where the scene goes from light to dark.

✔ Changing the f-stop changes where the gradation line appears to be in the scene, so you have to adjust for that. After you've metered and positioned the filter, push the depth of field preview button, fine-tune the position of the filter, and take the picture.

After taking the reflection picture in Figure 5-28, I realized the contrast range between the canyon wall and its reflection would be too much. So I used a 2-stop graduated gray filter for the next photo. The 2-stop reduction of light in the darker part of the scene (due to the filter) increased the length of the shutter speed by 2 stops.

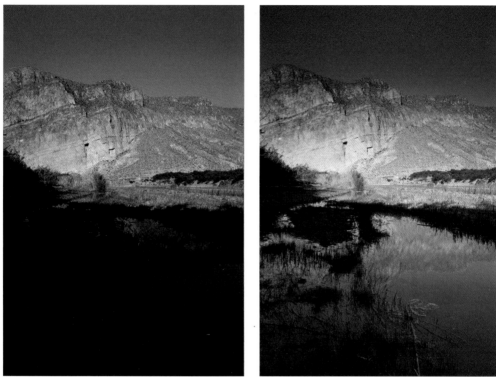

50mm, about 1/60 sec., around f/11, 50 *50mm, about 1/15 sec., around f/11, 50*

Figure 5-28: The Rio Grande River and Boquillas Canyon, shot without a filter (left) and then with a 2-stop graduated gray filter (right).

Taming contrast with HDR software

High dynamic range (HDR) software allows you to combine several exposures of the same scene. With your camera on a tripod (so all the photos line up), take several pictures of a scene with different exposures for the lighter and darker parts of the scene. The software then combines the best parts (exposures) from each photo to create your ideal image. Do an online search for "HDR photography" for more information and tons of examples. Adobe Photoshop and Photomatix Pro are two popular brands of computer software for this kind of work.

The whole process is called *High Dynamic Range photography,* or HDR for short. You can also take one Raw digital file (JPEG files usually don't have enough information) and process the same file twice, once for the highlights in the scene and once for the darker areas. Then you can layer them in almost any image-editing software to combine the best parts of each layer for one good image. You can also do the same thing by taking two different exposures of the same scene (on a tripod, of course) and then layering them in your image-editing software to use the best of each layer. (**Note:** You can use the Shadow/Highlight tool in Photoshop for a single photo of some scenes that don't have too much contrast, but this approach is less effective than double processing a Raw file.)

Waiting for the right light

A group of photographers — myself included — gathered at a lake an hour before sunset. We photographed cattails and swans in the warm light, and then we shot the sunset reflected in the lake. More time passed, and slowly the light cloud cover dissipated, allowing pale pastel light to sweep over the scene as shutters clicked. Delicate pinks were later replaced by the magical blue light of late dusk, and finally by the stars, accompanied by the click of shutters and questions about exposures when the meters could no longer see. Then the moon rose, and we shot by moonlight.

A week later, we were all gathered in a room filled with "Oh, wows!" as we shared our photos. It was a lesson in patience, but it was also about waiting for a different kind of light.

Part II
The Art of Exposure

In this part . . .

Often, you'll find yourself in situations where half a dozen combinations of camera settings all give you exactly the same exposure, but each combination gives you a different look for your image. You get to choose the combination that will give you the look you want — that's the true beauty of exposure. It's also where the art of exposure comes into play.

The chapters in Part II show you how to use apertures, shutters speeds, and ISO settings to dramatically change the look of your images. You can experiment with the art of exposure as you try out the exercises included in each chapter. Prepare to discover how to use your exposure choices to create memorable images.

6

Changing the Look of Your Images: Apertures and Depth of Field

In This Chapter

▷ Discovering how and why aperture has such an effect on the sharpness of your images

▷ Getting the depth of field you want with a little help from the "Big Three"

▷ Recognizing the role camera formats and sensor size play

▷ Viewing depth of field *before* you click the shutter

*B*y controlling the *depth of field* (the amount of near-to-far sharpness) in an image, you can dramatically change the look of your images. A photo in which everything appears sharp from right in front of the camera to the distant horizon has a lot of depth of field. A photo in which the subject appears sharp but everything in front of and behind the subject seems soft and blurry has very little depth of field.

One of the primary ways in which you determine the depth of field is by adjusting your camera's *aperture,* the opening that controls the amount of light coming through the lens. Other key factors affecting depth of field are the focal length of the lens, the *focused distance* (the distance from the camera to the focused subject), the size of the digital sensor in the camera, and the size of the print you make from your digital file. In this chapter, you get to explore all the creative tools that determine depth of field. You also get a chance to grab your camera and experiment with depth of field for yourself.

You can't make the best creative choices in terms of apertures and shutter speeds if long shutter speeds aren't an option. That means you need some kind of steady camera support. Although beanbags and wadded-up sweaters are good in a pinch, sometimes there's really no substitute for a good-quality tripod. (Case in point: Several of the photos in this chapter would've been impossible to capture without a tripod.) If you don't already have a decent tripod, turn to Chapter 18 for tips on purchasing one.

Depth of Field Examples

Have you ever admired a photo of a single flower standing out in bold relief against a soft, gauzy sea of blurry color? The photographer made the artistic decision to minimize depth of field to put the emphasis on the flower. For my photo of shooting star blossoms (see Figure 6-1), I used a longer focal length lens and got very close to the flowers to minimize the depth of field.

100mm, 1/4 sec., f/11, 100

Figure 6-1: Shooting star blossoms, with minimal depth of field thanks to a longer lens and close shooting distance.

Have you looked at a landscape photo and wondered how the photographer got everything sharp, from the nearby flowers all the way to the distant mountains? The photographer made the artistic decision to maximize depth of field. In Figure 6-2's photo of White Sands, New Mexico, at sunset, I used a wide-angle lens and a small aperture to maximize the depth of field.

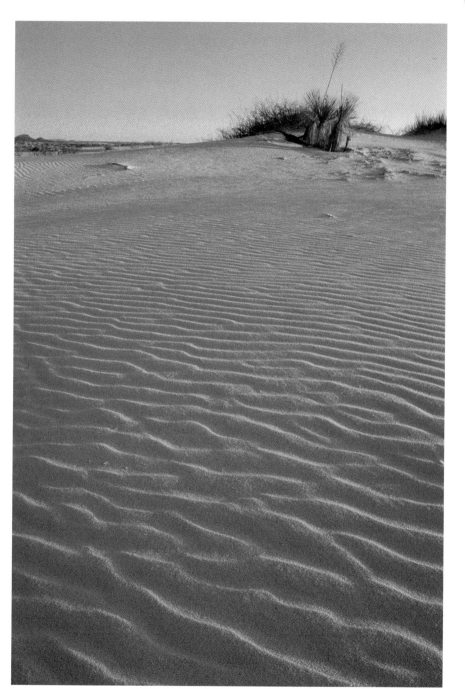

24mm, about 1 sec., f/22, 50

Figure 6-2: White Sands at sunset, with maximum depth of field thanks to the small aperture and a wide-angle lens.

Exploring Aperture's Effect on Depth of Field

The aperture is the opening in a lens that lets in the light. Most lenses have an *iris diaphragm* that consists of several aperture blades that close down to create different-sized aperture openings. You can see what I mean by this in Figure 6-3, which shows a 50mm lens at f/8.

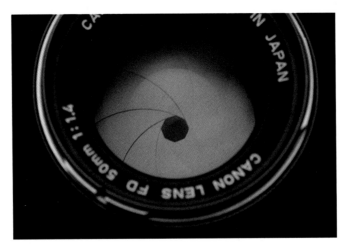

Figure 6-3: A 50mm lens with the aperture blades stopped down to f/8.

When a lens is *wide open* (at its widest aperture), the aperture blades are completely out of the way. When you select smaller apertures, the blades close down to create smaller openings. You can see a typical series of aperture settings, along with the aperture blades, in Figure 6-4.

Moving from larger apertures to smaller apertures is called *stopping down*. Changing from smaller apertures to larger apertures is called *opening up*. Both phrases reference what the aperture blades are doing.

You need to have a solid grasp of the basics of aperture settings in order to fully understand depth of field and the effect it can have on your images. Have no fear! In the following sections, I reveal the details behind why the right aperture setting creates the depth of field you want. I also introduce you to aperture-related terminology and arm you with exercises so you can play around with different aperture settings.

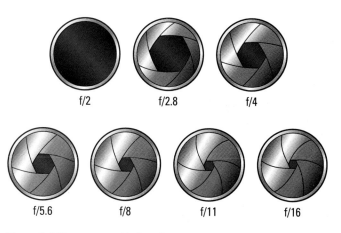

Figure 6-4: The aperture blades allow less light into the lens when you select a smaller aperture.

Clarifying the relationship between circles of confusion and aperture settings

Variations in depth of field are made possible by the laws of optics: When a subject is in focus, light passes through the camera's lens and strikes the digital sensor as millions of microscopic circles of light. Consequently, you can think of a photo as a mosaic made up of millions of microscopic circles of light known as *circles of confusion.* You may not hear circles of confusion discussed in many circles — pun intended — but if you really want to be able to control and maximize depth of field, you must understand how circles of confusion affect your images.

When a subject is significantly out of focus, the circles of light that strike the digital sensor are much larger, spilling all over each other and creating a blurry, out-of-focus image. On the other hand, if a subject is only slightly out of focus, the circles of confusion, although bigger than the in-focus circles, are still small enough that the subject continues to look sharp and in focus.

The choices you make that keep the circles of confusion small maximize the depth of field in your images. Anything you do to magnify the circles of confusion minimizes the depth of field in your photos.

Aperture size, lens focal length, and subject distance all work together to determine the size of the circles of confusion. If the lens focal length and focused distance don't change, smaller apertures create smaller circles of confusion and more depth of field. Large apertures result in larger circles of confusion and less depth of field. However, all three factors influence each

other. If you switch to a smaller aperture but zoom your lens to a much longer focal length, the circles of confusion could end up being larger rather than smaller. (I fill you in on the specifics in the later "Controlling Depth of Field with the 'Big Three' Variables" section.) When I captured the image in Figure 6-5 of aspen leaves on a wooded road, I used a very-wide-angle lens and a very small f-stop in order to keep the circles of confusion small so I could maximize my depth of field (which in this scene is from 12 inches in front of the camera to infinity).

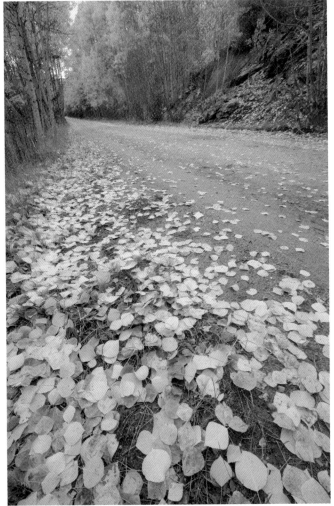

10–22mm lens at 10mm, 1/8 sec., f/22, 100

Figure 6-5: This photo of Marshall Pass Road in Colorado has a lot of depth of field because it has millions of very tiny circles of confusion.

Nowhere is the effect of circles of confusion more obvious than in different-sized prints. As you make prints of your images, remember that the bigger the print, the more those circles of confusion are enlarged. That's why a photo can look great printed at a small size and blurry in a big print. If you want big prints, you have to keep the circles of confusion that hit your camera's digital sensor much smaller than the person who rarely wants anything bigger than a 5-x-7 print. I explain how to do this in Chapter 7.

Speaking the language of aperture size and lens speed

Aperture size is measured in *f-stops* (sometimes called *f-ratios*), the ratio of the lens opening (also known as the *aperture diameter*) to the focal length of the lens. If the lens opening is 30 millimeters and the focal length is 60 millimeters, the ratio is 30/60 (the same as 1/2), so the f-stop is written as f/2. Large apertures, such as f/2.8 and f/4, let in a flood of light, whereas small apertures, such as f/16 and f/22, let in a trickle of light. Just remember that f-stops are fractions, so f/4 = ¼. The next sections compare the different lens speeds and types of apertures.

Fast versus slow lenses

The *speed* of a lens is determined by its maximum aperture. Lenses with wide maximum apertures are called "fast," and lenses with smaller maximum apertures are "slow." Lens speed is also relative to the type of lens. For example, many zoom lenses have a maximum aperture of f/4, so a zoom lens with a maximum aperture of f/2.8 is a fast lens, whereas a zoom lens with a maximum aperture of f/5.6 is a slow lens. On the other hand, f/1.8 is a pretty standard maximum aperture for a single focal length 50mm lens, so a 50mm f/1.4 lens would be fast, and a 50mm f/2.8 lens would be slow.

Fast lenses have a wealth of advantages. Specifically, they

✔ Let in more light, making it easier to focus manually.

✔ Autofocus better in low light. (Really slow lenses, ones with an aperture of f/5.6 or f/8, make it hard for a camera to autofocus in low light.)

✔ Have more exposure options.

✔ Have more creative options with wider apertures, which means they can minimize depth of field better than slower lenses.

Yet fast lenses also have some disadvantages. Namely, they're bigger, heavier, and *much* more expensive than their slower counterparts.

Slower lenses are just the opposite: They're small, lighter, and less expensive. However, because they have smaller apertures and let in less light, they're

harder to focus manually in low light, they make it harder for the camera to autofocus in low light, and they give you fewer aperture choices so you can't minimize depth of field as effectively as you can with a faster lens.

It may not be worthwhile to spend megabucks on a fast f/2.8 zoom lens, but it *is* often worthwhile to choose an f/4 lens over a slower f/5.6 lens, especially if you like to shoot in low-ambient-light conditions. Given a choice among three lenses with maximum apertures of f/2.8, f/4, and f/5.6, most photographers would choose the f/4 lens because it represents the best quality for the price.

In Figure 6-6, the photographer focused the lens on the person in both "photos." The difference is in the aperture chosen. In the upper example, the photographer used a wide aperture (f/4) so the zone of sharpness includes the person, but the flower in front of the person and the distant mountains are blurry and out of focus. In the lower example, the photographer used a small aperture (f/16) so the flower and mountains are included in the zone of sharpness.

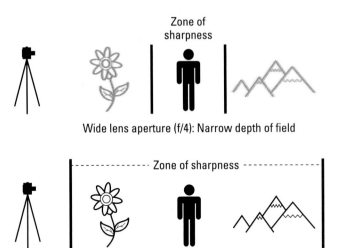

Wide lens aperture (f/4): Narrow depth of field

Small lens aperture (f/16): Wide depth of field

Figure 6-6: A small depth of field (f/4) versus a larger depth of field (f/16).

If you're buying a new lens and have several options from which to choose, keep in mind that lenses with more aperture blades usually have smoother out-of-focus backgrounds when depth of field is minimal. So a lens with eight blades is usually better than a lens with five blades.

Constant versus variable aperture zoom lenses

Constant-aperture lenses have the same maximum aperture at every focal length, which means your exposure doesn't change as you zoom from one

focal length to another. *Variable-aperture lenses,* on the other hand, change the maximum aperture as you change the focal length. With one of these lenses, you may start at f/4 at one focal length, but as you zoom to a longer focal length, the maximum aperture may change to f/5.6 or slower, causing you to lose up to a stop and a half of light.

You may prefer a variable-aperture lens if

- ✔ Size and weight are an important consideration.
- ✔ You usually shoot in bright light.
- ✔ Cost is a major consideration.

Choose a constant-aperture lens if you

- ✔ Shoot often in low light.
- ✔ Don't mind the extra size, weight, and cost.
- ✔ Do a lot of shooting in manual-exposure mode.

Variable-aperture lenses are smaller, lighter, and less expensive than their constant-aperture counterparts. These advantages may outweigh the disadvantages of having a lens that's slower at longer focal lengths, but you still need to pay attention to what's going on with your exposures and artistic choices. Going from f/4 to f/6.3 can change the look of your image and force you into a shutter speed that may be too slow for a moving subject.

Experimenting with lens apertures

If you're ready to start playing around with different aperture sizes, you're going to love this exercise. Just do me a favor and suspend your disbelief for a little while because you're about to shrink down to microscopic size. Your neighbor's yard light will be a microscopic beam of light, and your camera sensor will be so small that it can't be seen by the unaided human eye.

About 30 minutes after sunset, take a series of photos of one of your neighbor's yard lights or porch lights. But first, you should probably make sure that's okay with your neighbor (unless of course you want to take pictures of the police when they show up). After that's out of the way, go ahead and follow these steps to see what a small lens aperture can do to an out-of-focus beam of light:

1. **Pick a small yard or porch light that's located about 100 feet away (about two or three houses down from yours).**

 This light is going to be your simulated point light source.

2. **Choose the right lens.**

If you have a choice of lenses, pick one with a telephoto focal length in the 100 to 150mm range. If you have just one lens, use the longest focal length on your lens.

3. Set up a tripod or some other kind of steady camera support for the long shutter speeds.

If you don't have a tripod, place a beanbag or a wadded-up sweater on the hood of your car.

4. Wait for the right light.

Take your pictures about 30 minutes after sunset. You want it to be dark enough so the yard or porch light stands out from the background, but you still want to be able to see the background.

5. Put your camera in manual mode (M).

6. Begin with the widest aperture setting on your lens.

This setting will probably be f/2.8 or f/4 (or maybe even f/5.6).

7. Meter the background around the light and set your shutter speed to a half-stop less than the meter indicates.

Be careful not to meter the light itself. If you do, the photo will be under-exposed, and you won't be able to see the background.

8. Focus on the yard or porch light and take one picture.

9. With the camera still pointed at the light, manually focus the lens to its closest focus distance.

The closest focus distance with your average telephoto lens is usually around 2 to 4 feet. At this point, the light should now be a large round blur in your viewfinder.

10. Take another picture.

11. Leave the lens at its closest focus setting; don't change the focal length, but do change the lens aperture to its smallest setting.

The smallest setting is usually f/16, f/22, or f/32.

12. Change the shutter speed so you'll have an equivalent exposure.

The yard light will still be a big, round, out-of-focus blur in the viewfinder. That's okay. (Not sure what an equivalent exposure is? Flip to Chapter 2 for the scoop.)

13. Take another picture.

If you follow this process step by step, your photos should look something like the ones in Figures 6-7, 6-8, and 6-9. Figures 6-7 and 6-8 are just what you'd expect to see: a sharply focused beam of light and a huge circle of confusion from the out-of-focus beam of light. The pleasant surprise is Figure 6-9.

The small aperture has narrowed the beam of light so that the yard light, although not sharp, is at least recognizable. In this pretend microscopic world, this is how a small aperture creates a small circle of confusion from an out-of-focus beam of light.

Note: When you took the third picture, the light looked big and round in the viewfinder just before you clicked the shutter, but in the actual photo it was small. Why? Because your camera has an automatic lens diaphragm that closes down to the selected aperture while your viewfinder goes dark.

Figure 6-7: Yard light in focus, f/4.

The star effect in Figure 6-9 is created by light rays bending around the angles where the aperture blades meet. Whenever you have small light sources, you can intentionally create this effect by using very small apertures.

Figure 6-8: Yard light totally out of focus, f/4.

Controlling Depth of Field with the "Big Three" Variables

When you grab your camera and head out to take pictures, three variables determine the depth of field in your photos: aperture, focal length, and focused distance. If you adjust any one of these variables without adjusting the other two, your depth of field will change. If you play with two or more of these variables, the depth of field may change even more dramatically; then again, it may not change at all.

Figure 6-9: Yard light still totally out of focus, f/32.

The "Big Three" variables always work in relationship to each other, and sometimes those relationships are complicated. The following sections explore each of the "Big Three" variables and how to use them to achieve creative results with your images, but the information I share is merely a guideline to get you started. The more you experiment with adjusting aperture, focal length, and focused distance, the better you'll be able to adjust depth of field to suit your needs. (I show you more specific ways to control depth of field in Chapter 7.)

Adjusting apertures

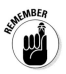

Changing the aperture can make a huge difference in the look of a photo. *If the focal length and the focused distance stay the same, depth of field increases with small apertures (think f/16 and f/22) and decreases with big apertures (think f/2.8 and f/4).* To see what I mean, compare the two trumpet photos in Figures 6-10 and 6-11. In Figure 6-10, the aperture was set to f/4 to minimize depth of field; in Figure 6-11, it was set to f/32 to maximize depth of field.

When you take pictures, you can use apertures to minimize depth of field, maximize depth of field, or keep it anywhere in between. The more you experiment with different apertures, the better you'll get at anticipating the results.

With short telephoto to wide-angle lenses, changing the aperture can dramatically affect the depth of field. If you're shooting landscapes and want a lot of near-to-far depth of field (from near the camera to far away), use a smaller aperture (anywhere from f/11 to f/22) and a wide-angle lens with a shorter focal length. As an example, if you have a 28mm wide-angle lens focused at 10 feet and an aperture of f/22, the depth of field ranges from 3 feet to infinity. If you change the aperture to f/4, the depth of field is only 7 feet to 15 feet.

To further see how smaller apertures maximize depth of field, grab your camera and follow these steps:

1. **Choose a wide-angle lens.**

 If you have only one lens, set it to its widest focal length.

2. **Go outside, focus on something that's 3 feet from the camera, and then turn off the autofocus feature.**

3. **Frame your photo so that you see your subject (which is 3 feet away) as well as something that's 20 to 30 feet away.**

4. **Take pictures at the f/4, f/8, and f/16 apertures.**

 You should see a dramatic jump in the depth of field from f/4 to f/8 and from f/8 to f/16.

70–200mm lens at 155mm, 1/25 sec., f/4, 100

Figure 6-10: This trumpet has very little depth of field thanks to the wide lens aperture.

70–200mm lens at 155mm, 2.6 sec., f/32, 100

Figure 6-11: This trumpet has a lot of depth of field complements of the small lens aperture.

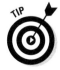

If you're photographing a subject and you want to show a sense of place without the background being sharp, use a normal focal length lens and an aperture of f/4 or f/5.6. With, say, a 50mm lens focused at 10 feet and an aperture of f/4, the depth of field will range from 9 feet to 11 feet, making the background blurry but still quite recognizable. Remember that the smaller the aperture, the sharper the background will be, so experiment with smaller and larger apertures until you find the combination that gives you the right amount of contrast between sharpness and blurriness.

Playing with focal lengths

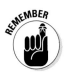

If the focused distance and the aperture stay the same, lenses with shorter focal lengths have more depth of field, and lenses with longer focal lengths have less depth of field. This is because the magnification of longer focal length lenses (think bigger circles of confusion; see the earlier related section) results in less depth of field. Shorter focal lengths mean less magnification (smaller circles of confusion) and more depth of field. The focal length of a lens also determines its field of view. Short focal length, wide-angle lenses have a wide field of view, whereas long focal length, telephoto lenses (which work like a telescope) have a narrow angle of view. At the same focused distance, the difference in field of view is what creates the difference in magnification. Changing the focal length can have a big effect on your pictures. For example, you can place the front of your lens just 1 foot from a group of flowers, keep the same aperture setting, and still end up with radically different photos just by changing the focal length.

You can see for yourself the difference that focal length makes in Figures 6-12 and 6-13. The aperture in both photos is f/16, and in both photos the lens was positioned about 12 inches from the nearest flower. In the poppies photo (Figure 6-12), the depth of field is from 1 foot to infinity, but the closest flower still looks pretty good. In the hibiscus photo (Figure 6-13), the depth of field is less than 1 inch. The only difference is the focal length, which was 15mm for the poppies and 100mm for the hibiscus.

The sections that follow offer suggestions on working with different focal lengths. They also present an exercise you can try to help you explore the relationship between focal length and aperture and its effect on depth of field.

15mm, 1/30 sec., f/16, 50

Figure 6-12: California poppies shot with a short focal length lens have a huge amount of depth of field.

100mm macro lens, 1 sec., f/16, 100

Figure 6-13: A hibiscus flower photographed with a long focal length lens has a much smaller depth of field.

Trying out short focal lengths

The following list gives you some ideas of how to use short focal lengths when you're experimenting with depth of field and trying to capture

- **Landscapes:** Short focal length lenses really shine when combined with small apertures to create amazing depth of field in landscape photos.

- **Architecture:** Short focal lengths and small apertures also work well in architectural photography when you need sweeping interior views with lots of depth of field.

- **Sports:** Short focal lengths are great for getting right in the middle of things in sports. Use your widest lens and shoot from the ground up in the middle of the pregame huddle. If you're up in the cheap seats at your favorite stadium, you can get one of those sweeping wide-angle shots of the whole stadium. Just use your widest lens and a small aperture so you can take it all in.

- **Events from the ground level up:** Wide-angle (short focal length) lenses are great for shooting events from the ground level, and I do mean ground. When I started learning my craft, I was shooting some colorfully dressed dancers at a Czech festival. As they swirled by, the newspaper photographer sitting next to me put his camera on the ground, inched out toward the dancers, and shot up at an angle. Great idea, I thought, so I did the same thing and ended up with a photo dominated by colorful swirling skirts and lots of depth of field.

Looking at long focal lengths

The following tips can help you achieve your desired depth-of-field results when working with long focal lengths:

- **When you want to isolate a subject from its background, use a telephoto (long focal length) lens.** If you're doing head-and-shoulders portraits with a short telephoto lens (80mm–100mm) and you want to soften the background, use a wide to medium aperture (f/4 to f/8).

- **When you want to really blur the background, use a longer telephoto lens (150mm–200mm) and pick the right aperture.** Use wide apertures like f/4 to blur the background. If you have a fast lens, see the earlier "Fast versus slow lenses" section, use f/2.8.

Note: When using telephoto lenses at 400 mm, the rules change. The usual advice to use wide apertures to isolate the subject may give you too *little* depth of field. A 400mm lens focused at 10 feet with an aperture of f/5.6 will have a total depth of field of about ½ inch, which isn't very much to work with when you have a three-dimensional subject. When I shoot at 400mm at close distances, I go back to f/8 or f/11, even when minimizing the depth of field.

Figure 6-14 shows a golden-mantled ground squirrel on a rocky outcrop in the Rocky Mountains. My lens was positioned at 400mm, focused around 10 feet, and had an aperture of f/11, making the total depth of field less than ¾ inch. As a result, the squirrel's eye is in focus, but its far ear isn't.

If you look at the rocks in Figure 6-14, you can quickly see how objects become blurry when you have such limited depth of field. At a 24mm focal length, the change in the image from sharp to slightly sharp to slightly blurred to blurred is very gradual. At 400mm, the change from sharp to blurry is very abrupt.

100–400mm lens at 400mm, 1/250 sec., f/11, 100

Figure 6-14: A ground squirrel photographed with very little depth of field.

The 400mm lens was on a cropped-frame digital camera, giving it the equivalent field of view of a 640mm lens on a full-frame digital camera.

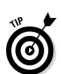

Experimenting with focal length and aperture

Follow these steps to explore the relationship between different apertures and focal lengths (note that the aperture used for each photo should be stored in the metadata for each file):

1. **Line up ten plastic cups in a straight line in your driveway, each about 2 feet apart.**

2. **Put your camera about 2 feet from the cup that's closest to your garage door.**

3. **Choose a short focal length lens.**

 If you have more than one lens, put your widest-angle lens on your camera. If you have one lens, use the widest focal length on your lens.

4. **Focus on the third cup, which should be about 6 feet from the camera, and frame the scene so you can see all ten cups plus something much farther away.**

5. **Put your camera in aperture-priority mode (Av).**

6. **Take a picture with the widest aperture on the lens (around f/2.8 or f/4), another photo at f/8, and a third one at the smallest aperture (around f/16 or f/22).**

7. **Compare the photos to get an idea of what happens at that focal length with different apertures.**

After you've tried this exercise with a short focal length lens, repeat it using first a normal focal length lens (if you have only one lens, use a focal length that's in the middle of the range) and then a short telephoto lens (use the longest focal length if you have just one lens).

Focal lengths and your camera sensor

The focal length of a lens determines its field of view, but even with the same lens, the field of view can change with the sensor size of a digital SLR. A 50mm lens is a normal (not long or short) focal length for a full-frame digital SLR camera. But the same 50mm lens becomes a short telephoto focal length for a cropped-frame digital SLR, and it becomes a long telephoto for a digital fixed-lens (point-and-shoot) camera.

A *normal focal length lens* is often defined as one that has a focal length that's approximately the same as the diagonal measurement of the digital sensor frame. For more information on focal lengths and the differences between full-frame digital cameras and cropped-sensor digital cameras, go to JimDoty.com, click the Search link, and search for "focal length" and "FOV crop."

No matter which focal length you use, small apertures give you more depth of field. With a wide-angle lens and a small aperture, all the cups (as well as whatever's in the distant background) should look sharp. With a normal focal length lens focused at 6 feet (the distance to the third cup) and at the smallest aperture, some of the cups should be sharp, and some should be a little blurry. The depth of field is most limited at the longer focal length, especially at the widest aperture.

The more you practice, the more intuitive and instinctive matching aperture to focal length becomes, so keep experimenting.

Changing the focused distance

With the same focal length and the same aperture, depth of field increases as the focused distance increases. So when you're, say, 8 feet from your focused subject, you have more depth of field than when you're 4 feet from it.

The two aspen photos shown in Figures 6-15 and 6-16 were taken on the same day, with the same camera and lens, about 200 yards apart. Both were photographed at an aperture of around f/22 to maximize depth of field. The only difference (other than the subject) was the distance at which the lens was focused.

The camera was only a couple feet from the dew-covered aspen leaves in Figure 6-15, but even at f/22, the total depth of field was only a few inches. The point of focus was on the leading edges of the leaves, so the leaves in the back are going out of focus.

80–200mm lens at around 80mm, 1/30 sec., f/22, 64

Figure 6-15: Dew-covered aspen leaves shot from a few feet away.

In Figure 6-16, I set up my tripod so that the evergreens in the foreground would frame the aspen in the middle ground and the mountains in the background. I wanted all three subjects to look sharp. The foreground trees were about 40 feet away, so I used the depth of field scale on my lens, which indicated I could keep everything in focus at an aperture of f/16 and a focal length of 80mm. I focused on the aspen grove, set the aperture at f/22 for a little extra depth-of-field insurance, set the shutter speed around 1/30 of a second, and took lots of photos. The depth of field was from 30 feet to infinity.

80–200mm lens at 80mm, 1/30 sec., f/22, 64

Figure 6-16: A photo of an aspen grove, taken from a distance of 40 feet.

Here are some ways you can play with depth of field by changing your focused distance:

✔ **Alter your distance to your subject.** Minimize depth of field by getting close to your subject, and maximize it by backing away from your subject. For example, if I see a beautiful flower but the background is less than appealing, I move in really close and use a longer focal length lens and a wide aperture to blur the background.

✔ **Use smaller apertures to maximize depth of field when you need to get really close to a subject.** Using smaller apertures allows you to fight for every last bit of depth of field that you can manage.

Putting all three together

To get the most out of depth of field requires experimenting with changes in aperture, focal length, and the focused distance, so let experience be your teacher. Start with these suggestions and go have fun capturing your very own images:

✔ **To minimize depth of field, use wide apertures and longer focal lengths and move in closer to your subjects.** Also, try to avoid having distracting objects right behind your subject. A blurry tree or fencepost growing out of the subject is the kind of thing photographers tend to miss while they're totally focused on their subject but kick themselves for when they look at the photos later.

If there's a lot of distance between your subject and the background, the subject will pop out more against the blurry background.

✔ **To maximize depth of field, use smaller apertures and wide-angle lenses and back up a bit from your subject.** How far back you need to get depends on the lens you're using and the aperture you choose. Inexperienced photographers are prone to have boring foregrounds in their wide-angle, maximum depth of field photos. To avoid this, have a "center of interest" close to the camera, even if it isn't your main subject. It could be flowers, a cactus, a spot between the rails of a railroad track, or a yellow stripe in the highway. Whatever it is, put the camera down low and get in close. The center of interest will draw the viewer's eye into the rest of the frame.

✔ **When you need a medium amount of depth of field, stick with midrange apertures.** For wide-angle to normal focal length lenses, use apertures of f/5.6 or f/8. At longer focal lengths, switch to an aperture of f/11 or f/16.

Camera Formats, Sensor Size, and Depth of Field

Cameras come in all kinds of sizes, from the large-format kind that take 8-x-10-inch sheet film to the *digital fixed-lens* (point-and-shoot) cameras with tiny ¼-inch sensors. The sensor in a digital camera is the "film" that captures the image, and the size of the sensor makes a big difference in the depth of field. Cameras with a larger sensor have the advantage when it comes to minimizing depth of field, whereas those with a smaller sensor have the advantage when it comes to maximizing depth of field. In fact, with the same angle of view and the same aperture, smaller-format cameras have more depth of field than their larger counterparts.

Here's an example: Three photographers are taking pictures of their families at Rocky Mountain National Park. One has a 35mm lens on a full-frame digital SLR, the second has a 22mm lens on a 1.6x field-of-view-crop digital SLR, and the third has a 6mm lens on a digital point-and-shoot camera. All three lenses provide the same field of view. If all three lenses are set to an aperture of f/4 and are focused at a distance of 10 feet, the depth of field for each camera and lens is as follows:

✔ Full-frame digital SLR: 8 feet to 13 feet

✔ Cropped-frame digital SLR: 7 feet to 16 feet

✔ Digital point-and-shoot camera: 4 feet to infinity

The families will all look sharp, but at f/4, the mountains in the background will only look sharp in the photo taken with the point-and-shoot camera. To get the same type of image, the other two photographers need to *stop down* their lenses, that is, use a smaller aperture to have enough depth of field for the mountains to look sharp. For the full-frame digital SLR, that means an aperture of f/18, and for the cropped-frame digital SLR, that means an aperture of f/13. The lesson here? Digital SLR photographers have to deliberately choose a small aperture in order to get enough depth of field, whereas point-and-shoot users can get lots of depth of field without even thinking about it.

But what the small format giveth, it also taketh away. Minimizing depth of field in order to isolate a subject is very difficult when you're using a tiny format point-and-shoot digital camera because of the increased depth of field that's inherent in the format. Digital SLR users, on the other hand, can isolate subjects pretty easily with minimal depth of field thanks to the laws of optics that allow digital SLRs to have less depth of field than the smaller formats. Just use long focal lengths, get close to your subject, and use wide lens apertures. Larger-format cameras also have a big advantage when it comes time to make big, high-quality prints.

When I was taking the photo featured in Figure 6-17, I was losing light rapidly and needed enough depth of field to capture the cactus 10 feet above me on the ridge and the moon at infinity. A 24mm lens at an aperture of f/8 gave me enough depth of field. In the low light, the shutter speed was around 30 seconds. I knew what aperture and lens I needed to use to get enough depth of field by using the depth of field preview button (see the next section) and by checking a hyperfocal distance chart (see Chapter 7).

"Seeing" Depth of Field Before You Click the Shutter

Modern lenses have automatic diaphragms, which means no matter what aperture you select, the aperture blades stay wide open until the moment you click the shutter. This feature makes it much easier to see through the viewfinder and focus.

The problem with automatic lens diaphragms is that when you look through the viewfinder of a camera, the lens is wide open, which means you see exactly what your picture will look like if you take it with the lens at its widest aperture. But what if you want to see what your photo will look like with the lens stopped down? The following sections share two ways to preview what your picture will end up looking like with whatever aperture you select.

Using the depth of field preview button

Depth of field preview is, in my opinion, an essential camera feature; in fact, I use it whenever my camera is on a tripod. If your camera has a depth of field preview button (check your camera's manual to see whether yours does), use it. Choose an f-stop, push the depth of field preview button and look through the viewfinder. Now you can see what your photo will look like when the lens is stopped down to your chosen aperture. If the depth of field is too shallow or too deep, just change the aperture setting.

When you preview depth of field, everything looks darker thanks to the stopped-down lens. You can see better if you take a tip from large-format landscape photographers and pull a dark cloth, coat, or sweater over your head to block out the outside light (after giving your eyes a little time to adapt to the dark, of course).

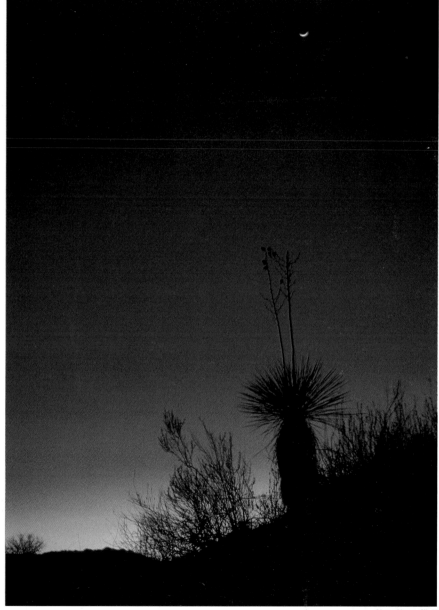

24mm, 30 sec., f/8, 50

Figure 6-17: A wide-angle lens and a medium aperture provided plenty of depth of field in this nighttime photo.

The depth of field preview button really comes into its own when you're isolating a subject with wide to medium apertures. All you have to do is focus on your subject, push the button, turn the aperture dial back and forth from f/4 to f/8 (or to f/11 if you're working with a really long lens), watch both your subject and the background as you change the aperture settings, and pick the aperture that gives you the best combination of a sharp subject with a soft background.

Even though depth of field preview gives you a good idea of what you're going to get, you can still be surprised. The viewfinder image is pretty small compared to an 8-x-10-inch print, so a sharp-looking image in the viewfinder can look a little soft in a print. It's always wise to double-check your focal length and aperture decisions with one of the methods I describe in Chapter 7.

Enabling live view

Some recent digital SLRs have a *live view* feature. If you turn it on and then press the depth of field preview button, you can check out the depth of field on the LCD screen. If you're lucky, your camera model will lighten the image it sends to the LCD screen so you can see the depth of field without having to put up with a really dark view.

The live view feature is especially useful when you want to achieve precise manual focus with nonmoving subjects when your camera is on a tripod. Just enable it, magnify the image on the LCD screen, and manually focus the lens. (Note that when it comes to moving subjects, *predictive autofocus,* a camera feature that tracks a moving subject, wins hands down over live view.)

7

Taking a Deeper Look at Depth of Field

*I*n Chapter 6, I introduce you to the concept of depth of field and show you the basics of achieving the amount of depth of field you want. In this chapter, you get to explore four ways to control depth of field with greater precision. This chapter is for you if you love photos with tons of depth of field, such as the big, sharp, crystal-clear landscape photos of world-class photographer David Muench. I have one of his prints hanging on my wall that shows a luscious Colorado landscape with amazing depth of field. (You can see some of Muench's work for yourself at www. muenchphotography.com.)

Of course, sometimes less depth of field is more. With the tools I present in this chapter, you can choose to have as much or as little depth of field as you want. I end this chapter by providing some insight into how to adjust your aperture settings when depth of field isn't a consideration.

Trying a Depth of Field Calculator

A *depth of field calculator* is a handy tool that tells you the depth of field for a given situation after you plug in the f-stop, focal length, focused distance, and camera format. All depth of field calculators are based on a variety of mathematical formulas that are related to *circles of confusion* (the millions of tiny, microscopic circles of light that make up a photo; see Chapter 6 for more info). The best depth of field calculators let you plug in your own circle of confusion values for the camera you're using and the print size you want to make. Following is a list of the different types of depth of field calculators you can use:

- ✔ **Online versions:** These are very useful at home for getting an idea of how depth of field works. You can try out your favorite focal lengths and apertures and make notes to carry with you when you head out to take pictures. One of the best online calculators is available at www.dofmaster.com/dofjs.html.

- ✔ **Manual versions:** These look like flat, plastic, circular slide rules, and they work very much like the depth of field scale found on a lens (see the later "Understanding Depth of Field Scales" section for the scoop on this). You can buy a commercial depth of field calculator such as the ExpoAperture at www.expoimaging.com. Or you can download the Windows software to make your own at this site: www.dofmaster.com/custom.html.

- ✔ **Smartphone versions:** These are available for a variety of smartphones, including the iPhone. My favorite is the Simple DoF Calculator by Dennis van den Berg. You can also download depth of field software for devices that run the Palm operating system; just head to www.dofmaster.com/custom3.html.

After you have a depth of field calculator, set the circle of confusion (CoC) value for the camera format you're using. You can choose your camera by brand and model, or you can set your own values. Just be sure to pick the right CoC for your camera; if you don't, you won't get the right results.

When I use a depth of field calculator, I use CoC values that are calculated for making prints up to 11 x 16 inches in size for whatever camera format I happen to be using. Here are the values I use and recommend:

- ✔ CoC = 0.023mm for a full-frame digital SLR (24-x-36mm sensor)

- ✔ CoC = 0.018mm for a 1.3x field-of-view-crop digital SLR

- ✔ CoC = 0.014mm for a 1.6x or 1.5x field-of-view-crop digital SLR (15-x-23mm sensor)

- ✔ CoC = 0.012mm for a 2x field-of-view-crop digital SLR

- ✔ CoC = 0.004mm for a fixed-lens, point-and-shoot digital camera (4.31-x-5.75mm sensor)

Understanding Depth of Field Scales

The *depth of field scale* on a lens shows you the depth of field for a given aperture and the focused distance for that lens. Check out Figures 7-1 and 7-2 to see depth of field scales on a 50mm lens and a 24mm lens, respectively. These scales are going the way of the dinosaurs on zoom lenses, but they're still provided on the best *prime* (meaning single focal length) wide-angle lenses. If you happen to have a lens that's equipped with one, consider yourself blessed because they make determining depth of field very quick and simple to do.

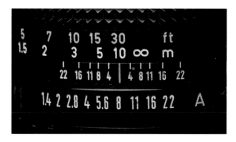

Figure 7-1: Depth of field scale on a 50mm lens.

Figure 7-2: Depth of field scale on a 24mm lens.

Here's how to read a depth of field scale:

✔ The bottom row of numbers lists the aperture settings. (Most recent lenses don't have this row of numbers because the aperture is set by the camera and not on the lens.)

✔ The number directly below the orange index mark is the aperture that's currently in use.

✔ The pairs of numbers on either side of the index mark indicate the depth of field for each aperture when you look at the distance scales just above them (green is for feet; white is for meters).

✔ The number above the orange index mark is the focused distance.

After you know what all the parts represent, you're ready to put all that information together to figure out the depth of field at a particular aperture setting and focused distance. Try it out with Figure 7-1. This 50mm lens is focused at 30 feet, and the aperture in use is f/8. Both of these settings are opposite the index mark. When you look to either side of the index mark, you find a pair of 8s (which stand for f/8). You can read the distances just above the 8s to determine the depth of field. To the left, you read 15 feet; to the right, you read infinity. Put all that together, and you discover that with the aperture set to f/8 and the lens focused at 30 feet, the depth of field is from 15 feet to infinity.

With the 24mm lens (refer to Figure 7-2), the focused distance is between 4 and 5 feet, and the aperture in use is f/16. If you look at the distance scale above the pair of 16s, you can see that the depth of field is a little less than 2.5 feet to infinity.

Most lenses (like the ones in Figures 7-1 and 7-2) omit some of the f-stops on the depth of field scale to avoid overcrowding, but you can estimate where they should be based on the aperture series I present in Chapter 2. If, for example, your depth of field scale shows nothing between f/4 and f/8, you can look to the aperture series to know that the missing aperture is f/5.6.

The following sections explain how to use a depth of field scale to achieve the depth of field you want and how to tweak what the scale says if the recommended aperture can't give you your desired look.

Choosing the right depth of field

Determining the depth of field you need by using a depth of field scale is as easy as 1-2-3. Okay, so technically there are really four steps.

1. **Focus on the closest subject you want to be sharp and read the distance above the orange index mark.**

 Note that the index mark on your lens may be a different color depending on the brand of lens you prefer.

2. **Do the same thing with the farthest subject you want to be sharp.**

 If you're using a 24mm lens and you need depth of field from 3 feet to 10 feet, put those two distances equally far apart from the orange index mark, which is exactly where they happen to be on the 24mm lens pictured in Figure 7-2.

3. **Read below the two distances to see the aperture you need to use.**

 Below 3 feet and 10 feet on a 24mm lens are the aperture marks for f/8.

4. **Set the aperture accordingly and take the picture.**

Most manufacturers calculate their depth of field scales by using a CoC value that allows for prints up to 8 x 10 inches in size. If you want to make 11-x-16-inch prints, follow the preceding steps but set your aperture to 1 stop smaller than the scale indicates. So for the preceding 24mm lens example, you'd use an aperture of f/11 rather than f/8 if you wanted to make an 11-x-16-inch print. For more examples, go to JimDoty.com and search for "depth of field."

I created Figure 7-3's photo of Trillium Ravine Nature Preserve in Michigan by using the depth of field scale on my lens. The large trillium was about 1.5 feet from my camera. When I centered 1.5 feet and infinity on either side of the index mark, an aperture setting of f/22 didn't quite cover the depth of field that I needed, so I focused closer to the trillium to get the distance of 1.5 feet well inside the left-side f/22 mark on the depth of field scale. I sacrificed a little sharpness in the distance to ensure that the foreground trillium was sharp.

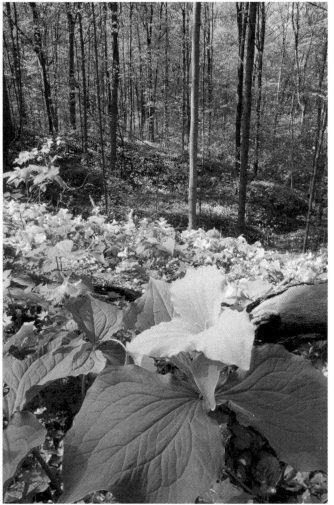

24mm, about 1/30 sec., about f/22, 100

Figure 7-3: An example of the depth of field you can create by using a depth of field scale.

Making adjustments if you can't achieve your desired depth of field

A depth of field scale eliminates lots of guessing as to exactly what aperture you need to cover the depth of field that you want for a given focal length. However, even if you go with the smallest aperture on the lens, the focal length you want to use may not be able to deliver the depth of field that you need. When that happens, you have the following options:

✔ Switch to a wider-angle lens.

✔ Sacrifice a little of the near or far depth of field where it's the least essential to the look of your image.

✔ Back up a bit from your subject to gain a little more depth of field. Then crop the photo later on your computer to restore your subject to the size that you want.

Using a Hyperfocal Distance Chart

If you don't have an electronic depth of field calculator (which I describe earlier in this chapter), using hyperfocal distance charts is one of the best ways to maximize depth of field in a photo because they give you excellent depth of field results in the near and middle distances (although subjects at infinity can be slightly soft). These charts are simple, effective, and low-tech; they're also incredibly easy to use, carry, and make (out of a 3-x-5 index card no less).

Before you can create a hyperfocal distance chart, you need to have a basic grasp of what *hyperfocal distance* is. Essentially, it's the closest distance at which the lens can be focused and still keep everything looking acceptably sharp all the way to infinity (theoretically anyway — what happens in the real world can be different from the results indicated by a mathematical formula). It gives you the maximum amount of depth of field you can achieve with a given focal length at a particular aperture. When you focus your lens at the hyperfocal distance, the depth of field extends from half the hyperfocal distance all the way to infinity. When you focus the lens at infinity, the hyperfocal distance is the closest point in the photo that will appear acceptably sharp. (*Note:* The hyperfocal distance also changes with the camera's sensor size and the print size.)

The hyperfocal distance chart in Table 7-1 is for cropped-frame digital cameras that have a 1.5x or 1.6x field of view (FOV) crop, which includes many of the Canon and Nikon digital SLRs. (See the nearby sidebar on FOV crop for the lowdown on cropped-frame digital cameras.) The chart in Table 7-2 is for full-frame digital cameras with 24-x-36mm sensors. Feel free to photocopy either or both of these charts and carry them in your camera bag.

Table 7-1	For Digital SLRs with a 1.5x or 1.6x FOV Crop							
Aperture	**Focal Length**							
	50mm	**35mm**	**28mm**	**24mm**	**20mm**	**17mm**	**15mm**	**12mm**
f/32	19 ft	9 ft	6 ft	4.5 ft	3 ft	2.2 ft	1.7 ft	1.1 ft
f/22	27 ft	13 ft	9 ft	6 ft	4.5 ft	3.5 ft	2.5 ft	1.6 ft
f/16	37 ft	18 ft	12 ft	9 ft	6 ft	4.5 ft	3.5 ft	2.2 ft
f/11	54 ft	27 ft	17 ft	13 ft	9 ft	6 ft	5 ft	3 ft
f/8	75 ft	37 ft	23 ft	17 ft	12 ft	9 ft	7 ft	4.5 ft
f/5.6	107 ft	52 ft	34 ft	25 ft	17 ft	12 ft	10 ft	6 ft
f/4	150 ft	73 ft	47 ft	35 ft	24 ft	17 ft	14 ft	9 ft

Table 7-2	For Digital SLRs with a Full-Frame Sensor						
Aperture	**Focal Length**						
	70mm	**50mm**	**35mm**	**28mm**	**24mm**	**20mm**	**17mm**
f/32	22 ft	12 ft	5.5 ft	3.5 ft	2.6 ft	1.8 ft	1.4 ft
f/22	32 ft	17 ft	8 ft	5 ft	4 ft	2.5 ft	2 ft
f/16	44 ft	22 ft	11 ft	7 ft	5 ft	3.5 ft	2.5 ft
f/11	64 ft	33 ft	16 ft	11 ft	8 ft	5 ft	4 ft
f/8	90 ft	45 ft	22 ft	14 ft	11 ft	7 ft	5 ft
f/5.6	130 ft	65 ft	32 ft	21 ft	15 ft	10 ft	7 ft
f/4	190 ft	90 ft	90 ft	28 ft	21 ft	15 ft	10 ft

Here are a couple examples of how to use a hyperfocal distance chart:

✔ For a cropped-frame camera, use Table 7-1 to find that the hyperfocal distance for a 24mm lens set at an aperture of f/16 is 9 feet and that a 20mm lens set at f/8 gives you a hyperfocal distance of 12 feet.

✔ For a full-frame camera, use Table 7-2 to find that the hyperfocal distance for a 28mm lens set at an aperture of f/16 is 7 feet and that a 24mm lens set at f/11 gives you a hyperfocal distance of 8 feet.

If you focus your camera lens at the hyperfocal distance, the depth of field will be everything from *half* the hyperfocal distance to infinity so long as you want to make prints no larger than 11 x 16 inches. If you want to make 16-x-20-inch prints, pick the hyperfocal distance you need from either Table 7-1 or Table 7-2 and set the focus accordingly. Then set the lens for one aperture smaller than the chart indicates (so if the chart says f/8, use f/11).

The next sections show you how to put a hyperfocal distance chart to work using a real-life example as well as how to create your own charts by performing a few calculations.

Working through an example

I used the hyperfocal distance chart for a full-frame digital camera (see Table 7-2) to come up with the settings I used for Figure 7-4's photo of Point Iroquois Lighthouse in Michigan. Pretend you're standing next to me, looking at the lighthouse, and follow these steps to see how I used the chart to determine the aperture and focused distance for the focal length I wanted to use.

1. **Determine the distance of the closest subject that needs to be in focus, either by estimating or by focusing on the subject and looking at the distance scale on your lens.**

 In Figure 7-4, the closest rocks were about 2.5 feet away from my camera.

2. **Double the distance of the closest subject to determine the hyperfocal distance.**

 Doubling 2.5 feet gave me 5 feet as the hyperfocal distance.

3. **Choose the lens and focal length you want to use.**

 Looking through my 17–40mm lens, the focal length of 22mm gave me the framing that I wanted.

4. **Find the hyperfocal distance you need in the column for your preferred focal length and look across the row to determine the aperture you need to use.**

 If your focal length is in between two focal lengths on the chart, use the longer focal length. For example, 22mm is in between 24mm and 20mm,

so I used 24mm. For my photo, the indicated aperture was f/16. (I looked under the 24mm column for my hyperfocal distance of 5 feet, which was in the f/16 row.)

5. **Set your lens to the indicated aperture (or use a smaller one if you want a little extra depth-of-field insurance) and pick a shutter speed to give you the right exposure**

Flip to Chapters 3 and 4 if you need metering help for choosing shutter speeds.

6. **Focus at the hyperfocal distance and take the picture.**

I focused the lens at 5 feet. I looked through the viewfinder again at this point, and everything in the distance appeared out of focus (this is pretty typical). That was a-okay because the lens aperture was wide open. When I clicked the shutter, the lens stopped down to f/22. When this happens to you, trust the chart. If you have a depth of field preview button (which I cover in Chapter 6), use it and you'll be reassured.

7. **Check the results on your LCD screen.**

At my chosen shutter speed of 1/15 second, the rocks in the photo looked blurred due to the moving water bending the light rays. Consequently, I changed the ISO from 100 to 400 and changed my shutter speed from 1/15 second to 1/60 second. These settings worked; 1/60 second was enough to freeze the apparent motion of the rocks.

A primer on field of view (FOV) crop

Many digital SLRs look just like full-frame (24-x-36mm) film cameras, and many of them use some of the same lenses. But the sensors in many digital cameras are smaller than 24-x-36 mm. If you take the lens off of a full-frame digital camera and put it on a camera with a cropped-frame digital sensor, the smaller sensor won't see everything the full-frame camera sees because the image has been cropped. The cropped image fills the viewfinder, making the image look magnified. Consequently, a field of view (FOV) crop is also called the *magnification factor*. It's just like using the ASPECT control on a digital television to magnify the image. Everything is bigger on the screen, but you're no longer seeing the whole picture that's being sent to your TV set.

For a 1.6x FOV camera, it's as if all of your lenses have suddenly become 60 percent longer. For a 2x FOV camera, it's as if all of your lenses have grown 100 percent longer. Both situations are great for telephoto photography but not for wide-angle photography because your wide angle lenses no longer have a wide-angle field of view.

Note: Canon's 1Ds and 5D cameras are full frame, and its 1D cameras have a 1.3x FOV crop. The rest of Canon's digital SLRs have a 1.6x FOV crop. Nikon's FX series cameras are full frame, and its DX cameras have a 1.5x FOV crop. Other companies are also introducing full-frame digital cameras.

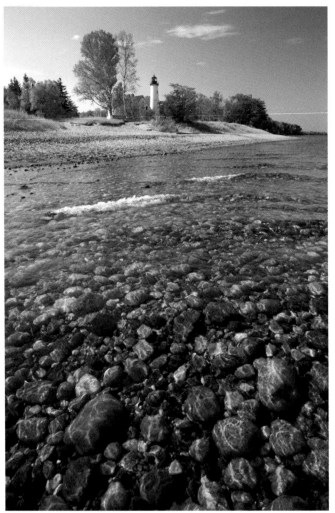

17–40mm lens at 22mm, 1/60 sec., f/16, 400

Figure 7-4: A lighthouse photographed with maximum depth of field.

Creating custom charts by calculating the hyperfocal distance

If you're mathematically inclined, or if you just want to make your own hyperfocal distance chart that's tailor-made for your camera format and preferred print size, you can calculate hyperfocal distance by using the following formula:

$$HM = [(F \times F) \div (C \times N)] \div 1{,}000$$

$$HM \times 3.2808 = HF$$

The following list defines the variables for the formula:

HM = Hyperfocal distance in meters

HF = Hyperfocal distance in feet

F = Focal length of the lens in millimeters

N = Lens aperture

C = Circle of confusion on the digital sensor in millimeters

To custom design charts for different camera formats and print sizes, plug the following values for C into the aforementioned formula:

✔ **For full-frame digital cameras with 24-x-36mm sensors:** Use the value given for C for a print of the following sizes (note that these values aren't correct for digital cameras with cropped-frame sensors):

- C = 0.0313 for an 8-x-12-inch print

- C = 0.0227 for an 11-x-16-inch print

- C = 0.0156 for a 16-x-24-inch print

✔ **For digital cameras with a 1.5x or 1.6x FOV crop:** The following numbers were specifically created for a 15.1-x-22.7mm sensor (like the ones used in many Canon digital SLRs), but these values are close enough to work for any digital camera with a 1.5x FOV crop (like many Nikon digital SLRs). Use the value given for C for a print of the following sizes:

- C = 0.0189 for an 8-x-10-inch print

- C = 0.0137 for an 11-x-16-inch print

- C = 0.0094 for a 16-x-24-inch print

✔ **For digital cameras with a 2x FOV crop:** Use the value given for C for a print of the following sizes:

- C = 0.0157 for an 8-x-12-inch print

- C = 0.0115 for an 11-x-16-inch print

- C = 0.0078 for a 16-x-24-inch print

Try calculating hyperfocal distance with this example for an 11-x-16-inch enlargement, where a 50mm lens on a full-frame digital camera (so C equals 0.0227) with a 24-x-36mm sensor is set at f/8:

$$HM = [(50 \times 50) \div (0.0227 \times 8)] \div 1,000$$

$$HM = [(2,500) \div (0.1816)] \div 1,000$$

$$HM = 13,766 \div 1,000 = 13.766 \text{ meters}$$

$$HF = HM \times 3.2808$$

$$HF = 13.766 \times 3.2808 = 45.16 \text{ feet}$$

When using any depth of field tool, keep in mind that the depth of field in a scene doesn't change instantly from "in focus" to "out of focus" at some mathematically determined distance. Depth of field is a transition from sharp at the focused distance to blurry as you get farther from the focused distance. With wide-angle lenses at small apertures, the transition from sharp to blurry is very gradual. With long lenses at wide apertures, the transition is much more abrupt. You should also be aware that although depth of field formulas can be calculated out to umpteen decimal places, depth of field in the real world isn't that precise. So take depth of field tools seriously but not too seriously. If the calculated hyperfocal distance is 45.16 feet and the near depth of field limit is 22.58 feet, don't expect something to be totally blurry at 21 feet and razor sharp at 23 feet. It's better to think that things will be a little blurry at 20 feet and pretty sharp at 25 feet. Don't stress out over a few decimal points.

Maximizing with Merklinger

Using hyperfocal distance charts like those in the earlier "Using a Hyperfocal Distance Chart" section can make a world of difference in your ability to get the depth of field you want, at least in most situations. But sometimes distant subjects won't be as sharp as you wanted them to be. In these cases, you may want to turn to the method developed by Harold M. Merklinger. You can read the full details of Merklinger's method for getting lots of depth of field with distant objects that look sharp by visiting www.trenholm.org/hmmerk and clicking the All PDF and MOV files link (it's in the second bulleted list on the page). If you just want the crash course, then check out my oversimplified version of one way Merklinger describes to maximize depth of field.

1. **Focus the lens on infinity and stop the lens down to a small aperture.**

 The lens will resolve everything down to the size of the aperture diameter, regardless of the camera format you're using. For example, if you're using a 20mm lens at f/10, the aperture diameter is 2 millimeters (you find the aperture diameter by taking the focal length and dividing it by the f-stop). If you focus at infinity, the lens will resolve everything that's 2 millimeters wide and larger (like leaves and blades of grass). It won't resolve details that are smaller than 2 millimeters (like eyelashes and the veins in a leaf).

2. **Look at the smallest subject in your photo that needs to be resolved.**

3. **Pick a focal length and an f-stop that'll give you an aperture diameter that's at least as small as the smallest subject from Step 2.**

In the photo of an Alaskan mountain in Figure 7-5, I used Merklinger's approach and focused on infinity to keep the mountain sharp. I was shooting at f/8 and 1/500 second, as well as at f/11 and 1/250 second. At around f/8 or f/11, my 15mm lens would resolve anything around 1.5 to 2 millimeters and larger (15 roughly divided by 8 or 11). The label in the bottom-right corner of the window, which was about 1 foot from the camera, is a little fuzzy, so it isn't totally resolved. In a 12-x-18-inch print, the wheel, struts, wing, and mountain all look sharp.

Merklinger's approach gives you sharp backgrounds, but fine details in the foreground may not be resolved. Using a hyperfocal distance chart (see the earlier related section) favors the foreground but can leave the background slightly fuzzy. So which method to use and when? For some scenes, I use the hyperfocal distance approach; for others, I use Merklinger's approach. Then again, sometimes I try both and decide later which version I like best. What you choose to do depends on the scene and your preference.

To really see the difference between photos shot using Merklinger's approach and a hyperfocal distance chart, give this exercise a try:

1. **Choose a scene that has interesting subjects with fine detail very close the camera, a few feet away from the camera, and all the way out to infinity.**

2. **Choose a wide-angle lens and put the camera and lens within a foot of the nearest subject.**

3. **Set your lens to its smallest aperture.**

4. **Choose a shutter speed that'll give you a good exposure.**

5. **Select the appropriate hyperfocal distance from the chart that matches your camera and the aperture you're using.**

6. **Take a picture.**

7. **Focus the lens at infinity.**

8. **Without moving the camera or changing the aperture, take another picture.**

9. **Compare the photos.**

Which image do you like best? Which one renders fine detail better in subjects close to the lens? Which photo looks best for subjects far away? You may be waiting for me to answer which photo *should* look better than the other one, but I can't. The answer depends entirely on what you want the outcome to look like. So, it's completely up to you!

15mm, around 1/500 sec. and 1/250 sec., around f/8 and f/11, 100

Figure 7-5: The focus on infinity keeps the mountain sharp; the small aperture diameter creates lots of depth of field.

Choosing an Aperture When Depth of Field Doesn't Matter

Sometimes depth of field just isn't a concern, like when everything is the same distance from the camera or when everything is fairly far away from the camera (think of a distant landscape photo without a foreground). When most any reasonable aperture will do, how do you know which aperture to pick? You just need to find your lens's sweet spot.

All lenses have *optical aberrations* (imperfections in the optical design) that are usually most apparent when the lens is set at its widest aperture. Stopping the lens down 2 or 3 stops from its widest aperture usually minimizes aberrations.

At the other end of the aperture scale, *diffraction* rears its ugly head. As f-stops get smaller and smaller, a higher percentage of light rays bend around the aperture blades and scatter randomly across the digital sensor, softening the image. At some point, the sharpness gained by more depth of field is overshadowed by the effects of diffraction, so think twice before you use the smallest aperture on your lens. If you really need it to achieve the depth of field you want, use the aperture; if you don't, pick a different aperture.

Between aberration and diffraction, the middle apertures usually provide the best image quality. These apertures are the "sweet spot" for most lenses. When experienced photographers are asked how they captured a particular image, the classic response is "f/8 and be there." In plain English, this translates to: Be in the right place at the right time with the right light and use f/8, one of the highest-quality apertures.

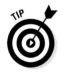

When depth of field doesn't matter, I usually shoot at f/8 if I'm using a wide-angle to normal lens. If I'm using a longer lens, I start to think about using f/11.

In Figure 7-6's photo of a Colorado mountain, everything was at a reasonable distance from the lens, so I didn't need a huge amount of depth of field. Consequently, I used an aperture of f/11 for high image quality and a little extra depth-of-field insurance due to the longer focal length.

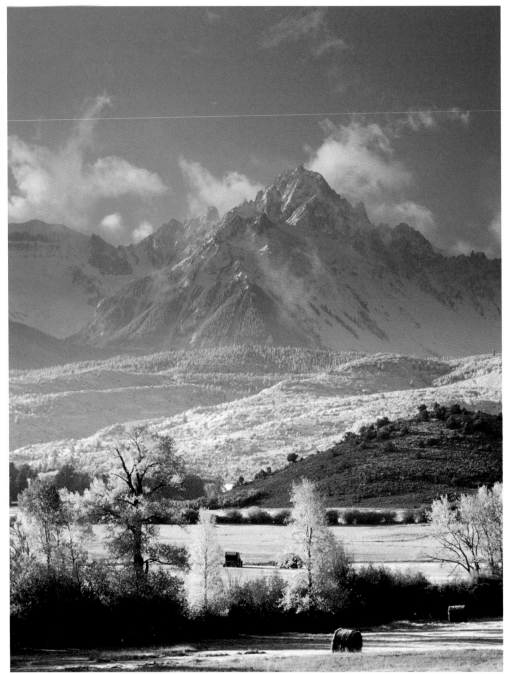

70–200mm lens at around 140mm, about 1/60 sec., around f/11, 100

Figure 7-6: Colorado's Mt. Sneffels at sunrise.

The Passage of Time: Shutter Speeds

In This Chapter

▹ Recording the passage of time (or not)

▹ Freezing a subject in its tracks

▹ Embracing a little blur in your images

*T*he wide range of shutter speeds available gives you the freedom to make wonderful artistic choices. For instance, if your subject is moving and the light is right, you can

✔ Freeze time to reveal details that look blurred to the human eye

✔ Choose shutter speeds that keep your subject sharp, mostly sharp, slightly blurred, or very blurred

✔ Lock your shutter open to record the passage of time in a still photo

Clearly, playing with shutter speeds gives you a wide range of creative possibilities. Get ready to explore those possibilities in this chapter. I show you how to use all kinds of shutter speeds in a wide variety of photographic situations and give you several exercises to try so you can practice selecting the shutter speeds that will give your photos the look you want. If you complete every exercise in this chapter and write down the shutter speeds that you like best from each one, you'll have a valuable reference that you can use in a variety of photographic situations.

In the world of shutter speeds, a *fast* shutter speed is equivalent to a *short* one, and a *long* shutter speed is equivalent to a *slow* one. Shutter speed terminology is relative to the subject, and different photographers prefer different terms. For a sports photographer, 1/2000 second is a fast shutter speed, and 1/60 second is a slow shutter speed. For a photographer who prefers to take pictures of wildflowers in soft light, 1/30 second is fast, and 2 seconds is long. For a photographer shooting the night sky, 2 minutes is a short shutter speed, and 1 hour is long. For the average photographer, fast shutter speeds don't require a tripod to support the camera, but long shutter speeds do.

Letting Time Go By

When light levels are low, "letting time go by" is a simple technique that you can use to create memorable images of things the human eye can't see except in a well-crafted photo. The idea is to record the passage of time.

To let time go by, simply lock open the shutter and wait. To make the subject dramatic, try combining stationary subjects (such as mountains, trees, or lit buildings) with something moving through the frame to show the passage of time. Large, diffuse subjects, such as clouds, end up as long, interesting, blurred shapes, and subjects such as taillights and airplane lights etch their well-defined shapes across your photo.

Figure 8-1 features an example of what letting time go by can do for your photographs. When taking this photo of the Las Vegas Strip, my goal was to photograph brightly lit, in-focus buildings with the contrasting look of long, streaking taillights. With my camera on a tripod, I set up on a part of a pedestrian overpass, poked my lens through the fence, metered the scene, checked a nighttime exposure guide for bright city lights at night, and used small apertures and long shutter speeds. I ended up with the streaking taillights I was after, but I came up with a different idea. I wanted to capture cars sitting at the red light and then driving away after the light turned green. To capture this image, I timed the length of the red light cycle a couple times. Then I opened the shutter a few seconds before the next red light turned to green. The resulting image (Figure 8-1) is one my favorites.

Try the following exercise to get some experience with letting time go by and creating images of sharp-looking buildings combined with long, streaking taillights:

1. **At night, head for the nearest busy street lined with nice buildings.**

 The buildings will provide the background for your photo.

2. **Set your camera on a tripod where you can record the lights of passing vehicles.**

 Your photos will have more of an impact if you shoot down the length of the street rather than across it.

3. **Set the ISO on your camera to 100.**

4. **Use a normal to wide-angle lens and set the aperture to f/16.**

5. **Take pictures at the following shutter speeds: 2, 4, 8, 15, and 30 seconds.**

6. **Make note of your favorite photos and write down the shutter speed(s) used on a 3-x-5 card that you can keep in your camera bag for future reference.**

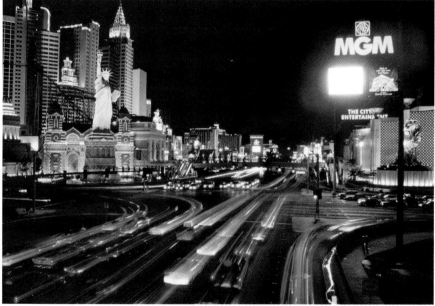

About 24mm, about 8 sec., around f/22, 100

Figure 8-1: Long shutter speeds and good timing allowed me to catch the cars sitting and in motion.

Letting time go by can create some distinctive images, but you still have to pay attention to your exposure. Because exposure can be tricky in low-light situations, here are some factoids to keep in mind:

- **Bright lights in the frame can fool your camera meter into underexposing the scene.** Add a few stops of light to what the camera is telling you, or meter the side of a brightly lit building.

- **Some subjects defy accurate metering.** I recommend keeping a good exposure guide in your camera bag as a reference (my favorite is the Black Cat Extended Range Exposure Guide). Guides are just guides though, so remember to bracket your exposures (I explain how to do this in Chapter 4).

- **Past experience is important in making exposure decisions.** Make your best guesstimate about a good exposure, take the picture, look at the LCD screen, and reshoot if necessary. Be sure to check the histogram to make sure you haven't blown out important highlights (I cover histograms in Chapter 3). You can expect street lights to be stacked up on the right side of the histogram, but most of your scene should fall in the middle to dark range of the histogram.

- **If you want longer exposure times than the lighting conditions and aperture setting will allow, put a neutral density filter on your lens.** *Neutral density filters* are a dark neutral gray. They reduce the light so you can use longer shutter speeds and come in different *densities* (strengths) to suit your purposes. A really strong (dark) neutral density filter can give you such long exposures during the day that you can photograph a busy freeway and the cars will all but disappear because they aren't in any one place long enough to be recorded on your digital sensor.

- **If your camera has a long exposure noise reduction feature, do some long exposure comparison photos with noise reduction on and off.** Aggressive noise reduction can soften an image. Not only that, but when noise reduction is turned on, many cameras spend as much time removing the noise as they did taking the original exposure. Shoot for 15 seconds, and noise reduction takes another 15 seconds before you can shoot again. If you need to shoot again quickly, turn noise reduction off. (For more on noise reduction, head to Chapter 9.)

Even though you're letting time go by, the exact moment you choose to click the shutter may be very important. Then again, it may not matter at all. Think about what you want. The flashing lights of an airplane high in the night sky, for example, can either add to or detract from your image. It's your choice.

The timing of the shutter in Figure 8-2's nighttime image of Cook's Bay in Mo'orea wasn't critical. Nothing but the water was moving when I shot this photo, so the timing wasn't nearly as complicated as it was when I shot the previous photo of the Las Vegas Strip (refer to Figure 8-1). All I had to do was lock open the shutter and wait.

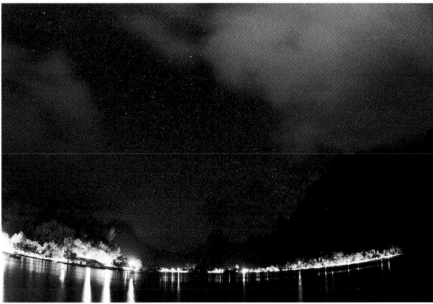

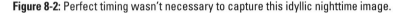

15mm, 30 sec., f/4, 1600

Figure 8-2: Perfect timing wasn't necessary to capture this idyllic nighttime image.

Freezing Time

Freezing time is the opposite of letting time go by (see the preceding section). Some things happen so quickly that they're a blur to the human eye. If you want to freeze a speeding bullet, you need highly specialized equipment, but fortunately that's not the norm. Lots of subjects lend themselves to freezing time with ordinary camera gear. Water fountains are a good example. The human eye sees rapidly moving water as slightly blurred, but a really fast shutter speed (1/1000 second) can freeze the fountain into individual water droplets. The effect is more dramatic if the water is backlit by the sun and there's something dark behind it. You can see what I mean in Figure 8-3.

Whenever you have fast-moving subjects (such as fast-moving water or fast-moving sports) and shutter speeds of 1/1000 second and faster, you have the potential to create an image that the human eye can't see unaided. However, you generally need a lot of bright sun and sometimes a higher ISO setting to capture these images (along with quick reflexes if you're photographing fast-moving sports). The basic daylight exposure (BDE; see Chapter 4) for ISO 100 is 1/2000 second at an aperture of f/4. If you need that shutter speed but more depth of field than f/4 would give you, you must increase the ISO setting so you can use a smaller aperture (flip to Chapters 6 and 7 to read all about depth of field; head to Chapter 9 for the scoop on ISO speeds).

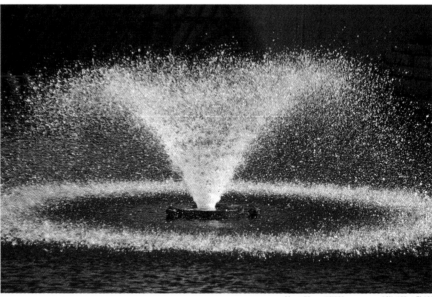

About 70mm, 1/1000 sec., around f/4, 100 at EI 160

Figure 8-3: A water fountain, with the water droplets frozen in midair.

Whenever you photograph fountains, it's helpful to know what your personal shutter speed preferences are. Following these steps on a bright, sunny day can help you hone in on that:

1. **Create your own fountain by setting up a sprinkler in your yard so that it's backlit by sunlight but with a dark, shady wall behind the sprinkler.**

 This is easiest to do on the north side of a building when the sun is high in the sky. No yard? Borrow a friend's.

2. **Expose your fountain at BDE, BDE +1, and BDE +2 using these exposure combinations: 1/2000 second at f/4 for BDE, 1/1000 second at f/4 for BDE +1, and 1/500 second at f/4 for BDE +2.**

3. **Then try this range of equivalent exposure combinations (which are all at BDE +1): 1/1000 second at f/4, 1/500 second at f/5.6, 1/250 second at f/8, 1/125 second at f/11, 1/60 second at f/16, 1/30 second at f/22.**

Now it's time to analyze your photos. Which exposure from Step 2 do you prefer for a backlit fountain: BDE, BDE +1, or BDE +2? Looking at your photos from Steps 2 and 3, which shutter speed allowed you to freeze the water, and which shutter speed(s) gave you the look(s) you like best? Write down your favorites for future reference.

Stopping Motion

In between the extremes of freezing your subject and letting time go by, you have the option of either keeping your subject sharp (or mostly sharp) or blurring it to varying degrees. The shutter speed you need to stop (or mostly stop) the motion of your subject depends on the

- ✔ **Speed of your subject:** The faster your subject is moving, the faster your shutter speed needs to be.

- ✔ **Direction of your subject:** If the subject is moving toward you, your shutter speed can be slower than if it's moving across your field of view.

- ✔ **Distance from you to the subject:** The closer your subject is to you, the faster the shutter speed needs to be.

- ✔ **Focal length:** Longer focal lengths require faster shutter speeds to stop the motion of a subject.

In Figure 8-4, I wanted a shutter speed that was just fast enough to keep the cyclist pretty sharp but also slightly blurred. I knew something in the 1/250 second to 1/500 second range would be close. The cyclist did each trick once, so I experimented with shutter speeds on each trick in order to set the proper shutter speed for this jump over another person.

Here's a handy way to start figuring out the right shutter speed to stop a subject's motion. Pretend you're sitting on your front porch with a normal focal length lens, ready to photograph whatever happens to come down your street. The following shutter speeds should stop the motion of your subjects (assuming, of course, that you point your camera at the street as your subjects move across your field of view):

- ✔ Walker: 1/125 second
- ✔ Jogger: 1/250 second
- ✔ Sprinter: 1/500 second
- ✔ Minivan going 50 miles per hour: 1/1000 second
- ✔ Sports car going 100 miles per hour: 1/2000 second

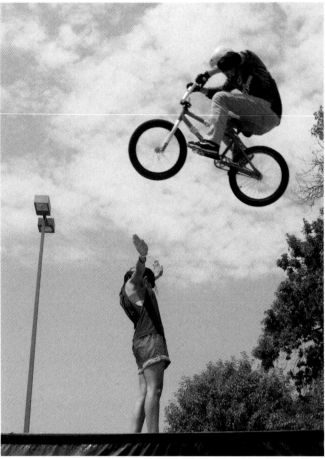

28–135mm lens at 28mm, 1/250 sec., f/11, 200

Figure 8-4: A fast shutter speed stopped most of the cyclist's motion.

You can apply these examples to most moving subjects. For instance, a shutter speed of 1/250 second to 1/500 second works for most fast-moving sports. Downhill skiers can approach sports car speeds (85 to 95 miles per hour), and race horses are almost as fast as a minivan (about 45 mph) for short distances. The speeds of cheetahs and antelope are in between a minivan's and a sports car's, and the top speed for most other large mammals is somewhere between sprinters and minivans.

In the football photo in Figure 8-5, the shutter speed was around 1/250 second. As you can see, the image is mostly sharp, but it could be sharper. I would've preferred a shutter speed of 1/500 second, but the light levels were dropping.

300mm, about 1/250 sec., around f/4, 100

Figure 8-5: If the shutter speed had been a tad faster, this stop-motion photo would be sharper.

Sometimes you need to make adjustments to the recommended shutter speeds I provide earlier in this section. Continuing with that front porch scenario, following are some specific situations along with tips on how to adjust your shutter speed so you can still stop the motion in a scene:

- ✔ If you walk halfway to the curb, use shutter speeds that are 1 stop faster.

- ✔ If you walk all the way to the curb, getting even closer to your subject, go 2 stops faster.

- ✔ If you stay on your porch but use a moderate telephoto (100mm) or longer telephoto lens (200mm), use shutter speeds that are 1 or 2 stops faster.

- ✔ If you stand at the curb with a normal focal length lens and point your camera down the street to photograph your subject as it comes toward you, use shutter speeds that are 2 stops slower.

"Safe" hand-held shutter speeds and image stabilization

Sometimes you wind up with a blurry photo despite your best efforts. Why, you ask? The reason may have to do with you moving, especially at slower shutter speeds when you're shooting with the camera in your hand and not on a tripod. The general rule of thumb for safely holding a camera is to use a shutter speed that's at least as fast as the reciprocal of the focal length of the lens. For example, if you're shooting with a 50mm lens, use a shutter speed that's 1/50 second or faster. Or if you're shooting at 300mm, use a shutter speed that's 1/300 second or faster.

You can increase your stability by holding the camera firmly, pushing it against your face, pressing your elbows into your chest, and squeeeezzzing the shutter button. Make the camera part of your body. No jerky movements allowed. Or you can try resting your elbows on something solid or leaning against a wall or lamppost. Anything that keeps your body stable will allow you to take photos at slower shutter speeds without the use of a tripod.

A real plus for slower shutter speeds when handholding the camera is the invention of *image stabilization* (which also goes by other names such as *vibration reduction, vibration compensation,* and *optical stabilization*). In a camera that has an image stabilization feature, a mechanism is built into the lens or the camera body to compensate for the photographer's motion. Image stabilization can increase the ability to handhold the camera at shutter speeds that are 2 to 4 stops slower than what would ordinarily be possible. This feature comes in handy at museums, cathedrals, and other low-light places that allow photography but prohibit tripods.

Blurring and Panning with the Best of 'Em

Photographers can be obsessed with sharpness. That's a good thing for some subjects or if you want to hang a magnificent 16-x-20-inch landscape photo on your wall, but too often the pursuit of sharpness stands in the way of artistic creativity. Sometimes energy, motion, direction, and time are best conveyed with a little bit of blur (or maybe even a lot). If you really want to expand your digital photography skills, you need to embrace blurring. Only when you're comfortable with blurring and know how to make it work for you can you capture the whole world of blurred subjects that goes largely unexplored by the average person with a camera. (And trust me, it's pretty amazing.)

The best ways to get started are subject blur and panning. With one, you blur your subject against a sharp background. With the other, you pan with your subject to keep it reasonably sharp while blurring the background. Both are very effective approaches to creative photography.

In the following sections, I help you become more comfortable with blurring and share several creative ways to blur your subject, the background, or both.

Taking a break from sharpness

If you're one of those misguided souls who always tries to stop the motion of your subjects, set yourself free! Get that sharpness monkey off of your back by trying out the following steps:

1. **Head downtown at dusk to take pictures.**

 Don't cheat and bring your tripod with you.

2. **Handhold your camera.**

3. **Start taking photos using shutter speeds that are no faster than 1/4 second.**

4. **Be creative.**

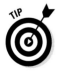

 Try zooming or defocusing the lens during long exposures, moving the camera to create light trails, or putting the camera on the dashboard of your car and taking long pictures while a friend drives you around.

 If you're overwhelmed by a desire to take a sharp picture, go ahead and lean against a lamppost for a photo or two, but no more than that.

How did that feel? Do you have a newfound sense of freedom? If so, good for you. Art Wolfe would be proud of you! He's a world-class photographer who can take razor-sharp photos, but he also takes glorious blurred photos when it suits his artistic goals.

Why not try checking out Art Wolfe's work to spur your creativity regarding all that you can do within the range of blurred to sharp images? Just go to www.artwolfe.com and click the Portfolios link at the top of the page. Browse through his images, paying attention to how he blurs all or parts of his images. Feel free to "ooh" and "ah" as often as you like.

Showing motion with blurring and panning

Blurring your subject against a sharp background is simple. Well, sort of. You do need to have an idea what shutter speed to use. (I suggest you begin with the shutter speeds I recommend in the earlier "Stopping Motion" section.) If you shoot at one or two shutter speeds longer than the ones recommended in the previous section, your subject will be mostly sharp to slightly blurred, keeping the background sharp. The subject will be more blurred if you go 2 or 4 stops slower. At 5 or more stops slower, your subject will be very blurred. If your shutter speeds get too long to have a sharp background, use a tripod.

You can blur your subjects as much as you want, assuming you point your camera in one direction with the subject moving across your field of view and click the shutter as your subject comes into view, blurring the subject and keeping the background sharp. Experiment!

Another very effective way to show motion is to *pan* with your subject to blur the background. Here's how: Follow your subject in a smooth motion, gently squeeze the shutter, and make sure to follow through after the shutter closes so you don't have a jerky motion at the end that can mar the photo. With a little practice, you can use panning and pretty long shutter speeds (as in shutter speeds that are much longer than what's traditionally considered a "safe" hand-held shutter speed) to totally blur the background and slightly or greatly blur your subject.

Depending on the speed of your subject and how much you want the subject to be blurred, shutter speeds ranging from 1/30 second to 1/4 second work well.

For an example of using panning to blur only part of an image, check out Figure 8-6. This young Tahitian woman was paddling quickly across the water in a pirogue (a form of outrigger canoe). When I spotted her, it was after sunset, and the light levels were low. I panned with her at a 1/15 second shutter speed. The result? She's slightly blurred, and her arms are more blurred. When I took photos of the runner in Figure 8-7 during an evening track meet, I panned with the runner while experimenting with various shutter speeds to create a very blurred effect. A shutter speed of 1/8 second gave me the look that I wanted.

Try your hand at this exercise to increase your comfort level playing with motion, shutter speeds, and the blurriness of your subjects:

1. **Ask a friend to drive by your house several times at the same speed each time (try 20 or 25 miles per hour, and within the speed limit, of course).**

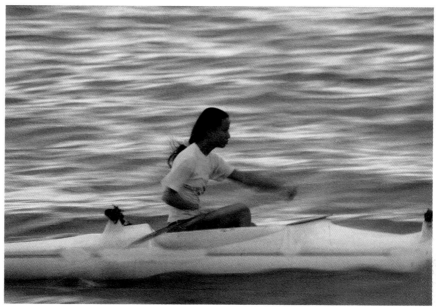

70–300mm lens at 300mm, 1/15 sec., f/8, 400

Figure 8-6: Blurring only a portion of an image.

2. **Take pictures at several shutter speeds, ranging from 1/125 second to 1/2000 second.**

 Don't pan with the car. Your goal is to have sharp to blurry pictures of the car against a sharp background.

3. **Compare the photos for the degree of sharpness or blurriness against the sharp background.**

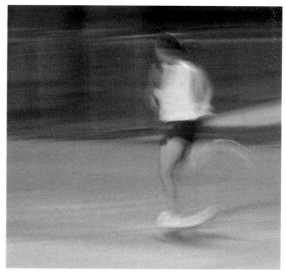

28–135mm lens at 122mm, 1/8 sec., f/5.6, 400

Figure 8-7: Blurring all of an image.

4. Try several more photos at a variety of slower shutter speeds (1/30 second to 1/4 secon while panning with the car.

5. Compare the shutter speeds for the sharpness or blurriness of the car against the blurred background.

This next exercise is good practice for creating blurred backgrounds and sharp subjects. It also helps you figure out how to shoot in unpredictable situations.

1. Go to a local high school track meet.

2. Without panning, try various shutter speeds to create both sharp and blurred runners against a sharp background.

3. Panning with the runners, try a variety of slower shutter speeds to get sharp and blurred runners against a blurred background.

The best way to get a feel for balancing blurriness and sharpness in your photos is to practice and experiment. Grab your camera, head out into the world, and photograph all kinds of moving subjects against sharp backgrounds and pan with subjects to get blurred backgrounds. You can even experiment with blurring moving water. I captured Figure 8-8's image of an angel hair waterfall in the evening at Ash Cave in Ohio. The light levels were low, but the quality of the light was magical. The 8 second shutter speed I chose to use gave me a perfect photograph.

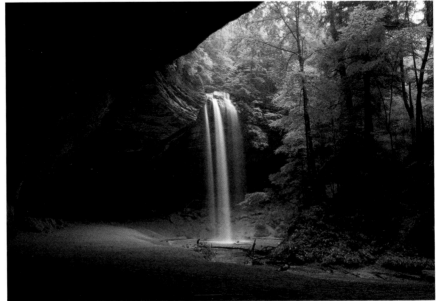

17mm–40mm lens at 17mm, 8 sec., f/11, 100

Figure 8-8: A waterfall shot in low, good-quality light with a long shutter speed.

9

Sensitivity to Light: ISO

*I*SO speed has long been the ugly duckling of exposure. Spin the aperture dial or the shutter speed dial, and you get dramatic changes in the look of your image. Change the ISO speed and — well — nothing much happens (other than the image getting lighter or darker) unless you change something else (like the f-stop or shutter speed).

ISO speed may not be terribly exciting, but ISO settings are important because they take the impossible and make it possible. If you were limited to just one ISO setting on your digital camera, all kinds of creative doors would be slammed in your face. The ability to use different ISO speeds is the key to unlocking those doors. I help you further understand the role of ISO and get comfortable working with ISO settings in this chapter.

Adjusting ISO, or Your Camera's Sensitivity to Light

ISO speeds indicate the sensitivity of a digital camera's sensor to light. Along with apertures and shutter speeds, ISO speeds determine the exposure and are indicated in both full stops (25, 50, 100, 200, 400, 800, 1600, 3200, and so on) and fractions of stops. The higher the ISO number, the more sensitive the sensor is to light.

When you change the ISO on a digital camera, you boost the signal from the sensor, but the sensor doesn't actually become more sensitive to light. The practical benefit is the same, however. Changing the ISO from 100 to 200 makes your photo 1 stop lighter, just like using a longer shutter speed or a wider aperture, so the photo *looks* like the sensor has become more sensitive to the light.

ISO speeds go back to film. Film speeds were originally indicated by ASA/ DIN numbers, but these were eventually replaced by ISO numbers (ISO being the International Organization for Standardization). Theoretically, digital ISO settings and film ISO settings should be equivalent in terms of exposure. However, there can be slight variations. If you've switched from film to digital, your favorite exposures for a given situation (like a bright, sunny day) may be a little different.

To change ISO speeds on a digital camera, just access the ISO settings on your camera and spin the dial to select any available ISO that the camera offers.

Figure 9-1 is an example of how a higher ISO setting can open up creative possibilities. I wouldn't have been able to capture the Northern Lights, which were slowly shifting across the sky, or stop the motion of the stars without a shutter speed of 30 seconds, which was made possible by an ISO of 320. An ISO of 100 would've meant a shutter speed longer than 90 seconds, and that would've blurred the Northern Lights and made the stars look like short streaks across the sky. The higher ISO speed really makes this photo.

Because shutter speeds, apertures, and ISO work together to determine exposure, if you don't like the shutter speed and f-stop combination you come up with at one ISO setting, just change the ISO to create a new combination. For example:

- If you change the ISO from 200 to 400 (in other words, if you make the camera 1 stop more sensitive to light), you can choose a shutter speed that's 1 stop faster or an aperture that's 1 stop smaller.

- If an aperture of f/4 and a shutter speed of 1/2 second create a good exposure at ISO 100 but you want a much faster shutter speed, change the ISO to 3200 (that's 5 stops faster than ISO 100). You can then change your shutter speed to 1/60 second (5 stops less light than 1/2 second) at the same aperture.

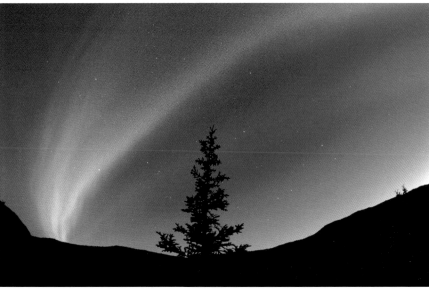

15mm, 30 sec., f/4, 320

Figure 9-1: The Northern Lights up in Alaska, shot with a higher ISO to minimize star trails.

One of the wonderful advantages of digital photography is the ability to change ISO settings as often as you want. If you're taking photos of people outside and the light level drops, no problem. Just boost the ISO on your camera to keep the shutter speeds up where you want them. Forced to shoot in a low-light museum with a no-tripod rule? Again, just boost the ISO. Shooting the night sky and want superlong shutter speeds? Use lower ISO settings. Digital cameras have made it much easier to capture impressive images because you no longer have to lug around two (or more) film cameras loaded with high- and low-speed film to take photos in both bright and low-light conditions.

Capturing the fleeting father-son moment shown in Figure 9-2 in low light wouldn't have been possible at a low ISO setting. Fortunately, I was shooting with a digital camera, so with a quick spin of the digital ISO dial to 1600, I was ready to go. Using an electronic flash would've allowed me to select a lower ISO setting, but the flash would've killed the mood of the moment. In this case, a little noise in the photo (see the next section) was worth it to me to be able to get the shot in natural light.

28–135mm lens at 135mm, 1/100 sec., f/5.6, 1600

Figure 9-2: A father and his son, photographed with a higher ISO speed to capture the moment in natural light.

Using Digital ISO Settings to Deal with Noise

Shutter speeds and apertures are pretty much equal opportunity choices, but high ISO settings have a somewhat tarnished reputation. The nemesis of high ISO in the digital photography world is *noise* (a digital byproduct of higher ISO settings). Many photographers think noise is just plain ugly, and they go to great lengths to either avoid it or minimize it. In the sections that follow, I show you how noise affects your images as well as how you can both minimize and maximize noise in your photos.

Lower ISO speeds are a good way to minimize noise in your digital photographs.

Understanding what the noise is all about

Digital noise is more prevalent at high ISO settings. The higher the digital ISO, the higher the noise level. Choosing a higher ISO setting on a digital camera means the gain is turned up on the signal from the sensor. Think of turning up the volume on an old radio to hear a distant station. The station sounds louder, but you get a lot more static. With the "volume" on your digital sensor turned up, you get more visual static.

To see what noise looks like in a photo, check out Figure 9-3. This photo is a cropped version of Figure 8-2 in Chapter 8. The section of the photo that's printed on this page is the equivalent of seeing the whole photo printed at 20 x 30 inches in size. At an ISO setting of 1600 with an older-model digital camera, the digital noise level is quite high.

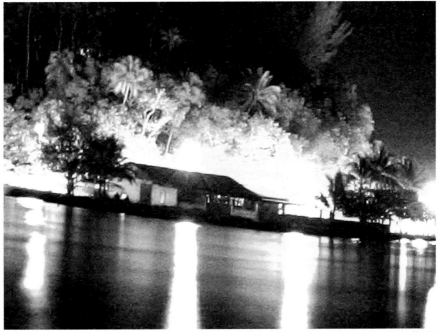

15mm, 30 sec., f/4, 1600

Figure 9-3: This noisy, cropped image was captured by using a high ISO at nighttime.

So here's the good news and bad news about noise:

✔ **The good news** is that noise levels in digital SLRs have gotten much better. The highest ISO setting that provides an acceptable level of noise has climbed steadily from ISO 400 to 800 to 1600 in just a few short years. How much noise is acceptable? That's a matter of personal preference, the subject matter, and the importance of the moment, but here are some factors to keep in mind:

• Highly textured subjects (such as animal fur and sand dunes) disguise noise, whereas smooth subjects (think human skin or a clear blue sky) reveal noise. Therefore, you can get by with higher noise levels more easily when photographing an elk in a snowstorm than when taking a portrait of a friend.

• If a Pulitzer Prize–winning moment happens right before your eyes and you're the only photographer around, noise levels don't matter. So if you're taking pictures in Yellowstone National Park and an albino elephant walks out of the forest, who cares about digital noise? Just click the shutter!

✔ **The bad news** is that no matter how much better the noise levels have gotten in digital SLRs, the noise is still there. Digital noise is also worse on cameras with smaller sensors. Translation: Digital point-and-shoot cameras have higher noise levels than digital SLRs at higher ISO settings.

Noise also increases with underexposure, even at low ISO speeds. So if you shoot a high-contrast scene (one that has both sun and shade) at a low ISO speed, the sunlit parts of your subject will have little or no noise, but the darker parts of the scene may wind up with a lot of noise.

Minimizing noise

Minimizing noise isn't always as simple as dialing down the ISO. You have to take other factors, such as shutter speed, aperture, and your subject, into account. Some situations require a higher ISO to give you the shutter speed and aperture setting that you need. But there are steps you can take to minimize noise, as you discover in the next sections.

With noise reduction

If your camera has a built-in noise reduction feature, try it out. You may like it. Then again, you may not because built-in noise reduction can soften the overall image.

If your camera has several levels of noise reduction, try them all out by photographing the same subject in low light so you can accurately compare all the photos.

Here's how to experiment with noise reduction:

1. **Set your camera up in the evening when light levels are low.**

 Use a tripod or a beanbag so the camera doesn't move.

2. **Pick a subject that has some texture and some smooth areas.**

 A brick wall next to a smooth garage door works well.

3. **Make sure your camera's noise reduction feature is turned off.**

4. **With shutter speeds around 1 second or longer at a medium aperture setting (such as f/8), take a series of photos at different ISO settings without changing the aperture.**

 Use as many ISO speeds as the light will allow and remember that each time you change the ISO speed, you also need to change the shutter speed to get the same exposure. Or you can just put your camera on the aperture-priority mode and let it pick the shutter speeds.

5. **Turn on the noise reduction feature.**

 If you have different noise reduction settings available, use the strongest first, followed by the weaker settings.

6. **Repeat Step 4.**

The first set of photos (the ones you took in Step 4) gives you an idea what noise looks like on your camera for both textured and smooth subjects. The rest of the photos (those you took during Step 6) tell you whether or not you like noise reduction turned on and, if you have several setting options, which noise reduction setting you like best.

With other techniques

If your camera doesn't have a noise reduction feature, or if you just don't like how noise reduction makes your images turn out, check out the following additional ways you can minimize noise:

✔ **Use a low ISO setting.** Whenever you have a choice, use the lowest ISO setting that still allows you to use your desired shutter speed/aperture combination, but be prepared to have to make compromises in some situations. For instance, if you're shooting in low light and you want to stop a subject in motion, you may decide on a wider aperture with less depth of field in order to use a lower ISO setting to ensure less noise. If you need the depth of field of a smaller aperture and the motion-stopping capability of a faster shutter speed, then a higher ISO setting (and more noise) may be your only option.

✔ **Expose to the right.** Generally, if you meter to shift medium tones to be light tones and dark tones to be medium tones, they'll have less noise than if you meter them normally. You'll need to darken them down to

their regular tonalities on your computer by using your photo-editing software, but you'll wind up with better image quality as a result. (*Note:* In some situations, exposing to the right may be just about the same as using a lower ISO setting and exposing normally.)

You can't expose to the right if you have very-light-toned subjects in your scene because you don't want to burn out the highlights. Keep an eye on the histogram and keep pixels from bunching up at the far-right edge (the white point) of the histogram (see Chapter 3).

✔ **Set your camera to record Raw files or RAW+JPEG files.** Raw files can be processed after the fact to minimize noise, and they have more *overhead* (room for slight overexposure errors) than JPEG files. (Some slightly overexposed light tones that would burn out in a JPEG file can be saved in a Raw file.) To find out more about the advantage of Raw files, head to Chapter 3.

If you shoot Raw files, you can reduce the noise in your images by using Raw conversion software such as Adobe Camera Raw (ACR). For JPEG files, you can reduce noise by using Noise Ninja or Neat Image software. Just keep in mind that it takes some practice to get the right amount of noise reduction without oversoftening the image detail. (Sadly, this is another photographic trade-off.)

Of the three RGB color channels, the blue channel is usually the noisiest. If your photo-editing software lets you view channels, open some of your high-contrast images and look at the blue channel. If you convert your images to black and white, think about minimizing or deleting the channel with the most noise. For color images, think about applying just a bit of Adobe Photoshop's Gaussian Blur filter to the noisiest channel.

Maximizing noise

Most photographers don't want to maximize the noise in their images. Noise isn't considered very appealing, which is one reason camera manufacturers go to great lengths to reduce noise levels with each new generation of cameras. However, there may be a time when having a lot of noise in a particular image suits your artistic vision. If you want to maximize noise, you have a couple options:

✔ Crank up the ISO as high as it goes.

✔ Underexpose your photo by a few stops and then bring it back to a normal exposure by using photo-editing software.

My suggestion? Do a little experimenting. Try one option, then the other, then both together, and pick the final result you like the best.

A Pocketful of Sun: Electronic Flash

In This Chapter

▸ Getting a grip on flash and light falloff

▸ Simplifying your exposures with TTL flash

▸ Calculating the guide number when you use an accessory flash

▸ Playing around with flash and ambient light

▸ Looking at off-camera flashes and studio flash units

S ometimes having a little extra sunlight — in the form of an electronic flash unit — in your pocket comes in handy. Most small to medium-sized cameras have a built-in flash unit. These units usually work in an auto-only mode and have a limited range. Fortunately, you can purchase accessory flash units that mount in a camera's *hot shoe* (a spot on top of the camera) or studio flash units that put out a lot more light (which allows you to use lower ISO settings and smaller apertures).

In this chapter, I help you make the most of the built-in flash on your camera and explore ways you can use accessory flash units and light modifiers to make the light right for the kinds of images you want to create.

Flash 101

You use an electronic flash when the *ambient* (natural) light source is inadequate for the exposure you want to take. Case in point: Figure 10-1's photograph of mating birds would've been impossible to obtain without a

flash unit because the ambient light levels were too low and the birds were moving too quickly and fluttering their wings like crazy.

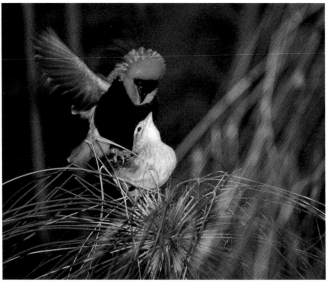

100–300mm lens at about 300mm, around 1/60 sec., about f/8, 50 at EI 40

Figure 10-1: An example of a photo made possible only by flash.

Flash is close to the color temperature of sunlight or slightly cooler, so when you decide to use your camera's built-in flash unit, set the white balance on your camera to the flash setting. (I tell you all about the color temperature of light in Chapter 5.)

Small light sources, like the sun and an electronic flash unit, provide hard light with sharply defined shadows because the light rays all come from the same direction. Big light sources, like the sky on a cloudy day, provide soft light with very soft shadows because the light rays come from many different directions. Because soft light is usually more flattering when you're photographing people, photographers come up with all kinds of light modifiers to soften the light from a flash unit.

The sun is considered a small light source because the size of a light source isn't determined by its actual physical size. Instead, it's determined by its apparent angular size relative to the subject. Although the sun is huge, it's so far away that it appears as a small light source when viewed from earth. (Any light source that you can hide behind your little finger is small in size.)

Looking at Light Falloff

Light falloff refers to light falling off with the square of the distance. In terms of exposure, this means you lose 2 stops of light every time you double the distance from the subject to the light source. If the distance between the subject and the light source increases from 10 feet to 20 feet, you lose 2 stops of light.

If you increase the distance to the light source by the square root of 2, you lose 1 stop of light. To keep the math simple, use 1.4 for the square root of 2. So if your subject is 14 feet from the light source, you have 1 stop less light than at 10 feet.

The human eyes and brain can't measure light falloff accurately because people don't see light intensity in a linear fashion. Instead, humans see light intensity as a little lighter or darker, even if the light is actually a lot lighter or a lot darker. In a photograph, all of that changes. Light falloff is obvious in a digital image, regardless of whether the light source is a light bulb or an electronic flash unit.

Light falloff also means flash units have their limits. Barring some miracle, you aren't going to light up the middle of a football field with your camera's built-in flash if you're sitting up in the nosebleed seats.

You need to be aware of light falloff and understand how to work with it because it changes how you light your subjects. In the following sections, I help you see for yourself how light falloff works and present ways to deal with it when you light your subjects.

Working with light falloff

To visualize light falloff, perform this simple exercise at night (or at any time in a room with no windows):

1. **Put a lamp in a corner of a room, preferably near an empty or mostly empty wall.**

2. **Take the shade off the lamp in order to expose the bare light bulb.**

3. **Turn off all other lights so the bare bulb is the only light in the room.**

4. **Set your camera to ISO 800 and set the aperture to f/4.**

5. **Meter the center of the wall and lock in that exposure.**

6. **Back up and take a picture of the whole wall.**

The light falloff in the resulting photo will be obvious: The farther from the light source, the darker the wall. If you meter the wall at 2 feet, 4 feet, and 8 feet from the light bulb, you should lose 2 stops of light with each jump in distance. A subject that's 22 feet from the light source will have 2 stops less light than a subject that's 11 feet from the same light source. At 5½ feet from the light source, a subject will have 2 stops more light than at 11 feet.

Figure 10-2 illustrates the concept of light falloff. The girl to the left is 5½ feet from the flash, the girl in the middle is 11 feet from the flash, and the girl to the right is 22 feet from the flash. I set the flash exposure manually for the girl in the middle. Consequently, the girl on the left is 2 stops overexposed, and the girl on the right is 2 stops underexposed.

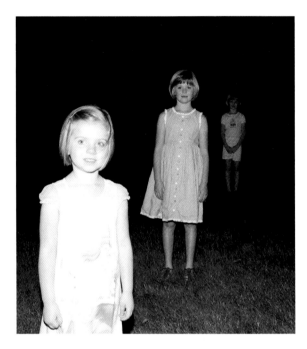

Figure 10-2: An example of light falloff (the flash was set manually for the middle subject).

If you have several subjects in your photo and you want all of them to receive the same amount of light, they need to be close to the same distance from the light source. Yep, you read that right. Your *camera* doesn't need to be at the same distance from all the subjects in your photos, but the *light source* does. If you use off-camera flash, you can position the flash at the same distance from all of your subjects while you shoot at a different angle to your subjects (as opposed to straight on).

Controlling backgrounds with light falloff

Light falloff doesn't have to be a detriment to your photos. You can actually use it to control the tonality of your backgrounds. If you like the background, put your subject closer to it. If you don't like it, move your subject farther away from it and position the flash closer to your subject. The resulting light falloff will make the background darker and less obvious.

If, for example, you expose for cousin Billy, who's 4 feet from the flash and standing right in front of a white wall, Billy will look fine, and the wall will look white. If, however, Billy is 4 feet from the flash, and the white wall is 11 feet from the flash, the wall will be gray due to the 2-stop loss of light. If Billy is 4 feet from the flash and the white wall is 44 feet from the flash, the white wall will be almost black due to the light falloff.

Instead of fussing with the math and multiplying by 2 or 1.4 (as I tell you to do in the earlier "Looking at Light Falloff" section), another way to think of light falloff is to convert the aperture series into feet to indicate the distance from the light source. Here's what the converted series looks like:

2 ft, 2.8 ft, 4 ft, 5.6 ft, 8 ft, 11 ft, 16 ft, 22 ft, 32 ft, 44 ft

On this distance scale, each time you move a step to the right, you lose 1 stop of light. For example, if you go from 8 feet to 16 feet, you lose 2 stops of light, and if you go from 2.8 feet to 11 feet, you lose 4 stops of light. With each step to the left, you gain 1 stop of light. So moving from 22 feet to 11 feet gives you 2 more stops of light.

Keeping Exposure Simple with Automatic TTL Flash

In my opinion, automatic through-the-lens (TTL) flash is just plain terrific. That's why it's a feature on most cameras. It works very well most of the time, and it's relatively easy to use. With TTL flash, the camera meters the light coming through the lens and turns off the flash when enough light hits the metering sensor. The flash exposure is therefore determined by what the camera sees.

TTL flash is a huge technological leap forward for the reliability of automatic flash, and it's getting better with each new generation. The next sections get you up to speed on all things related to the current state of automatic TTL flash.

Flash exposure compensation

TTL flash tries to make subjects look middle gray, or medium in tone. That means it's fooled by very light and very dark subjects. Enter *flash exposure compensation,* a quick way to tell your camera and flash to make your subject lighter or darker than a medium tone. It's the flash equivalent of the

ambient light exposure compensation I tell you about in Chapter 3. Most recent camera models have some form of flash exposure compensation (abbreviated FEC). Review your camera's manual to see whether yours does and to figure out how to access it.

Generally, here's how to use FEC:

- ✔ If your subject is light or very light, add ½ to 1½ stops of FEC to keep the subject light.

- ✔ If your subject is dark or very dark, set the FEC to –½ to –1 stop of exposure compensation.

In Figure 10-3's photo of a bride and groom, there's more white than black in the photo. Because of this, I set the FEC to +½. If the bride, in her white gown, had been the sole subject of the photo, I would've set the FEC to +1.

The amount of FEC is different for every camera. To test the FEC on your camera, take pictures of a very-light-toned subject and try all the plus (+) FEC settings to see which one works best for photographing a very-light-toned subject with your camera. Be sure to review the histogram as an additional check on the accuracy of your exposure (I explain how to use this feature in Chapter 3). Then take pictures of a dark-toned subject and try the minus (–) settings to see how much minus FEC you need to dial in for a dark-toned subject.

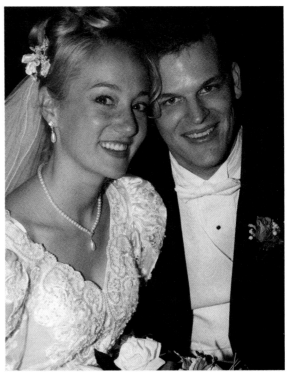

28–135mm lens at around 50 mm, around 1/125 sec., about f/8, 400

Figure 10-3: A bride and groom, shot with TTL flash set to +½ compensation.

If you can set FEC on a separate flash unit *and* on your camera, don't set both because they can throw each other off (at least with some camera models). Get in the habit of using one or the other — preferably the one that's simpler to adjust.

Don't confuse flash exposure compensation with exposure compensation. *Flash exposure compensation* changes the flash exposure without changing anything else. *Exposure compensation* changes the ambient light exposure by altering the aperture and/or shutter speed. If you're mixing flash and ambient light, use FEC to change the flash exposure without changing the ambient light exposure.

Note: On some camera models, exposure compensation also changes the FEC. So, for instance, if you set the exposure compensation to –1 and the FEC to –1, the net FEC will end up being –2, and the ambient light exposure will still be –1. Check your manual to find out whether your camera does this.

Flash duration and subject distance

Light from a flash looks instantaneous, but it has duration even if it lasts for a very short period of time. What I mean by this is that when you click the shutter, the flash starts pumping out light, which bounces off the subject and returns through the lens. When enough light passes through the lens, the camera tells the flash to stop pumping out light. If the subject is farther away or if you're using a smaller aperture setting, the flash pumps out light for a longer period of time, like 1/500 second. If the subject is closer or if you use a wider aperture, it pumps out light for a much shorter period of time, like 1/25000 second. Either way, flash appears to work in the blink of an eye. After it pumps out all the light it has to give, it quits, regardless of whether the subject has received enough light for a good exposure.

Most accessory TTL flashes have a scale on the back that lets you know the maximum and minimum distance the flash can cover for a given f-stop and ISO setting. If you don't have enough flash power for a distant subject, use a wider aperture to let in more light or switch to a faster ISO speed.

Figure 10-4 shows the back of a flash unit set to automatic TTL metering (Canon's version is called ETTL). The camera ISO is set to 100, and the aperture on the 24mm lens is set to f/11. The distance range is 1.7 feet to 10 feet. If you were to use these camera settings for a subject 20 feet away, the flash would run out of light, and the subject would be underexposed. You'd need to change the ISO to 400 or change the aperture to f/5.6 to make up for the 2-stop loss of light. Either choice would give you a good exposure at 20 feet.

When you're working at very close distances at high ISO speeds and/or wide apertures, sometimes the flash and camera can't properly communicate. By the time the camera tells the flash to stop, it's too late — your photo is already overexposed. To avoid any unpleasant exposure scenarios, always pay attention to the distance scale on the flash; it indicates the closest safe distance for a given aperture and ISO.

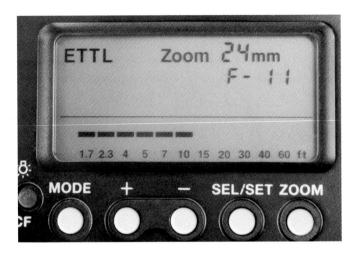

Figure 10-4: Newer Canon flash unit in TTL mode.

Built-in versus accessory TTL flash units

The main advantage of the built-in TTL flash on your camera is that you always have it with you. It's quick and convenient, and you don't have anything else to carry or buy. The disadvantages are the flash's lack of power, the inability to control the direction it's pointing, and its proximity to the line of sight of the camera lens (which increases the chances of red eye in your subjects).

Accessory TTL flashes that mount in your camera's hot shoe have a lot more power (that is, they can pump out a lot more light) than a built-in flash unit. Many of them swivel and tilt so you can point them wherever you want, allowing you to bounce the light off a nearby white wall or ceiling to create softer light (don't bounce the light off a colored wall, though, unless you want to color your subject). The light from a shoe-mount flash sits higher above the camera's lens than a built-in flash, reducing the chances of red eye.

If all of that isn't enough, there's the additional bonus of being able to use accessory TTL flash units off camera for even greater lighting flexibility. You can also use an accessory flash in manual mode for those tricky situations when the automatic TTL mode just can't get the exposure right.

Accessory TTL flashes can also be used with several light modifiers to soften or shape the light. You just have to mount your accessory flash and an umbrella on a tripod or light stand (as shown in Figure 10-5) and start shooting. The umbrella softens the light, giving you a quality of light that's impossible to achieve with the camera's built-in flash.

When you buy a shoe-mount flash, be sure it's specifically designed for your brand and type of camera. Also, be very careful about using an older flash unit on your new whiz-bang digital camera. If the trigger voltage of the older flash unit is too high, it'll fry the brains out of your digital camera and void the warranty. Do the research before you put an old accessory flash in your new camera's hot shoe.

Figure 10-5: Accessory flash, adapter, and umbrella.

Determining the Guide Number of Your Accessory Flash

Automatic TTL flash has changed the flash world, and it works well most of the time. However, it's easily fooled by some subjects, such as coats with bright reflective tape (like those worn by rescue workers). Whenever your

automatic TTL flash can't give you the right look, switch to manual flash mode and determine the proper f-stop with the help of your personal guide number.

A *guide number* (GN) is a way of expressing a flash's maximum power output for a given ISO. You can find it in the accessory's manual, or you can conduct a simple test to determine your own personal GN for the way you want your subjects to look. (*Note:* You can't determine a personal guide number for a built-in flash unit because this unit doesn't have a manual mode. In this case, your only option is to go with the manufacturer's published GN.)

When you use your flash at full manual power, the GN is equal to the flash-to-subject distance (D) multiplied by the aperture (F), or GN = D × F. Following are a couple different versions of this formula:

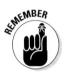

- ✔ **F = GN ÷ D:** This one means that the f-stop you should use is equal to the GN divided by the flash-to-subject distance. This is the formula you'll use most often.

- ✔ **D = GN÷ F:** This one means the flash-to-subject distance is equal to the guide number divided by the f-stop in use.

In the following exercise, you use the first formula, GN = D ÷ F, to determine the GN for your flash. Create a set of large white cards with the following apertures written on them in bold letters: f/4, f/5.6, f/8, f/11, f/16, f/22. Then grab your cards and a partner and head outside late in the evening (you want to perform this exercise when it's getting dark outside so the ambient light doesn't affect your overall exposures).

1. **Set your camera to ISO 100, manual exposure mode, shutter speed at 1/125 second (or the flash sync speed — check your manual).**

 The *flash sync speed* is the fastest shutter speed at which the flash can illuminate the whole frame at one time.

2. **Set the flash to full manual power for all the pictures; if your flash has a zoom function, set it manually to the widest zoom setting.**

3. **Have your assistant stand 11 feet from you and your camera-mounted flash.**

4. **Ask your assistant to hold up the f/4 card, set your aperture to f/4, and take a picture of your assistant.**

5. **Do the same with the rest of the cards, making sure to match the aperture to the card.**

When you're all done, you should have six pictures that look something like Figure 10-6. Select the one with the best exposure (that's the one you like best) and multiply the aperture used in that photo by 11 feet (the distance from the flash to your assistant) to figure out your personal GN for your flash when you shoot at ISO 100. So if you like, say, the f/8 picture best, your GN is 88 (f/8 × 11 feet).

Depending on what the GN is for your flash at a particular ISO (and assuming you want to use the flash in full manual mode), you need to divide the GN by the flash-to-subject distance to discover the f-stop you need to use. If, for example, the GN for your flash at ISO 100 is 88 and the subject is 22 feet from the flash, the f-stop is f/4 (88 ÷ 22 feet).

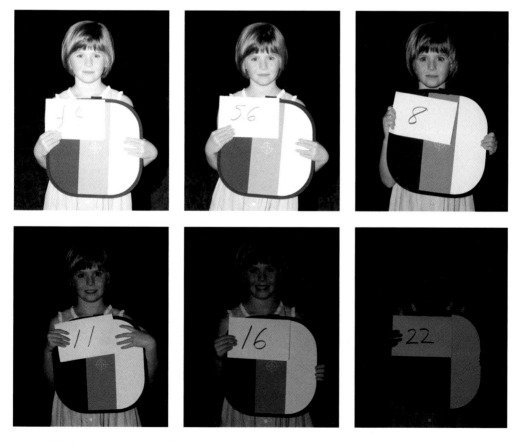

Figure 10-6: Guide number test at different apertures.

Sooner or later, either with your built-in flash or your accessory flash, you'll divide the flash-to-subject distance into the GN and discover you don't have a wide enough lens aperture to give you a good exposure. When that happens, you must either move the flash closer to the subject (if possible) or boost the ISO.

If you increase the ISO by 1 stop (say from ISO 100 to ISO 200), you multiply the GN by 1.4 ($88 \times 1.4 = 123$). When you increase the ISO by 1 stop, you also increase the effective maximum working distance of the flash by the same factor of 1.4. If you increase the ISO by 2 stops, you multiply the GN by 2 ($88 \times 2 = 176$), doubling the effective maximum working distance of the flash.

Say your subject is 44 feet away. The f-stop would be f/2 (88 divided by 44). If the fastest f-stop on your lens is f/4, you either need to move the flash so it's only 22 feet from the subject or you need to change the ISO from 100 to 400. Both actions let you take the photo with an aperture of f/4 (the ISO 400 GN of 176 divided by 44 feet equals f/4).

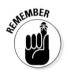

With the GN of your flash locked securely in your head, you're guaranteed to know the smallest aperture you can use for the subject distance when you use your flash in automatic TTL mode. For instance, if your GN is 88 and the subject is 11 feet away, divide 88 by 11 to get f/8 — the smallest aperture you can use and still get a good exposure. (If you use a smaller aperture, like f/22, the flash will run out of light before the subject is properly exposed.)

Mixing Flash and Ambient Light

Technically speaking, every time you use flash and push the shutter button, you're creating two exposures: a flash exposure and an ambient light exposure. Practically speaking, in dark conditions with fast shutter speeds, the ambient light exposure doesn't show up in the photo.

The ambient light exposure is determined by both the shutter speed and the aperture, whereas the flash exposure is determined solely by the aperture. Shutter speed has no effect on the flash exposure, which means you can change the ambient light exposure without changing the flash exposure simply by changing the shutter speed. Use faster shutter speeds to minimize or eliminate the ambient light exposure, and use longer shutter speeds to increase the ambient light exposure.

Note: There is a limit to how fast a shutter speed you can use. Most cameras don't let you use a shutter speed faster than the flash sync speed.

In the following sections, I show you several ways to mix flash with different ambient light levels.

Exploring the different combinations through your camera's various modes

You can mix flash and ambient light automatically or manually, but the exposure modes and how they work vary a bit from one brand and model of camera to the next. Always check your camera's manual for the most specific instructions.

Here's what happens with the modes on many camera models if you set your flash to automatic TTL exposure:

- **Program mode (P):** In program mode, some cameras give priority to the flash exposure and ignore the ambient light exposure. You end up with a dark background and a subject that's lit well by the flash.

- **Aperture-priority mode (Av):** In aperture-priority mode, you set the aperture, and the camera gives you a good exposure for the flash-lit subject. It also gives you a long enough shutter speed to create a good ambient light exposure. Keep in mind that in low light, your camera needs to be on a tripod if the camera picks a slow shutter speed.

- **Manual mode (M):** In this mode, you make all the ambient light decisions, and the camera gives you a good flash exposure for your subject.

- **Shutter-priority mode (Tv):** In this particular mode, the camera gives you a good flash exposure for your subject and picks an aperture that gives you a good ambient light exposure for the background. Sometimes that isn't possible though, so you have to pick a different shutter speed. Personally, I never use shutter-priority mode when I'm working with flash.

In manual and aperture-priority mode, you use the GN to make sure the aperture isn't too small for the flash-to-subject distance. In shutter-priority mode, after you choose a shutter speed, you make sure the camera doesn't pick an aperture that's too small for the subject distance. If it does, you have to pick a different shutter speed. (If you're getting the idea that shutter-priority mode creates extra work for you, you're right.)

Adding just a touch of flash in high ambient light levels

When you mix flash with high ambient light levels, the ambient light is usually the main light, and the flash is usually the *fill light* (the light that helps fill in the shadows).

If you're photographing a scene in which there's a great deal of ambient light, like a sunny day with strong shadows, meter for the ambient light level first, as if you aren't even going to use flash. Then turn on your flash and set it to some minus (–) FEC. The goal is to throw just enough light into the shadows without it being obvious that a flash was used.

I've learned from past experience to set the FEC to –1 or –1½ stops to achieve the look I like. You can see how this setting turns out in a high ambient light scenario by looking at Figure 10-7. I took one photo without flash; the sunflower petals looked great, but the dark seeds in the center disappeared. I added flash with FEC set to –1 and the photo came out just right.

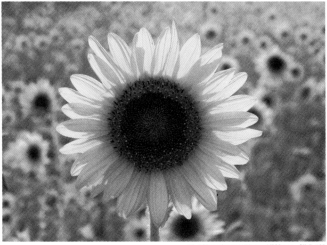

28–135mm lens at 53mm, 1/200 sec., f/9.5, 100

Figure 10-7: Sunflowers shot with auto TTL fill flash at –1 FEC.

Knowing my FEC preference in high ambient light scenarios is all well and good, but the real question is this: What look do *you* like? To find out, you'll need a victim, I mean friend, to photograph in the sunlight. After you have one lined up, pick a bright, sunny day, one where the sun's fairly high in the sky, and follow these steps:

1. **Set your camera for basic daylight exposure (BDE) without exceeding your camera's flash sync speed.**

 An aperture of f/16 and a shutter speed of 1/100 second should be just fine at ISO 100. For the full scoop on BDE, refer to Chapter 4.

2. **Have your friend turn so the sunlight is coming across her face at an angle, with about two-thirds of her face in the sunlight and the rest of her face in shadows.**

3. **Set the FEC to –⅓ or –½ and take a picture.**

4. **Take more pictures using the other minus FEC options available to you, all the way down to –2 stops.**

5. **Compare the photos and decide how much minus FEC gives you the look you like.**

Relying on flash in low ambient light levels

In low ambient light levels, the flash is usually the main light. If it's not, it's at least equal in intensity to the ambient light.

If you want the ambient light levels to be close to the flash in intensity, you're faced with either slow shutter speeds and blurred subjects or higher ISO settings (which give you faster shutter speeds in low light). You can take either approach, but bear in mind that slow shutter speeds can be pretty cool. You can end up with a subject that's not only frozen by the flash but also blurred due to the long shutter speed. See for yourself the next time the light levels are low and people are moving (like at a dance or wedding reception).

Improving Light Quality with Off-Camera Flash

Flash isn't available solely on your camera. Off-camera shoe cords, infrared transmitters, and radio-controlled units allow you to create off-camera flash in both automatic TTL and manual mode, which opens up all kinds of possibilities for your photos. Getting the flash off the camera immediately gives you a different look from 97.3684 percent of the photos taken with flash. Granted, I made that statistic up, but I bet it isn't too far off. With the flash off the camera, you can experiment with different lighting angles for a more dramatic look. Check your flash manual and the manufacturer's Web site for ways your flash and camera can communicate with each other when the flash is off the camera.

If you're using a flash in manual mode, you can use a simple optical *flash slave,* a device that sees the light from another flash and fires the flash to which it's connected. You can use your camera's built-in flash to trigger the optical slave to fire the accessory flash.

The off-camera flash photo in Figure 10-8 was pretty simple to take. The flash was my main light source. I metered the sky in manual exposure mode, and I put a wireless transmitter on the camera and a tripod-mounted flash out in the street, facing the model on the sidewalk. The flash was in auto TTL mode and set to slave mode so it would listen to the transmitter. The camera, wireless transmitter, and flash took care of the flash exposure automatically.

Of course, there's nothing like seeing for yourself the difference off-camera flash can make. If you have a camera with a built-in flash, a shoe-mounted flash unit, and a tripod, all you need to get your flash off the camera is a simple optical flash slave like the Wein HS Hot Shoe Slave, which costs about $35. You need to use the flash in manual mode, so determine your personal guide number following the steps I provide in the earlier related section. Then grab a friend and follow these steps.

1. **Head downtown shortly after sunset with your gear and your friend and pick a wide sidewalk that has city lights and a deep blue sky for a background.**

2. **Put your shoe-mounted flash on your camera and set it to auto TTL.**

3. **Set your camera to aperture-priority mode, making sure you haven't picked too small of an aperture for the flash-to-subject distance.**

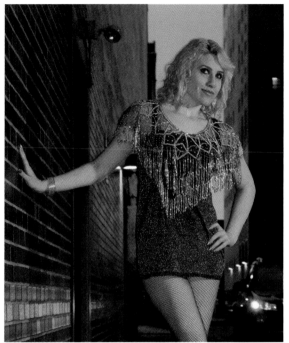

24–105mm lens at 105mm, 1/8 sec., f/8, 400

Figure 10-8: The results of off-camera flash set to TTL auto.

4. **Take a picture of your friend with the city lights and the deep blue sky in the background.**

 Your camera should give you a good flash and ambient light exposure. If it doesn't, adjust the FEC and/or the exposure compensation until you like the exposure mix.

5. **Set up your tripod, screw the flash slave onto the tripod, slide your flash into the slave, and place the tripod-mounted flash so your model will be sidelit.**

6. **Point the clear dome (containing the light sensor) on the slave toward your camera position and rotate the flash head so it faces your model.**

7. **Turn on your built-in flash and set FEC to its lowest minus (–) setting.**

 The only purpose of the built-in flash is to trigger the flash slave.

8. **Use the aperture on your camera (which should still be in aperture-priority mode) and the GN for your tripod-mounted flash to determine the flash-to-subject distance and place your tripod accordingly.**

9. **Take another picture of your friend and check the exposure.**

 To adjust the ambient light exposure, use exposure compensation on the camera. To change the flash exposure, move the tripod closer or farther away from your friend. Experiment until the exposure mix is just the way you want it.

 Your final sidelit, off-camera flash photo should be dramatic and noticeably different from the first photo taken with the accessory flash on the camera.

Stepping Up to Studio Flash Units

Studio flash units are the ultimate in terms of power (light output) and flexibility (several light modifiers are available for shaping and controlling the light). Studio lights allow you to use a variety of apertures, ISO settings, and flash-to-subject distances that are harder to use with shoe-mount flash units. These units run on 120-volt household current and are bigger and heavier than shoe-mount flashes, which is why they're a pain to use on location. But for studio work, they're great.

You can spend a fortune on studio lighting, or you can purchase a studio flash, stand, and umbrella kit for about $300.

Figure 10-9 shows a small studio setup with studio flash units, stands, and umbrellas. Lots of photographers use a setup like this in a room or garage in their home.

Studio flash units are manual only, meaning you must change the power output with controls on the unit. The best way to use these units is with an incident light meter (I describe this type of meter in detail in Chapter 4). Hold the meter close to the subject's face (the distance really matters), point the white dome at the flash unit, and fire the flash. The meter will tell you the right f-stop to use. If you want to use a different aperture, change the power output of the flash unit and check again with the meter. If you have multiple flash units, you can meter each one separately and meter again with all of them on together.

TIP

If you don't have an incident light meter, you can take a picture of a calibration target at the subject's position and check the histogram. Simply adjust the output of the flash until you get a good histogram (I cover histograms in detail in Chapter 3).

Figure 10-10 shows the three separate parts of a typical three-light setup for portrait work. In this setup, you have a main (or key) light to the right of the subject (you "key" in on this light as the basis for your exposure; see the top-left photo in Figure 10-10), a fill light to the left of the subject (to put some light in the shadowy areas; see the top-right photo in Figure 10-10), and a hair light high and behind the subject (to add highlights to dark hair and give the photo some extra pizzazz; see the bottom-left photo in Figure 10-10). I moved the output slider for the fill light up and down until the modeling lamps for both flashes showed a pleasing balance of light and shadow. (*Modeling lamps* are light bulbs built on studio flashes that track the relative brightness of the flashes, a feature that allows you to preview the relative intensity of the light output before you take the picture.) The bottom-right photo in Figure 10-10 shows the result when you put all three lights together.

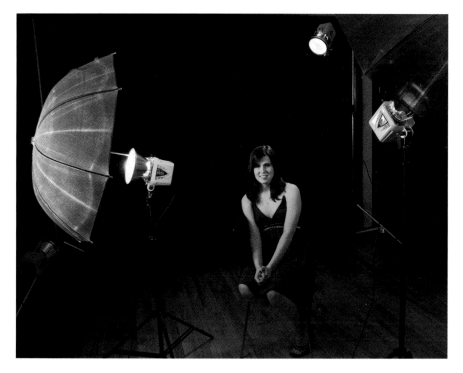

Figure 10-9: A common studio lighting setup.

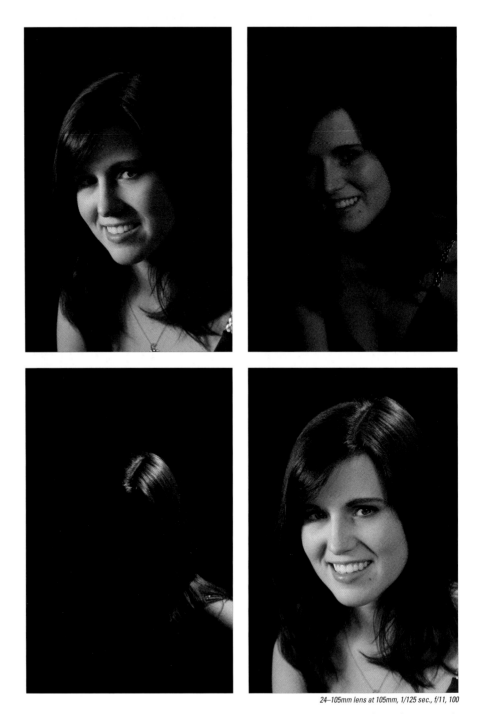

24–105mm lens at 105mm, 1/125 sec., f/11, 100

Figure 10-10: Different types of light for portraits: Main (top left), fill (top right), hair (bottom left), and all three put together (bottom right).

Part III
Taking Exposure a Step Further: Creating Great Images

The 5th Wave By Rich Tennant

"It's a seascape I took in Hawaii with a polarizing filter. That would explain the igloos on the beach."

In this part . . .

A world of photographic possibilities is out
there — each with its own unique exposure
challenges and creative choices. The chapters in
Part III send you on a photographic quest to
explore these challenges and choices in real-
world scenarios. If nature is your thing, you can
find chapters on landscapes, wildlife, and flowers.
If you like to explore the human drama, turn to
the chapters on photographing people and sports.
Basically, try out anything that interests you.

11

Candids, Portraits, and More: People Photography

More pictures are taken of people every day than any other subject. And why not? People are fascinating, and capturing those fascinating — and often fleeting — moments creates memorable photos.

This chapter shows you how to put some pizzazz into your people photography. Whether you're photographing indoors or outdoors, taking candids or portraits, or snapping photos of family and friends or total strangers, this chapter is full of hands-on ideas that you can put into practice right away. I take you through the basics, show you the best equipment, and then give you several ideas and options for everything from finding ideal locations (both outdoors and indoors) and posing people to working with children and arranging groups.

Diving into the Basics

Eye-catching people photography often comes down to several basics. Make sure the following list of basics becomes second nature to you if you plan on photographing people:

- Focus on the eyes (99 percent of people photos with blurry eyes are worthless).

- Use lenses in the 70–150mm range for head-and-shoulder portraits and the 40–60mm range for full-length portraits.

- Shoot on "cloudy bright" days with minimal shadows because soft light is best.

- Put the sun behind your subject on sunny days, except at sunrise and sunset.

- Pick good locations and avoid distracting backgrounds.

- Take lots of photos.

- Shoot every face from slightly to the left, slightly to the right, and straight on.

- Position your subject's body so it's at a slight angle to the camera.

- Build a rapport with your subject by taking the time to ask about his interests. Look for natural smiles and capture those moments, along with moments when your subject is more reflective. If you ask people to smile or say "Cheese," you often get a forced or unnatural smile. Catching a natural smile is better, even if it takes more time.

After you have the basics down pat, go ahead and change 'em! You may find that you get some of your best shots this way.

Note: One more basic point to keep in mind is that great moments are fleeting. Just look at Figure 11-1. I happened to have a camera when I noticed these brothers taking a nap. One was just about to wake up the other. If I'd waited just a couple minutes before clicking the shutter, the opportunity would've been lost.

24–105mm lens at 40mm, 1/8 sec., f/4, 1600

Figure 11-1: Always be prepared for perfect, fleeting moments.

Changing the Perspective with Lenses

In the photography world, *perspective* is the size relationship of things at different distances from the camera lens. Although photographers talk about "wide-angle perspective" and "the telephoto look" as a matter of convenience, the *location* of the camera changes the perspective of the photo, not the focal length of the lens you're using. If your lens is too close to someone's face, the resulting photo will be distorted.

To fill a camera's frame with a person's face by using a 200mm lens, you need to be about 7 feet from your subject. To fill the frame with a subject's face by using a 15mm lens, the distance shrinks to about 1 inch from your subject's nose. It's this change in distance that distorts the subject. Such distortion is obvious in Figure 11-2, which I shot with a 15mm *fisheye lens* (this type of lens bends all straight lines that don't go through the center of the frame). On the flip side, if you photograph a person with a 15mm lens at 7 feet and crop the photo to show just the face, the face looks the same as the photo at 7 feet with a 200mm lens.

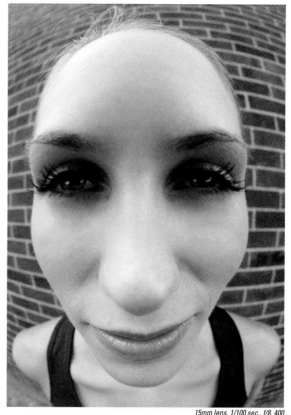

15mm lens, 1/100 sec., f/8, 400

Figure 11-2: A portrait created with a fisheye lens.

Keep the following perspective pointers in mind when doing portrait work:

✔ When taking head-and-shoulders portraits, the perspective looks more natural if you use short telephoto focal lengths in the 70 to 150mm range (35mm equivalent). If you're taking full-length portraits, 40 to 60mm focal lengths are okay. When in doubt, the longer the focal length, the better. (**Note:** If you're using a cropped-frame digital camera, multiply the recommended focal lengths by ⅔.)

✔ Head-and-shoulders portraits usually look best if you have the camera a little above your subject's eye level. This camera positioning puts the emphasis on the eyes. Shooting from a lower angle puts more emphasis on the nostrils, mouth, and chin.

✔ When you take full-length portraits, back up and put the camera at the level of your subject's waist. Doing so keeps the body in proportion. For instance, the photo in Figure 11-3 was taken at 38mm on a cropped-frame digital camera, the equivalent of 60mm with a full-frame digital camera.

✔ Full-length portraits look best when taken at the waist level. When you shoot a full-length portrait at your subject's eye level with a wide-angle lens, the lower half of his body looks odd, and the legs look short. If you shoot from down low with a wide-angle lens, the legs look long.

28–135mm lens at 38mm, 1/45 sec., f/8, 100

Figure 11-3: The camera was even with the subject's waist for this full-length portrait.

Metering Faces

Metering for portraits is almost always easy because you can just walk up to your subject and check the light — something you shouldn't do with most wildlife subjects. You have several metering options:

✔ Take an incident light meter reading with the white dome right in front of your subject's face or meter a gray card in the same light as your subject. If your subject has light skin, no exposure compensation is necessary. If your subject has very dark skin, add ½ to 1 stop of light. (I explain how to perform exposure compensation in Chapter 3.)

✔ Meter your subject's face with your camera meter. If the face is light in tone, add ½ to 1 stop of light. If the face is dark in tone, subtract ½ to 1 stop of light. For Figure 11-4, I metered the model's face and added a stop of light.

24–105mm lens at 55mm, 1/40 sec., f/5.6, 400

Figure 11-4: Adding light to the meter reading allowed for an accurate shot of the model's skin tones.

When using a short telephoto lens, f/8 and f/11 are good, all-purpose portrait apertures. Low light or the need to blur a distracting background may force you into using wider apertures. The need for more depth of field when shooting groups calls for smaller apertures, such as f/16 or f/22.

When you begin a portrait session, take some pictures from the left side of the face (at a slight angle and with the right ear just barely out of view), from the right side of the face (at a slight angle and with the left ear just out of sight this time), and from straight on. Why? Because some people have a "good side" that photographs better. Show the photos to your subject and without mentioning "sides," ask which photos he likes best. If all the photos he picks are from one side or the other, you'll know his preference right away. For the rest of the session, spend more time on the preferred side of the subject's face.

Shooting Outside

Shooting pictures of people outside means you have to be prepared to deal with several factors you can't control completely, such as the weather and the light. The following sections give you some ideas on how to work with the different types of light you can encounter outside, as well as how to coach your subjects into effective poses.

Scouting out favorable locations before you photograph someone outside is always a good idea. For instance, the location used in Figure 11-5 is one of my favorites for creating digital multiple exposures. With my camera on a tripod and the focus and exposure set manually so they wouldn't change between frames, I asked the model to try several different poses in each of the three primary areas of the chosen location (left, middle, and right), about a dozen in all. I created the digital multiple exposure on my computer by picking one pose from each area of the location and combining them by using photo-editing software. (*Note:* For a multiple exposure to work, the light can't change between frames.)

24–105mm lens at 32mm, 1/4 sec., f/9, 400

Figure 11-5: A digital multiple exposure.

Working with sunlight

Although people usually look best in soft light (as I explain in the next section), sometimes you have to work with the sun. When photographing people in sunlight:

- ✓ **Crop a backlit person as tightly as possible to minimize the blown-out areas in the photo.** In Figure 11-4, the sun is behind the subject, and the light is bouncing off the columns and back into her face. Cropping the top of the photo as much as possible minimizes the washed-out background.

- ✓ **Avoid frontlight.** People tend to squint when the sun is in their face, and you can get dark shadows in the eye sockets as a result, so frontlight is rarely a good choice. If you're stuck with frontlight, use fill light (which I describe in Chapter 10).

- ✓ **Take advantage of sidelight.** It can provide some interesting possibilities, so it's worth trying. A face half in sun and half in shade can be quite interesting. Sidelight amplifies skin imperfections (just like it enhances textures in landscapes), so you need either excellent retouching skills or a subject with flawless skin.

Using soft light

Soft light is beautiful light for photographing people because it hides imperfections in the skin, whereas hard light amplifies every pore, flaw, wrinkle, and crease. See the benefits of soft light for yourself in Figure 11-6. (Also notice how the gritty look of the stairs is a natural fit for a black-and-white image.)

24–105mm lens at 80mm, 1/60 sec., f/8, 200

Figure 11-6: Soft light creates beautiful portraits.

Soft light is available on cloudy-yet-bright days when a thin layer of clouds softens the sunlight so there are minimal or no shadows. They're the best kind of day for photographing people outside.

You can create your own soft light on a sunny day by looking for a little shade. Colors can shift in the cool direction though, so set a custom white balance with your camera (check your camera manual for directions).

Posing

If you don't happen to be working with a professional model, be prepared to give your subject some advice about how to pose. Helping others pose is an art that you acquire over time, and the more you work at it, the better you get. Here are some ideas for achieving comfortable, yet effective, poses:

✔ **Study poses in magazines.** Fashion magazines in particular are bound to have models in all kinds of interesting and creative poses that you can mimic with your subjects. Put the pictures you like in a folder and study them to figure out what you like about the poses.

✔ **Use a chair as a simple posing tool.** Ask your subject to straddle a chair while facing the back of it and leaning on it with his arms. This is a comfortable, natural pose that puts your subject at ease. You can include the hands and arms or crop tighter for a head-and-shoulders portrait.

✔ **Always have your subject doing something.** The worst thing you can do as a portrait photographer is let someone stand there and face the camera with his arms hanging by

70–200mm lens at 106mm, 1/160 sec., f/10, 400

Figure 11-7: A casual look rather than a posed one.

his sides. Instead of committing this crime, have your subject lean on something, sit down, or do something. When taking the photo in Figure 11-7, I suggested the subject lean against a column and cross his arms for a nice, casual look.

✔ **Make sure the hands aren't both hanging limp.** When your subject is standing, never let both of his hands hang limp. At least one hand should be doing something, whether that's resting on a hip, leaning on something, or holding something (like a jacket slung over a shoulder). You can even have a thumb tucked into a pocket or belt loop. The important thing is to keep the hand from looking lifeless.

24–105mm lens at 84mm, 1/200 sec., f/7.1, 100

Figure 11-8: A natural pose when sitting.

✔ **Have standing or sitting subjects turn their bodies at an angle to the camera.** People generally look better when positioned this way, as opposed to straight on. Figure 11-8 is an example of a pose with a person sitting at an angle to the camera with his arms on his legs and his hands together.

Shooting Inside

You can take pictures of people anywhere — inside and outside — but the indoor environment gives you more control over the light (although it's harder to do initially). When you first start doing portrait photography, it's easier to create great portraits outdoors in soft light than indoors in artificial light. Soft, outdoor light is very forgiving. You don't need to give too much thought to the light, so you can spend more time thinking about exposures,

lenses, poses, and facial expressions. Artificial, indoor light, however, demands all of your attention. Fortunately, with a little guidance and experience, you can get the lights sorted out and go back to focusing on poses and expressions.

Working with light in a home studio

If you get seriously involved in portrait photography, a home studio may be in your future. Relax! Your home studio doesn't need to be fancy or frightfully expensive. Start small and acquire equipment a little at a time, starting with the basics: a backdrop of some sort and some lights. The sections that follow explore your lighting options in a home studio setting and present some suggestions for different types of portrait scenarios.

Window light

If you have a window in your studio that provides good light, use it. You can get some very nice, soft, directional light this way. You can see a formal window light portrait in Figure 2-5 of Chapter 2.

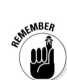

The light diminishes rapidly as you get farther from a window, so keep your subject close to the window.

When you use window light, you can meter the side of the subject's face that's toward the window and let the rest of the face go darker (this is my preference most of the time). Another option is to meter the darker side of the face and let the bright side go lighter. Try it both ways and see which you prefer.

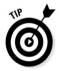

If the light from the window is too hard (especially if the window faces south), use a white, translucent window blind to soften the light.

Studio lights

For studio lights, you can start with the same kind of shoe-mount flash units that go on your camera. If you already have one, all you need to add is an umbrella and either a bracket (so you can mount your flash and umbrella on a tripod) or a light stand. A lot of studio photographers get started this way. This approach is nice because it gives you a chance to see whether you like studio photography before making an investment in more powerful studio lights.

One of the advantages of small flash units is their portability. Because they run on batteries, you don't need an outlet when you're out shooting on location. Some wonderful location work is being done with these small, battery-powered flashes. The big disadvantage is that they have a lot less power than traditional studio lights, so you have to use higher ISO settings with a slight increase in digital noise (see Chapter 9 for more on this).

You can also try flash units specifically designed for studio use. Such studio lights have a lot more power than shoe-mount flash units. Two kinds of studio lights exist:

- ✔ **Monolights:** These are self-contained units, each with its own built-in power supply and separate power cord.
- ✔ **Flash outfits:** These kits have separate flash heads that all plug into one power pack.

Chapter 10 shows how to use a basic three light studio setup, but you don't need to start with three lights. You can begin with one or two lights and still have a lot of creative possibilities.

I used two studio lights with umbrellas to create fairly even lighting in the left photo in Figure 11-9, and then I used a single studio light with an umbrella to create a high-contrast portrait of the same model (see the right photo in Figure 11-9). You can do it the other way around and create even light with just one studio light and a high-contrast portrait with two lights. The difference lies in how you choose to position your lights.

24–105mm lens at 105mm, 1/125 sec., f/11, 100 24–105mm lens at 75mm, 1/100 sec., f/11, 100

Figure 11-9: A comparison between even (left) and high-contrast (right) lighting.

If you want to have two studio lights but aren't ready to get both right now, you can purchase one studio light kit (which consists of a flash, a stand, and an umbrella) from a manufacturer such as Alien Bees (www.alienbees. com) for about $300. You can use a commercial or homemade reflector (like a

sheet of white foam core from an art-supply store) to bounce light back into the shaded side of your subject's face until the day comes that you can purchase a second light kit.

Purchasing studio lights is a major commitment toward doing studio portrait photography. If you only do an occasional indoor portrait shoot, you may be happiest with umbrellas and one or two shoe-mount flash units. If the time ever comes that you need studio lights, you'll know.

Picking up tips for studio portraits

Following are some portrait pointers that may help you in the studio:

✔ If you're taking a formal portrait of a couple, put their faces on the diagonal from each other, as in Figure 11-10. One way to do this is to have one person sit on a stool and have the other person stand behind the seated person. You can use an adjustable posing stool or stools of different heights to change the height relationship between the two subjects. Regardless, make sure you use a small aperture to create enough depth of field.

24–105mm lens at 73mm, 1/125 sec., f/14, 100

Figure 11-10: This couple's faces are on a diagonal.

✔ After children get past a certain age, most of them can pose quite nicely in the studio. One simple pose is to have a child straddle a child-sized chair and rest his arms on the back of it. Or you can ask the child to keep his elbows on the back of the chair and rest his head gently on his hands (see Figure 11-11).

When photographing children in your studio, be sure to take some time to find out what they like. Talking about what they like gives you more natural smiles than if you ask them to smile (which can result in some pretty weird smiles).

24–105mm lens at 65mm, 1/60 sec., f/11, 100

Figure 11-11: A studio pose for a boy.

Keeping Up with Moving Children

Photographing an active, young child is more like photographing a sporting event than shooting a portrait. Your best bet is to let the child do the things he likes to do and follow him around with a camera while he does them. Stay at his eye level, not yours, or just sit on the ground while the child plays around you. Take lots of pictures and keep an eye out for those fleeting priceless moments.

Photographing children on playgrounds is a great way to get happy faces, like the one in Figure 11-12. The subjects have fun playing, and you get lots of exercise.

If you have an opportunity to photograph kids playing sports, turn to Chapter 15 for pointers on sports photography.

28–135mm lens at 30mm, 1/125 sec., f/7, 100

Figure 11-12: Boy inside a blue slide.

Arranging Groups

The better your picture-taking skills, the more likely it is that you'll be asked to photograph groups of people. Here are some tips and ideas for arranging and photographing groups:

- ✔ **Be creative when you arrange everyone.** Don't just line up everyone in a row.

- ✔ **Create height differences among the subjects when you're photo-graphing three people.** The usual advice is to pose people so that a line drawn between their heads forms a triangle. The simplest way to

do that is to have two people sit on posing stools and have the third person stand slightly behind and in between them. Stairs are another option with two people on one step and the third on a lower step.

- ✔ **Cluster larger groups of people.** In a large family group, this usually means having some people sit on the ground, more people sitting in chairs, and some people standing. Put the tall people on the ground and have the short people stand. This trick keeps everyone's heads closer together.

- ✔ **Use soft, even light for the whole group.** The fun and creative tricks with lights and shadows that you use when lighting one person just don't work for groups.

- ✔ **Use smaller apertures for more depth of field.** This is necessary because some people are farther from the camera than others. I frequently use an aperture of f/16 when photographing groups of people.

Sometimes a little creative thought helps you come up with a unique arrangement. Take the photo of three generations of women in Figure 11-13. With no posing stools in sight, I decided to line up the women from front to back with their faces in profile. As luck would have it, their heights lined up. (If they hadn't, I'd have been looking for phone books for one or two of them to stand on.) I used an aperture of f/16 in order to have enough depth of field. The cloudy day made for soft light, but I needed to boost the ISO setting to 800 to get the shutter speed I wanted.

28–135mm lens at 80mm, 1/90 sec., f/16, 800

Figure 11-13: This arrangement turned out just the way I wanted.

Choosing the Best Equipment

Like all of photography, your subject can dictate the type of equipment you need. The following list gets you well equipped for taking pictures of people:

- **Camera (specifically the type):** The type of camera you use depends on the type of people you're photographing. If you're:

 - **Taking pictures of teenagers and adults:** Almost any camera will do. Portraits aren't a fast motion kind of thing, and you can get by with surprisingly slow shutter speeds if your camera is on a tripod.

 - **Taking pictures of children:** Fast, predictive autofocus and a minimal shutter lag time are important. Compared to digital SLRs, point-and-shoot cameras generally have a less responsive auto-focus system and a longer lag time between when you push the shutter button and when the camera actually takes the picture.

- **Lens:** You can use any lens you want to take pictures of people so long as you realize that using wide-angle lenses can seriously distort faces and bodies, depending on how you use them. Middle range to short telephoto focal lengths are the most useful for head-and-shoulders portraits; they provide a pleasing perspective.

- **Flash:** A digital camera's built-in flash is handy, but a *shoe-mount flash* (an external flash that you insert into the camera's hot shoe) offers more power (that is, light) and flexibility. Regular studio flash units give you a lot more light output, allowing you to use smaller ISO settings for better image quality. They also offer greater flexibility in controlling the light. (*Note:* An incident light meter is a huge help if you use studio lights.) Turn to Chapter 10 for pointers on using off-camera and studio flash units.

If you want to do studio photography, you need one or more off-camera flash units with umbrellas. These can be the same kind of flash units that you use on your camera, but you also need to invest in the right accessories so your camera and flashes can talk to each other. Read up on the options to figure out what works best for your brand and model of camera.

Taking a Walk on the Wild Side: Photographing Wildlife

*W*hen asked what I like to photograph, my stock answer is, "Anything that wiggles and some things that don't." If you're like me and you prefer to photograph wildlife over buildings and skylines most any day of the week, then this chapter is for you. In it, I show you how to find, approach, meter, and photograph wildlife. So prepare to practice your wildlife photography skills at home and then use the tips and tools I give you in this chapter to go out and photograph wildlife in its natural habitat.

Practicing Your Wildlife Metering Skills on Fluffy and Rover

When you're face to face with a cougar in tricky winter lighting, that's really not the time to try to figure out your metering preferences for dark fur. You may get only one chance at a classic photo before the moment is gone, and you want to make it count. I strongly encourage you to practice your wildlife metering skills under "non-game conditions" before you go out and do the real thing.

To get started practicing, find both a light-colored pet and a very-dark-colored pet, either yours or a friend or neighbor's. Then proceed as follows:

1. **On a bright, sunny day, take pictures of the very-dark-colored pet outside in frontlight, sidelight, and backlight.**

2. **Experiment with the exposure.**

 Try shooting with basic daylight exposure (BDE; see Chapter 4). Because the pet is dark, remember to add ½ to 1 stop of light to the basic BDE to keep the pet from being too dark. Also be sure to add light for the sidelit and backlit photos.

3. **Meter the pet's dark hair and subtract light by using exposure compensation.**

 I cover the topic of exposure compensation in Chapter 3.

4. **Next, take pictures of the light-colored pet in frontlight, sidelight, and backlight.**

5. **Experiment with the exposure once again.**

 When using BDE, remember to subtract light from the basic BDE to keep the pet from washing out.

6. **Meter the pet and add light to keep it light in tone.**

Your mission isn't to create great artistic photos here. It's simply to get used to photographing light- and dark-toned animals with the light coming from several directions and to figure out your BDE and exposure compensation preferences. If you practice enough to nail the exposure with light- and dark-toned animals with the sunlight coming from any direction, you can easily handle situations with soft lighting as well as more medium-toned subjects. So the next time you encounter a moose in a bog or a white mountain goat high on a peak, you'll know how to meter it.

After practicing your metering skills on pets, head for the zoo. You won't be able to walk around the animals to have the sunlight coming from every direction, but you can hone your skills with animals that are more like the ones you'll encounter in the wild. Try to create some memorable photos that look like they were taken in the animal's natural habitat, not the zoo.

Locating Wildlife

Wildlife photography, like real estate, is all about location, location, location. The shot of a green anole in Figure 12-1 wouldn't have been possible if I hadn't known where to go and what to do after I got there. I wanted to capture the shadow the anole was casting on the palmetto leaf, but the little

reptile was very active so I didn't have long to grab the picture. I positioned myself beneath the leaf, metered the underside of the leaf away from the anole's shadow, and clicked the shutter.

REMEMBER

Aside from stalking the neighborhood pets and becoming a regular at the zoo, the best way to find wildlife is to read magazines such as *Outdoor Photographer* and some of the first-class wildlife guidebooks out there. (See JimDoty.com for some suggestions.) These resources can tell you where and when you're most likely to find wildlife within a reasonable shooting distance of your lenses. You could spend days looking for elk in some remote mountain wilderness and get only fleeting glimpses from hundreds

100–300mm lens at about 200mm, around 1/60 sec., about f/8, 100

Figure 12-1: A green anole on top of a palmetto leaf.

of yards away. Or you could go to the right national park at the right time of year when the elk gather in large numbers within mere yards of the park roads. Of course, there are no guarantees with wildlife, but it can't hurt to boost your chances.

Case in point: One cold winter day, I was reading my newest issue of *Outdoor Photographer*. In it, one of the columnists recommended a great wildlife park that's only a day's drive from my home. I quickly packed the car and took off on a two-day adventure. I set my tripod up on a bridge overlooking the cougar enclosure (fortunately the larger trees near the fence were sheathed in metal so the cougars couldn't climb out). It wasn't long before a cougar headed my way and promptly climbed up an impossibly thin sapling not too far from the fence. In no time at all, we were eyeball to eyeball and about 15 feet apart. I metered her dark fur and subtracted about ½ stop of light to keep the fur medium dark in tone and started taking pictures. I had only one chance to catch the intense expression you see in Figure 12-2.

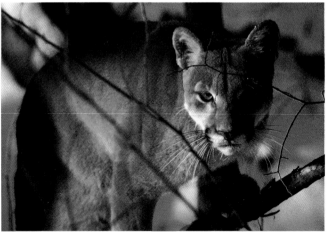

70–200mm lens at around 200mm, around 1/250 sec., about f/8, 100

Figure 12-2: A cougar, metered off of its dark fur.

If you don't have the time to flip through a few magazines for prime wildlife-spotting locations, check out the following short list of recommended sites:

- ✔ Bosque del Apache in New Mexico is the place for shooting images of wintering birds numbering in the tens of thousands.
- ✔ Denali National Park in Alaska and Yellowstone National Park in Wyoming are both great places to photograph wildlife of all kinds.
- ✔ J.N. "Ding" Darling National Wildlife Refuge in Florida is the place to be for photographing wading birds in the winter.
- ✔ Point Pelee National Park in Ontario, Canada (about an hour from Detroit, Michigan) is one of the five best places in North America to photograph migrating birds in mid-May.
- ✔ Rocky Mountain National Park in Colorado is a good place to digitally capture elk during the fall mating season.
- ✔ The Santa Ana National Wildlife Refuge at the southern tip of Texas is home to more bird species than any other location in the entire United States, including several rare species that can't be found farther north. Santa Ana is also home to half of all U.S. butterfly species.

Getting Close to Wildlife

Wildlife photographers have a few traditional ways of approaching animals to capture gorgeous images. Some opt to stay inside a *photo blind* (a small camouflage tent with openings for the camera's lens) all day long, making

no sound except for the soft click of the shutter. Others prefer the stalking method; they creep up on wildlife so slowly and carefully that the wildlife doesn't know they're coming — at least, that's what they think. With the finely tuned senses animals rely on to stay alive, chances are they'll spot you before you spot them. Finally, some wildlife photographers, like me, favor slowly approaching animals in a way that doesn't make them nervous.

Following are my suggestions for approaching wildlife:

- ✔ Be patient and take your time.
- ✔ Freeze if the animal gets nervous and don't move until it relaxes.
- ✔ Don't make direct eye contact.
- ✔ Zigzag your way toward the animal. (Walking straight toward an animal is more likely to make it nervous. Sometimes zigzagging works, sometime it doesn't. Each animal is different.)

Although it takes a few attempts to figure out how patient you have to be and how long to freeze, this approach works enough of the time for it to be worthwhile. I put the following steps (which are based on the advice in the preceding bullets) into action to capture Figure 12-3's image of antelope in a field:

1. **Have your camera and lens on the seat next to you in the car while you're driving along the highway.**

2. **As soon as you spot an animal ahead that's near the highway, turn off any music and roll down the front windows.**

3. **Slow down gradually and stop near the side of the road.**

 If the animal looks up, sit quietly until it goes back to whatever it was doing before you arrived.

4. **Turn off the engine.**

 When the animal looks up, sit quietly until it relaxes.

5. **Open the car door that's facing away from the animal.**

6. **Pick up your lens and get out of the car.**

 Again, stand there quietly until the animal is calm.

7. **Walk quietly down the highway, away from the animal.**

8. **Then turn and walk the other way, gradually getting a little closer.**

9. **Keep zigzagging one way and then the other, getting closer to the animal with each zigzag, taking pictures every now and then.**

 Freeze every time the animal seems nervous and move again when it relaxes. Keep taking pictures intermittently because you never know when the animal might run off.

10. **When you get as close as you think you can get, wait a while and then start taking pictures.**

11. **When you're done, walk away quietly.**

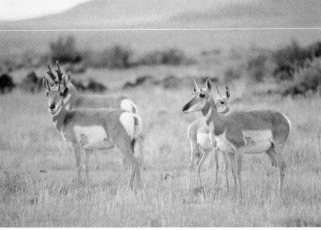

Around 150mm, around 1/125 sec., about f/8, 64

Figure 12-3: A group of antelope, shot after much waiting, freezing, and zigzagging.

Some national parks and wildlife refuges have limits when it comes to approaching wildlife. Pay attention to these limits. If you're taking photos in a location without restrictions, don't harass the wildlife by getting too close.

Staying Safe in the Wild, or Avoiding the Inconvenience of Being Eaten Alive

Getting eaten alive can really put a damper on your day. So can some of the less traumatic ways of running afoul of wildlife. Your best bet is not to get too close to dangerous animals. Follow these tips to keep yourself and the animals safe whenever you're photographing wildlife:

✔ **Do a little reading about the animals you plan to photograph and the places you'll be going.** Discover some of the do's and don'ts and some of the classic warning signs animals give.

✔ **Never approach animals who are caring for their young.** Doing so can put them (and sometimes you) at unnecessary risk.

✔ **Don't feed the animals.** Their survival depends on their ability to rely on their natural food sources. Feeding them habituates them into viewing people as a source of food, which is never a good thing.

✔ **Always respect your animal subjects.** Don't do anything that puts their survival and well-being at risk.

Photographing certain species of animals requires taking extra precautions, like the ones I list here:

✔ **Avoid getting close to alligator-infested waters.** If an alligator can burst from the water and pull down a deer in full flight, it can grab you.

✔ **Never walk alone late in the day, at night, or early in the morning in mountain lion country.** Mountain lions move silently, jump long distances, and try to kill instantly with a quick bite to the back of the neck that snaps the spinal cord.

✔ **Be careful around bull elk during the fall mating season.** The behavior of bull elk can be unpredictable, especially if you get close to their ladies.

✔ **Don't play snake handler unless you know what you're doing.** Watch where you put your hands and feet. Always photograph snakes from a safe distance with a long lens.

Going on a Photo Safari

How best to photograph wildlife depends on more than a handful of factors, and experience is often the best teacher. Because it may take you a while to build up experience photographing different types of wildlife, I'm using this section to take you on a photo safari around the United States so you can get to know some of the challenges and techniques for photographing wildlife based on my experiences.

First stop, San Francisco. At the San Francisco Bay National Wildlife Refuge, you spot some birds and want to take a photo from underneath a bridge so it looks like you're in the middle of nowhere. Choose a shooting angle that hides all signs of civilization and keep a very low profile as you approach the birds to avoid spooking them.

In a scene with a lot of tonalities, like the one in Figure 12-4, meter for the medium-toned one (in this case, the blue water). Lock in your exposure and take the picture.

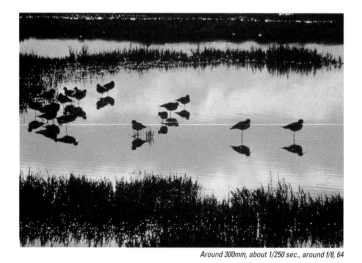

Around 300mm, about 1/250 sec., around f/8, 64

Figure 12-4: Birds in San Francisco Bay, metered off the water.

Moving east, you arrive at Trail Ridge Road in Colorado's Rocky Mountain National Park, home to the marmot shown in Figure 12-5. Subject tonality is the major exposure decision here because the rocks are lighter than medium in tone, and the marmot is darker. Meter the marmot and subtract about ½ stop of light, or meter the rocks and add a stop of light. The good news is that marmots are willing to sit still for a while, so you don't need a really fast shutter speed. The light level is low, though, so be sure to turn up the ISO.

100–400mm lens at 400mm, 1/30 sec., f/9, 800

Figure 12-5: A marmot, metered at −½ stop of light.

The next stop on this little photo safari is Denali National Park in Alaska. The exposure challenge for the photo of a caribou against the snow-covered peaks (see Figure 12-6) has two parts: the huge tonality range and the depth of field needed to show the background. The caribou is sidelit, and the sun is high in the sky, so try BDE +1. This setting will burn out the snow, but the sacrifice is worth it for the tundra vegetation and the light around the caribou to look good. For enough depth of field, use a fairly small aperture to maintain some definition in the background.

100–400mm lens at around 300mm, about 1/125 sec., around f/11, 100

Figure 12-6: A caribou against a mountain backdrop, shot using a small aperture.

The next stop is Michigan. Right away you spot a virtually motionless Eastern ribbon snake high up in a wild blueberry bush (see Figure 12-7). Here's your chance to photograph wildlife using a long shutter speed. Meter the scene as it is and begin with an aperture of f/4. As long as the snake remains still, you can keep trying smaller apertures to create a lot of depth of field.

100mm, around 1/4 sec., about f/16, 100

Figure 12-7: An Eastern ribbon snake, shot with a slow shutter speed.

You're back in Colorado for the next few photos on the safari when a Wyoming ground squirrel teaches you the beauty of patience. This little guy isn't more than 50 feet from the parking lot. You spot him eating and then heading for his burrow. Watch for a while to figure out his preferred travel routes before grabbing your camera and a long lens and making your approach (being careful to avoid his usual travel route so as not to spook him). Move forward while the squirrel is under-

Around 300mm, around 1/30 sec., about f/18, 100

Figure 12-8: A Wyoming ground squirrel peeking out of his burrow.

ground and sit tight while he's above ground. Before you get too close, meter a gray card (I explain how to do this in Chapter 4) in the soft even light and open up ½ stop so the squirrel doesn't look too dark. Then set your camera accordingly. As you move closer, get down on the ground and crawl forward on your belly. Stop about 10 to 15 feet from the burrow. When the squirrel peeks out to look at you, take a picture (see Figure 12-8). It won't be long before he's back to his usual routine, aware of you but basically ignoring you (see Figure 12-9).

As you drive along Guanella Pass in Colorado, an area known for bighorn sheep, you discover that sometimes a great photo just falls into your lap. As you come around a switchback, you see a bighorn sheep standing by the side of the road. Stop the car, roll down your front windows, and set the camera ISO to 800 due to the low light levels. You should also set the camera to f/8 in aperture-priority mode because the sheep is medium in tone. With the camera ready, drive slowly down the road until you're even with the sheep and take a picture out the window (see Figure 12-10). Let the camera determine the exposure, and the sheep will be medium in tone.

The next stop on the safari is the Long Lake area in northern Colorado. When you watch wildlife for a while, you begin to recognize repeated patterns of behavior. The chipmunk in Figure 12-11 gathers seeds from the tops of long-stem grasses and eats them on top of two or three rocks that he returns to again and again. He's too nervous for you to approach him, so use the car as a blind. (The chipmunk can still see you, of course, but as with a lot of animals, he's less nervous when a person is sitting in a car.) While the chipmunk is elsewhere, drive to within 15 feet of one of his favorite rocks, turn off the car's engine, and wait. He'll eventually show up and eat some grass seeds while you take pictures. Just meter the scene or meter a gray card and add ½ stop of light.

Around 300mm, around 1/30 sec., about f/18, 100

Figure 12-9: The same squirrel, photographed after he began to ignore my presence.

100–400mm lens at 400mm, 1/350 sec., about f/8, 800

Figure 12-10: The camera made all the shutter speed decisions and did a good job.

If you're observant and quiet, some animals will come much closer to you than you can get if you try to approach them. The coyote in Figure 12-12 is a perfect example. You spot this coyote making his way along a grassy, partially shaded ridge just above Bear Lake Road in Rocky Mountain National Park. Grab your camera and long lens and sit quietly near the area you think he'll pass by. (Naturally, this is a gamble because wildlife is unpredictable.) The coyote moves from sun to shade and back again, so you set the camera to autoexposure mode with –⅔ stop of exposure compensation (because you don't have time to set the exposure manually). The coyote is aware of you, but you don't concern him at all. When he stops in front of you and looks to his left, you meter his side and take the picture.

100–400mm lens at 400mm, 1/320 sec., f/6.3, 400

Figure 12-11: A Least chipmunk, photographed from inside a car.

100–400mm lens at 400mm, 1/60 sec., f/10, 100

Figure 12-12: A coyote, shot by metering the side of his body.

The last stop on the photo safari is back at Rocky Mountain National Park's Trail Ridge Road. The Rock Cut parking lot is one of the best places to photograph a pika, a cute little ball of fur about the size of your fist. Pika are always moving, and they're fast — too fast and erratic for reliable autofocus or manual focus. You spot a pika gathering yellow flowers and decide to try prefocusing on a specific spot. You notice that the pika pauses at one specific rock for a split second before heading for his burrow. He stops at that rock about every third or fourth trip. Focus manually on the rock, meter the rock surface, and wait. When the pika stops on the rock, click the shutter. With a little luck and several attempts, you should get one pretty sharp photo (like the one in Figure 12-13).

100–400mm lens at 400mm, 1/160 sec., about f/8, 400

Figure 12-13: A pika, shot by manually prefocusing on the rock and metering the rock surface.

Choosing Equipment

Most wildlife photography is done with long lenses. These lenses allow you to get up close and personal with animals without getting physically close to them (most won't let you anyway, even if it wasn't dangerous to do so).

If you want to photograph animals out in the wild, I suggest using whatever gear you have now. When you decide to get a longer lens, consider purchasing one of the zoom lenses in the 70–300mm or 100–400mm range. Depending on the brand and the specifications, a new lens of this kind is likely to cost from $250 to $1,600. Do your research and read reviews because these lenses do vary in quality. However, these lenses are a lot less expensive than the megamonster, high-dollar lenses, and they still do a good job. If you want to step the optical quality up a notch, you can purchase a prime (nonzoom) 300mm f/4 lens with a matched 1.4x teleconverter. This combination runs about $1,600 to $1,800. You get better optical quality with this lens, but you give up the focal length flexibility that a zoom lens provides. I happen to prefer the flexibility of a zoom lens.

Anytime you use a long lens, you need a tripod for support. Handholding a long lens for any length of time is an exercise in frustration and an invitation to take blurry photos. See Chapter 18 for specific tripod recommendations.

TIP

If you don't already own a tripod, Manfrotto and Gitzo are two of several highly respected brands. For wildlife photography use, purchase a sturdy tripod with independent leg movement (no cross-bracing) so you have complete flexibility for setting up the legs on uneven terrain. Also buy a quality ball head for maximum flexibility when following wildlife with your lens.

Putting it all together

Every once in a while, everything you know about photographing wildlife comes together in a rare photo opportunity. I experienced one of these magical moments when I was at Whitefish Point on Michigan's Upper Peninsula, which is a prime location for photographing migrating birds at the right time of year.

I took my time wandering the beach and woods until I finally spotted a Great Gray owl. The owl had already spotted me, so I froze. When the owl lost interest in me, I put my long lens and camera on a tripod with the legs extended and ready to go. Then I began my zigzagging approach, freezing when the owl got nervous. I took my first insurance shot about 60 to 70 feet away, and I took more shots as I got closer, just in case the owl took off.

An hour and a half later, I was within 10 feet of the owl, which was in dappled sunlight and shade. I metered for the dappled sunlight and took some pictures, knowing the shaded part of the owl would be quite dark. Then I added fill flash to even out the light on the owl and bracketed exposures (see Chapter 4 for the how-to). The owl was quite calm about what I was doing, looking my way, looking elsewhere, and occasionally closing its eyes for long periods of time, almost as if it were asleep. You can see the result in the following photo.

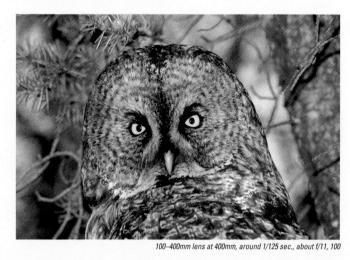

100–400mm lens at 400mm, around 1/125 sec., about f/11, 100

13

From Sea to Shining Sea: Landscape Photography

*T*here's something wonderful about getting outside and taking pictures of the *landscape,* any wonderful expanse of scenery, whether large or small. For many people, heading out to photograph the mountains, seashore, or desert renews the spirit. Other folks are rejuvenated by capturing a sea of skyscrapers. My point is that you're entitled to photograph whatever kind of landscape you want, whether it's a jungle, a concrete jungle, or the scene in your own backyard.

With the information I present in this chapter, you can create compelling landscape photos. I share ideas you can use and give you suggestions for working with the light (rather than against it). Just be sure to practice so you're equipped with good landscape photography skills when you need them.

Metering for Landscapes: It's Complicated

Metering for landscapes can range from simple to challenging because landscapes present more variations in light and tonality than most any other kind of subject. Consequently, there's no one way to meter landscapes. The metering techniques you use depend on each unique situation, and sometimes more than one technique works.

Following are a couple examples of how metering a landscape can be challenging:

✔ The photo of Otto Lake in Figure 13-1 would give most camera meters a hard time because they'd try to turn the middle of the photo into a medium tone, washing out all the rich colors in the sky and lake. The solution is simple: Meter the pink area of the sky (which is in the upper-left corner), make it medium or medium-light tone, lock in the exposure, and take the picture.

Around 28mm, around 1/4 sec., about f/11, 100

Figure 13-1: Metering the pink area of the sky prevents the colors from washing out.

✔ The dark areas in Figure 13-2 could be a challenge for a camera meter because the meter would try to lighten the dark areas and overexpose the light areas. The easy solution for this bright, sunny, daytime photo of an Alaskan landscape is to use basic daylight exposure (BDE; see Chapter 4) and subtract ½ to 1 stop of light to keep the sunlit snow from burning out.

Around 28mm, around 1/500 sec., about f/11, 100

Figure 13-2: On a sunny day, using BDE with a bit of exposure compensation is a good way to handle a high-contrast mix of snow and shadows.

Finding the Best Spots and Making Them Look Awesome

Landscape photography is incredibly popular. Don't believe me? Just spend a day at the Grand Canyon and watch the hordes of tourists stream to the lookout points to capture an image of a truly grand landscape. If you want to lay claim to landscape images that are the envy of your friends and family, you need to know how to find the best landscapes (both grand and intimate) and how to make the most of them. Not sure where to get started? Never fear. The following sections give you ideas for finding the best landscapes as well as how to make them vibrant and eye-catching.

Finding grand and intimate landscapes

To photograph grand landscapes, you first have to be able to find them. I can easily make a list of locations that would go on forever, but instead I'm limiting myself to the following list of my favorite national parks. Denali, Mt. Rainier, Glacier, Yosemite, Yellowstone, Rocky Mountain, Grand Canyon, Big Bend, White Sands, Carlsbad Caverns, Great Sand Dunes, and the Great Smoky Mountains are all terrific spots for capturing sweeping landscape shots.

A great example of the wonderful landscape opportunities you can find at national parks is "The Window" at Big Bend. It's one of the best places to be at sunset, as you can see in Figure 13-3. "The Window" is the only view of the outside world when you're inside the natural basin created by the Chisos Mountains. Late April or early May is a good time to photograph a sunset through "The Window."

100mm, around 1/8 sec., about f11, 50

Figure 13-3: National parks are home to wonderful landscape photo opportunities.

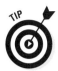

If frequenting national parks and other faraway grand landscape destinations is out of your budget or comfort zone, become acquainted with the scenic areas within an easy driving distance of where you live. I bet you'll be surprised how beautiful the area around you is when you really take the time to look. Wonderful light can turn almost any location into a great landscape location. (I help you figure out what constitutes wonderful light in Chapter 5.)

If you don't have a great subject or dramatic light, look for a more intimate landscape that works well with the light you have. For instance, a simple tree stump may look quite ordinary most of the year, but add some red leaves in the fall and some soft light, and you have a nice, intimate landscape (see Figure 13-4).

100mm, around 1/8 sec., about f/8, 100

Figure 13-4: You don't need dramatic light for intimate landscape shots.

Intimate landscapes are easier to come by if you keep your eyes open. They're less dependent on location than grand landscapes.

Leading the eye into the scene

In many photographs, you want to lead the viewer's eye into the frame. The natural temptation when shooting a landscape is to try to capture the whole scene using a wide-angle lens, but this approach often gets you into trouble because it's all too easy to wind up with uninteresting stuff in the foreground. Creating a dramatic landscape image is actually easier when you use a long lens and fill the frame with the part of the scene that's most interesting to you.

When you do decide to use a wide-angle lens, make a point of finding something interesting to put in the foreground to lead the viewer's eye into the frame. In Figure 13-5, the fallen and decaying tree leads the eye off to the distant Colorado mountains.

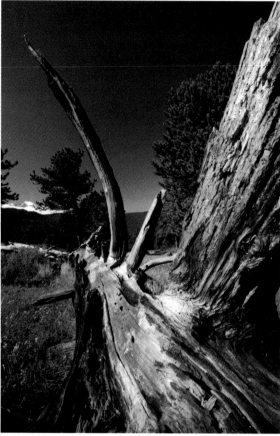

17–40mm zoom lens at 17mm, 1/10 sec., f/22, 100

Figure 13-5: The tree dominates the foreground, and the trees and mountains fill the background.

Using Light to Make the Best Images

Landscape photographers generally don't have the power to move the sun where they want it or to add or take away clouds to alter the quality of the light. The light is what it is. Great landscape photos come from working with the light, waiting for the right light, and knowing when it's best to just put the camera away. I help you discover how to work with light in Chapter 5.

In the next sections, though, you explore ways to use light in landscape photography, including matching the subject to the light and making sure you take full advantage of *magic light* (the light found before and after sunrises and sunsets).

Matching the subject to the light

Landscape photography is a delicate dance between light and subject. Sometimes the two dance well together; sometimes they don't. If your subject isn't dancing well with the light that you have, it's time to either find another subject or wait for the light to change. The more time you spend photographing landscapes, the more you'll know what works and what doesn't.

The color of the morning light was incredibly intense in Figure 13-6's photo of mountains along Sprague Lake in Colorado. However, that light didn't last long. Soon it was blocked by rapidly gathering clouds, changing from wonderfully warm to boring gray (see Figure 13-7).

Avoiding a boring gray sky

Soft light is great for all sorts of subjects, including all kinds of flowers (see Chapter 14), some intimate landscapes, and autumn leaves. However, soft light also brings with it a major problem: a gray sky. This boring-colored sky is one of the reasons why you see so many wonderful soft-light photos of autumn leaves with no sky in the frame at all.

You never want a lot of flat gray sky in your landscape images, but sometimes part of your scene is too important to leave the sky out entirely. An example is the photo of Yosemite's Merced River in Figure 13-8. If you were to crop out the sky entirely in this photo, you'd lose much of the height of the trees along the river's banks. The trick is to crop out as much of the gray sky as you can without losing anything that's important to the whole scene.

On the other hand, if a gray sky actually has some interesting-looking clouds, incorporate that sky as well as the clouds into your shot. When clouds closed in on Mt. Rainier as I took the photo in Figure 13-9, they added some interest to the gray sky, and the mountain looked good, so I didn't give up on the scene.

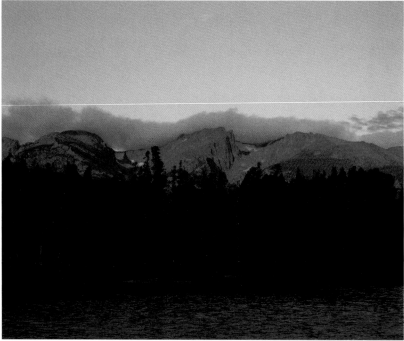

50mm, around 1/30 sec., about f/11, 100

Figure 13-6: The warm morning light suits the mountain peaks perfectly.

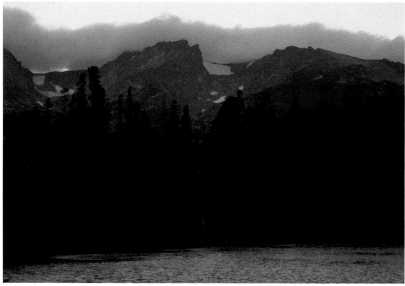

100mm, around 1/4 sec., about f/11, 100

Figure 13-7: When the light changes, the same peaks look boring.

50mm, around 1/4 sec., f/8, 25

Figure 13-8: A little gray sky in the frame doesn't hurt this photo.

24–105mm lens at 84mm, 1/8 sec., f/8, 100

Figure 13-9: In the soft light, the shapes of the storm clouds add interest to the scene.

Using the color of the light for different looks

The same subject has a different look and feel as the color of the light changes. The vast majority of photos are taken when the color temperature of the light is neutral (I fill you in on the color temperature of light in Chapter 5). If you take photos when the light is warm or cool, your photos will stand out from the crowd.

If you have the opportunity to photograph the same subject in different kinds of light, make the most of it for a wider variety of looks.

The following photos of Denali (also called Mt. McKinley) in Alaska are a perfect illustration of how the same subject can appear differently depending on the color of the light. In Figure 13-10, the warm early morning light on Denali sets up an interesting juxtaposition of light that looks warm on snow that you know is cold. The late-evening photo of Denali with the cool temperature of the light from the darkening blue sky (see Figure 13-11) is a very different kind of photo. Thanks in large part to the color of the evening light, this photo is all about the peace, quiet, and calm of a cold winter night, even though it was taken on a very pleasant fall evening.

About 300mm, 1/60 sec., around f/8, 100

Figure 13-10: Warm morning light gives Denali an interesting glow.

50mm, around 8 sec., about f/11, 100

Figure 13-11: Cool evening light changes the look of Denali entirely.

Creating contrast with sidelight and backlight

Sidelight is all about form and shadows and comes in handy whenever you're photographing a grand landscape because it makes your subjects look three-dimensional while maintaining the colors in your image. Backlight works best when color is less important and when you want the emphasis to be on bold shapes or silhouettes rather than three-dimensionality.

Sidelight is good for creating contrast while maintaining the color of your subject, as you can see in Figure 13-12. The sun was setting when I took this photo of Boquillas Canyon in Texas as the bold shadows climbed the 1,200-foot-tall canyon walls. I based my exposure on the sidelit canyon wall to make it medium in tone and keep the rich, warm color of the reflected sunlight. (**Note:** The contrast inherent in photography adds to the darkness of the shadows, looking better in your photos than it does to your eyes.)

24mm, around 1/8 sec., about f/16, 50 at EI 40

Figure 13-12: Sidelight creates contrast in this photo of a canyon.

In contrast to sidelight, backlit subjects often lose most or all of their color and silhouette to black, as in Figure 13-13's photo of this Haitian palm tree. The trick to capturing this type of image is to meter the sky to the side of the subject (so the dark subject doesn't throw off the meter reading) and add 1 stop of light to keep the sky lighter than a medium tone.

50mm, around 1/250 sec., about f/8, 25

Figure 13-13: The backlight puts the subject in silhouette.

Capturing magic light in the golden hours

The light before and after sunrise and sunset is a landscape photographer's dream. With just a quick glance at Figure 13-14, which was taken early in the day at Mackinac Bridge in Michigan, you can easily understand why the light produced during the *golden hours* (just before and just after sunrise and sunset) is called *magic light.* It's a gorgeous mixture of warm and cool light with long, dramatic shadows. Of course, light is unpredictable. I've watched magic light come and go in less than five minutes or stretch out for an hour or more. Often it doesn't show up at all.

24–105mm lens at 75mm, 1/25 sec., f/8, 800

Figure 13-14: Dawn is a great time to capture cool light with a little warmth thrown in.

The sections that follow help you figure out how to take landscape photos during and after sunset (that's right; sometimes the light may not be entirely gone).

Photographing sunsets

Almost everyone loves sunsets. They're the occasional, extravagant color splash at the end of the day. When the clouds are right, sunsets are generally more vivid than sunrises due to dust and moisture being stirred up in the atmosphere throughout the day. If too many clouds are present in the sky, there's no sunset; if there aren't enough clouds, then the colors are weak. But when the clouds are just right, wow!

You can make any colorful sunset as light or as dark as you want. The key to metering sunsets is to keep the sun out of the frame while you're metering for a normal-looking exposure. After you lock in your meter reading, you can include the sun in your photos. When metering sunsets (or sunrises, for that matter), follow these additional guidelines:

- Meter the sky near the sun, lock in the exposure, and you'll get a darker, more dramatic sunset.

- Meter the sky farther away from the sun, and you'll get a lighter exposure.

- Pick any area of sky and use exposure compensation (which I cover in Chapter 3) to make that part of the sky as light or as dark as you want.

- Include the sun in the frame while you're metering for a *very* dark and dramatic sunset.

Here are some examples of how to put the preceding sunset guidelines to work:

- For the sunset shown in Figure 13-15, I wanted a light-toned sky near the sun, so I metered the sky near the sun and added a stop of light. I used a wide-angle lens to include the trees and darker blue sky above the golden sunset.

- For the very dark sky and bold, dramatic sunset in Figure 13-16, I metered the sun as my base exposure and added a couple stops of light to the meter reading. I also used a long lens.

 Never point a long lens at the sun when it's bright. Make sure the sunlight is heavily filtered through the thick atmosphere at sunset so you don't risk damaging your eyesight.

28–135mm lens at 28mm, around 1/125 sec., f/11, 100

Figure 13-15: A sunset over French Polynesia, metered for the sky near the sun.

Sticking around after sunset

Don't give up after the sun goes down. The color show isn't over yet. Depending on the clouds, the color can fade and then return again as the sunlight bounces off a different set of clouds beyond the visible horizon.

Figure 13-17 shows the kind of photo you can get after sunset when light bounces off the right clouds. One fine day I observed a sunset from Camp Denali in Alaska and thought the show was over when the light had faded. Then a warm glow from the west began flooding back into my cabin. I grabbed my camera and went back outside to capture the second sunset.

Metering a second sunset is the same as metering the first sunset. You can still make the sky as light or as dark as you want depending on whether you add or take away from what your camera meter says.

100–400mm lens at 400mm, around 1/80 sec., about f/8, 100

Figure 13-16: A sunset over Rocky Mountain National Park in Colorado, metered for the sun with a couple extra stops of light.

100–400mm lens at around 300mm, around 1/8 sec., about f/8, 100

Figure 13-17: A warm glow returned to the sky for a second Alaskan sunset.

Choosing Equipment for Landscapes

You can use any camera and lens you own to shoot wonderful landscape photos, but you'll be happier if you have a lens (or lenses) that covers a wide angle, normal, and telephoto focal length range. Investing in the following equipment can make your landscape images even better:

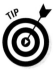

- **Lens focal lengths in the 24–28mm range on the wide end to 200–300mm on the long end:** These focal lengths work well in most situations when you're using a full-frame sensor. For a 1.5x or 1.6x cropped-frame digital sensor, 15–18mm on the wide end and 125–200mm on the long end gives you good coverage for most situations.

 Start with the gear you currently own and make the most of it. If you find yourself wanting to get a lot more landscape in your shots, buy a wider-angle lens. If you find yourself trying to grab a tiny piece of distant landscape and you can't quite do it, purchase a longer lens. Just remember that "focal-length envy" (as in feeling like your widest lens isn't wide enough and your longest lens isn't long enough) can be hazardous to your bank account.

- **Tripod:** There's no substitute for a good tripod when you're taking photos in lower light levels with longer shutter speeds. This piece of equipment opens doors to all kinds of wonderful photos that are difficult or impossible to take without it. I fill you in on good-quality tripods in Chapter 18.

- **Polarizing filter:** The one essential filter for landscape photographers is a polarizing filter. This tool darkens blue sky at a 90-degree angle to the sun and reduces glare on vegetation. (***Note:*** Blue sky can often be 2 or 3 stops lighter than dark green evergreens. Making the blue sky darker in comparison to the evergreens means you can make the evergreens lighter without the sky washing out.)

 To get an idea of how polarizing filters work, check out the following photos. Figure 13-18 was shot without a filter, and Figure 13-19 was shot with a polarizing filter.

 In Figure 13-20, the edges between the trees and the sky were made more impressive by the color of the maple leaves. I pointed my tripod-mounted camera straight up and used a polarizing filter to darken the blue sky, increasing the boldness of the leaves. Without the filter, the leaves would've turned out very dark.

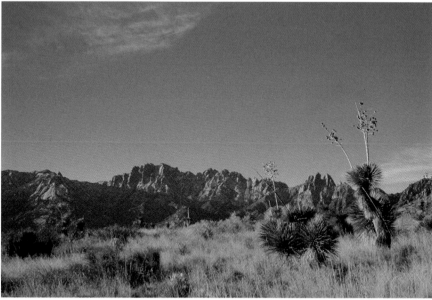

50mm, around 1/30 sec., about f/16, 50

Figure 13-18: A New Mexico landscape, shot without a filter.

50mm, around 1/8 sec., about f/16, 50

Figure 13-19: The same scene but shot with a polarizing filter.

24mm, around 1/8 sec., about f/11, 50 at EI 40

Figure 13-20: On a sunny day, a polarizing filter can help you darken the sky so leaves really pop.

14

Petals in the Wind: Capturing Flowers with Your Camera

I like flowers. They don't run away like wildlife. They stay put while you photograph them, so you have the dual luxuries of getting any angle you want and being able to pick a day with the best light. Plus, they're everywhere, which means you have a ton of chances to capture just the right flower photo. Of course, this abundance of flowers means *everyone* has flower photos. As a result, you need to take a few extra steps to create flower images that stand out from the multitude of ordinary flower photos. These extra steps are what this chapter is all about. In it, I highlight the simple things you can do to create dramatic flower photos. Treat every section in this chapter as an invitation to go out and try something new with your camera.

Making the Best Choices

Getting the best flower photo means making the best choices when it comes to how you take the photo, the settings you choose for your digital camera, and how you use the colors in front of you. But just what are those "best choices," and how do you arrive at them? The following sections equip you with a few guidelines to help you sort this out.

Positioning yourself for the best point of view

Not many dramatic flower photos are taken with the camera 5 or 6 feet off the ground because flowers usually look best when photographed from eye level — *their* eye level, that is. Capturing a stunning flower photograph depends in large part on where you put the camera.

Sitting or lying on the ground usually gives you the best angle of view; it also gives you a perspective that your friends likely won't try. But don't just take my word for it. Check out Figure 14-1 for an example of what I mean. When I took this photograph, the camera was practically on the ground, and the side of my head was literally in the dirt as I tried to see up through the viewfinder. The California poppies make a great backlit subject, and the sunlight shines through them like nature's little stained-glass windows.

To capture the backlit poppies, I used a 15mm semi-fisheye lens (although any wide-angle lens will do) with the aperture set to f/16, and I hid part of the sun behind a poppy. The combination of a partially hidden sun and the small lens aperture created a natural sunstar. I bracketed exposures from BDE +2 to BDE –2 (I explain how to do this in Chapter 4). The best exposure was about BDE –1, which gave me a deep blue sky and richly saturated poppy colors.

You can achieve a similar-looking image with a wide-angle lens, a flower with translucent petals, a low camera angle, a deep blue sky, and a small lens aperture. The real trick is to find the right kind of blue sky. Step outside on a sunny day, hold your hand out at arm's length, close one eye, and block out the sun with your thumb. If you can see deep blue sky right up to the edges of your thumb, you have the right kind of day. If you see bright, hazy sky around your thumb, pick another day.

Getting low and close to a flower can give you a unique point of view. In Figure 14-2, the camera wasn't more than 12 inches off the ground. The light was soft, and the light levels were low, which meant long shutter speeds. A low-to-the-ground tripod ensured the photographs were sharp.

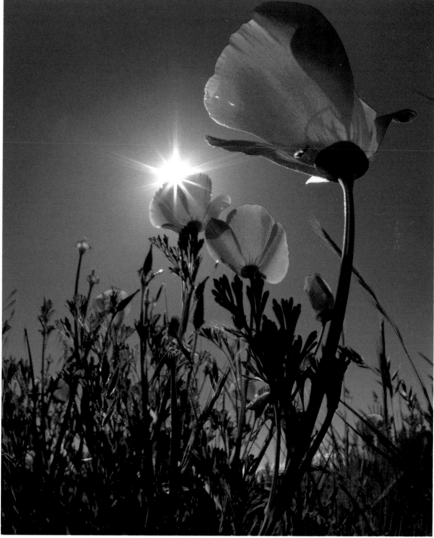

15mm, 1/125 sec., f/16, 50 at EI 40

Figure 14-1: California poppies, shot from ground level.

100mm, around 1/8 sec., about f/8, 50 at EI 40

Figure 14-2: Getting low and close made the most of this photo of dew on blue chiming bells.

Mixing colors to suit the mood

Although it's an evolving field with lots of variations, color theory is always about the emotional effect certain colors and color combinations are supposed to have on the viewer. Theoretically, warm colors (think red and orange) tend to "come forward" and grab your attention, whereas cool colors (think green and blue) tend to recede and are more peaceful.

According to some color theorists, color combinations such as orange and blue should jump out at you and create a sense of visual tension and energy. On the other hand, *complementary colors* (colors that are opposite each other on the color wheel), such as yellow and blue, are supposed go well together; enhance each other's vividness; and feel more restful, calm, and harmonious. See for yourself in Figure 14-3. The blue lupine can stand on its own, but I like it better with the yellow coreopsis thrown into the mix.

Decide for yourself whether one color combination is more harmonious or energetic than another and experiment with combining colors to create more vivid images. (*Tip:* Take note of the different ways color combinations are used in this chapter.)

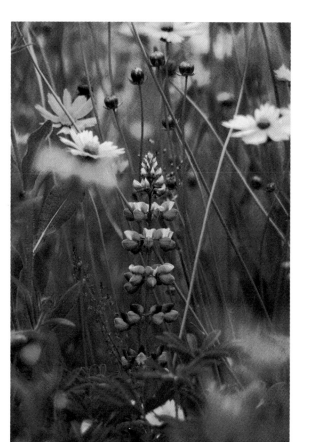

100–300mm lens at 300mm, about 1/60 sec., around f/5.6, 25

Figure 14-3: The yellow coreopsis and blue lupine enhance each other's colors.

Selecting the Right Equipment

Here's the great news: You can photograph flowers with whatever equipment you have. The photos in this chapter were taken with lenses ranging in focal length from a very-wide-angle 15mm semi-fisheye lens to a long 300mm lens. If you have a wide-angle lens for lots of depth of field, a medium focal length lens, and a telephoto lens to isolate flowers, you're good to go.

However, if you own a digital SLR camera and you want to take your flower photos to the next level, you should consider investing in equipment that allows you to take sharp close-up shots. Examples of such equipment include an extension tube, a close-up filter, and a specially designed close-up lens. (I delve further into the topic of close-up equipment in Chapter 16.) If you own a point-and-shoot camera, you probably have a macro mode that lets you get very close to your subjects, which means you don't need to worry about purchasing extra equipment.

There's no law that says you have to show the whole flower. Feel free to fill the frame with just part of the flower to create a different kind of look, like I did in Figure 14-4's close-up of a Michigan lily.

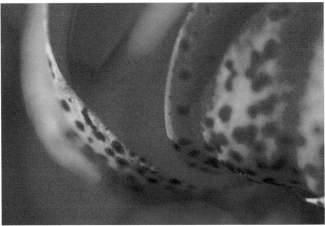

100mm macro lens, around 1/250 sec., about f/5.6, 100

Figure 14-4: Just a couple petals of a Michigan lily.

One piece of equipment you should definitely purchase if you're serious about photographing flowers is a good-quality tripod with widely spreadable legs so you can get close to the ground for some unique angles in your photos. Manfrotto and Gitzo make excellent versions of such a tripod. For additional recommendations, head to Chapter 18. (Figure 14-5's photo of a wild iris in soft light wouldn't have been possible without a tripod.)

100mm, 1/8 sec., about f/5.6, 50

Figure 14-5: This photo in low light with a long shutter speed wouldn't have been possible without a tripod.

Metering for Flowers

Metering for flowers is pretty simple. You simply meter a gray card in the same light as the subject and set your camera accordingly. For the orange poppies in Figure 14-6, I held up a gray card in front of the flowers, metered it, locked in that exposure, and took the picture. (I fill you in on how to use a gray card in Chapter 4.)

You may need to do some exposure compensation after metering flowers. For very light or white flowers, subtract ½ to 1 stop of light from the gray card reading. For dark or very dark flowers, add ½ to 1 stop of light to the gray card reading. Add 1 stop of light for sidelit subjects and 2 stops of light for backlit subjects.

If you don't have your gray card with you, you can use your hand as a substitute gray card. Just remember to add or take away light from your hand card reading based on the tonality of your hand. I help you figure out how to use your "hand card" in Chapter 4.

100mm, around 1/60 sec., about f/8, 100

Figure 14-6: Orange poppies, metered using a gray card.

Working with the Light

If you choose to photograph flowers that look best in the kind of light available to you, you'll have better images; if you force your subjects to appear in unflattering light, they won't look as good as they could. You'll gradually develop your own preferences, but don't be surprised if you decide that some flowers — such as sunflowers and buttercups — look great in sunlight. Others, such as tulips and Queen Anne's lace look beautiful in sunlight and soft light. Many other flowers (think orchids and gentian) usually look best in soft light, just like people.

When it comes to photographing flowers after the sun goes down, set your camera to the daylight white balance setting (see Chapter 5) and keep shooting to capture the interesting color shifts caused by post-sunset light. In other words, keep your camera out as the light changes and take more pictures. Some of the photos will be disappointing, but some will end up being your favorites.

One evening, long after the sun had set, a cactus caught my eye. The blooms had shifted from their usual daytime color to an unusual red that was different and more intense than the same flowers in the sunlight. With nothing to lose and an interesting photo to gain, I set up my gear and took a few pictures. The resulting image, shown in Figure 14-7, captured the unusual color perfectly.

If it gets too dark for your camera to meter a dark subject, try metering something white and add 2 stops of light.

80–200mm lens at around 80mm; 30 sec., f/8, 50

Figure 14-7: Despite being shot late in the evening, this photograph captures the shift in color of the claret cup blossoms.

Looking for something different to catch the eye

If you want your images to stand out, look for something different, something unusual. Yellow Fringed Orchids are found in wet soggy bogs and are enough out of the ordinary to deserve a second look.

100mm lens, around 1/15, about f/16, 100

On Your Mark, Get Set, Go! Photographing Sports and Action

In This Chapter

▷ Figuring out what equipment you need for winning action shots

▷ Catching all the action, from the field to the fans

▷ Showing people in their best light with good lighting techniques

Most people love looking at good action photos. They're filled with the drama of human achievement and written with the bold letters of tangible, visible effort. Lots of people also like to get close and shoot action photos, and if you're one of them, this chapter is for you. Dig into this chapter and then go take pictures, trying out what you read here.

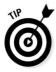
TIP

The best way to hone your sports photography skills is to start at home base — *your* home base. Photograph your (or your friends') children or grandchildren at their sporting events. Practicing at small-scale events is a great way to deal with all the lighting, metering, and action challenges that sports photography provides.

Using the Right Equipment

When it comes to photographing sports and action, some equipment is useful, and other equipment doesn't help much at all. Long lenses and a monopod are the most helpful pieces to bring along.

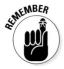
REMEMBER

The one thing you don't want at most sporting events is a tripod. Tripods are typically banned from the sidelines for the safety of the players. A better option is a monopod to support your long lens and camera.

Long lenses are important for sports photography because you want to get as close as you can to the action. At your children's sports events, you can probably get physically close to the action, but at major sporting events, where sometimes the closest you can get is halfway up the stands, long lenses help you get closer shots.

TIP

No matter how long a lens you have, you'll undoubtedly decide you want a lens that's just a little longer. You can mortgage your house to buy a megabucks, high-speed, monster lens, but a telephoto lens in the 80–300mm or 100–400mm range serves most sports photographers very well at a small fraction of the cost of those huge lenses.

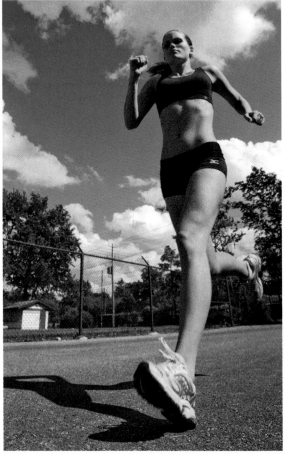

17–40mm lens at 17mm, 1/500 sec., f/8, 100

Figure 15-1: A runner, shot with a wide-angle lens low to the ground.

REMEMBER

Although a long lens is the usual tool of choice for action photography, shooting with a wide-angle lens can give you a unique perspective. Close-to-the-ground, wide-angle shots (as shown in Figure 15-1) have become iconic, and they're simple to obtain. To get this look, grab your widest lens, lay on the ground, and shoot up at a pretty steep angle. Getting the timing exactly right is the only part of this shot that's complicated; see the later "Photographing the moment of action" section for tips on tweaking your timing.

Capturing Every Moment

They key to photographing a sporting event is to capture *all* the interesting moments you can. Get the telling scenes on the sidelines as well as the action on the field. The following sections give you tips on what to look for when photographing the action, no matter where it happens, as well as how to choose the best angle for shooting.

Photographing the moment of action

The whole point of sports photography is to catch the action, yet the usual tendency when capturing moments of action is to push the shutter button a little late. Anticipate the peak moment and push the shutter button earlier than you think you really need to.

Even if your camera has a rapid-fire mode, don't count on it to catch the best moment. Practice taking a photo at just the right time. When you're pleased with your ability to catch the right moment, turn on the rapid-fire mode. For the shot in Figure 15-2, I pushed the shutter just a hair earlier than I thought I needed to in order to catch the moment of impact between tacklers and the pass receiver.

300mm, around 1/250 sec., about f/4, 400

Figure 15-2: Capturing the moment of impact at an Army versus Eastern Michigan football game.

Telling the sideline stories

Some of the action at sporting events is off the field, and you don't want to miss anything interesting. During timeouts and other lulls in the action, turn around and watch what's happening with the coach, the players on the sidelines, and the fans in the stands. Look for action and emotions, cheering or tears. Zoom in close to a few exuberant faces. After the game, look for moments of celebration or defeat, high fives or a head hung low.

After a soccer match that I photographed, some of the players turned the cool water of the mist tent into an impromptu mud slide celebration. A fast shutter speed helped me catch the flying mud (see Figure 15-3, left). Capturing a shot of a mud-splattered face helps to tell the story (Figure 15-3, right).

100–300mm lens at 130mm, 1/320 sec., f/8, 200 *100–300mm lens at 300mm, 1/320 sec., f/6.3, 200*

Figure 15-3: You can get great post-game shots if you stick around after the main event.

Choosing a shooting angle

Where you put the camera when photographing any type of action is important. Location can make a big difference in how well your photos turn out. Move around and try different shooting angles.

If you're at a small event, you may be able to gain access to up-close locations. (Just be sure to ask first before you try.) After doing all of the usual long-lens shots at a soccer match, I put on a wide-angle lens, pushed it through the net at the goal, and waited for something to happen. It wasn't long before a goal was scored; I captured the shot in Figure 15-4.

10–22mm lens at 10mm, 1/320 sec., f/8, 100

Figure 15-4: By cherry-picking a location around the goal, I was lucky enough to capture this shot.

Most sports are somewhat unpredictable. Murphy's Law says the most important action will take place at the opposite end of the field from where you happen to be. Don't be discouraged if you're at the wrong place at the right time; your moment will come. However, if you want to photograph a

sport where you always know exactly where everyone is going, head to a swim meet. A great angle for photographing the action is lying down at the side of the pool. Get your camera as close as possible to the water level and shoot across the pool as the swimmers go by to snag a photo like Figure 15-5.

At football games, a good location is on the sideline, about 5 to 10 yards ahead of the offense. If the quarterback tends to throw long passes, move a little farther down the sideline. When the action gets within 20 to 30 yards of the goal line, shoot through the end zone for a nice point of view (check out Figure 15-6 to see what I mean).

100–300mm lens at 300mm, 1/90 sec., f/5.6, 1600

Figure 15-5: Shooting down low from the side of the pool allowed me to capture the action.

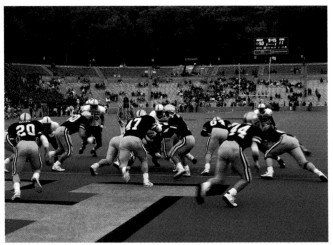

50mm, around 1/60 sec., about f/8, 100

Figure 15-6: Football shot through the end zone.

Dealing with the Light

Sports lighting causes more headaches for photographers than almost any other kind of lighting situation. The light can change from frontlight to backlight as a player runs the length of the field, and indoor lighting can be either good or dreadful. Knowing in advance how to deal with sports lighting lets you focus on the action when game day comes. The sections that follow arm you with the knowledge you need.

Soft outdoor light

A light, overcast day provides nice, soft light, which makes metering pretty straightforward. Take an incident light meter or gray card reading and shoot away (I explain how to use both metering tools in Chapter 4). Check the light every ten minutes or so if the light is changing. If the day is getting darker, make sure to adjust your shutter speed.

Sunlight

When the sun is behind you, everything looks nice and bright, and metering is simple. If the sun is high, use Basic Daylight Exposure (BDE; see Chapter 4). If it's getting later in the day, use an incident light meter or gray card reading.

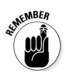

Sidelight is more of a challenge. If you meter for the sunlit side of a subject, the dark side looks very dark. If you meter for the dark side of a subject, the sunlit side gets terribly washed out. White reflective uniforms just add to the problem. One solution is to meter for the sunlit side of the subject and add a little light. Take an incident light meter reading with the dome facing the sun and add a half-stop of light. Or turn your back to the sun, meter a gray card that's facing the sun, and add a half-stop of light or more.

As for backlight, I'm no fan of it when it comes to sports. If you're facing the sun at a sporting event, move to the opposite side of the field so you have frontlight. If you have to shoot into the sun, take an incident light meter reading with the white dome facing the sun and add 2 stops of light. Or meter a gray card with the card facing the sun and add 2 stops of light. (**Note:** If the sun is very low, you have the chance to get players surround by *rim light,* a bright glow that outlines the body. Good rim light is impressive.)

Sun with shade

When half a field is in sunlight and half of it is in shade, you can't manually change the metering as the players run back and forth, so let the camera do things automatically. Pick an ISO that gives you a fast enough shutter speed for the shady part of the field, put your camera in aperture-priority mode, and set a reasonably fast aperture such as f/4. This approach ensures that the camera picks the fastest shutter speed for each side of the field. (Using aperture-priority mode to get the fastest shutter speed may seem counterintuitive, but it works as long as you pick a wide aperture.)

Don't go with shutter-priority mode. In this mode, the camera changes apertures as the players move from sun to shade, meaning you can't get the fastest shutter speed possible for the sunny side of the field.

Stadium light

Stadium light at night ranges from dreadful to okay, but one thing is always the same — it's never bright enough. Stadium light means high ISO settings, and even then you're forced to use slower shutter speeds that may not adequately freeze the action for a crisp photo. Given a choice when the lighting was good, I used shutter speeds of 1/250 second and faster in order to stop the action for most of the photos in this chapter. I used slower shutter speeds when lighting conditions were too low or when I used flash.

Some stadium lights are so dim that you have to use flash. Flash distances are limited at low ISO settings, though, so use ISO 400 or ISO 800 so your flash unit has a chance to reach the action halfway across the field.

Arena light

Arena light varies not only in brightness, making an adequate shutter speed a challenge sometimes, but also in color. Some arena lights are deficient in part of the visible spectrum, which means the color spectrum is shifted to the warm or cool side and missing some colors altogether. Consequently, you can't get truly natural-looking colors. The best solution is to set a custom white balance for the lighting conditions (check your camera's manual to find out how) and hope for the best. See Chapter 5 to find out all about white balance.

I had the opportunity to photograph Olympic gold medalist Shannon Miller in two kinds of arena light. In Figure 15-7, Shannon was working on the balance beam under ordinary arena lighting with the color balance shifted to the red-orange end of the spectrum. Digitally removing the color cast results in almost no color at all, so a different solution is to shoot with flash (as shown in Figure 15-8). The color is natural, and the arena totally disappears, giving no sense of place. Of course, you may or may not like the disappearing arena. Another solution when the lighting has a strong color cast is to convert the photo to black and white.

50mm, around 1/30 sec., about f/4, 100 *50mm, around 1/60 sec., about f/8, 100*

Figure 15-7: Shannon Miller under arena lighting with a red-orange color cast.

Figure 15-8: The arena disappears when Shannon is lit with a flash.

Even in an indoor arena, the lighting can vary. In Figure 15-9, the overhead lights were turned off, and Shannon Miller performed under a spotlight. The color balance of the spotlight was just a little cooler in color temperature than daylight and much better than the other arena lights. It was also bright, allowing for a faster shutter speed.

80–200mm lens at around 150mm, around 1/125 sec., about f/4, 100

Figure 15-9: Cooler, better lighting from arena spotlights.

Part IV
Exposure in Special Situations

The 5th Wave — By Rich Tennant

"Wow, I've never seen so many lightning strikes! Did you get any of them?"

In this part . . .

As you discover in Part IV, in the world of
specialized photography (which includes
close-up, night, and low-light photography), what
looks simple can be more challenging than you
may expect, and what looks difficult at first can be
remarkably simple. Get ready to add some unique
images to your portfolio with the exposure advice
I present in this part.

16

Itty-Bitty Things: Close-Up Photography

Close-up photography, also called *macro photography,* is an enjoyable and fascinating specialty. The world of small things provides nearly infinite photographic possibilities: Bugs, beetles, bluebonnets, bees, beans, BBs, buttons, bluebells, bottle caps, baby's breath, and barn spiders all await you, and that's just a partial list from one letter of the alphabet.

This chapter gives you the keys to good close-up photography. I explain how to determine the magnification you need and help you choose and use the right equipment. I also share techniques for shooting good close-ups and handling the exposure challenges you're bound to encounter.

Determining the Magnification for Your Subject

First things first in close-up photograhy: You need to determine the magnification for your subject. *Magnification* is the ratio of the size of the subject projected on your digital sensor to the subject's size in real life. Put another way, the magnification ratio is the size of the subject on your sensor divided by the size of your subject in real life. Magnification can be written as a ratio (1:4), a fraction (¼x), or a decimal (0.25x).

If your lens projects a 1-inch-tall image of a flower on your sensor and the flower is 4 inches tall in real life, the magnification ratio is 1:4 or ¼x on the sensor. If a postage stamp is 1 inch tall on the sensor and 1 inch tall in real life, it's 1:1 or 1x magnification, or *life-size,* in your camera. If a beetle is 1 inch tall in your camera and ½ inch tall in real life, the magnification ratio is 2:1 or 2x magnification on the sensor.

To give you a visual idea of what magnification looks like, check out the left photo in Figure 16-1. This is a stargazer lily at close to ⅙x magnification (the lily on the sensor is one-sixth its real size). You can create an image like this with almost any lens without any special accessories. For the right photo in Figure 16-1, a 50mm macro lens was inside the lily; the resulting magnification is 4x (four times life-size on the sensor). The lens was mounted on a *bellows unit* (an expandable, accordion-like unit with the camera on one end and the lens on the other). A bellows unit can extend to provide up to 175mm of extension, with the lens providing another 25mm for a total of 200mm of extension. (The longer the extension, the greater the magnification. Find out more about extension in the later "Extension tubes" section.)

Around 80mm, around 1/125 sec., about f/8, 64　　　　　*50mm macro lens, around 1/2 sec., about f/8, 64*

Figure 16-1: Stargazer lily at about ⅙x magnification (left) and 4x magnification (right).

To estimate the approximate magnification you need to photograph your chosen subject, just imagine a frame around it. The magnification you need is the reciprocal of the size of your frame in inches. So if you're photographing a flower with a 4-inch imaginary frame, the magnification you need is about ¼x. And if you put a ¼-inch frame around a grain of rice, the magnification you need is about 4x, or four times life-size in your camera. Digital sensors can vary in size, but the frame trick gets you close to the magnification you need.

To illustrate, Figure 16-2 shows a not-so-imaginary hand frame around some hosta flowers. The frame is about 5 x 7 inches, so the magnification necessary to photograph these flowers is ⅕x to ⅐x, depending on the size of the camera's sensor. Here are some guidelines:

100mm macro lens, 1/250 sec., f/11, 100

Figure 16-2: Sizing up a hand frame around hostas.

✔ Use the short side of the frame to determine the magnification if you have a full-frame digital camera because the short side of the sensor in the camera measures about 1 inch.

✔ Use the long side of the frame to determine the magnification if you have a cropped-frame digital camera with a smaller sensor because the long side of the sensor in many of these cameras measures about 1 inch.

Measuring How Much Your Lenses Magnify

Most normal lenses, set at their point of closest focus, have a maximum magnification somewhere between ⅛x and ⅓x. If your subjects don't require any more magnification than your lens can handle, you don't need any special equipment. If your favorite zoom lens has a maximum magnification of ⅕x, you can fill the frame with anything 5 inches or bigger.

You can (and should) check the maximum magnification of each of your lenses because you can't predict which lenses have the most close-up potential. All you need are a ruler (or a yardstick) with clearly readable numbers and the following steps:

1. **Lay the ruler on the ground.**

2. **Manually set your lens at its closest point of focus and don't touch the focus ring again.**

3. **Make sure the ruler is parallel to the frame.**

 If you're using a full-frame digital camera, the ruler should be parallel to the short side of the frame (see Figure 16-3).

 If you're using a cropped-frame digital camera, the ruler should be parallel to the long side of the frame.

4. **Look through the viewfinder and move the camera closer or farther away from the ruler until it's in focus adjust the focus, being careful not to adjust the focus dial.**

5. **Line up the edge of the frame with the 0 inch end of the ruler and either take note of the highest number you can read on the ruler or take a picture and then check.**

 The number of inches you can see is the reciprocal of the maximum magnification of that lens.

Figure 16-3: Ruler shot with a 70–200mm lens at maximum magnification without accessories.

You should end up with a picture something like Figure 16-3 (except the ruler should run the length of the frame if you're using a cropped-frame digital camera). Figure 16-3 is the closest my 70–200mm zoom lens can focus without any accessories. The magnification is close to ¼x, which means I can fill the frame with anything 4 inches wide or larger.

Note: You can perform the same test to measure how much your close-up accessories magnify a subject. I introduce you to the various accessories in the next section.

If you want to skip all the magnification stuff, you can just measure how many inches (or centimeters) your lens covers at its closest focus points and use that as your guide. However, so much of the literature on close-ups deals with magnification ratios that understanding the numbers is really useful.

The magnification numbers in this chapter apply only to magnification on the camera's sensor when you take a picture, not to the magnification in a print. If you have 1x magnification on your sensor when you take the picture and turn it into an 8-x-10-inch print, the subject on the print will be eight times bigger than life-size.

Getting the Magnification You Need

If you get seriously involved in close-up photography, sooner or later you're going to need more magnification than your lenses can give you. Enter close-up accessories. In the following sections, I give you a quick rundown of the most commonly used accessories. But keep in mind that you can do some nice close-up work without any special equipment. Many lenses will focus close enough to take pictures like the ones throughout this chapter.

Single-element close-up filters

Simple one-element, close-up, diopter filters (often marked +1, +2, +3) are an inexpensive way to get close to your subject. *Diopter* refers to power. The higher the number, the more powerful the diopter correction, the closer you can get to your subject, and the greater the magnification. The numbers are additive: Using a +1 filter and a +2 filter together is the same as using a single +3 filter. The *working distance* (the distance between the subject and the front of the lens) with these filters is small, especially with the higher-powered filters. If you stack two of these close-up filters on your lens, put the one with the higher diopter number on your lens first.

Single-element filters have several advantages. They're cheap, small, lightweight, and they don't cost you any loss of light. The chief disadvantage is loss of image quality, especially closer to the edges of the frame. Quality is reasonably good close to the center of the frame.

Single-element close-up filters are a great way to get started in close-up photography without committing much money. If you discover you really like close-up photography, you may want to upgrade to the better equipment options I describe in the next sections.

Double-element close-up filters

Double-element close-up filters are often called *close-up lenses* or *supplementary lenses*. They're lenses, but they look and act just like screw-in filters. (***Note:*** Some brands call their product a *filter;* others use the term *lens.* Although I use the filter terminology throughout this section, rest assured I'm referring to comparable products.)

These fancy close-up filters have two glass elements rather than one, which means they're *much* better in quality than single-element close-up filters. They're also more expensive but not frightfully so.

Double-element close-up filters are designed to be used on telephoto zoom lenses in the 70–300mm range. If you already have a telephoto zoom lens, this is the best, most reasonably priced way to go. (Also, these filters don't take up much room in a camera bag.) A real plus with a long zoom lens and a double-element close-up filter is that you have a lot of working distance between the lens and the subject. This is the best way to photograph skittish little creatures.

The magnification you get depends on the strength of the filter and the amount of magnification built into your lens. With a lot of 200–300mm lenses, you can expect at least ⅓x to ⅔x magnification.

The next sections fill you in on Canon and Nikon double-element close-up lenses. Both brands are excellent in quality. Either brand works on any brand of lens, provided you get the correct size for your lens. If your lens is in between the standard filter sizes, the next sections also explain your options.

Canon 500D close-up lens

The Canon 500D close-up lens comes in four filter sizes: 52, 58, 72 and 77mm. The 500D is a +2 diopter lens (the only strength available), which is between the Nikon double-element lenses in power (see the following section for the scoop on these) and comparable to the Nikon filters in quality. If your telephoto lens takes filters larger than 62mm in diameter, get a Canon 500D. The Nikon close-up lenses are too small for you.

A word of caution: If you come across a less expensive Canon 500 lens (without the *D*), keep in mind that it's a single-element lens, so it doesn't match the 500D in quality.

Nikon 3T, 4T, 5T, and 6T close-up lenses

Nikon lenses come in two strengths and two sizes, as detailed in Table 16-1.

Table 16-1	Nikon Close-Up Lenses	
Lens Size	*+1.5 Diopter*	*+3 Diopter*
52mm size	3T	4T
62mm size	5T	6T

Technically, the 4T and 6T are 2.9 diopter lenses. The 4T and 6T provide more magnification than the Canon 500D, and the 3T and 5T provide less. In close-up photography, more power is good, so if you have a zoom lens that takes 52mm or 62mm filters, get the Nikon 4T or 6T for maximum power.

If your zoom lens takes 58mm filters, you have a choice between power and convenience. For more power, get the +3 diopter Nikon 6T and buy a 58–62mm step-up ring (see the next section) in order to put the Nikon 6T on your lens. If you prefer convenience, get the Canon 500D in a 58mm size; you avoid the need to get a step-up ring this way, but you also wind up with less magnification.

A telephoto zoom lens and a Nikon 6T double-element close-up lens provided the magnification needed for Figure 16-4's photograph of a praying mantis eating a honey bee.

Step-up rings

If no manufacturer makes a close-up filter in a size that exactly matches the filter size of your telephoto zoom lens, you can get the next largest close-up filter and buy a step-up ring to go between your lens and the filter. For example, if your lens takes a 67mm filter and you buy a 72mm double-element close-up filter, you need a 67–72mm step-up ring.

Extension tubes

Extension tubes are a high-quality way to do close-up work at a reasonable cost. Quality and price are about the same as using double-element close-up filters (see the previous section). Their purpose is to get your lenses farther from the camera body so they can focus closer. They're essentially hollow tubes with couplings and/or electronic connections so your lens and camera body can talk to each other. You mount the extension tube on your camera body and then attach your lens to the extension tube (be sure to buy extension tubes that are designed for your brand and type of camera).

 The longer the tube and the shorter the focal length of the lens, the more magnification you get. Magnification equals the amount of extension (the length of the tube) divided by the focal length of the lens. So a 25mm tube with a 100mm lens equals ¼x magnification, and a 25mm tube with a 25mm lens gives you 1x magnification, four times as much. You can stack more than one extension tube to get more extension and therefore more magnification. The bottom line is that you get a lot more magnification by putting an extension tube on one of your shorter lenses.

The big disadvantage of extensions tubes is the very short working distance from the lens to the subject. This isn't a big deal with flowers and stamps, but skittish critters like butterflies will be gone long before you get within working range.

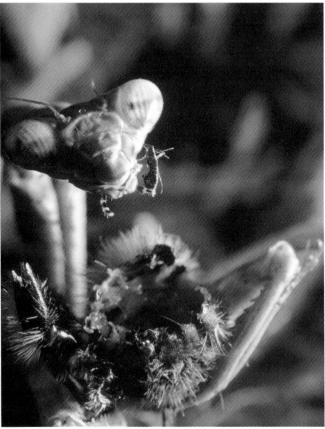

80–200mm lens at 200mm, around 1/60 sec., about f/8, 50

Figure 16-4: A praying mantis eating a honey bee, photographed with a telephoto zoom lens and a double-element close-up filter.

Macro lenses

Macro lenses allow you to do the highest-quality close-up work, especially when photographing flat subjects such as stamps, but they're also expensive (several hundred dollars in the 50–100mm focal lengths and a lot more for the longer ones). They're commonly available in 50, 60, 90, 100, 105, and 200mm focal lengths (depending on the brand). Shorter macro lenses usually reach ½x magnification by themselves and 1x with the appropriate extension tube (which usually comes with the lens). Longer macro lenses reach about 1x magnification without an extension tube. You can add one or more extension tubes to the macro lens for even more magnification.

Macro lenses focus closer than normal lenses of the same focal length (they basically have a lot of built-in extension). They're also some of the sharpest

lenses available because they're optically corrected to make images sharper all the way to the edges of the frame. Macro lenses lose light at higher magnifications, but this is handled automatically by a built-in, through-the-lens (TTL) camera meter.

I photographed the Michigan lily in Figure 16-5 with a macro lens. The magnification is about ¼x, so the photo could have been taken with a telephoto zoom lens and a double-element close-up filter. A macro lens provides the best image quality, but a good zoom lens and a double-element close-up filter can do very well.

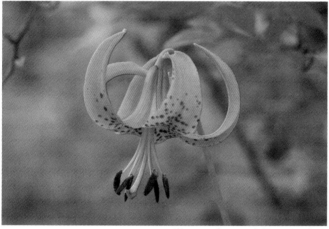

100mm macro lens, around 1/30 sec., about f/8, 100

Figure 16-5: A macro-lens shot of a Michigan lily.

Choosing and Combining Close-Up Gear

Perhaps you're wondering what close-up gear to get or how to combine this gear with what you already own. For starters, if you use a long telephoto zoom lens, a double-element close-up filter may be the best choice for you (plus it takes up very little space in your camera bag).

One or two extension tubes are the best option for lenses in the wide- to mid-focal-length range (24–70mm). If you put a long extension tube (25mm) on a wide-angle lens, you can practically focus on the front element of the lens, which allows you to take pictures from interesting vantage points. You can get so close that the front of your lens is inside the petals of a flower while you photograph the stamens and pistils.

If you want a lot of flexibility, you can get a double-element close-up filter and an extension tube. When the lens/filter combo doesn't give you enough

magnification, adding the extension tube to the combo will give you even more magnification. The point here? Don't be afraid to try more than one close-up accessory at the same time.

I decided I needed all the magnification I could get to capture the aphids in Figure 16-6, so I used a 50mm macro lens combined with 175mm of extension to get to 4x magnification.

50mm macro lens, around 1/4 sec., about f/11, 50

Figure 16-6: Aphids at 4x magnification.

If cost, weight, and camera bag space aren't an issue, invest in a macro lens for optimum image quality. If you tend to photograph skittish subjects, a 100mm or longer macro lens gives you more working distance.

Whatever close-up gear or combination of gear you decide to go with, do the ruler test described in the "Measuring How Much Your Lenses Magnify" section so you know the maximum magnification for each of your close-up options. For easy reference, write them all on a 3-x-5 notecard and carry the card in your camera bag.

Metering for Close-Ups

As you focus closer, most lenses get longer, and you lose some light. If you use extension tubes, you lose more light. Most macro lenses get a lot longer, so you lose a lot of light. Because an incident light meter doesn't know your close-up gear is costing you light, using one is impractical in close-up photography. (See Chapter 4 for info on incident light metering.) Instead, your best options are gray card metering and reflected light metering.

I introduce you to gray cards in Chapter 4. To use one, set up your camera and focus on the subject. Make sure autofocus is turned off. Then put your gray card in between the lens and the subject, in the same light as the subject. Don't refocus; if you do, the metering will change. Lock in the exposure reading of the gray card and take the picture. Note that if the subject is very light or very dark, you have to do some exposure compensation (check out Chapter 3 for the scoop on this).

If you're photographing an animal, it may not appreciate you putting a gray card anywhere near it, so go with a meter reading from your camera. Meter the subject and use exposure compensation if the subject is lighter or darker than a medium tone.

✔ When you have a light subject in front of a dark background, the dark background fools your camera meter into overexposing your subject. To fix this problem, turn on spot metering (which meters a very narrow angle of view). If you don't have this option on your camera, dial in some minus exposure compensation to allow for the dark background.

✔ When you have a dark subject in front of a light background, the light background fools your camera meter into underexposing your subject. Again, the best solution is to turn on spot metering. If you don't have spot metering, dial in some plus exposure compensation to allow for the light background.

The yellow-fringed orchid in Figure 16-7 is against a dark background, a situation that leads most camera meters astray. I didn't have a spot meter, but I also didn't have to worry about scaring away my subject, so a gray card was the best way to meter. If the subject had been a butterfly instead of a flower, adjusting the exposure compensation would've taken care of the problem.

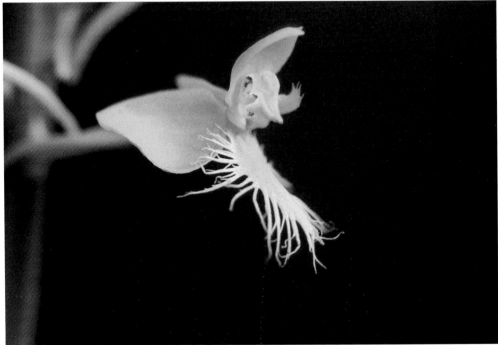

100mm macro lens, around 1/15 sec., about f/11, 100

Figure 16-7: A yellow-fringed orchid at 1x magnification, metered using a gray card.

Dealing with Close-Up Challenges

Photography wouldn't be an art if it didn't have any challenges, and close-up photography has its own unique uphill battles. However, you can work through these challenges like a pro by following the advice in the next sections.

Focusing up close

When you're new to close-up photography and using an accessory, don't be surprised if you have trouble getting the subject in focus. Close-up photography is in another world compared to other types of photography, and that's especially true of the way you focus. In the "normal" world, the focusing range for a lens is from infinity to just a few feet from the camera. Put a close-up accessory on a lens, and the range of focus becomes very limited. For example, with a 25mm extension tube and a 50mm lens, the focusing range may be only from 1 to 3 inches in front of the lens. If you're 5 or 10 inches from the subject, you can turn the focusing ring all day long and never get your subject in focus because you're too far away.

The secret to focusing up close is to focus by moving the camera closer or farther away from the subject. Turn off autofocus, avoid touching the focusing ring, and focus with your body. Look through the camera and rock backward and forward with your body until the subject comes into focus. If need be, you can fine-tune the focus with the lens, but do the major focusing by moving the camera and lens. If you're using a tripod, rock back and forth until you figure out how far the camera needs to be from the subject and then place the tripod accordingly. If you can't bring the subject into focus, the camera/lens is too close or too far away from the subject.

If you're using a double-element close-up filter on a zoom lens, consider the zoom ring the magnification ring. Focus by moving the camera and lens closer or farther away from the subject. If the subject isn't big enough, zoom to a longer focal length and refocus by moving the camera and lens closer or farther away.

With a double-element close-up filter on a telephoto lens, the right distance may be 1 to 3 feet away from the subject. With an extension tube and a normal lens, the subject will probably come into focus when the front of the lens is just a few inches from the subject. With a little practice, you can figure out the working distance you need for each particular lens and close-up accessory combination.

Working with a reduced depth of field

At the high magnifications necessary for close-up photography, depth of field shrinks dramatically. (I cover depth of field in detail in Chapters 6 and 7.) Even at f/16, if you shoot at 1x magnification, your depth of field is less than ½ inch. Apertures from f/11 to f/22 aren't uncommon in close-up photography, so you can count on long shutter speeds as part of the routine. And because close-up accessories can cost you 1 or 2 stops of light, you need even longer shutter speeds just to keep part of your subject in focus. Adjusting to long shutter speeds and avoiding "the shakes" is just part of the routine. The next section can help.

Avoiding the shakes

As magnification increases, so do the challenges from camera and/or subject movement. At high magnifications, the slightest bit of camera or subject movement seems to make the subject dance and shift. The two obvious choices for reducing movement are to use a tripod or flash, and sometimes you need both.

At magnifications around ⅛x to ¼x, camera movement isn't such an issue if you're in bright sunlight because your shutter speed can be sufficiently fast. At 1x and higher magnifications, a tripod becomes more and more important, even in bright sunlight, because your shutter speed usually isn't fast enough to freeze the jiggles caused by handholding the camera — not to mention any movement by the subject.

If you're photographing a spider in a web, a tripod is fine, but if you're shooting bees going from flower to flower, a tripod doesn't make as much sense. In that case you're better off going with a hand-held camera and small apertures to try to keep some of the bees in focus, using flash to "stop" their motion. Or you can put your camera on a tripod, focus on one flower, and hope that it's the flower that some bee decides to land on. I've done it both ways; you may want to give them both a try, too.

The Buffalo Treehopper shown in Figure 16-8 is an example of a high magnifaction situation in which flash was essential.

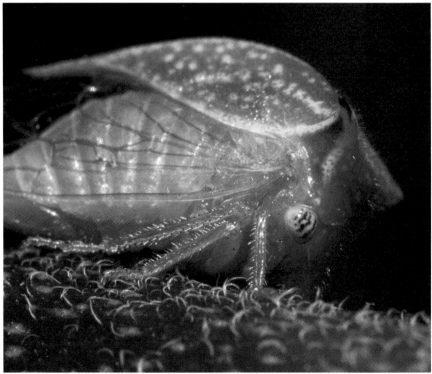

65mm, 1/125 sec., about f/16, 100

Figure 16-8: A buffalo Treehopper, about 3x magnification, shot with flash

But I Can Hardly See! Night and Low-Light Photography

In This Chapter

▶ Gathering the right gear for taking photos at night and in low light

▶ Exercising patience and shooting stars

▶ Taking advantage of moonlight and long exposures

▶ Adjusting for city lights at night

▶ Shooting fireworks and lightning

▶ Getting creative

*A*ll kinds of wonderful things can happen to the light after the sun goes down. Of course, you can never predict exactly what will happen. It could be nothing, or it could be something amazing. The anticipation keeps photography exciting.

Whenever I go on a series of field trips with a group of photographers, one of the first trips is to start at sunset and shoot until the stars come out. Inevitably, someone asks whether it's possible to shoot in light that's so dim. My response? If you can see your subject and it doesn't run away, you can photograph it, no matter how dim the light is.

Low-light and nighttime photography (also called *existing-light photography* or *available-light photography*) includes just about anything that doesn't happen in sunlight. It can mean dusk in the desert, city lights at 1 a.m., or photos inside a roadside diner just before dawn. Low-light photography calls for longer shutter speeds, higher ISO settings, or both. This chapter helps you know what's most appropriate for some typical low-light situations. It also fills you in on the proper equipment for this specialized type of photography.

Choosing Equipment for Low-Light Photography

Whether you're photographing stars, moonlit landscapes, or any other low-light scenario, a fast, single focal length lens is a great asset because you can use faster shutter speeds or lower ISO settings. Although I use zoom lenses most of the time, when I'm going to shoot the night sky or a city street at night with a hand-held camera (or stars in the sky with my camera on a tripod), I prefer to use either a 50mm f/1.8 lens set to an aperture of f/2.8 or f/4 or a 24mm f/2.8 lens set to an aperture of f/4. The most important lens to get is a "fast 50." A 50mm, f/1.8 lens will set you back only $100 to $125, and it's a great hand-held lens for taking photos at night in the city. For stars in the night sky, get a fast (f/2.8) wide-angle lens (20, 24, or 28mm), which runs about $275 to $575 depending on the focal length you choose. If concerts and the theater are your thing, get an 85mm f/1.8 lens for about $400. Of course, you can always crank up the ISO, live with the digital noise, and have fun in low light with your zoom lens!

Note: Just about every lens is sharper when stopped down 1 or 2 stops, so a lens with a maximum aperture of f/2.8, stopped down to f/4 provides a sharper image than an f/4 lens used wide open. That's one more reason to get a fast lens.

Don't forget a quality tripod. This piece of equipment is absolutely essential in low-light situations for using long shutter speeds without camera shake. A wireless remote or electronic cable release will keep you from jiggling the camera. In a pinch, you can use the camera's self-timer to avoid the jiggles, but you may miss the moment you want to capture while the self-timer is doing its thing.

What Sunset? Scoring Stellar Images by Waiting for the Best Light

Although sunsets make gorgeous photographs, sometimes they're not the main event. If you're lucky and patient enough to wait around after sunset to see whether great light happens, you may wind up with a picture that's even better than the sunset you snapped earlier. However, you'll never know whether that great light came about without exercising a bit of patience. So after the sun sets, don't be in too much of a hurry to put your camera away. Instead, wait and see what happens.

Metering the light show is fairly straightforward. Meter an area of the sky that you want to make medium in tone and use that as your exposure. Just be careful not to burn out a large area of the sky that's much lighter in tone. Also, don't settle for just one exposure. Give yourself options between "light and bright" and "dark and dramatic." You can end up with several different great exposures when you work with Mother Nature's light show.

Figure 17-1 is a perfect example of what waiting for the best light possible can get you. When I shot this photo, I was disappointed that the sunset I'd hoped for didn't look like it would materialize. The light levels were dropping, telling me the sun had set behind the clouds, even though there was no sunset color whatsoever. I stuck around, and eventually the clouds started to part, and colors began returning to the sky. I grabbed my camera and tripod; metered the sky to the right of the clouds; and made the sky slightly lighter than a medium tone, letting the rest of the tones to the left become progressively darker and more dramatic. Because my camera was on a tripod, I was able to use a low ISO setting for maximum image quality.

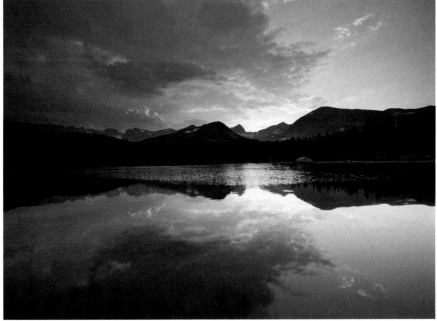

17–40mm lens at 17mm, 1/6 sec., f/8, 100

Figure 17-1: The reward for waiting for great light.

Capturing the Stars

After the warm light of the sun finally fades away, the cool colors of evening take over, and the stars come out. If you want to capture these stars in all their glory, be sure to set the white balance of your digital camera to the daylight setting so you get the nice, cool tones of late-evening light. This is a great time to photograph stars, and the process is quite easy. Start shooting when the sky looks just a little too light and keep shooting until it gets really dark. Somewhere in the middle, you'll find a nice balance between the stars and the deep blue of the sky.

Star photographs look even better when you include some of the landscape at the bottom of the frame.

Meter the sky as your beginning exposure and then subtract ½ to 1 stop of light from what the meter tells you for more exposures. Due to the rotation of the earth, the stars will create streaks across the sky called *star trails.* If you want to minimize star trails, use shutter speeds that are 30 seconds or shorter for a wide-angle lens (like 24mm) or 15 seconds or shorter for a normal focal length lens (like 50mm). When you're shooting the northern sky (if you're in the Northern Hemisphere), the stars move less in a given period of time so you can get away with longer shutter speeds. Choose an ISO that gives you the shutter speed you need.

As the sky grows ever darker, you'll hit the point where your camera's meter quits being helpful. When that happens, set the ISO to 400 and the aperture to f/4 and try shutter speeds of 15 seconds, 30 seconds, and 60 seconds (set the camera to B for bulb and count off 60 seconds). Then set the ISO to 800; leave the aperture at f/4; and try shutter speeds of 15 seconds, 30 seconds, and 60 seconds. If you're in the Northern Hemisphere and you point the camera toward the south, west, or east, you'll get some trailing of the stars at 60 seconds, even with a wide-angle lens. If you point your camera to the north, the star trails will be shorter.

If you want to maximize star trails, wait until the sky is very dark, set the ISO to 100 and the aperture to f/4 or f/5.6 and try shutter speeds of 15 minutes, 30 minutes, 60 minutes, and longer. The longer shutter speeds won't work unless you're a good 50 miles from the nearest city (or even farther for a really big city). The city lights will cause a hazy glow called *sky fog,* even if the sky looks dark to your eyes. A locking cable release can help so you don't have to hold the shutter for long periods of time or risk jiggling the camera while you're pressing down the shutter button for a 15-minute (or longer) exposure. (Flip to Chapter 18 for the scoop on this helpful accessory.)

The sky was looking pretty dark when I photographed the stars in the constellation Scorpius (The Scorpion) over the mountains in Rocky Mountain

National Park (see Figure 17-2). I set my camera on a tripod and used ISO 400 to avoid a lot of star trailing. This ISO allowed me to use a shutter speed of 30 seconds. Although the stars still trailed a bit, I achieved the look I wanted. (If I'd wanted star trails, I would've waited until the sky was even darker, gone with an ISO of 100, an aperture of f/5.6, and a shutter speed of 15 minutes.

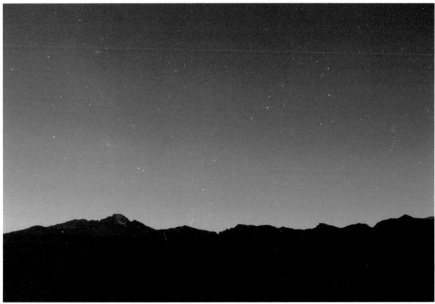

24mm, 30 sec., f/4, 400

Figure 17-2: Scorpius over the Rocky Mountains, shot to minimize star trails.

Mixing the Colors of Light

Never pass up a good opportunity to mix the color temperatures of light (I fill you in these in Chapter 5). The warm colors of artificial light can create a nice contrast to the cool color temperatures of the late-evening or night sky. You need enough blue in the sky to contrast with the warm artificial light, so timing is important. If you shoot too late in the evening, the blue will be too dark in comparison to the artificial lights. If you shoot too early, the lights won't have enough pop. A sliver of a moon in the sky won't change the light, but a full moon can cause problems if it's high in the sky and your exposures are running long.

To properly mix the different colors of light, you need to set the white balance of your camera to daylight.

Figure 17-3 is a good example of what happens when you start weaving warm and cool light into your photographs. Jupiter was shining brightly among the stars in the night sky when I passed the tents you see in this image. I walked up and metered the sides of the tents and added about 1½ stops of light to give me the longest shutter speed possible without burning out the tents. (They were actually very dimly lit.) I locked in the exposure, backed up, and recomposed to include Jupiter and a few stars in between the trees. Due to the long exposure, Jupiter and the stars created short streaks across the sky.

About 50mm, about 2 min., around f/4, 100

Figure 17-3: Combine cool evening light with warm artificial light for added interest.

Photographing Scenes by Moonlight

When you photograph a particular scene by moonlight, you're using very dimly reflected sunlight, so a full moon high in the sky works best to give you the most light possible. When the moon is half full (during the first or last quarter of the lunar cycle), the amount of moonlight drops dramatically, and exposure times become much longer.

To capture a landscape lit by a full moon, make sure the moon is behind you and set your camera to daylight white balance. Set the ISO to 100 and the aperture to f/4 and try shutter speeds of 2 minutes, 3 minutes, and 4 minutes. If you need more depth of field, try an aperture of f/8 and shutter speeds of 8 minutes, 15 minutes, and 30 minutes. (Note that with these settings, you'll wind up with significant star trails.) If you want shorter shutter speeds, try an ISO of 800, an aperture of f/4, and shutter speeds of 15 seconds, 30 seconds, and 1 minute. If the moon is to your side, giving you a sidelit landscape, add a stop of light to all the previously mentioned exposure settings by doubling the shutter speed. If you use a wider aperture, you may not have enough depth of field. *Tip:* If you're photographing a snow-covered landscape by the light of a full moon, cut your moonlit landscape shutter speeds in half.

In Figure 17-4, I photographed El Capitan in Yosemite National Park by the light of the rising moon. Landscapes with some light tones are perfect for moonlit photos because the exposure times aren't so terribly long. Although the exposure was six minutes long for this photo, it would've been closer to an hour if I'd taken a picture of just the evergreens because they're at least 3 stops darker than the granite cliffs.

50mm, 6 min., f/4, 25

Figure 17-4: Granite cliffs in moonlight.

Adding the Moon to a Landscape

The moon is smaller and much brighter than the landscape it lights — two issues you must deal with whenever you add the moon to a photo of a moon-lit landscape.

When viewed through a 50mm lens, the moon looks pretty small — much smaller than it looks to the human eye in a dark night sky. If you think that's bad, wait until you peek at the moon through a 24mm lens. Then it appears downright tiny! If you want the moon to look "normal" in a photograph, use a 100mm lens (60mm if you have a camera with a cropped-frame digital sensor). For a more dramatic moon, use longer focal lengths.

In the left-hand photo in Figure 17-5, the lens on the Canon 10D was set to a 65mm focal length to photograph the moon between the trees. (A 65mm lens on a Canon 10D is the equivalent of a 104mm lens on a full-frame digital camera.) Compare the two images in Figure 17-5, and you can see that the moon looks more normal when shot with a 104mm focal length (left) than with a 24mm focal length (right).

28–135mm lens at 65mm (104mm equivalent), 6 sec., f/11, 400 *24mm, around 30sec., about f/8, 50 at EI 40*

Figure 17-5: Different focal lengths change the size of the moon when you add it to a landscape photo.

The exposure for a full moon is BDE +1 or BDE +2 (I explain BDE, short for Basic Daylight Exposure, in Chapter 4). The light reflecting off the moon comes from the sun, but the moon is darker than most people think, specifically about 1 stop darker than an 18 percent gray card. It only looks bright because you typically see it surrounded by a very dark sky. When you photograph the moon at BDE, it looks very dark. BDE +1 gives you a gray moon, and BDE +2 gives you a lighter, creamier-looking moon (which happens to be how I like my moons).

At ISO 100, BDE +1 is f/11 and a shutter speed of 1/100 second (or an equivalent exposure; see Chapter 2 for how to create one). BDE +2 at ISO 100 is an aperture of f/8 and a shutter speed of 1/100 second. Try both the next time there's a full moon and see how you like your moon.

The exposure for a moon that's half full (first or last quarter) is BDE +2 or BDE +3.

The shutter speeds for photographing the moon are much, much shorter than the shutter speeds for photographing a moonlit landscape. If you expose for the moon, the moonlit landscape disappears in inky blackness. On the other hand, if you expose for the landscape, the moon becomes a burned-out white blob. Sometimes, though, you have no choice, so you expose for the landscape and let the moon wash out. The smaller the moon (refer to Figure 17-5), the more acceptable it is for it to be washed out. On the other hand, a big, washed-out moon would ruin most photographs. The main way to get around this exposure disparity is to shoot a full moon when it's low in the sky, either shortly after sunset or shortly before sunrise. This way there's enough light on the landscape to balance the exposure between the moon and the landscape.

Showing the Passage of Time with Long Exposures

One of the nice things about low-light photography is the ability to use long shutter speeds and subject motion to show the passage of time. However, metering in low light can be tricky. If you have a deep blue sky, meter the sky and subtract light from the meter reading to keep the sky dark. If you're metering nothing but lights, the best results come from adding light to what the meter tells you. An additional 1 or 2 stops usually does the trick, but sometimes you need to add more.

Because lighting situations are so variable after sunset, some photographers use an exposure guide (see Chapter 4 for more on these).

Figure 17-6 shows you how you can experiment with shutter speeds to blur the motion of a Ferris wheel. A long shutter speed can completely blur the circular motion of the lights on the Ferris wheel (see the left-hand image in Figure 17-6), and somewhat shorter shutter speeds can break up the motion of the lights (see the right-hand image in Figure 17-6). ***Note:*** I added about 1½ stops of light to what the camera meter suggested to get these images.

As for long taillight streaks, they aren't just for the city. Most any highway or country road will do, provided someone is driving by. When you do low-light photography in the country, you have the advantage of not having to deal with other lights that can limit the length of your shutter speed. As long as you can see the sky, you can take pictures. Meter the sky and subtract ½ to 1 stop of light to keep it dark. Your results may wind up looking something like Figure 17-7.

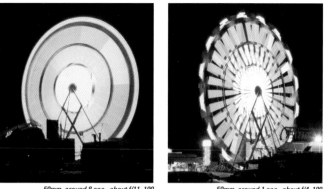

50mm, around 8 sec., about f/11, 100 *50mm, around 1 sec., about f/4, 100*

Figure 17-6: Using different shutter speeds helps show how time passes.

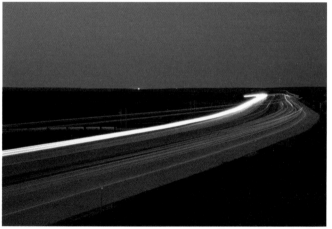

50mm, around 60 sec., about f/8, 100

Figure 17-7: Long exposures allow you to create taillight streaks from passing cars.

Metering for City Lights

Bright lights, like those found in some urban environments, can fool a camera meter, so when you photograph a scene with a lot of lights, like the River Walk in San Antonio, Texas (see Figure 17-8), add 1 or 2 stops of light to what the camera meter tells you to keep the lights looking nice and bright in your photograph. Note that city lights vary a lot in intensity, so it doesn't hurt to bracket exposures (see Chapter 4 for the scoop on this technique).

If you shoot down the length of a street (or in this case, down the length of a river) rather than across the street, you can pack a lot more lights into the frame and have a more impressive photo. Medium to long focal lengths work best when you shoot down a street. Stay away from wide-angle lenses unless you're in one of those rare urban settings where lights are everywhere.

Getting up on a bridge, overpass, or building gives you a different point of view. By the way, if you're shooting from a bridge that isn't frequented by pedestrians, don't be surprised if a friendly law enforcement officer checks you out. If you're pleasant and describe clearly what you're doing, you likely won't be asked to move on.

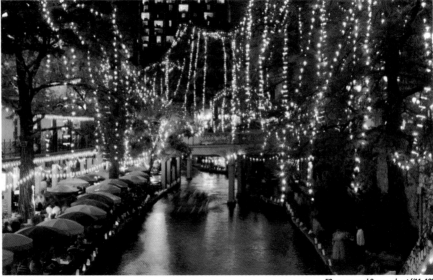

50mm, around 8 sec., about f/11, 100

Figure 17-8: Add 1 or 2 stops of light when metering bright city lights.

Shooting Illuminated Objects at Night

When photographing illuminated subjects such as buildings, trees, waterfalls, or bridges at night, jewel box lighting is one of the best ways to go. *Jewel box lighting* is a technique for photographing illuminated objects and structures in late-evening light so it looks like night but there's still some color left in the sky. The challenge is to balance the lighting on the building with the deep blue of the sky.

To take advantage of jewel box lighting, start photographing your illuminated subject when the sky looks too light. If you wait until the sky looks just right, you'll probably miss the best light. Meter the sky and subtract ½ to 1 stop of light from what the meter says in order to keep the sky dark. Lock in the exposure, recompose to include your lighted subject, and take a picture. Wait five to ten minutes, meter the sky again, subtract ½ to 1 stop of light, and take another picture. Keep repeating this process every five to ten minutes until the sky is too dark. At the end, you'll have a series of photos in which the sky is the same dark blue every time (because you're metering the sky each time) but your illuminated subject gets lighter and lighter in comparison. In one of the photos, you'll have the perfect balance between the deep blue sky and the illuminated subject, kind of like the photograph of the lighthouse in Figure 17-9.

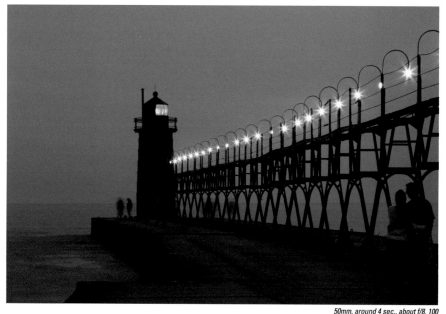

50mm, around 4 sec., about f/8, 100

Figure 17-9: Jewel box lighting at work.

Photographing Fireworks

How do you meter quick explosions of light? Basically, you don't. Turn to any trusted exposure guide (see Chapter 4) and look up fireworks. Many guides say to put your camera on a tripod, set the aperture to f/8 or f/11, and hold the shutter open as long as necessary. Those are the basics, but here's a more detailed description of the process (if you follow it, your pictures may just turn out like Figure 17-10):

1. **Put your camera on a tripod and set the right aperture for the ISO you're using.**

 For ISO 100, use an aperture of f/8; for ISO 200, use f/11; and for ISO 400, use f/16. If you like bolder, brighter bursts, use a wider aperture. If you want to capture the delicate filigree patterns that some bursts have, use a smaller aperture. And if the fireworks start while there's still color in the sky, combine one of the recommended apertures with a shutter speed that will give you a deep blue sky.

2. **Focus the lens at infinity and point it at the place in the sky where you expect the fireworks to appear.**

 If you have a zoom lens, focusing at infinity requires some thought because many zoom lenses can focus past infinity. Before the fireworks start, set the lens at the focal length you want to use. Then focus on some distant object that's at least a block or two away. Don't change the focal length later on without refocusing the lens. (With a lot of recent autofocus lenses, changing the focal length changes the focusing point.)

3. **Set the shutter on B (for bulb) and either hold the shutter button down or use a locking cable release.**

 Using the bulb setting is better than using your camera's long shutter speeds because if you capture a particularly impressive burst of light, you want to be able to close the shutter before it's cluttered up with other bursts. Unlike long shutter speeds, the bulb setting gives you immediate control over when you close the shutter. As for locking cable releases, I tell you all about these in Chapter 18.

4. **Wait until you've recorded one or more bursts and then release the shutter or the locking cable release.**

Knowing where to point your lens involves some guesswork. You can use a wider focal length so you cover more sky and have more of a chance to capture everything (you can always crop the image later), or you can use a longer focal length and take your chances. I've done it both ways.

By handholding your camera, you can sometimes track fireworks. As soon as you hear the initial loud "thunk" of the rocket taking off, follow the rocket's trail of sparks up into the sky until the main package explodes. This method works well more often than you may expect. When handholding your camera in this fashion, forget using a locking cable release. If you have two cameras with you, put one on a tripod with a wide-angle lens and handhold the other with a longer lens.

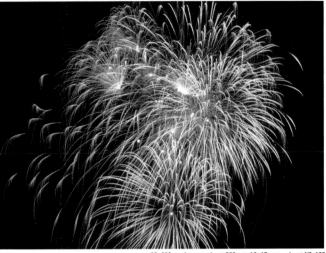

80–200mm lens at about 200mm, 10–15 sec., about f/8, 100

Figure 17-10: Several firework bursts, captured with a long shutter speed.

Most fireworks displays happen in parks, stadiums, and other locations that may not be very visually interesting. To make up for this, try digitally combining a fireworks photo with a photo of a city skyline. Just remember that the lights of the skyline will limit your exposure time. Use the apertures I recommend earlier in this section and pick a shutter speed that's guaranteed to give you a good exposure for the cityscape. Or you can try combining photos that have been taken years apart. Just make sure that the sky in the fireworks photo is truly black.

Figure 17-11 combines four digital photos taken over a span of seven years (I used photo-editing software to create the combined image). The photo of the Las Vegas Strip was taken recently; it combines two exposures: one of the Strip and one of the MGM Grand sign (which I used to replace the overexposed sign in the first photo). The burst in the center was taken seven years earlier with my first digital SLR camera, and the burst on the right was taken several years after that.

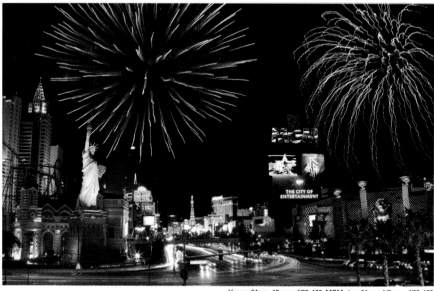

Vegas: 24mm, 15 sec., f/22, 100; MGM sign: 24mm, 1/6 sec., f/22, 100; Center burst: 28mm, 1024 sec., f/5.6, 200; Right burst: 33mm, 7/10 sec., f/6.7, 1600

Figure 17-11: Fireworks over Las Vegas, a combination of four digital images.

Capturing Lightning without Getting Fried

The number one thing you should know about photographing lightning is that it's a dangerous practice. When you shoot lightning, you do it at your own risk. According to what I've read, being struck by a powerful main bolt turns your brain to liquid, and being hit by a small feeder bolt can stop your heart. Be safe whenever you head out to photograph lightning. Bring a friend who knows CPR and have him or her stay in the car. If you get hit by a feeder bolt, your friend can attempt to restart your heart.

If you're ever photographing lightning and your hair starts to stand up on end, make yourself as small as possible by scrunching down in a little ball and putting your feet together. Only your feet should touch the ground.

The procedure for taking pictures of lightning on a dark night (or any quick burst of light, for that matter) is the same as it is for taking pictures of fireworks at night (see the preceding section). Use an aperture of f/8 for an ISO of 100, f/11 for ISO 200, and f/16 for ISO 400. If you want your bolts to look bolder, open up 1 or 2 stops. For thinner bolts, close down 1 or 2 stops. Put your camera on a tripod, use infinity focus, and lock open the shutter until

after you've captured one or more lightning bolts. Then close the shutter and start again. The result should look something like the photo in Figure 17-12, which I shot after driving through a Texas thunderstorm late one night.

50mm, 10–20 sec., about f/5.6, 64

Figure 17-12: Lightning in the clouds.

During the day, you probably aren't going to be fast enough to see a lightning bolt and click the shutter. However, you shouldn't be afraid to try because sometimes a major bolt is preceded by a small feeder bolt. So if you're fast and click the chutter the instant you see the feeder bolt, you may catch the main bolt.

If you want to capture stellar lightning shots in the United States, head west. The arid, southwestern United States is lightning heaven. You get these wonderful, clearly defined storm fronts that you can shoot from a mile or two away as they pass by, leaving you completely dry (and a little safer). In the eastern United States, however, the lightning can be surrounded by so many clouds and rain that seeing it is rather difficult. The lack of a clearly defined, visible storm front also makes photographing lightning more dangerous in this part of the country.

One day I was photographing a sunset in Yukon, Oklahoma. I was all set to head home when the light show was over, but then a thunderstorm rolled in from the southwest. I love lightning, and Mother Nature can provide some great photographic opportunities. So, I set my camera and tripod back up. By this point, the sun had set, and the streetlights had come on.

I wanted long, streaking lights from the cars on old U.S. 66, so a shutter speed of 30 seconds sounded good (this shutter speed was also long enough to catch a full red-green-yellow cycle of the traffic lights. I metered the sky to

the right of the frame and used that as my medium tone, but because my camera meter's limit was 8 seconds (meaning I couldn't meter a 30-second exposure), I had to meter at an equivalent exposure. With my camera shutter set to 8 seconds, the meter told me the correct aperture was f/4. An equivalent exposure would be 30 seconds at f/8, the shutter speed I wanted. (See Chapter 3 for the full story on doing equivalent exposures.) So I set the aperture to f/8 and the shutter to B (for "bulb," which allows shutter speeds for as long as you hold down the shutter button) and plugged in a *locking cable release* (a photographer's tool that allows you to open the shutter without touching the camera).

With my shutter speed determined and the cable release ready, I just needed some lightning. Sometimes a small bolt of lightning is followed by a much bigger second bolt. If you're fast when you see the first pulse of light, you can catch the second. At the first flicker of light, I hit the cable release and counted off 30 seconds to capture the cityscape and car light streaks. Fortunately, I was fast enough to capture the beautiful lightning strike shown in Figure 17-13.

A cable release is an important tool for achieving sharp pictures, especially at longer shutter speeds. It keeps you from jarring the camera when you click the shutter. Even a slight amount of movement can ruin an otherwise great photo. A locking cable release with the camera on the B (bulb) setting keeps the shutter open until you let go of the cable release.

About 50mm, around 30 sec., about f/5.6, 50

Figure 17-13: I used a cable release to capture this lightning shot.

Getting More Creative with Your Night Shots

When you're ready to make your night sky photos a bit more artistically interesting, include something else in the picture that can help frame the picture, like trees or mountains. Here are some more ideas for improving your night sky photos:

- ✔ If you're framing the stars with something nearby, like a tree, you can "paint" the tree with a flash or flashlight during the long exposure.

- ✔ If you don't want star trails, stick with ISO 400, use wide-angle lenses and shutter speeds of no longer than 30 seconds, and point your camera north where the stars move less in a given period of time than they do as you get farther from the North Star and closer to the *celestial equator* (an imaginary line in the sky that's directly above the earth's equator). If you live south of the equator, point your camera at the south celestial pole.

- ✔ If you like star trails and the sky is dark, set the ISO to 100, and use shutter speeds of 8 minutes, 15 minutes, and longer.

- ✔ If you want longer star trails and you have a *very* dark sky, use a medium to long focal length, point your camera toward the celestial equator and away from the North Star (or away from the south celestial pole), and extend your shutter speeds from 30 minutes to an hour, or even longer. The longer the shutter speed, the longer the star trails.

- ✔ If you want circular star trails, point your lens at the North Star (or the south celestial pole in the Southern Hemisphere) and lock the shutter open for 15 minutes or more.

Check out Figure 17-14 for an example of how you can frame your night sky shots and create star trails. When I captured this photo, I was looking at the night sky from the deck of the *Spirit of Columbia,* a small ship sailing Prince William Sound in Alaska. Because the ship was moving, I figured the stars would look erratic. Then insanity (or what I like to call curiosity) kicked in, and I grabbed my tripod, camera, and some lenses and started experimenting. Based on past experience, I decided a shutter speed of about 1 minute would give me a reasonable exposure for the aperture and ISO I was using. Any longer and I was pushing my luck in terms of the ship changing course in midexposure.

15mm, about 1 min., around f/4, 200 at EI 640

Figure 17-14: Stars photographed from the deck of a moving ship.

Playing with Lights at Night

Photographers usually think of light as shining *on* a subject, but sometimes light *is* the subject. There's a wide, wide world of lights out there, just waiting for you to capture it with long shutter speeds. Photographers have used long shutter speeds to achieve creative effects with light in all kind of situations.

You can practice photographing lights year-round, but one of the best times to try taking light photos with long shutter speeds is the December holiday season because lights abound this time of year.

The all-purpose holiday light exposure for ISO 100 is 1 second at f/4. Some equivalent ISO 100 exposures are as follows:

- ✔ 4 seconds at f/8
- ✔ 8 seconds at f/11
- ✔ 15 seconds at f/16

Each combination gives you the same exposure, but the longer shutter speeds give you more time to change the focal length and/or the focus during the exposure. You can use any of these equivalent exposures for the following exercise (although I generally find 4 seconds and 8 seconds to be good for creating special effects):

1. **With your camera on a tripod, focus on some decorated trees or a string of lights.**

2. **After you click the shutter, defocus the lens through the duration of the exposure time.**

3. **Try the exercise again, but leave the lens in focus for the first half of the exposure and then defocus the lens for the second half of the exposure.**

4. **Vary the amount of time that the lens is in and out of focus.**

5. **Try Steps 1 through 4 with a different lens.**

 Some lenses change focal length as the focus is changed, giving you comma-shaped blurs (see Figure 17-15). Other lenses maintain the same focal length as the focus is changed, so you get out-of-focus round balls around each focused light.

Another approach to achieving creative effects with lights and long shutter speeds is to zoom the lens during the exposure. Here's how:

24–105mm lens at 80mm, 4 sec., f/8, 100

Figure 17-15: Defocused lights on a Christmas tree.

1. **Put a zoom lens on your camera and set your camera on a tripod.**

2. **Focus on a group of lights.**

3. **Start at the wide end of the zoom range.**

4. **After clicking the shutter, zoom smoothly to the long end of the zoom range for an exploding effect (see the left side of Figure 17-16).**

 You can vary how long you leave the lens at it widest focal length before you start to zoom.

5. **Start again with the zoom at the wide end of its range.**

6. **Use a 15 second shutter speed with an aperture of f/16.**

7. **As you zoom the lens, stop periodically for a staggered zoom effect (see the right side of Figure 17-16).**

70–200mm lens zoomed from 70mm to 200mm, 8 sec., f/11, 100

70–200mm lens zoomed from 70mm to 200mm, around 15 sec., about f/11, 50

Figure 17-16: Zoomed-in Christmas lights, shot to look like spotlights (left), and shot to create a staggered effect (right).

Defocusing and/or zooming a lens during a long exposure is a technique that's suitable in a variety of situations when you're trying to shoot lights at night, so get out there and experiment. Just don't show all of your experiments to everybody. You want to be able to form your own opinions of when lighting effects make sense and when they're overkill. Used sparingly, these techniques can be very effective.

After practicing with a string of Christmas lights, you can start looking for creative ways to photograph the lights you find around you the rest of the year. For example, while waiting for pizza one night, I was intrigued by a sign in the restaurant's window. Out came my camera with a 70–200mm zoom lens. I braced my elbows on the table for extra stability and experimented with various shutter speeds and *zoom speeds* (the

70–200mm lens zoomed from 70mm to 200mm, 1/2 sec., f/11, 100

Figure 17-17: What happens when you shoot a pizza sign at a long shutter speed.

speeds at which I zoomed from one focal length to the other). The photo in Figure 17-17 is my favorite of the bunch. At a shutter speed of 1/2 second, I had to zoom quickly. I used the camera's self-timer so one hand could steady the camera and lens, leaving the other hand ready to zoom the lens as soon as the shutter opened.

Part V
The Part of Tens

The 5th Wave — By Rich Tennant

RICHTENNANT

X-RAY ROOM

"If you don't mind, my kid's got a new digital camera and he's looking for fun things to photograph for school..."

In this part . . .

The extra info contained within this part is both interesting and helpful. Chapter 18 introduces you to some photographic goodies that are guaranteed to simplify your photographic life. (Some of them can even allow you to take pictures that you couldn't take before.) Chapter 19 introduces you to photographic decisions you can make now that wind up costing you later. You're going to have far fewer what-was-I-thinking moments thanks to the information in this chapter.

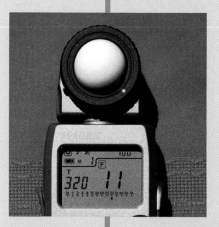

18

Ten Accessories to Make Your Life Easier

*Y*ou could spend your life collecting photo accessories (and some photographers do just that), but not all accessories are created equal. Some make a big difference in your photography; others just gather dust on a shelf or get lost in an old camera bag. To help you avoid cluttering your house with unnecessary digital photography accessories, in this chapter, I list the ten accessories that either expand your photographic possibilities or just make your life easier. (Head to my Web site, JimDoty.com, to see illustrations of and more information about all of these accessories.)

The value of any accessory depends on what you like to shoot, so pick and choose the accessories that will make the biggest difference for you and the way you shoot. The best accessory makes shooting easier or improves the look of your images.

Extending Your Exposure Range with a Tripod

Next to your camera and lenses, nothing makes a bigger difference in your photography than a good tripod. In particular, a tripod allows you to create images in all kinds of low-light situations that would be impossible to create without a tripod.

A good tripod is

- ✔ Sturdy enough to easily support your heaviest lens and camera combination
- ✔ Light enough for you to carry
- ✔ Tall enough to reach your normal viewing height without extending the center column very much
- ✔ Flexible enough to use in a variety of situations
- ✔ Well made and well designed

Manfrotto and Gitzo are two highly respected and widely used tripod brands. If you're looking for a smaller, lighter, economical tripod that's still sturdy and very well made, something in the Manfrotto 190X series is a good option. For a normal-size tripod, I suggest a tripod from the Manfrotto 055X series. If you want high quality in a lighter-weight tripod and don't mind paying a higher price for the newer high-tech materials, such as carbon fiber, opt for something from the Gitzo Mountaineer series. (**Note:** My tripod suggestions are biased due to my preference for landscape, nature, and wildlife photography. You're welcome to consider them as starting points, but you should ultimately pick a tripod that's best suited to your needs and the kind of photography you like to do.)

Don't forget to also purchase a tripod head to go on top of your tripod legs. I started with three-way tripod heads that have separate controls for panning the head left and right, tilting the head up and down, and going from horizontal to vertical. If you take your time and mostly shoot landscapes, a three-way head (like the Manfrotto 056 3D junior camera head) is a good choice. If, however, wildlife or other moving subjects are in your future, a quality ball head is the best choice.

If you do landscape and nature photography, invest in a tripod that also has independent leg movement for uneven terrain (no center bracing) and legs that spread wide so you can get low to the ground. Prefer to photograph football games (or other sporting events) from the sidelines? Purchase a good monopod instead because tripods aren't allowed on the sidelines of many sporting events.

Simplifying How You Put the Camera on the Tripod with a Quick-Release System

An Arca-Swiss compatible quick-release system solves the problem of having to fumble to attach your camera to a tripod when you're taking photos on a cold, rainy night. This system has two parts:

- ✔ A grooved, dovetail mounting plate or bracket that you attach to the bottom of the camera via the tripod socket
- ✔ A clamp with "jaws" that screws onto the tripod head

For less than $100, you can buy a universal mounting plate for your camera and a clamp to screw onto your tripod head (see Figure 18-1). However, I strongly recommend you purchase a mounting plate or bracket that's custom designed to fit your specific camera model. Even better is a custom-fitted L-bracket that wraps around your camera with dovetail grooves on both the bottom and the left side so you can mount your camera horizontally or verti-cally without having to tip your tripod head to the side (see Figure 18-1). This way the weight of the camera is always over the tripod head, which is more stable than tilting a camera to the side. ***Note:*** If you have a telephoto lens that mounts on a tripod, you need a mounting plate for it too.

My two favorite sources for Arca-Swiss compatible quick-release systems are Kirk Enterprises (`www.kirkphoto.com`) and Really Right Stuff (`www.really rightstuff.com`). Both companies are excellent to deal with and make high-quality ball heads that have the clamp manufactured onto the head.

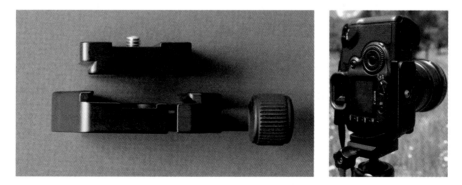

Figure 18-1: Mounting plate and clamp (left); L-bracket (right).

Eliminating Camera Shake with a Cable Release

At longer shutter speeds (usually slower than 1/60 second down to around 2 seconds), the act of pushing the shutter button can cause a little blurring of the image — even with the camera on a tripod. You can fix this problem by using a *locking cable release,* a device that's specific to the camera model and eliminates vibrations between the photographer and the camera. (***Note:*** At shutter speeds longer than 2 seconds, the vibration time is so short in comparison to the total exposure time that the blurring usually goes away — unless of course you're really heavy handed with the camera.)

The locking feature of the cable release is handy when you need to use exposure times that are longer than the longest shutter speed on your camera (a lot of recent cameras have a limit somewhere between 4 seconds and 30 seconds). Exposure times of 1 minute, 4 minutes, 15 minutes, and longer are no longer a problem. Just set the camera on B (for bulb), lock open the shutter with your locking cable release, check your watch, and wait. When enough time has passed, release the cable release.

Some electronic locking cable releases have a built-in timer so you don't even need to check your watch, and some also have an *intervalometer,* a device that allows you to program your camera to take a whole series of images at set intervals of time at any shutter speed you choose, long or short, or on autoexposure.

Staying Straight with a Double Bubble Level

Take my word for it: It's all too easy to end up with photos that feature leaning horizons. To avoid this embarrassing look in your images, invest in a double bubble level, which is almost as fun to use as it is to say. Just slide one into your *hot shoe* (the mounting slot on top of many cameras where you usually put an auxiliary flash unit) and use the lower bubble when you're shooting horizontally and the upper bubble when you're shooting vertically.

If you're using a shoe-mount flash unit, level the camera first and then put the flash unit in the hot shoe.

Note: Some camera models have a built-in level in the viewfinder or on the rear camera screen when the camera is in live view mode (see Chapter 6 for the scoop on this). Check your manual to find out whether yours does. If you have a viewfinder level, you don't need an accessory level. If you have a live view level but you aren't shooting in live view mode, you can decide for

yourself whether it's more convenient to pop over to live view to level your camera or whether you prefer having an accessory level.

Creating Better Images with Filters

The two most important filters for landscape and nature photographers are a polarizing filter (see Chapter 13) and a graduated neutral density filter (see Chapter 5). Although infrared filters are also cool to play with. The following sections cover the basics of what you need to know about filters.

Choosing filters

As with many products, the quality of a filter is related to its price. Singh-Ray, Heliopan, and B+W are good brands for polarizing filters. As for graduated neutral density filters, I happen to prefer the Singh-Ray brand in a size that fits a Cokin P–sized rectangular filter holder. With this system, you can slide the filter up and down in the holder or rotate it to match a slanted horizon. A 2-stop, soft-edge filter or a 2-stop, hard-edge filter is a good first choice.

If you want to avoid the expense of a graduated neutral density filter, you can take identical, tripod-mounted photos of the same scene with different exposure times (keep the focus and aperture the same) and combine them later by using photo-editing software.

Getting the most out of polarizing filters

Unlike graduated neutral density filters, you can't simulate the glare-removing qualities of a polarizing filter in the digital darkroom. A polarizing filter is the only way to go for fixing glare, and it works on both sunny and cloudy days. Here are some of the things you can do with a polarizing filter:

✔ Remove some or all of the glare on glass when you're shooting through a window (provided you're shooting at the right angle)

✔ Get rid of reflections on water (which isn't always a good thing but is a big help when you want to see below the water's surface)

✔ Darken blue skies when you use the filter at a 90-degree angle to the sun

✔ Intensify a rainbow when you rotate the filter slightly for minimum effect or erase a rainbow if you rotate the filter for maximum effect

You can rotate a polarizing filter to increase or decrease the amount of polarization. To work properly, the "camera side" of a polarizing filter needs to face the camera. With a threaded filter, the camera side is obvious. With

a threadless filter that drops into a slotted holder, be sure you know which side is which (just take a look through the filter and rotate it to figure it out).

Most modern cameras can't meter or autofocus accurately through a linear polarizing filter. (Without getting bogged down in the physics of how these filters work, suffice it to say that linear polarizing filters confuse the metering and autofocus systems of modern cameras.) Consequently, you'll probably need to buy a circular polarizing filter; check your camera's manual to confirm whether you do. ***Note:*** The terms *linear* and *circular* refer to how the filter works with the light, not the physical shape of the filter.

Taking infrared photos

Digital cameras vary in their sensitivity to infrared light, but many of them can take infrared photos if you use an infrared filter like the Hoya R72 to eliminate most of the visible light spectrum. If you, like me, like the light, glowing look of vegetation in infrared light, try an infrared filter. ***Note:*** These filters are very dark, so don't expect to be able to see through one or focus with the filter on your lens.

To use an infrared filter, set your camera and lens on a tripod and manually focus the lens. Then add the filter. In full sunlight at ISO 100 in manual mode, set the aperture to f/8 and the shutter somewhere between 30 and 60 seconds (note that each camera model's response to the light will be a little different). At f/16 in full sunlight with an ISO of 100, your shutter speed will be around 2 to 4 minutes. The photo you take will look red. Use photo-editing software to convert it to a black-and-white image and adjust the look with levels or curves in the software.

Handling Difficult Situations with an Exposure Guide

In difficult exposure situations where the camera meter isn't much help, a good exposure guide is a better alternative than flat-out guessing. I recommend the Black Cat Extended Range Exposure Guide, but other exposure guides are out there. Really, any guide is better than no guide when you're facing a puzzling exposure situation. (You can read more about exposure guides in Chapter 4.)

Simplifying Exposure with an Incident Light Meter

There's nothing quite like an incident light meter, whether digital or analog, for simplifying exposure decisions when you're faced with scenes possessing a broad range of exposure tonalities. Most of these meters also feature a built-in ability to meter flash. If you use off-camera flash in manual mode with an umbrella or you end up getting studio lights, an incident light meter will make your exposure life a lot easier.

When using a digital incident light meter, set the ISO, choose an aperture or shutter speed, point the white dome in the appropriate direction (I explain how to figure this out in Chapter 4), and push the button. The meter will then give you a recommended shutter speed if you picked the aperture, or vice versa. ***Note:*** Don't forget to adjust for exposure compensation if need be.

With an analog incident light meter, set the ISO, point the white dome, and push the button. Turn the main dial until the meter needle reads zero. The metering scale will show you all the possible aperture and shutter speed combinations at once. If you want to use some exposure compensation, set the needle to whatever plus or minus amount you want and read the aperture and shutter combinations.

Less expensive alternatives to incident light meters include ExpoDiscs, gray cards, and calibration targets (I cover these tools in Chapter 4). Any one of these options would be a valuable addition to your camera bag.

Living in Panorama Heaven

If you use an Arca-Swiss compatible quick-release system like the one I describe earlier in this chapter and you want to do panoramic photography, a great panoramic system is available from Really Right Stuff. All you need to get started are a PCL-1 panning clamp and an MPR-CL II nodal slide. Drop the panning clamp into the jaws of your tripod head, slide the nodal slide into the panning clamp, mount your camera on the nodal slide, and you're ready to start creating beautiful panoramas. For more information, go to www. reallyrightstuff.com and click the Panoramas Made Simple link.

Using a Flash Bracket and an Off-Camera Shoe Cord

Getting your flash up above the camera has the benefit of eliminating red eye and, more importantly, dropping shadows down behind your subject. That's exactly what a flash bracket does for you. Your camera sits on the bottom of the bracket, and your flash sits on top of the bracket.

Flash brackets come in every design imaginable. The ideal flash bracket allows you to rotate the camera from horizontal to vertical and keeps the flash above the lens. An example is the Stroboframe Camera Flip bracket.

Improving the Light with an Umbrella

Getting the flash off the camera and bouncing the light off an umbrella dramatically improves the look of anyone's flash photography. People just look better in the softer light that an umbrella provides.

In order to mount the flash and umbrella on a light stand or tripod, you need a bracket. As I note in Chapter 10, you also need a way for the camera to talk to the flash. If you want to explore a whole world of flash information, check out www.strobist.blogspot.com.

Ten Decisions That Can Cost You

*P*hotography is all about decisions. First, and most important, are the artistic decisions that determine the look of your images. Then come the technical decisions that determine whether or not the images you end up with in the camera are the images you envisioned when you clicked the shutter. Next up are all the decisions that determine whether or not you keep or accidentally lose the photos you've taken. Creating a wonderful image only to have it evaporate before it makes it to your computer, the family album, or your Web site is a terrible feeling.

This chapter guides you in making the right nonartistic decisions so the photos you want to create are the photos you end up with and get to keep.

Being Lax about Photo Storage

Even if you're completely digital now, you probably have important photos from your film days. My guess is you don't want them to fade away prematurely, but poor decisions can easily cut the life of your analog photos to a fraction of their expected life span.

Color dyes in film and prints fade with time. However, you do have a few options for preserving your precious images as long as possible. If you still shoot film, buy films that are more resistant to fading. A film that lasts 100 years without significant fading, all things being equal, is better than a film that fades in 30 years.

Head to www.wilhelm-research.com to download a free copy of *The Permanence and Care of Color Photos,* the best resource for film life information. Just click the link at the top of the page.

The other thing you can do to protect your analog photos is to store them under the right conditions and in the safest materials. Your prints on display will last longer if you hang them where they're never hit by direct sunlight. (Actually, the less light the better.) Prints framed under *UV glass* (glass that filters out harmful UV rays) last twice as long as prints framed under regular glass. If you have some prints for which you don't have the original negatives, scan them, display a copy, and store the original in the dark in an archival storage medium, such as poly pages.

The good words for film and print storage are *polypropylene, polyethylene,* and *polystyrene.* These are the "good polys" and the preferable storage materials. The bad poly is *polyvinylchloride* (PVC). PVC gives off harmful gases that can damage film emulsions.

Scan your precious old family photos while they look like the left-hand photo in Figure 19-1. If you don't, some of them will fade to look like the photo on the right.

Figure 19-1: An old family photo in good shape (left) and seriously faded (right).

Forgetting What You Really Need

You can't use it if you don't have it with you, so if you forget your equipment, you're out of luck. For instance, if you want to take pictures of the stars in the night sky and you forget your fast 50mm f/1.8 lens or your 24mm f/2.8 lens, you may have a more difficult time getting what you want with a zoom lens at f/5.6.

Of course, you can't use anything that requires a battery if the battery dies, so always keep a spare battery for your camera around and make sure it

stays charged. If you have a separate flash unit, have spare batteries for that too. If you tend to forget things when you're away from home, I suggest keeping a spare camera battery and charger in the trunk of your car. It's also a good idea to keep a checklist of your essential gear so that you don't forget anything vital.

Overjuicing Your JPEG Images

Most digital cameras allow you to pick from a variety of picture styles (including bland, normal, and dripping with color). You can also set individual image parameters (such as contrast, color saturation, and sharpening). If you like your JPEG files to come out of the camera looking great without needing to do anything to them on your computer, you can use these image parameters to juice up your images, but you have to do so carefully.

Whenever you jazz up the contrast, color saturation, and sharpening in the camera, you risk severely limiting how much you can work with your photos after the fact on your computer. If you go to correct an overjuiced image by changing the exposure, adjusting the color, or digitally retouching parts of the image, you can end up with all kinds of ugly digital gremlins (think blotchiness and weird localized color shifts).

A safer approach is to set your camera to bland (or normal, standard, neutral, or whichever other word the manufacturer uses to indicate this setting), which is how the images look when they come out of the camera. The color looks a bit muted, the contrast is low, and very little sharpening is applied. These settings give you the maximum potential for working with your images after the fact on your computer.

Shooting Small JPEGs

You get the best image quality possible if you shoot the largest JPEG files your camera is capable of producing. Memory is cheap, so don't scrimp on file sizes.

If you make too large a print from a small file size, the quality will inevitably fall apart. Save yourself this hassle and just shoot larger-size files from the start.

Figures 19-2 and 19-3 are cropped from two 13-x-17-inch head-and-shoulders portraits. Figure 19-2 was printed from a full-sized JPEG file, and Figure 19-3 was printed from a small JEPG file. The quality difference is dramatic.

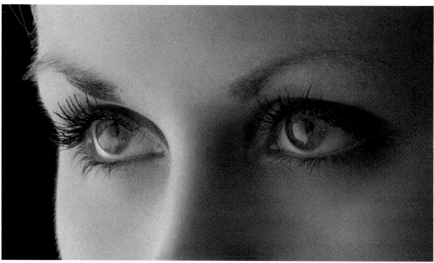

65mm, 1/8 sec., f/8, 400

Figure 19-2: Eyes, close-up from a large JPEG file.

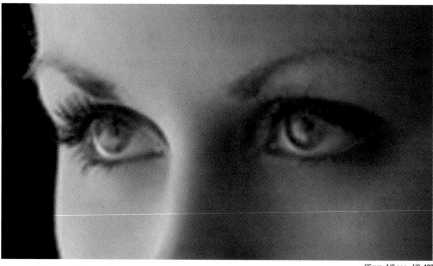

65mm, 1/8 sec., f/8, 400

Figure 19-3: Eyes, close-up from a small JPEG file.

Asking JPEGs to Do a Raw Job

When your camera creates a Raw file, it saves all the image information that it captured when you pressed the shutter. Later on you use image-editing software to convert the Raw file into a photo that has the look you want. So

in the same way that big JPEG files are better than small JPEG files (see the preceding section), Raw files are even better than JPEG files. Why? Because you have all the camera-captured information to work with. If you decide to change an image by using your favorite image-editing software, a Raw file allows you to make bigger changes before you encounter problems such as posterization. A Raw file also has a lot more exposure latitude. One of the insights from the color checker exposure exercise in Chapter 3 is that you can overexpose a Raw file by 1 stop and still have a great image. With a JPEG file, even 1 stop of overexposure means you have an unusable image.

Even if you don't want to deal with Raw files now, consider shooting RAW+JPEG files in your camera. This way you have the Raw files if you want to use them in the future.

The photos in Figures 19-4, 19-5, and 19-6 are from a simultaneous RAW+JPEG capture. The photo was deliberately overexposed by 2 full stops. Figure 19-4 is the uncorrected JPEG file straight from the camera. In Figure 19-5, I tried to correct the exposure of the JEPG file by using Adobe Photoshop, but the results aren't very good, even after a lot of work. The highlights are too far gone, the sunlit side of the house is totally blown out, and the blue in the sky has lost much of its color quality. Figure 19-6 is the Raw file after being opened and processed with Adobe Camera Raw (ACR) using the Exposure and Recovery sliders — a process that took all of 30 seconds. For a seriously overexposed file, this photo came out surprisingly well. Note that the Raw file is clearly superior to the JPEG.

24–105mm lens at 24mm, 1/30 sec., f/11, 100

Figure 19-4: Original JPEG file.

Figure 19-5: Corrected JPEG file.

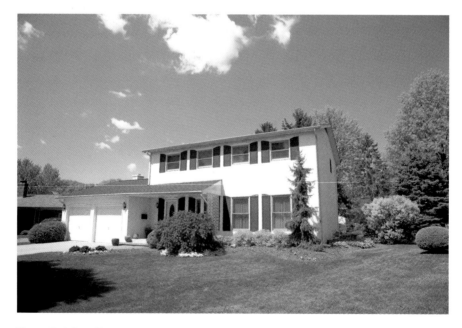

Figure 19-6: Raw file processed with Adobe Camera Raw.

Using and Abusing Memory Cards

Filling up a memory card and then losing all or most of your photos is a terrible feeling. You improve your chances of not losing images by doing all you can to prevent the data on a memory card from getting corrupted. I recommend putting the following pointers into action:

- **Buy quality, name-brand memory cards such as SanDisk and Lexar.** The cheap price of a no-name card won't make up for the pain of lost images.

- **Format a new memory card in the camera before taking your first picture on it.** Doing so helps protect the integrity of the file structure.

- **Have separate memory cards for each camera body that you own.** When you buy a new camera, buy new cards to go with it. Don't use cards from another camera.

- **Use a card reader to download files on the memory cards to your computer.** Don't download photos directly from the camera; instead, buy a quality, name-brand memory card reader.

- **Avoid using your computer to format the memory card or delete images.** Format the card only in the camera.

- **After downloading photos to your computer, use the proper procedure on your operating system to safely remove the hardware (on a PC) or eject the card reader (on a Mac) before unplugging the card reader from the USB port.** Again, this helps maintain the files' integrity.

- **Always format a memory card when you put it back in the camera after downloading the photos to your computer.** Don't put a memory card back in the camera and take more pictures without formatting the card first.

- **Use the camera to format the memory card instead of deleting all the photos.** You can delete an occasional photo while you're shooting, but keep deletions to a minimum.

- **Always leave a little room on a memory card.** When you get to the point where you only have room for a few more photos, switch to another memory card.

- **Have several cards for each camera.** Memory cards are cheap. It's better to have a major photo shoot on two or three cards rather than one big card. That way if a card dies, you only lose part of the shoot and not the whole thing.

Giving Up on Lost Images

If you have a problem with a memory card and you think you've lost some images, don't use the card; don't take a single additional picture; don't format the card; don't delete any images from the card; and, most importantly, don't give up on recovering the images. Odds are your photos (most of them, anyway) are still on the card; the file names have simply been corrupted so that your computer (and maybe your camera) can't see the photos.

Use PhotoRescue (available at www.datarescue.com for around $30) and a card reader to recover your photos from the memory card. PhotoRescue is one of the best photo-recovery programs out there. It can't rescue all lost photos every time, but it has recovered photos when most other programs have failed.

Chimping Too Much or Too Little

Chimping (looking at photos on the back of your digital camera) is fun and one of the great reasons to have a digital camera. But if you're chimping too much, you could miss a great moment.

On the other hand, if you don't chimp enough during a photo session, you could miss a problem. Snap several photos and wait for a nonactive moment to look at a few photos just to make sure everything is okay. Avoid the temptation to look at every single image.

Failing to Back Up Your Images

Hard drives fail, and photos are lost. If your photos aren't backed up, they can be gone forever. Reliable data recovery companies charge hundreds of dollars to attempt to recover files from your hard drive — a service that you pay for even if the company isn't successful in recovering your files.

Here's a simple rule that can spare you cash and frustration if a hard drive crashes: Have at least two sets of your photos and keep them in two separate locations. At home, I download photos to my computer and then transfer them to external hard drives and DVDs. I store one set of photos at home and the other set in a different location. This way if there's a disaster at one location, the other set is still safe. You can keep a backup set at a relative's or friend's home or at an indoor storage facility. Or you can swap backup storage space with another photographer.

Fussing with Proprietary Raw Files

Raw files have become a digital quagmire because most camera manufacturers have their own proprietary Raw file formats that tend to change over the years. Consequently, some older Raw file formats have been orphaned. Some photographers can't open Raw files from several years ago because the old conversion software doesn't work with the latest computer models. Fortunately, there's an alternative: the DNG file format, which stands for Digital Negative. Adobe created the DNG format as a publicly available Raw format for digital camera files.

If you shoot Raw files, do the following:

- ✔ **Set your camera to capture RAW+JPEG files so you at least have a JPEG copy of all of your images.** JPEG files, new or old, are universally readable with all kinds of software.

- ✔ **Use Adobe's free DNG converter and convert all of your Raw files to the DNG file format.** DNG files should be readable for a long time to come, and there's a lot of software out there that's capable of reading DNG files. You can find a good Raw-to-DNG file converter at www.adobe.com/products/dng.

Not Visiting the Digital Darkroom

If you have digital images that are dark (but not too dark) or a little too light (but don't have blown-out highlights), there is hope. You can fix them on your computer with the appropriate software, a setup that's often referred to as the *digital darkroom*. The digital darkroom provides all kinds of ways to correct for exposure errors. The two most important methods are levels and curves.

Adjusting levels is a quick, simple, and effective way to correct basic exposure problems. *Levels* refers to the brightness level of the pixels in the photograph. Some version of levels adjustment can be found in most varieties of image-editing software. The photo of Rachel on the left in Figure 19-7 is seriously underexposed, so I used the Levels feature in Adobe Photoshop to lighten the image in less than 30 seconds. The results are on the right.

Using Curves to add contrast gives you more control than Levels. You can do basic exposure adjustments (just like with Levels), but you can also do a lot more. This function is called *Curves* because when you make changes in the Curves dialog box, the straight diagonal line that represents the contrast in the original image bends into simple or complex curves.

The flight photo on the left in Figure 19-8 looks pretty flat and a little dark. All of the contrast is lost due to the high moisture content in the air, so photos

taken from a plane often look flat. The solution for this photo is to correct the exposure with Levels and add some contrast with Curves. The photo on the right looks much more appealing.

Working with Photoshop and other software in the digital darkroom (such as Lightroom and Aperture) is really beyond the scope of this book. I would need many more pages to give you adequate instruction. You should check out the latest version of *Photoshop For Dummies* by Peter Bauer and the fine folks at Wiley Publishing.

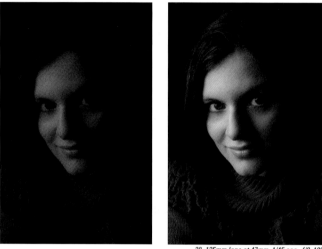

28–135mm lens at 47mm, 1/45 sec., f/8, 100

Figure 19-7: Rachel before and after level corrections.

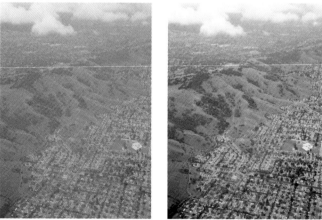

24–105mm lens at 47mm, 1/40 sec., f/11, 100

Figure 19-8: Flight photo before and after changes with Curves.

Index

• *M* •

Notes

Apple & Macs

iPad For Dummies
978-0-470-58027-1

iPhone For Dummies,
4th Edition
978-0-470-87870-5

MacBook For Dummies, 3rd
Edition
978-0-470-76918-8

Mac OS X Snow Leopard For
Dummies
978-0-470-43543-4

Business

Bookkeeping For Dummies
978-0-7645-9848-7

Job Interviews
For Dummies,
3rd Edition
978-0-470-17748-8

Resumes For Dummies,
5th Edition
978-0-470-08037-5

Starting an
Online Business
For Dummies,
6th Edition
978-0-470-60210-2

Stock Investing
For Dummies,
3rd Edition
978-0-470-40114-9

Successful
Time Management
For Dummies
978-0-470-29034-7

Computer Hardware

BlackBerry
For Dummies,
4th Edition
978-0-470-60700-8

Computers For Seniors
For Dummies,
2nd Edition
978-0-470-53483-0

PCs For Dummies, Windows
7 Edition
978-0-470-46542-4

Laptops For Dummies,
4th Edition
978-0-470-57829-2

Cooking & Entertaining

Cooking Basics
For Dummies,
3rd Edition
978-0-7645-7206-7

Wine For Dummies,
4th Edition
978-0-470-04579-4

Diet & Nutrition

Dieting For Dummies,
2nd Edition
978-0-7645-4149-0

Nutrition For Dummies,
4th Edition
978-0-471-79868-2

Weight Training
For Dummies,
3rd Edition
978-0-471-76845-6

Digital Photography

Digital SLR Cameras &
Photography For Dummies,
3rd Edition
978-0-470-46606-3

Photoshop Elements 8
For Dummies
978-0-470-52967-6

Gardening

Gardening Basics
For Dummies
978-0-470-03749-2

Organic Gardening
For Dummies,
2nd Edition
978-0-470-43067-5

Green/Sustainable

Raising Chickens
For Dummies
978-0-470-46544-8

Green Cleaning
For Dummies
978-0-470-39106-8

Health

Diabetes For Dummies,
3rd Edition
978-0-470-27086-8

Food Allergies
For Dummies
978-0-470-09584-3

Living Gluten-Free
For Dummies,
2nd Edition
978-0-470-58589-4

Hobbies/General

Chess For Dummies,
2nd Edition
978-0-7645-8404-6

Drawing
Cartoons & Comics
For Dummies
978-0-470-42683-8

Knitting For Dummies,
2nd Edition
978-0-470-28747-7

Organizing
For Dummies
978-0-7645-5300-4

Su Doku For Dummies
978-0-470-01892-7

Home Improvement

Home Maintenance
For Dummies,
2nd Edition
978-0-470-43063-7

Home Theater
For Dummies,
3rd Edition
978-0-470-41189-6

Living the
Country Lifestyle
All-in-One
For Dummies
978-0-470-43061-3

Solar Power Your Home
For Dummies,
2nd Edition
978-0-470-59678-4

Available wherever books are sold. For more information or to order direct: U.S. customers visit www.dummies.com or call 1-877-762-2974.
U.K. customers visit www.wileyeurope.com or call (0) 1243 843291. Canadian customers visit www.wiley.ca or call 1-800-567-4797.

Internet

Blogging For Dummies,
3rd Edition
978-0-470-61996-4

eBay For Dummies,
6th Edition
978-0-470-49741-8

Facebook For Dummies, 3rd
Edition
978-0-470-87804-0

Web Marketing
For Dummies,
2nd Edition
978-0-470-37181-7

WordPress
For Dummies,
3rd Edition
978-0-470-59274-8

Language & Foreign Language

French For Dummies
978-0-7645-5193-2

Italian Phrases
For Dummies
978-0-7645-7203-6

Spanish For Dummies,
2nd Edition
978-0-470-87855-2

Spanish For Dummies,
Audio Set
978-0-470-09585-0

Math & Science

Algebra I For Dummies,
2nd Edition
978-0-470-55964-2

Biology For Dummies,
2nd Edition
978-0-470-59875-7

Calculus For Dummies
978-0-7645-2498-1

Chemistry For Dummies
978-0-7645-5430-8

Microsoft Office

Excel 2010 For Dummies
978-0-470-48953-6

Office 2010 All-in-One
For Dummies
978-0-470-49748-7

Office 2010 For Dummies,
Book + DVD Bundle
978-0-470-62698-6

Word 2010 For Dummies
978-0-470-48772-3

Music

Guitar For Dummies,
2nd Edition
978-0-7645-9904-0

iPod & iTunes
For Dummies,
8th Edition
978-0-470-87871-2

Piano Exercises
For Dummies
978-0-470-38765-8

Parenting & Education

Parenting For Dummies,
2nd Edition
978-0-7645-5418-6

Type 1 Diabetes
For Dummies
978-0-470-17811-9

Pets

Cats For Dummies,
2nd Edition
978-0-7645-5275-5

Dog Training For Dummies,
3rd Edition
978-0-470-60029-0

Puppies For Dummies,
2nd Edition
978-0-470-03717-1

Religion & Inspiration

The Bible For Dummies
978-0-7645-5296-0

Catholicism For Dummies
978-0-7645-5391-2

Women in the Bible
For Dummies
978-0-7645-8475-6

Self-Help & Relationship

Anger Management
For Dummies
978-0-470-03715-7

Overcoming Anxiety
For Dummies,
2nd Edition
978-0-470-57441-6

Sports

Baseball
For Dummies,
3rd Edition
978-0-7645-7537-2

Basketball
For Dummies,
2nd Edition
978-0-7645-5248-9

Golf For Dummies,
3rd Edition
978-0-471-76871-5

Web Development

Web Design
All-in-One
For Dummies
978-0-470-41796-6

Web Sites
Do-It-Yourself
For Dummies,
2nd Edition
978-0-470-56520-9

Windows 7

Windows 7
For Dummies
978-0-470-49743-2

Windows 7
For Dummies,
Book + DVD Bundle
978-0-470-52398-8

Windows 7 All-in-One
For Dummies
978-0-470-48763-1